MW01056576

THE ART OF LOVING KRISHNA

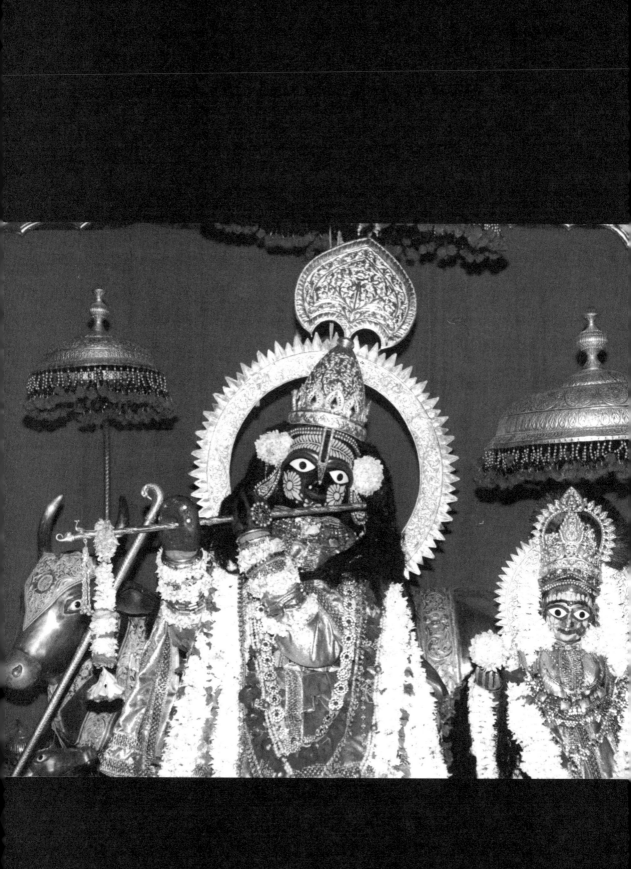

THE ART OF LOVING
KRISHNA

Ornamentation and Devotion

Cynthia Packert

Indiana University Press

Bloomington & Indianapolis

This book is a publication of

Indiana University Press
601 North Morton Street
Bloomington, Indiana 47404-3797 USA

www.iupress.indiana.edu

Telephone orders	800-842-6796
Fax orders	812-855-7931
Orders by e-mail	iuporder@indiana.edu

⊖The paper used in this publication meets the
minimum requirements of the American National
Standard for Information Sciences—Permanence of
Paper for Printed Library Materials, ANSI Z39.48-1992.

Manufactured in the United States of America

Library of Congress Cataloging-in-Publication Data

Packert, Cynthia.
 The art of loving Krishna : ornamentation and devotion / Cynthia Packert.
 p. cm.
 Includes bibliographical references and index.
 ISBN 978-0-253-35478-5 (cloth : alk. paper) — ISBN 978-0-253-22198-8 (pbk. :
alk. paper) 1. Krishna (Hindu deity)—Art. 2. Hindu decoration and ornament—
India—Vrindavan. 3. Hindu decoration and ornament—India—Jaipur. 4. Hindu
temples—India—Vrindavan. 5. Hindu temples—India—Jaipur. 6. Krishna (Hindu
deity)—Cult. I. Title. II. Title: Ornamentation and devotion.
 N8195.3.K7P33 2010
 704.9'48945—dc22
 2009048172

1 2 3 4 5 15 14 13 12 11 10

For Nick and Mira,
the two greatest blessings in my life

Contents

Acknowledgments *ix*

Prologue: Seeing Krishna, Loving Krishna *xv*

INTRODUCTION *A Sense of Place, an Open Heart, and an Educated Eye* *1*

1 The Radharamana Temple *Divine Time, All the Time* 28

2 The Radhavallabha Temple *One Is Better than Two* 74

3 The Govindadeva Temple *From the King's God to the People's God* 123

4 Krishna to Go 176

CONCLUSION *All Dressed Up and Everywhere to Go* 200

Notes 209

Bibliography 219

Index 225

Acknowledgments

Just as an Indian cook blends a number of different ingredients to produce a *masala* ("spice") mixture, so is this book the outcome of the work of many different contributors. And, like a well-blended *masala,* where one or more flavors might be dominant but the whole is the complex sum of its many parts, this book has benefited from some contributors more than others—but every single contribution, no matter how small, has made it richer, deeper, and, I hope, more enticing. I am deeply thankful for the consistent generosity that everyone with whom I have worked has extended to me over the course of far too many years and repeated trips to India.

Learning to see and understand the complexities of how India's beloved god Krishna is visually presented for daily worship in certain temples in North India and what those visual presentations mean, both in their details and in their entirety, took me a very long time. I was learning a new language, and I fear I was a frustratingly slow learner. In my defense, part of the learning process involved *unlearning* a lifetime of conditioned responses and priorities when looking upon works of art, especially religious art. I had to learn to see with my heart, and not just my eyes and head. Like the Tin Man in *The Wizard of Oz,* I needed to learn that my heart was in place before I could trust what it was telling me. For Krishna's devotees, an open heart is the first and most important ingredient in worship, and from that place of surrender, I learned, anything and everything is possible. And, once I was ready, my eyes saw things differently and my head followed suit.

Of those who reeducated me, I owe my greatest thanks to David Haberman and Shri Shrivatsa Goswami of the Radharamana temple for introducing me to the visual culture of Krishna worship in Vrindaban and Jaipur and for alerting me to important distinctions in sectarian histories and theologies. David's extraordinary scholarship on Krishna and Braj inspired me to experience the totality

of the subject: the history, hagiographies, geography, theology, ritual practices, aesthetics, and daily features of this immensely rich aspect of Hinduism. The study and appreciation of Krishna and Krishna worship are inexhaustible, and I have David to thank for introducing me to this intoxicating world. I also want to extend my gratitude to David's wife, Sandy Ducey, and their children, who welcomed me to Vrindaban long ago at the outset of this study. To say I could not have done this research without Shrivatsa Goswami is an understatement. I came to this enterprise girded with a list of academic questions and assumptions and almost immediately realized I needed new equipment. Shrivatsa was instrumental in gently, but firmly, steering me away from over-analyzing everything I saw before I really saw it. His incisive questions and perfectly timed challenges—laced with wonderfully humorous stories—stayed with me long after our meetings in his office at the ashram. The contacts he helped to make for me and the openness and generosity of his assistance were invaluable and made an enormous difference in the quality of my research. I also want to thank Shrivatsa's wife, Sandhya, for her wonderfully helpful insights about the aesthetics and meanings of *shringar* (ornamentation) and the temple arts. And finally, I owe a debt of gratitude to Shrivatsa's father, Shri Purushottama Goswami, who has welcomed and tolerated the foreign scholars who join his family in celebrating Krishna. Whether as scholars, devotees, aesthetes, or curious visitors, all who behold the care and beauty with which Maharaj-ji and his family tend to Radharamana-ji are moved by the sincerity and the caliber of their service to Krishna. I hope this work does some small justice to the contributions of this family to the living arts of Vrindaban.

To Robyn Beeche, I owe more than I can possibly repay. From the first moment I was introduced to her stunning images of temple *darshan*s, I have admired her extraordinary talent, strength, and generosity. Robyn is present in some fashion on every page of this book. She has been photography mentor, guide to Vrindaban, sounding board for ideas and questions, research and design consultant, support for my family, dear friend, and constant cheerleader. Her indefatigable good humor and sensible outlook have kept me going through the hardest of times.

At the Radhavallabha temple, Shri Radheshlal Goswami and his son Mohit taught me so much that I was at first unable to see. Radheshlal's passion for explaining Radhavallabha theology helped me to understand the distinctiveness of that denomination's approach to

the worship of Radha and Krishna. Mohit was endlessly patient, working with me in both Hindi and English so that he was sure I understood the subtleties of the details of Radhavallabha's ornamentation and their significance. He sat with me and worked through the handbooks and temple calendars, explaining the rhythms and meanings of the festivals. He also showed me—as much as he was allowed—some of what happens "behind the scenes" at the temple. Mohit was instrumental in launching the temple's website, which has become quite sophisticated over the last few years. I also owe Neha Goswami Tripathi special thanks for sitting with me on the ladies' balcony during the month of *adhik mas* and answering my endless questions. She was also a great help in securing images of the Khichri Utsav festival in the pre-website days.

Shri Anjan Kumar Goswami and his son Manas Goswami were my extremely helpful, thoughtful guides through the intricacies of coming to terms with Govindadeva's special history and ritual practices. In particular, I owe many thanks to Anjan Kumar Goswami for allowing me close access to the *janamashtami* festivities. In addition, he was extremely forthcoming about all aspects of running a large city temple with an increasingly public god at its center. The temple has entered the twenty-first century with a great amount of dignity: Manas Goswami, despite his relative youth, is an able manager who has launched the temple's website and produced *Govind Darshan,* a very useful printed guide to the temple.

As invaluable and generous as all the temple priests and their families have been to me, the devotees opened my eyes in other important ways. Although I have changed their names in the text, a number of dedicated patrons of the Radharamana and Radhavallabha temples were especially sincere interpreters of the emotional as well as the practical aspects of temple displays. Learning to see from the priest's perspective as well as the patron's was a highly instructive lesson in the ways that temple displays can be part of a creative collaborative process that literally sets the stage for emotion and devotion.

Another person who has been wonderfully supportive (at times, on woefully short notice) is Jack Hawley, whose scholarship on Krishna and Vrindaban paved the way for so many of us. Not only is he a model of warmth, generosity, and humility, but his elegant writing coupled with incisive analysis have set a scholarly standard for the field that I have always admired, though hardly attained. His thoughtful, detailed reading of the manuscript helped me to navigate around certain misassumptions, and his questions were al-

ways right on target. Whitney Sanford was also an important part of those early Vrindaban fieldwork days. Her work on Paramananda's poetry has inspired and parallels many of my own observations about the sensuality and potent imagery of Krishna worship. Her intrepidness always contributed to a sense of lively adventure, and I will never forget the epic journeys we made between Vrindaban and Delhi that would otherwise have been unbearable without her cheerful companionship. Margaret Case is another seminal figure in my early thinking about this subject. Her scholarship and her useful suggestions helped me to sort out where my own questions belonged, and what was feasible and what was not.

Pika Ghosh has kept me on my intellectual toes, as her work on Krishna temples in Bishnupur, West Bengal, has shown significant connections to Vrindaban's history, and she always asks stimulating questions. More than anything, she has encouraged me to write in a personal, authentic manner that is somewhat new to art-historical practice, and she has shared some of her own wonderful writing in the process. Similarly, Lindsey Harlan—compatible scholar, fellow traveler, and accomplished writer—has also played a major part in this book's evolution from a collection of thoughts and observations to a more accessible narrative that I hope will speak to many different kinds of audiences. Both Pika and Lindsey read the first draft of the manuscript and provided invaluable critical feedback that greatly improved the book. My Middlebury colleagues Carrie Reed and Kirsten Hoving also read the manuscript and gave me terrific feedback and support. Another Middlebury friend, Prem Prakash, also did me the honor of an enthusiastic reading.

Rick Asher and, especially, Cathy Asher have long been supportive leaders in the field of Indian art history, and I have depended upon Cathy's insightful scholarship on Jaipur and Vrindaban to help me to understand the complex unfolding of their interconnected architectural and political histories. Other scholars who have offered encouragement and who have seen this material evolve over a number of conference presentations are John Cort, Padma Kaimal, Susan Bean, Mary Beth Heston, Stephen Markel, and Janice Leoshko. The works of Sumathi Ramaswamy, Richard Davis, and Joanne Waghorne have been influential to my own thinking, especially in the ways they creatively examine the interconnections among history, religion, rhetoric, and art.

Finally, on a more personal note, I am indebted to Blair Orfall who, at the beginning of my research, home-schooled my children

in our little home away from home in Vrindaban; the lessons have not been forgotten. Sunder and Varna Ramaswamy and Mrs. Kausalya Ramaswamy (who has a wealth of insight about Krishna worship and Vaishnavism) generously hosted me during one of my stays in India. Blair Tate and Jeffrey Schiff have long indulged me as I have worked out my observations over the years, and we have shared some travel adventures and many meals together. Deborah Daw Heffernan has also been a source of support, especially as I have worked on my writing. Colonel Fateh and Indu Singh provide me with all the comforts of home at their wonderful guest house whenever I am in Jaipur. In New Delhi, the guest house of the American Institute of Indian Studies has always been a place of welcome and an intellectual milieu for meeting a variety of interesting people doing work in India.

To Scott Atherton, I am profoundly thankful for all the support he offered to me over many years while this book took shape. None of this would have been possible without his generosity and willingness to work around my numerous, and often lengthy, absences from the family. Thank you from the bottom of my heart. My children, Nick and Mira Atherton, have been an integral part of this book's whole process, and I count their time with me in India as one of life's most precious experiences. I also know they are relieved that the book is finally done.

I am extremely grateful for the funding support I have received, without which this volume would not have been possible. This book was funded in part by a National Endowment for the Humanities Fellowship for College Teachers, and I have Franci Farnsworth of the Middlebury College Grants Office to thank for putting me through my paces in the grant-application process. Middlebury College has also been very generous with funding from the Faculty Professional Development Fund and the Scholarly Publication Subvention Fund; thanks are especially due to Jim Ralph, dean for faculty research and development. My colleagues in the Department of the History of Art and Architecture, other faculty, and my students at Middlebury College have also been wonderfully welcoming of my presentations and have stimulated me to think ever more critically about my ideas. My students, in particular, have always provided great inspiration because I hope that they, and others like them, will form part of the audience for this book. In this work, I hope to provide some answers to the many questions about art and religion that I always get when I teach

about India. Special thanks go to Ruchi Singh (Middlebury College, class of 2011), who helped me with compiling the bibliography, and Jue Yang (also class of 2011), who made the map and the Govindadeva site plan. Rudabeh Shahid and Ali Hamdan (both class of 2010), as well as Andy Wentink (Curator, Special Collections and Archives, Middlebury College Library), have earned my enormous gratitude and deserve much praise for their quick and exacting work on the index.

I would also like to thank the editorial staff at Indiana University Press, who were helpful in all ways. I am particularly indebted to Merryl Sloane for her astute editing. This is a much better book because of her. Finally, I am very grateful to Rebecca Tolen, sponsoring editor at Indiana University Press, for her faith in this project and her patient encouragement.

A word about the transliteration of Hindi words and quotations from other sources: to make this more accessible to the general reader, I have chosen to dispense with all special formatting, even in quotations, and to follow common conventions for rendering sounds comprehensible, such as in *darshan, shringar, charanamrit.*

Unless otherwise noted in the captions, all the photographs were taken by the author.

Prologue SEEING KRISHNA, LOVING KRISHNA

A full moon presides over Vrindaban, its hazy glow illuminating the dense jumble of the vibrant pilgrimage town, pressed close against the banks of the Yamuna River. It is a sultry early evening in May, and residents, pilgrims, and visitors are hurriedly making their way to Vrindaban's myriad Krishna temples, responding to the resonant invitation of temple bells and gongs. There is a palpable sense of anticipation—all are trying to get to their chosen shrine or temple in time for the early evening *darshan* (the sacred viewing of a deity), when images of Lord Krishna and his partner Radha would be revealed after having been sequestered away from public view during the heat of the afternoon.

At that moment of visual revelation, a door will be opened or a curtain pulled aside, allowing worshipers to behold their god and his consort, elaborately dressed and decorated for the evening's presentation. The audience will not be disappointed: Krishna and Radha will be richly ornamented from head to toe with intricately embroidered gold or silver crowns, glittering patterned and embellished garments, and lavish jewelry on their foreheads, ears, noses, necks, waists, arms, wrists, and ankles. Their garments will be ornate with appliqués, embroidery, sequins, or metallic borders and designs layered upon the colorful fabrics. The altars and thrones upon which the figures stand will be arranged with ritual implements and offerings. Fresh garlands of seasonal flowers will wreath the deities' necks, and, as an added bonus during the hot summer months, fragrant floral stage settings will provide elegant background frames around the figures. And on nights such as this one, when the moon is full, the details of the finery will differ in ways that signal the moon's cyclical temporality to worshipers.

Visual spectacle is the nexus around which the majority of Krishna devotional practice is centered. Krishna is particularly admired because he is beautiful; he is the winsome baby who charms the world

through divine deceit, and he is also the handsome, boyish cowherd evocatively described in erotic poetry and paintings. His image is ubiquitous on calendars and posters, and his sculptural representations are splendidly displayed alongside those of his consort Radha in innumerable shrines and temples all over India. As a richly imagined, embodied divinity, he is lavished with limitless admiration and attention. Devotion to Krishna is expressed through care, attention, and embellishment: the acts of seeing and of ornamenting Krishna's body are thus primary means of expressing love. In the *Bhagavata Purana,* the canonical tenth-century text most sacred to worshipers of Krishna, Krishna explains to his friend and advisor Uddhava that ornamenting his body is one of the important ways a devotee can venerate his image:

> My devotee should (also) lovingly set Me off in the proper way with raiments, the sacred thread, jewels, wreaths of basil leaves, scents and sandal-paste. The worshipper should (then) reverently offer to Me water to wash My feet and rinse My mouth with, sandal-paste flowers and grains of unbroken rice (for decoration), incense, light, and articles of food.[1]

At the heart of such intense visuality lies the notion of celebrating one's love for Krishna by dedicating the very best one can to him. Beautifully prepared and elegant material offerings play a vital role in this process.

This book addresses the topic of ornamentation seriously and provides a more nuanced understanding of some aspects of Indian art and religion than is available in current scholarship on the god Krishna. I contend that Krishna's most familiar aspects—his body and its decoration—are worth exploring more fully not simply as objects of religious imagination and adoration, but as potent sites of cultural negotiation. The god's body and its ornamentation, I argue, are where multiple discourses—about visuality, desire, aesthetics, devotion, emotion, history, ownership, practice, time, and space— converge. Unlike the Christian concept of the divine body as a fragmented locus of suffering, distressed memory, and perishability, Krishna's body is instead noncorporeal, nondivisible, endlessly beautiful, and pleasurable. Anuradha Kapur describes the difference between a divine body and a human body in this way: "The divine body is not an organ of sense in the same sort of way as is the human body. It is a sign for other meanings that seek to encompass the relation of the divine to the worlds of prayer, devotion, and desire."[2] By focusing

on three historically significant images of Krishna in their temple contexts, this book will explore how Krishna's decorated body serves as a site and sign for such a wide variety of meanings.

In part because the constantly changing embellishment of Krishna images falls into the category of ephemeral or "decorative" art, the subject of decoration has, with some important exceptions, escaped the attention of scholars who are otherwise interested in religion, history, and the arts.[3] Much temple decoration is deliberately removable and disposable. Yet it is only through looking closely at this fluid category of temple arts that we can come to understand critical historical continuities for the Krishna images under consideration here. Important information about these images, their temples, their histories, their senses of themselves and each other, and their negotiations with the present and the past is encoded in the substance and details of material decoration. For it is through Krishna's ornamentation (including his bodily embellishment, his dress, his jewelry, and the stage props that comprise his environment) that worshipers connect with the god in general and the temple in particular. Moreover, it is through ornamentation that other cosmic and temporal notions are made manifest: the cycles of the moon and sun, astral symbolism, the changes of the seasons, and the significance and power of colors are all made visible through decoration. These notions play integral parts in the overall meaning of the visual presentations seen in temples and are expressed by a visual vocabulary rich in symbolism and suggestion. Ornamentation thus provides the viewer with a palette of important cultural concepts not readily available in other arenas.

My initial interest in the rhetoric of ornamentation and the worship of Krishna dates back a number of years. In early 1992, I was in the midst of revising a book on the style and iconography of eighth- and ninth-century Vaishnava and Shaiva temple sculptures in Rajasthan. While I had been puzzling out the details of their iconography and style, I kept feeling that an important component of the visual experience was missing and, unfortunately, forever lost to history. The rare beauty and the decorative intensity of the sculptures I was considering suggested that their creation was motivated by a deliberately affective and aesthetic sensibility, and, although it was clear that the images were carefully designed to elicit a response from the viewer, the terms of that response were long past recovery. I mentioned my frustrated interest to my colleague David Haberman, a

The Call of Krishna's Flute: Background and Overview of the Book

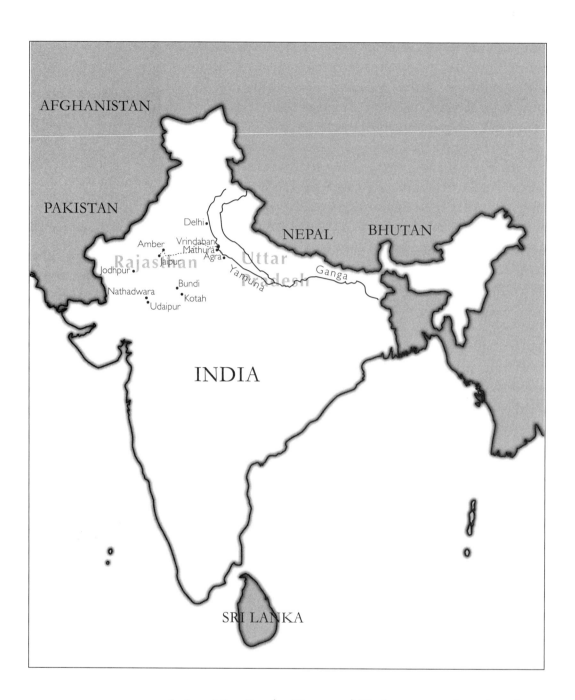

Map P.1. Map courtesy of Jue Yang

scholar of Gaudiya (or Chaitanya) Vaishnavism and Krishna devotionalism. David encouraged me to visit Vrindaban where, he assured me, many of its temples' visual practices still preserved an aesthetically meaningful combination of history, art, and religion.

For Krishna's devotees, Vrindaban and the neighboring city of Mathura form the nucleus of a sacred region known as Vraja (or Braj) that nurtured Krishna's birth and growth to early maturity (see map P.1). Vrindaban and its environs have consequently been

the focus of numerous important studies on the religious history of Krishna, the poetic traditions of Vaishnava devotionalism, and the hagiographies of important saints and religious leaders. There is a rich body of scholarship on the Braj pilgrimage circuit, and there are studies of the performing arts celebrating Krishna's life story, such as the *ras-lila* theater. For a scholar interested in the arts, there were enticing, but occasional, references to imaginative visual practices and artistic traditions that suggested an area rich in possibilities. I showed up on David's doorstep for a brief exploratory visit and never looked back. The decisive moment of revelation for me was an evening slide show—with images of the Radharamana temple and its Krishna icon projected onto the whitewashed walls of a traditional courtyard house—by the Australian photographer and long-time Vrindaban resident Robyn Beeche. As she projected slide after slide of some of the most beautiful imagery I had ever seen, David explained how the embellishment of the god in his temple environment revolved around a ritual cycle of veneration and decoration that made manifest different aspects of Krishna's day. Moreover, the decorative practices reflected a preoccupation with a wide spectrum of cosmic and seasonal references, numerous annual celebrations, and historically important observances. All of these occasions were accompanied by specific visual conventions, and they were continually changing; no two were exactly alike. I was hooked—lured especially by the prospect of exploring the interaction of patterns of historical continuity, ritual and aesthetic prescriptions, and contemporary practice.

It would not be until late in 1998 that I would return to pursue my interests more systematically. I ultimately decided to focus closely on two important Krishna icons (or, as I prefer, manifestations)[4]—Radharamana and Radhavallabha—and their temples in Vrindaban, and a third manifestation, Govindadeva, now in a temple in Jaipur but originally from Vrindaban. These form the core of my comparative examination of the meaning and significance of the ornamental traditions of each temple. These three temples each house historically important sculptural images of Krishna that made their appearances in the early sixteenth century in Vrindaban. Termed *svarupas* or *svayam-prakat-vigrahas*, these figures are "self-manifest images," that is, it is believed that they were not fashioned by human hands but by divine agency. Since their appearances in the sixteenth century, all of these manifestations have been under the continuous care of individual hereditary priestly lineages, and they are all liturgically at-

tended to in roughly the same fashion. In addition, they represent two different sectarian traditions that share much in common but that also diverge in important ways. Both Radharamana and Govindadeva belong to the Chaitanya Vaishnava denomination, and Radhavallabha belongs to the self-named Radhavallabha sect. But, as was famously remarked by Dale Berra of his father, Yogi, their "similarities are different."[5] Because of the important historical connections among these temples, those similarities and differences are made more meaningful in comparison.

Nothing in the literature I had read up to that point on these traditions quite prepared me for the scale and complexity of the contemporary visual practices surrounding the worship of Krishna.[6] In the acres of texts, translations, poetry, history, treatises on aesthetics and on pilgrimage, and ritual studies that focus on this god, there was surprisingly little that referred to what is one of the main preoccupations of the pilgrimage town of Vrindaban: the visual adornment of the Krishna images that draw believers to its many temples. One point struck me in particular: the main categories of gift presented by devotees to their temples are clothing (*poshak*) and jewelry (*shringar*), along with sponsorship of the temporary decorations and stage sets (*bangalas*) that dress up temples for special celebrations or festivals (*utsavs*) that occur on a periodic basis through the ritual year.

This preoccupation with ornamentation is not only limited to the temples. As I made my way through Loi bazaar, the main commercial artery of the town, I was struck by the sheer amount of merchandise available for dressing, decorating, and accessorizing Krishna and Radha. Dozens upon dozens of shops in this market and others cater to a lucrative trade in which pilgrims who come to Vrindaban return home with brass or stone images of Krishna and Radha and the wardrobes for adorning them. The bazaar functions as a veritable Saks Fifth Avenue for the gods; here, one can find all the necessary fashion items for a well-heeled deity. These include headdresses and crowns, a dazzling array of jewelry, clothes, garlands, small-scale altars, altar accessories, thrones, and so on; the shopping list is creative and extensive. My intention here is not to trivialize this preoccupation with adornment; on the contrary, I was profoundly inspired by its importance for the culture.[7]

In the following chapters, I begin by introducing readers to the general framework and practices of Krishna devotionalism; this is followed by case studies on the Radharamana, Radhavallabha, and Govindadeva Krishna images and the visual practices associated

with their individual temples. The book concludes by widening the scope of inquiry to explore the value of ornamentation at some contemporary temples in India and in diaspora contexts. I also consider the implications of what can happen when culturally specific ideas of place, art, religion, and emotion cross borders.

domestic?.

The introduction sets the geographic and historical context of Krishna worship in India, summarizing and compressing information that is widely available in many other publications. For the knowledgeable reader, most of this chapter can be skimmed; for those new to the subject, I provide a brief overview of major themes. "A Sense of Place" reviews the narrative of Braj as the setting for Krishna's birth and adolescence and discusses its historical and physical reclamation in the sixteenth century by the Bengali saint Chaitanya and other holy men; "An Open Heart" refers to the devotional practices (*bhakti*) associated with the worship of Krishna; and "An Educated Eye" provides an expanded notion of the practice of looking at or seeing divine images (*darshan*) by explaining its special significance for the devotional worship of Krishna.

The introduction concludes with a consideration of why these images of Krishna and the contemporary visual practices related to their worship have been understudied in the scholarly literature on Indian art and religion. I propose that the discrepancies between the classical aesthetic canon as originally expounded in Indian theoretical texts and the visual spectacles characteristic of many of today's temple displays are partially responsible for this oversight. I further suggest that there are resistances to what is considered decorative art that were engendered by the development of "fine art" as a separate cultural category in India in the late nineteenth and early twentieth centuries. The distinction drawn between "high art" and "low art" validates only select examples of visual production as worthy of scholarly attention. "Low," "decorative," or "popular" art is placed at the bottom of an assumed standard of visual hierarchy because it invites potentially uncomfortable emotional responses (especially with religious art) from viewers, and it raises suspicions about materiality, "kitsch," and the lowest common denominator of aesthetic appreciation. I have been greatly helped in this area by David Morgan's *Visual Piety*, Colleen McDannell's *Material Christianity*, and recent theories about visuality in Indian art discussed in Sumathi Ramaswamy's *Beyond Appearances?*[8]

The next chapter is a study of some of the visual practices of the Radharamana temple in Vrindaban, which aligns itself with the

Chaitanya Vaishnava sectarian tradition. While the temple is relatively well known to scholars in the field, I depart from previous considerations in the level of detail and description that I bring to my analysis of the ornamentation of the temple's image of Krishna, which was miraculously revealed in 1542 to the holy man Gopala Bhatta, a follower of the sixteenth-century Bengali saint Chaitanya. I consider the conceptual and historical backgrounds for understanding how and why Radharamana is ornamented, and I pay particular attention to the role of the hereditary temple priest as both arbiter of taste and curator of tradition. I also demonstrate how the god's ornamentation and the stage setting that surrounds his image in the temple not only provide the devotee with an aesthetically charged devotional experience but also serve as a visual guide to the machinations of the cosmos; this is done through a discussion of how the temple organizes its rituals around a temporal framework based on the lunar and solar calendars. My conclusions are drawn from extensive fieldwork and consultations with some of the Radharamana temple priests and devotees about the meaning and significance of the deity's decoration. I present the material in the form of several encapsulations of worshipers' viewing experiences that bring to life the texture and sensuality of being in the temple when the god is revealed at *darshan* time. Additionally, I discuss the creative and important ways in which priests and patrons work together to co-produce ritually and aesthetically potent visual displays.

I consider next the Radhavallabha temple, which holds itself apart from the Chaitanya Vaishnava sectarian tradition—as exemplified at the Radharamana temple—in several important ways. Its distinctiveness derives from the beliefs of its founder, Hit Harivansha (ca. mid-sixteenth century), a local poet and visionary who was not connected to Chaitanya and who espoused a different mode of worshiping Krishna and his consort Radha.[9] Specifically, Hit Harivansha elevated Radha to the position of devotional supremacy; this is expressed by intriguing variations in the ritual calendar and in the ornamentation of the temple's Krishna image. This image was divinely manifested to Hit Harivansha, and the story of its appearance plays a central part in the temple's fashioning of its unique identity. I compare and contrast the Radhavallabha temple traditions with those of the Radharamana, highlighting the varying ways in which each temple deploys its visual practices to proclaim its own sense of individuality. I examine in particular two highly distinctive and fascinating month-long celebrations in the Radha-

vallabha temple's ritual calendar, both of which are centered on playful and creative visual spectacles that are intimately bound up with the temple's history. I further pursue the implications and avenues through which individual patronage is invited from devotees; and through stories, vignettes, and personal experiences, I explore some of the ways in which worshipers personalize their connections to the deity by providing ornamentation and sponsoring special visual displays. I also analyze the organization of the temple's website as a document that purveys the temple's story in modern, yet deeply traditional terms.

A final comparative example is the image of Govindadeva Krishna, who first manifested himself around 1534 (eight years before Radharamana revealed himself to Gopala Bhatta) to Rupa Goswami, another of Chaitanya's followers. This image was initially installed in a modest shrine in Vrindaban, but unlike the other examples considered in this book, Govindadeva attracted royal patronage from a Rajput king who worked closely with the newly powerful Mughal ruler Akbar (1542–1605). I explore the complicated history of this representation of Krishna, which not only received large amounts of imperial largesse through the subsequent centuries but also was forced to evacuate Vrindaban in the late seventeenth century; it was eventually installed in a temple in the newly constructed capital city of Jaipur, Rajasthan. There, Govindadeva presided as the symbolic king of the fledgling city together with the *maharajah* of Jaipur as his human deputy—a situation that changed dramatically in the twentieth century with Indian independence. With the diminishment of private royal patronage, and as the temple's administration gradually came under the umbrella of the government, tensions surfaced over who was in charge of the temple: the erstwhile royal family or the hereditary temple priesthood? We will see that it is on and through the god's body that such claims to legitimacy are enacted, and I focus on a major temple festival—*janamashtami,* or Krishna's birth festival—to make the point that Govindadeva is no longer just the king's god, but is now more the people's god in terms of contemporary patronage and devotional allegiance.

In the fourth chapter, I consider how Krishna is worshiped outside of the three traditional temples that form the core of this book. In examining some of the basic issues and premises involved in negotiating between traditional practices and contemporary audiences, I discuss how Vrindaban's souvenir market not only provides pilgrims with replicas and images of Krishna to take back to their

homes, but also allows devotees the freedom to creatively personal-ize their relationship with their god. I also address the impact of modern technologies, such as photography, video, television, and the internet. A brief overview of some recently constructed temples in India, England, and the United States provides the opportunity to consider how today's global devotees adapt and shape visual and religious practices to new cultural and geographic contexts.

I conclude by addressing the important theme of nostalgia and the enduring power that Krishna's mythological homeland repre-sents for his devotees. I ask the question: are Vrindaban and the visual practices at its traditional temples still relevant, and if so, why? In bringing readers back to the starting point of the book, I argue that Vrindaban as a sacred utopia and pilgrimage destination continues to retain its validity because it is there that all those splendidly decorated, uniquely self-manifested Krishnas reside. Braj and Vrindaban are conceptualized and experienced as Krish-na's heaven on earth. Yet the notion of Vrindaban as utopia is seri-ously threatened by environmental degradation, overpopulation, and rampant commercialization. This is an issue that urgently needs attention from both devotee and global citizen alike.

The reader will find that this book is selective in the examples it provides and the amount of detail it includes. I do not strive for, nor is my interest in, complete documentation of the Radharamana, Radhavallabha, and Govindadeva temples' unique visual tradi-tions. Although those aesthetic traditions are all based upon cen-turies-old guidelines, they are ever evolving: they are stable and dynamic at the same time. Moreover, such a detailed enumeration would be tedious for readers. Instead, I focus on examples and themes that I feel best represent the intent, scope, and spirit of each temple. Differing from written historical documents or texts, the visual culture of each temple—with the primary focus on its own unique, decorated body of Krishna—reflects a complex fusion of historical patterns, contemporary practices, priestly stewardship, devotees' contributions, and the acknowledgment of the world out-side the temple. My aim is to discuss, as much as possible, the aims and ideals of these temples in the terms that they use themselves.

THE ART OF LOVING KRISHNA

Introduction: A Sense of Place, an Open Heart, and an Educated Eye

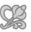

The worship of Krishna and Radha sounds a single devotional note in Vrindaban and much of the surrounding region, known as Braj (or Vraja), unlike the more diverse mix of religious practices encountered in the broader landscape of the surrounding cities, towns, and villages of Uttar Pradesh and Rajasthan. In these other contexts, there is active worship of the many forms of the goddess, and there is devotion to Shiva, Ganesha, Hanuman, various forms of Vishnu, and innumerable local and folk deities. The veneration of Rajput heroes, heroines, spirits, and ancestors, as well as the practices of Jainism and Islam, ensure that there is something for everyone. Yet, even though some of these other traditions are represented in Vrindaban, their presence is muted or even subsumed within the larger enterprise of devotion to Radha and Krishna.[1] Krishna and Radha are the main show in town.

Much of the hyperbole about Vrindaban centers on the oft-repeated claim that it hosts "many thousands" of temples and shrines. This might be difficult for the first-time visitor to Vrindaban to figure out, because many of those temples and shrines are not readily evident in the chaotic clutter of this medieval pilgrimage town. Most worship of the divine couple takes place behind walls, past the thresholds of private homes or public courtyards. The majority of temples (called *mandir*s) and shrines in Vrindaban are designed as homes for their gods and organized like traditional residences: enclosed within courtyards and turned inward, away from immediate public view. While the remains of some large, red sandstone structures attest to a short-lived tradition of monumental temple building in the late sixteenth century, these are the exception rather than the norm.[2] The focus of most temples and shrines is generally on the image and presence of divinity inside and not on the external manifestation of an overtly recognizable religious structure. Signs, flags, entryways, and

flower sellers announce the presence of temples and shrines, serving as the few external markers of an internal world of devotion centering on the body of the god. The landscape of Braj is Krishna's real temple—for Krishna is not meant to be confined in a dark sanctum, hidden away and attended only by priests. Krishna the cowherd and divine lover needs freedom to roam and play and follow his wayward desires. He graces the temples with his special presence, but he is neither defined nor confined by their architecture.

Worshipers of Krishna are deeply versed in the details of his origins, mythology, and attributes, expressing their connection to him through a range of actively cultivated devotional behavior. Devotees are primed to associate Krishna with a specific place, an appealing theology, and an aesthetically pleasing physical manifestation. Together, these comprise parts of what I term a "bhakti tool kit," contributing to the specially crafted emotional responses that are essential expressions of the loving devotionalism associated with the term *bhakti*. This chapter briefly reviews those tools, beginning with the sense of place and moving through a number of related issues to sketch out the contours of how devotees worship Krishna. I will also make some methodological observations about why some aspects of Krishna worship have been overlooked and, more relevantly, why they are important to know.

Bhakti Tool No. 1: A Sense of Place

There is an abundance of excellent studies on Krishna's mythology and background, and what follows is common knowledge. My purpose here is to synthesize the major themes that will have relevance for my later discussion of the temple arts. No theme is more fundamental to any consideration of Krishna than his connection with a specific place whose geographical features are inextricably bound with his history and his identity. His homeland is Vraja (or, more familiarly, Braj), an area south of modern Delhi and situated roughly within the parameters of the Delhi, Mathura, and Agra tourist circuits (see map P.1). Conceptually, Braj comprises a cluster of villages and towns central to the Krishna story, which radiate out in a rough circle from the city of Mathura. While in actuality those villages and towns now jostle to share space with all that has grown up between them in the last several hundred years, the "idea of Braj" nevertheless retains a vibrant conceptual unity and purity for believers.

As recounted in the *Bhagavata Purana,* Mathura is the place where the story of Krishna first unfolds. The city is anchored on the

western banks of the river Yamuna and hosts a number of ancient historical sites, shrines, and religious orientations. While it now has an eclectic, crowded, and industrially compromised identity, historically it was central to the incipient development of Buddhist and Jain figural arts spanning the early centuries before and after the beginning of the Common Era. Archaeological finds in the Mathura area attest to the widespread worship of nature deities, evidenced by the numerous images of local nature spirits known as *yakshas, nagas* (a form of snake god), and tree spirits. Ancient regional ancestor and hero cults are another important component of the religious landscape of the area, and some of their themes— such as the embodiment of divinity in human form and connections to royalty and heroism—ultimately influenced the development of the Krishna cult.[3]

Paradigms drawn from nature figure vividly in how Krishna's personality and iconography would eventually be conceptualized, and they literally set the scenes for his story. These include cattle, peacocks, the bucolic bounty and mythic potency of the earth, the rusticity of village life, and the purity and poetry of nature. He is seen as an irrepressible child who makes mischief in the humble, serene villages tucked among the many forests that once blanketed the land. Mathura, the city of his birth, was almost immediately left behind as Krishna entered the charmed world of Braj and spent his youth disguised as a simple cowherd (fig. I.1).[4] Differing from Mathura, where evil reigned in a royal and urban milieu, Braj was instead portrayed as idyllic, pastoral, innocent, and joyful. Braj was distinguished from other places by its lack of guile, and its very innocence left it vulnerable to the demons that were set upon it by Mathura's wicked King Kamsa. Divine intervention was necessary to protect the region, and one such protector was the river goddess Yamuna, who colluded in the infant Krishna's rescue from evil's clutches. By parting reverently as the baby Krishna was transported from Mathura across the watery divide to the cow-herding village of Gokul, her action was one of the first in a chain of events that would eventually free Braj from tyranny. Other natural formations such as ponds, rocks, hills or mountains, groves, individual trees, and magical markings on the land not only animated the landscape but also served as witnesses to Krishna's heroic exploits.

As he matures into a ravishing young man, Krishna augments his heroic contributions with amorous adventures. A critical broadening of his myth occurs when Radha, his female companion of choice

Figure I.1. Popular poster of Krishna as a cowherd with scenes from his life

among the innumerable cowherd girls (*gopi*s) who flock around him, enters the story. With her and the other *gopi*s' appearances, the family-oriented paradigm of Krishna the cowherd child makes room for an erotic mode of appreciation. And as Krishna transforms from a raucous child to a flirtatious adolescent, the landscape of Braj is correspondingly envisaged in a more nuanced manner. As any Krishna devotee is well aware, his adolescence was spent playing (termed his *lila*) in the fertile groves of Braj; thus, the Yamuna River, forests, and ponds also serve as venues of emotional intrigue and sexual connection. For Krishna's devotees, the hills are literally alive with the sound of music, story, myth, and romance.

Braj, as the pastoral site of Krishna's youth and adolescence, is not simply the construction of a long-ago mythic past: for believers, myth and divinity are tangible and eternally present. David Haberman's compelling study of Braj pilgrimage vividly brings to life the deep feelings contemporary pilgrims have for this ancient and hallowed land.[5] Worshipers, fueled with stories and visions of their god, seek to interact physically with the places and spaces that Krishna and Radha once graced with their presence. Walking barefoot on the land; prostrating their bodies against the earth; imbibing the water; bathing in the rivers, ponds, and wells; ingesting sacred basil (*tulsi*) leaves and even the dust on the ground are some of the ways in which devotees participate in their god's embodied presence. The body of Krishna is terrestrially manifested in the land of Braj, and, as Haberman cites from one of his sources, "There is no difference between Braj and Shri Krishna. Krishna is Braj. Braj is Krishna. Just living in Braj one is in contact with Krishna. Just being present in Braj is itself a religious practice [*sadhana*]."[6]

In a 2005 National Public Radio news series exploring the "geography of heaven," Vrindaban was one of the selected celestial locales. Correspondent Alex Chadwick spent a few days exploring Vrindaban, commenting, "This old town and the miles of low hill countryside around are sacred. This is heaven, not a metaphor for heaven or a way to heaven. This is it." He interviewed a number of people, among them a "spiritual teacher" named Nandan. Chadwick reported that, in "a garden setting on my final day in Vrindavan, I explained [that] our radio audience wouldn't really be able to experience this place and I asked him to say what this heaven he talks about is like." To which Nandan responded, "There where every word is a song, every step of walking is a dance, the air filled with fragrance of flowers, river is always flowing with nectarine water, every glance of everyone expresses love and affection to each other. The land is full of joyful singings of birds where everyone serves their life. That is known as a supreme heaven in Vrindavan, the abode of Radha and Krishna."[7] Nandan's characterization is typical of sentiments I repeatedly heard from devotees, priests, and visitors alike. Chadwick's summation of the potency of the Braj landscape was, however, considerably more prosaic: "That's it for the devotee. Merely the prospect of possibly encountering a speck of dust Krishna touched 5,000 years ago can get them to tromp around and sleep outdoors for a month. More than that, simply to be around Vrindavan is auspicious, good karma."[8]

Yet Braj was not always recognized as the special place that it is now. If the myth of the cowherd god and lover in his pastoral land of play looms large, so too does its temporary loss to memory. Of enormous importance is the theme of paradise lost and recovered: the account one hears over and over again is that Braj disappeared from human consciousness for a time, this loss partly set in motion by Krishna's departure from his homeland to fulfill his destiny as the destroyer of his evil uncle Kamsa, the lord of Mathura.[9] The important places of Krishna's youth eventually became obscured by heavy jungle, and the region reputedly became a haven for bandits in the subsequent centuries. By the sixteenth century, the area had been annexed by the early Mughal ruler Akbar; by then, it is recounted, all traces of Krishna worship were hidden or lost.[10]

One of the catalysts for cultural recovery came early in the sixteenth century with the arrival of Shri Chaitanya Mahaprabhu (1486–1533) from Bengal. Propelled, from his earliest years, by divine visions of Radha and Krishna's love play, this saint and mystic (who is also considered a joint incarnation of the divine couple) journeyed across India, eventually arriving in Braj in 1515, where his search for the original homeland of the divine lovers culminated in his recognition of several sites important to their love affair. Chaitanya set in motion what Haberman insightfully terms a "process of externalization; that is, in the sixteenth century a world that had existed primarily as an interior world, described in Vaishnava scriptures and realized in meditation, blossomed into an exterior world of material forms, and this culture was expressed physically."[11]

Of the many places Chaitanya is thought to have brought back to memory in Braj, certain spots along the Yamuna River in the town of Vrindaban garnered his particular attention. Vrindaban is a short distance north of Mathura on the same side of the river, and Chaitanya's hagiography relates that he arrived there on the autumnal full moon (Ras Purnima) that heralds Krishna's great circle dance, the *ras-lila*. On that auspicious occasion, Chaitanya isolated a particular *kadamba* tree as the one where Krishna had teasingly suspended the clothes he had stolen from the *gopi*s. Chaitanya was to spend another eight months in the area, continuing the process of re-visioning the sites of Radha and Krishna's love play.[12] Chaitanya ultimately left Vrindaban for Orissa, to worship at the great temple of Jagannath in Puri, but fortunately the process of uncovering that he had initiated in Braj did not come to a halt with his departure. That work was carried on by six emblematic figures who

are known under the rubric of the Six Goswamis.[13] Deputed to Vrindaban by Chaitanya, these specially guided people developed his incipient discoveries, systematized his approach to worship, and extended his teachings in important ways by setting Chaitanya's theology and insights down in writing. Chaitanya's approach came to be known as Chaitanyaite or Gaudiya (after his homeland of Bengal, or Gauda) Vaishnavism.[14]

Chaitanya and his followers were not the only ones who arrived in Vrindaban seeking divine inspiration. Other contemporaneous holy figures who contributed to the collective history of the area included Vallabhacharya (1479–1531), his son Vitthalnath, and their eight poet-disciples (*ashtachaps*), who are associated with the Vallabhacharya or Pushti Marg sect. Also important is the Radhavallabha poet-saint Hit Harivansha (ca. 1502–1552), and there are others.[15] An underlying "who-got-there-first" tension would later surface in the ensuing sectarian traditions that developed in these visionaries' wakes, but in the sixteenth century, the enlivening of Vrindaban's religious landscape was still in its infancy and still open to all comers. Vrindaban grew to accommodate a number of different, but related, sectarian orientations, all focused on the devotional worship of Krishna and Radha. One cannot overstate how vivid these founding figures are today in the public imagination about Vrindaban and the Braj region; their place in this narrative of recovery remains uppermost in the consciousness of Vrindaban's residents and visitors.

Bhakti Tool No. 2: An Open Heart

All of these religious visionaries were teaching and writing about the same thing: the wonders and joys of devotion to Krishna and, by extension, Radha. Central to the entire project of worshiping Krishna is the cultivation of *bhakti*, commonly thought of as "loving devotion." Richard Davis provides a very helpful summation that extends the meaning of the term: "It is a way of participating or sharing in divine being, however that is understood, of tasting and enjoying a god's presence, of serving and worshipping him, of being as intimate as possible, of being attached to him above all else."[16]

A mixture of inspirations initially enriched the *bhakti* movement: chief among them were the tenth-century *Bhagavata Purana* and Jayadeva's twelfth-century poem the *Gitagovinda*; South Indian Vaishnava devotional traditions also played a part. From this mélange of sources, the familiar images of Krishna took shape, with the narrative of his *lilas* unfolding in compellingly rapturous

language and evolving into an increasingly aestheticized system of worship. As devotional sentiments escalated, a new notion of *bhakti-rasa* emerged that tried to make intellectual sense of—or to recast in more acceptable religious terms—the rarified emotions evoked by these literary sources. As Lance Nelson explains:

> The notion of *bhakti-rasa,* the "sentiment of devotion," was important in all of the North Indian schools of Krsna devotion that drew inspiration from the *Bhagavata Purana.* A technical concept, the notion of *rasa* itself was borrowed from the writers on Sanskrit poetics (*alankara-sastra*). *Rasa*-theory was adopted by the Vaisnava devotionalists as a device for explaining their imaginative, emotional religious practice. The latter centered largely on identification with characters in the divine drama of Krsna's eternal sport (*lila*), as mediated through literary sources. The theory of *bhakti-rasa* received its most comprehensive elaboration at the hands of Rupa and Jiva Gosvamin, the leading theologians of the Bengal Vaisnava school.[17]

For Krishna's followers, the fact that he is both supreme divinity and human is profoundly important. Devotion to Krishna is intimate and personalized, couched in the familiar terms of human relationships. For here is not a multi-armed, weapon-laden, goddess-partnered figure like Vishnu, but a chubby, playful, naughty baby boy who matures into a sexy adolescent and who literally and figuratively woos both male and female alike: no one is immune to his appeal. Yet at the same time, Krishna's divine humanity is unsettling, potentially transgressive, and powerful. Krishna's power to turn the world upside down and to make his devotees act in ways that are antithetical to their orthodox upbringings is, of course, a large measure of his attraction. In a coded poetic language fraught with nuance and erotic suggestion, the *Gitagovinda* capitalizes upon the emotional confusion that Krishna wreaks upon his many lovers.

But the danger of such aesthetically seductive language is that it might be misinterpreted, and religious commentators and theorists from the sixteenth century on spent much of their time defining and refining the terms and conditions for appreciating and worshiping Krishna. In Barbara Stoler Miller's words, "The theorists dictated that the gestures exposing a character's mental states must be subtle, expressive enough to arouse a sensitive audience but never so crudely detailed that they stimulate wanton desire. In the *Gitagovinda,* this restraint functions to make potentially pornographic subject matter the material of esthetic and religious experience."[18]

Aesthetics played a major role in how later theorists and practitioners thought about how to love Krishna in a religious way. At the heart of this theorizing lies the irresistible pull of human desire, and worshipers of Krishna managed the positive—and subverted the destructive—potentialities of desire through elaborate systems of classification and analysis. Nothing was left to chance: desire is tamed and made productive by finding one's proper place in the network of yearning. As medieval Vaishnava theorists borrowed important aspects of *rasa* theory from the secular, literary domain, they reworked them toward new objectives in the religious context. One of the most important categories that received this revisionist treatment is erotic love (*shringara rasa*), which for certain devotees is the dominant means of conceptualizing the charged relationship between lover (worshiper) and beloved (Krishna); to this end, classical Indian culture provided a useful safety net of aesthetically acceptable conduits for expressing this kind of desire.[19]

It is in the real world of Vrindaban's temples that the aesthetic ideals of expressing love and devotion for Krishna and his beloved are—at least in part—made manifest. In the spectrum of devotional actions available to today's devotee, a primary activity is to see and participate in the worship of actual images of Krishna; this is where Vrindaban derives much of its renown in the Chaitanya and post-Chaitanya periods. For in the midst of all the poetic theorizing and nascent sectarianism of the sixteenth century and later, *actual* sculptural manifestations of Krishna made their appearances to various of Vrindaban's original founders, as well as in other sacred places in Braj: the deity Govindadeva manifested himself to Rupa Goswami; Sanatana Goswami was blessed with the form of Madan Mohan; Gopala Bhatta received the form of Radharamana; Hit Harivansha was gifted with Radhavallabha; and Vallabhacharya received the manifestation of Shri Nathji, to name some of the most important revelations. These deities had sat out the long period of Braj's loss to memory, and their manifestations were proof positive of its restoration. Each of these manifestations has its own special sacred history, and each now forms the centerpiece of its own shrine or temple in Vrindaban or elsewhere. Although, to the untrained eye, these manifestations might resemble any number of sculpted images of the god, they are not ordinary icons or idols, but forms of Krishna rewarded to special individuals who distinguished themselves by their devotion.[20]

The distinction between a self-revealed image of Krishna and one created by human agency is of fundamental importance. All

the case studies considered in this book center around such self-revealed manifestations. These antique images have powerful biographies; each serves as a singular beacon of one important part of Braj's past. Moreover, they manifested themselves after a long hiatus in the continuity of Krishna worship in the Braj region, selectively making their appearances at appropriate moments to specific individuals. They serve as witnesses to a process of reawakening, hence their continued power in today's Vrindaban.

These deities have been passed down through the generations, and because such manifestations are considered living presences, they require attention and care around the clock; this has been the case for close to 500 years. They are unlike Christian relics, as their connection to the past does not primarily point backward; instead, they are dynamic, fully present beings in the here and now. The singularity of such self-manifestations also grants them a special status in the hierarchy of representations of Krishna: they derive their intrinsic power not from human production, but from divine will.

From their starting points as personal deities for various visionaries, these revealed images rapidly became objects of worship. Because they needed homes and caretakers, the maintenance of these multiple Krishnas was entrusted to the hereditary lineages of *goswami* families that branched out from the original Chaitanyaite Six Goswamis and the other sectarian founders. Margaret Case, in her clear and illuminating study on the Radharamana temple in Vrindaban, notes, "Temples and shrines of every size, from spacious courtyards down to small household niches or altars, were built and maintained by these families, and Vrindaban is known for these thousands of shrines. A handful of these deities—Madanamohana, Govindadeva, and Radharamana among them—also became foci for the devotion of a wider community."[21]

Of the many self-manifestations that made their appearances, some stayed in Vrindaban and continue to receive worship there; others later left Braj altogether in response to political and religious threats and changing patronage. With the departure of such important images as Shri Nathji from Govardhan and Govindadeva from Vrindaban, the idea of Braj was communicated beyond the rural landscape, at times quite far afield.[22] But the sectarian mosaic that developed in the last several centuries remains well represented in Vrindaban's multiplicity of temples and shrines. While the town serves as a microcosm of the Vaishnava devotional universe, its

distinctiveness lies in the special manifestations that anchor the mythical Vrindaban in earthly history.

The *goswami* families are the stewards of a venerable and dependent relationship many hundreds of years old. The revealed images in their care require a special kind of ritual attention termed *seva*, most often translated as "service." David Haberman glosses the term as "religious performance," in the sense that worshipers are to consciously act out—and not simply visualize—their devotion to Krishna.[23] Mental and physical visualizations of the god in his many guises are fashioned through imaginative, performative actions. *Seva* as ritual performance comprises a spectrum of inward- and outward-directed behaviors: meditating on the form of the god; imaginatively taking on the roles of such paradigmatic devotees as the *gopis* or *sakhis*; chanting the names of Krishna; attending and participating in theatrical performances about Krishna's life; reciting important texts; singing devotional songs; and visiting temples to see the god in his decorated finery are but a few of the options.[24]

In practical terms, *seva* includes reciting the ritual liturgy and the care, feeding, ongoing maintenance, and adornment of the deity and his temple environment by the priests in preparation for his regular public presentations (*darshans*) in the temple. This last activity—adornment—is a primary component of *seva*. Not only are decoration and beautiful adornment means to lovingly serve Krishna, but they also attract patrons and pilgrims. Moreover, adornment is a way to maintain vital historical continuity, an important point that is a recurring theme in this book.

Temples are places where adornment and aesthetic elaboration can work together to create opportunities for emotional experience; they are environments, in other words, where *bhakti-rasa* can occur. In temples, the aesthetically meaningful presentation of the god provides a catalyst for dynamic interaction between deity and devotee. Seeing the god—*darshan*—is not a passive activity. This experiential, phenomenal mode of worship is frequently compared to performance or theater: the ritual stage is set, and the god as both subject and object becomes a device for focusing devotion and emotion.

The term *darshan* and the understanding of the role of the temple environment itself are fundamental aspects of worshiping Krishna. But the activity of *darshan* deserves consideration from the standpoint of the Krishna worshiper. In most studies of Indian religion

Bhakti Tool No. 3: An Educated Eye

and art, it is common and appropriate to refer to *darshan* as a charged moment of seeing the deity and being seen by him or her. In Stephen Huyler's beautiful book *Meeting God*, there are many examples of what *darshan* means in both ritual and non-ritual contexts. Noting its personal nature and transformative potential, Huyler writes, "Through whatever means it comes, darshan brings both peace and blessing to Hindu devotees, and through it, they believe, miracles can and do occur frequently."[25] Having the *darshan* of a deity, holy person, sacred place, or other object of holy power fuels the worshiper in a variety of ways, and its affective potential is constantly renewed by repeated viewings. *Darshan* is an ongoing, repetitive, endlessly renewable activity that never loses its potency. Devotees generally treat each *darshan* of a deity as a gift and a blessing, and every *darshan* is an occasion for heightened emotional response.

In most cases, the image of the deity is presumed to be invested with sacred power by the priesthood and enlivened on a regular basis by rituals. Often likened to a vessel in which the sacred presence of the god is invoked through rituals of invitation and offerings, the god or goddess is commonly considered a powerful guest. In making his or her appearance during *darshan,* the deity confers his or her grace upon the devotee in the form of consecrated leftover food offerings (*prashad*), holy water that has come in contact with the feet of the deity (*charanamrit*), and answered prayers. Access to the sacred presence is mediated by the temple priests, who manage the deity's affairs. Dwelling in the temple sanctum (which is referred to as a womb chamber), the deity's every need is attended to.

While much of this is applicable to the Krishna temples under discussion in this book, there are important differences. The notion of the fixed temple deity who resides in sculptural form in a dark, inaccessible womb chamber and who regularly descends into that sculptural form to be serviced and to be seen is only partially relevant for the self-manifestations considered here. With these Krishna images, the preferred paradigm is of the temple as the domestic residence of the god. The god is not an invited guest—instead, he is always present; the temple *is* his home. Devotees come to him in their imaginatively assumed roles of family or friend, and the temple functions more as a living room or even a *darbar* (royal audience) hall, though with less of the formality of the latter. Moreover, the Krishna temples operate as stages for religious performance—as a kind of domestic theater.

In fact, perhaps so much has been made of *darshan*'s unique potency that the customary fixation on the *process* of looking has blinded us to other things. In presenting *darshan* as a directed activity—as a lightning bolt of super-charged vision—one important aspect of the transaction is consistently overlooked: *what* the devotee is looking at—the *object* of all this looking—is rarely discussed. Or, if it is mentioned, it is not done so analytically.[26] From my experience in the Krishna temples I discuss in this book (and, I would suggest, in many other temples), *how* the deity looks is as important to the experience of *darshan* as the act of looking itself. The almost exclusive focus on *darshan* as a singular, definitive moment of religious transaction thus neglects the other kinds of looking going on: the appreciating, all-over kind of looking that savors the details of the body, surface, and environment of the god in much the same way as a poem is appreciated, word by word, phrase by phrase. As devotional poetry is structured around the format of seemingly endless descriptions that are repeated and savored in the mind's eye, so too does the aesthetic appreciation of the visual ornamentation of the god depend upon a similar process of description and reiteration.

Poetry has long fueled visualizations of divinity, and it serves as an active partner to the *darshan* experience. Nancy Ann Nayar has written about the "sensual spirituality" that imbues the highly emotional descriptions of *darshan* provided by the twelfth-century poets Kuresha and Bhattar, disciples of Ramanuja and adherents of the South Indian Shrivaishnava sect.[27] Inspired by devotional poets writing in South India around the sixth to the ninth centuries, these later poets write in a similarly emotionally attenuated vein. They speak evocatively of a yearning to see their god in physical form and of the beauty and splendor of the god's body once they do set eyes upon him. Although there are important differences in sectarian traditions and in the forms of the god that are being invoked, there are, nevertheless, significant correspondences in how *darshan* provides an occasion for rapturous appreciation of the physical beauty of the god. The object of the poet-devotees' desire in several of the poems is the icon of Vishnu in the Shrirangam (Tamil Nadu) temple. The poems lovingly describe Vishnu's physical form, its ornamentation, and its effect upon the poet-worshiper. And seeing is only part of the experience: all of the senses are marshaled toward a holistic immersion in the vision of the divine presence. "Looking at and into the body of the living God, in the form of a temple image," states Richard H. Davis, "can open out into the broader vista of the wholeness of God's being."[28]

Ornamentation plays a large part these visions, and it derives its particular charge not only from its intrinsic beauty, but also because it comes in contact with the body of the god. A particularly instructive passage is found in a poem in the *Shrirangaraja Stava I*, written by the poet Bhattar; as Nayar notes, there "[t]he Lord's ornaments, clothes, and decorations augment the loveliness of His body, and possess an incomparable beauty because they are made of *cit* (a 'non-material' substance); they appear to Bhattar to be in a state of horripilation [goose-flesh] . . . , thrilled by the touch of . . . His body."[29] Other poets also employ the same strategies, as Steven P. Hopkins has described in the work of the fourteenth-century South Indian Vaishnava poet Vedantadeshika. In a poem he wrote in praise of Vishnu in his iconic temple form as Lord Devanayaka, the poet describes how he can never witness the beauty of the god enough to feel satisfied. Vedantadeshika continues by describing the god in all his finery, literally animating the decoration that embellishes the deity's body. Hopkins notes that "the jewels and other ornaments are even seen to have themselves sought out the body in order to increase their radiance; it is the body that serves as ornament for the jewels!" This is seen further in the way the poet "describes the jeweled belt [worn by the icon] surrounded by the yellow waist-cloth—whose beauty 'enslaves' his mind—as itself thrilling to the touch of God's hand: like a lover or a possessed devotee in the conventions of the poets, the 'hairs' on the belt stand on end."[30] Vidya Dehejia, in her sensitive study of the adorned body in Indian art and literature, aptly notes that this "poetic effusion is an almost delirious contemplation of Vishnu as a temple icon: the image enthralls and mesmerizes him, evoking an insatiable yearning to continuously gaze at the exquisite beauty of Vishnu at Shrirangam."[31]

In a similar fashion, poetic descriptions, songs, and metaphors supply a rich, coded language for envisioning the mystery of all that is Krishna and for visualizing Krishna's relationship with Radha. Steven J. Rosen writes: "To articulate the beauty of Krishna's form, his *lila*, the nectar of his holy name, the glories of his abode, Vrndavana, and the sweetness of his love, then is impossible—except by poetic language."[32] Poetry, its verbalization in song, and sight all work together to produce heightened states of emotion for the knowledgeable devotee. Whitney Sanford notes in her illuminating study of the sixteenth-century Braj devotional poet Paramananda, "Although Krishna's beauty might be appreciated by

anyone seeing it, the strongest responses will come from those cul-
turally conditioned to respond to such stimuli."[33]

Ornamentation on the body of a temple deity is thus the visual
equivalent of poetic imagery.

The term *shringar* is generally used to refer to the "decoration" of
the body of the god and of his temple environment. Equally, the
more classical term for ornament, *alamkara*, while less commonly
encountered with reference to contemporary temple practices,
helps us to understand the long-standing historical importance of
ornamentation in Indian thought, and its definition and connota-
tions are useful for this study as it carries the same meanings for-
ward into the present. Ananda Coomaraswamy's famous essay on
ornament makes the oft-repeated point that "[w]hatever is unorna-
mented is said to be 'naked.' God, 'taken naked of all ornament' is
'unconditioned' or 'unqualified' (*nirguna*): one, but inconceivable.
Ornamented, He is endowed with qualities (*saguna*), which are
manifold in their relations and intelligible."[34] As anyone who has
spent time in India is aware, divinities—be they composed of a pair
of eyes affixed to a roadside stone embellished with colored foil or
rendered as a grand temple icon draped in the finest of jewels and
fabrics—are adorned in order to bring them fully into being. In-
deed, ornaments can be metonyms for personhood, as in the song
translated by Lindsey Harlan in her study of Rajput heroes, in
which news is conveyed to her village of a woman who has immo-
lated herself on her husband's funeral pyre (*sati*). The woman's
being is summarized in a series of verses, where "a bundle of pearls,"
"a bundle of ornaments," and "a bundle of cloth" successively and
collectively stand in for her departed presence.[35] Molly Emma Ait-
ken explains that when jewelry is deliberately removed—by renun-
ciates, by chastened or vanquished warriors, by women who have
lost their husbands or who are about to commit *sati*—"[t]he re-
moval of jewelry in each of these cases expresses a death to society."
Further, she states: "Ornament—by contrast—means life in India.
It is auspicious, and it protects and brings growth and prosperity.
It is inherent to beauty. It is a pleasure. But it is also a vital reposi-
tory of social meanings. To adorn a person is to offer him or her
protection, prosperity, respect, and social definition."[36]

Along with classical theories about ornament, it is customary in
the scholarship on *bhakti*, devotional poetry, Krishna, and related

Between Theory and Practice: Rapture, Ruptures, and Resistance

topics to spend a fair amount of time on the complexities and categorizations of *rasa* theory; the term *bhakti-rasa* has already been mentioned. However, an extensive review of *rasa* theory would be unhelpful for our purposes here. Rarely did any of the devotees with whom I spoke refer to the effect of ornamentation in a temple setting by using the rarified terms of *rasa* theory; instead, participants tended to respond more generally to what they saw.[37] The term most often used for the feelings that arise from a beautiful *darshan* is *bhava* or *bhav,* usually translated as a kind of "positive emotion."[38] Beautiful ornamentation is considered critical to the cultivation of an emotional state of happiness, enjoyment, or bliss—both for the deity and for the devotee. If a visual presentation is successful, devotees speak of it as "having *bhav,*" as constituting a meaningful aesthetic experience. The same terminology is used for poetry, music, and dance, indeed for any occasion in which the emotions are stimulated by aesthetics.

While devotees' responses will be considered in the following chapters, this book particularly concentrates on the ways in which ornamentation constitutes its own world of significance. I pay special attention here to the many ways in which ornament makes meaning: what it is composed of; what it signifies; what its sources are; how it can be interpreted in the culture in general and in individual temple contexts in particular. Conceptually, ornamentation plays a major part in the materialization of a description-obsessed theology.

The worshiper experiences Krishna through images—mental and physical—derived from a seemingly bottomless well of loving descriptions. Most devotional literature is at pains to name and minutely chronicle the appearances of Krishna, Radha, and their companions in their cosmic drama. The bodies, ornamentations, emotions, and settings inhabited by the divine couple and those around them are exhaustively enumerated. Such exacting descriptions provide important aids to visualization and meditation upon the deity; and the same impulse toward detailed specificity is reflected in the level of ornamentation in the temples. As such, the vast corpus of devotional literature on Krishna produced through the centuries provides templates for appreciating and making sense of the role of decoration in a temple setting.

But ornamentation is never exactly like what is found in the texts; moreover, despite the plethora of details, the texts supply only generic guidance for visual decoration. Although it is tempting to turn to the texts for explanations and the matching of written

to visual motifs, this is an enterprise doomed to frustration. The visual images constitute their own texts. It will be seen that all kinds of unexpected information comes to light when one looks closely, as much of this information is not available in texts but is located in other repositories. The vocabulary of much temple ornamentation derives from a host of other cultural sources and imperatives; there is much more going on than meets the eye. Ornamentation provides the interface between the mythic realm and this earthly world: the past meets the present through dress, decoration, and stage setting. Fashions come and go, but the body of the god stays the same; the body of the god and its decoration are in constant dialogue with one another. Understanding the visual codes in the temple displays ultimately depends upon a visual-cultural literacy that takes into account past and present meanings, as well as the vernacular of the individual temple.

The bias toward the past that pervades the mythology of Krishna's sojourn in Braj, coupled with the ongoing narrative of "Braj, lost and found," has hindered the development of a more up-to-date portrayal of Vrindaban as it has evolved through the centuries since its "recovery" by Chaitanya and others. There is a strong backward focus in much of the myth-making about Vrindaban and Braj; this is encouraged as much by the literature that abounds about Krishna and *bhakti* as it is by its interpretation. There is a deliberate and tenacious holding on to historical accounts by those invested in tailoring Vrindaban's image toward their own particular needs and objectives. But there exists a lively present, and there are many pasts, particularly with respect to sectarian accounts and developments. Moreover, the edges and contours of conflicts, problems, and changes have been smoothed and fashioned into narrative packages that seem suspended in a mythic Neverland of an exalted past. But Vrindaban is not an Old Sturbridge Village for Vaishnavas; what keeps it vital is its continual reconnection with and reworking of its past in contemporary terms. Rupert Snell's insightful article "The Nikunja as Sacred Space" remarks on a phenomenon in textual studies on Krishna and Vrindaban that seems equally applicable to the visual realm: "something which is in fact a complex and continuously changing pattern of development tends to be perceived and presented as a monolithically stable and *un*changing phenomenon. . . . The beguiling mythology of Krsna, with its extensive literature, is an area which has suffered more than most from this attitude." Or, as Lewis Carroll wrote, "It's a poor sort of memory that only works backwards."[39]

This is where looking carefully at contemporary temple practices can provide more of an on-the-ground perspective and a different kind of cultural analysis than staying within the historical parameters of written texts, as fascinating and valuable as those texts may be. The practices of decorating Indian temple images and making them available to viewers through *darshan* viewings are so commonplace that the role and presence of ornamentation is literally not "seen" and is hardly discussed, at least in most of the literature on Indian art and religion. It seems to me that the ornamentation or decoration is ignored because of its apparent insignificance. Even though the temples that form the subject of this book perpetuate ritual practices that reach back to ancient traditions of aesthetics—and even though those aesthetics are predicated upon the foundations of the classical Indian art canon—the significance of ornamentation in temples today has been largely overlooked as a topic worthy of scholarly analysis. Long considered a neutral arena, or a predictable garnish that accompanies ritual, ornamentation remains invisible, despite its sheer visual primacy. This book argues that ornamentation instead constitutes its own realm of richly textured meaning and import, although it is most frequently relegated to the role of visual wallpaper for the other, seemingly more meaningful ritual activities that take place in temples.

There are a number of reasons for this oversight. Part of the problem stems from the seeming disjuncture between the classical, written canon and its visual exposition: what one sees in temples is unambiguously spectacular, in the sense that the visual display *is* a spectacle. The sensuously arresting images detailed in the textual sources are manifested with great variability on the ground; those in search of a consistent level of rarified classical aesthetics based on *rasa* theory will be puzzled (and probably disappointed) by what may appear to be an excess of ornamentation lavished upon deities in most of today's temples. To the untutored eye, the embellishment of sacred images can often seem indistinguishably meaningless; yet for those familiar with the operative aesthetic codes, temple decoration is intensely meaningful.

Moreover, as noted earlier, the transitory nature of most temple decoration has relegated its study to irrelevance for art-historical interpretation; while it might be interesting to anthropologists, it is perhaps not particularly useful for constructing a history of images. Some of this attitude has been wryly noted by Wendy Doniger O'Flaherty in her essay "Impermanence and Eternity," where she comments:

In the West, we tend to think of art as permanent, perhaps as the only permanent thing there is. Western civilization tends to embalm the written word, to accord enduring status to physical incarnations of art. Our libraries are full of books, our museums full of paintings, and these books and paintings are often the only surviving traces of lost civilization[s]. . . . In India, by contrast, neither books nor paintings are assumed to have that sort of permanence. Material art there is fluid.[40]

Not only the fluidity, but also the very *materiality* of material art is suspect. There is a constant tension in Indian religious thought between the value of things of this world (*laukika*) and of the cosmic world (*alaukika*).[41] The material things of this world engender the gross desire (*kama*) and selfish grasping that bring out the worst in humanity, as opposed to the selfless love (*prema*) that a properly other-oriented perspective would generate. Even if, as Krishna devotees are enjoined, desire is the key to enjoying Krishna's *lilas*, it still has to be the right kind of desire. David Haberman draws on the philosophical approach of one of the Chaitanyaite theologians when he says, "an act of kama is done for the purpose of pleasing only oneself, whereas an act of prema is done solely for the pleasure of Krishna, the one who needs no pleasure. That is, kama is egoistic, useful desire, whereas prema is egoless."[42]

Debates about materiality and immateriality also pervade the scholarship on the history of religion in India. Even within the related *bhakti* traditions that center on the worship of Vishnu and Shiva, divine embodiment is often couched in poetic terms that stress the abstract and symbolic. This is in part due to what Richard H. Davis terms

the paradox inherent in conceptualizing the divine this way. However anthropomorphically the poets might portray their god, Siva and Visnu remained ultimately beyond, and unknowable as well. The tensions between [a] god's immanence and his transcendence (or, as Vaisnava theologians phrased it, his simultaneous "easy accessibility" and his "otherness"), and between the devotee's mixed feelings of intimacy and alienation provide central themes that run throughout Indian devotional literature.[43]

When viewed from this otherworldly perspective, material things then become but symbolic window dressing for an otherwise unattainable divinity.

Yet we need to be mindful that, to his devotees, the embodiments of Krishna under consideration in this book are not distant

abstractions. Indeed, Krishna's very accessibility—as baby, as cow-herd-companion, as friend, as lover—makes this god more humanly tangible than Vishnu and Shiva, who for many remain cosmically Other. Whitney Sanford explains:

> [I]n Braj devotion, objects such as images of Krishna can be coextensive with the divine, although the divine is never limited to an object. The material world is not rejected but used in service of Krishna. Devotees offer Krishna material objects, and the physical world reminds devotees that Krishna created the world for his own amusement. The material world is not glorified for its own sake but is lauded to the extent that it reflects Krishna.[44]

For the Krishna images under discussion, *materiality itself* has positive cultural meaning and value. Krishna's embodiments in the temples are physical manifestations that invite material expressions of devotion.[45] It is through material things that the devotee connects with the divine and the divine connects with the devotee. But because much of what one sees in the decoration and embellishment of Krishna temple images might be perceived as possibly overly materialistic and excessive, there is a correlative suspicion that it all adds up to "too much." Ornament, decoration, the accoutrements of worship, and the related unease about the potential impact of patronage on taste—all raise reservations about materialism and commercialism. Materialism and the material become conflated.[46]

In a 2004 work entitled *Being Indian*, Pavan Varma makes the related point: "It is important to understand first of all that there is no ideological reason, no unalterable philosophical premise, which would make Hindus reject the real world for the spiritual." He further remarks, "Rituals prescribe that the physical needs of even the gods must be looked after through periodic oblations. Hindu gods are not ascetics, shying away from the mundane pursuits of this world. Almost universally they are physically appealing, and enthusiastic participants in the affairs of mortals."[47] The positive value given to the material in Hindu religious practice derives, Varma asserts, from an underlying pragmatism and a clear-headed understanding of both its spiritual and worldly benefits. Joanne Waghorne's valuable study on middle-class urban Hindu temples also notes the dichotomy between the so-called purely spiritual world and the seemingly economically sullied material world, when she notes that "[t]emples, unlike ethereal images of philosophers, are solidly part of material culture, and expensive ones."[48] But this is an area that makes many uncomfortable, even within the Hindu tradi-

tion. Consequently, one encounters multiple mixed messages with respect to the relationship between the spiritual and the material.

Another fraught issue is tellingly encapsulated in the offhand remark once made by a friend that many people are dismissive of this Krishna material because of a deep-seated discomfort with sentimental imagery, popular art, and what appears to be kitsch to some unfamiliar with Indian aesthetic norms. Although my friend was referring to the sweetly—and, at times, cloyingly—appealing poster and calendar images of Krishna permeating popular culture (see fig. I.1), and not to the traditional temples under examination in this book, I believe this attitude deserves careful consideration. There are two major issues at work here: the first is the distinction between "high" fine art and "low" popular art; the second is the distaste for the messiness of emotions and sentimentality. Both issues find their way into generalized attitudes about art, aesthetics, religion, history, tradition, and value that have direct relevance for the questions posed by this book.

As regards the first point—"is it art, or is it something else?"—David Morgan's fascinating study on popular religious imagery in America helps us to understand how a similar distinction between "high" art and "low" art has gotten in the way of pursuing a deeper analysis of certain important Christian images—in his case, popular iconic images of Jesus. Although the focus of Morgan's study differs somewhat from the concerns of this book, it is nevertheless instructive and worth quoting at length:

> Another frequent criticism of popular religious imagery is that it represents a simple-mindedness, that images belong to a childish stage on the path to spiritual and intellectual maturity. Yet an examination of how images are used by the devout shows that the image is part of a larger cultural literacy, one that includes pointing, verbal narration, oral traditions, singing and pious devotion. Devotional images, in other words, participate in a visual piety that encompasses a range of interacting, interdependent forms of meaning-making.
>
> The argument of bad taste joins easiness, feeblemindedness, and immaturity to oppose the use of popular images in religion. What taste shaped by high-art practice fails to allow, however, is the centrality of usefulness in popular visual culture. Usefulness, though, conflicts at the most fundamental level with the traditional definition of aesthetic value. Unlike objects created for disinterested

or "aesthetic" contemplation, designed to celebrate craft and the history of stylistic refinement, popular iconography is thoroughly "interested," "engaged," functional, and extrinsically purposive.[49]

Morgan further provides a helpful discussion of the "aesthetic of disinterestedness," referring to the Kantian philosophical stance that requires the distancing of oneself from the object of contemplation. This in turn results in the "de-objectification" of the art object itself. In other words, the materiality of the art object becomes immaterial—even intrusive—to its proper aesthetic enjoyment. Desire and emotionality thus have no place in this disinterested approach, which holds apart the worlds of the imagination and the material. Morgan summarizes the differences:

> [A] popular aesthetic pivots on seeing as real what one has imagined, whereas the aesthetic of disinterestedness as Kant understood it consists of the excitement of the mental faculties of the imagination and the understanding into a harmonious relation, a free-play or nonpurposive mental state. The first attempts to meld inner and outer as reflective of one another; the latter turns inward and erects an impermeable barrier between the mental state and actual existence.[50]

This legacy of disinterestedness, so endemic to modernism, plagues the study of art and its objects, and it is all the more corrosive when considering the interplay between art and religion in India.

Kajiri Jain has written in a related vein about how the Kantian "reflective" (or disinterested) stance contrasts markedly with the thoroughly "interested" practices of devotional *seva* and of Hindu worship practices in general that center around the all-important notion of *darshan*. She makes the point that, "[i]n stark contrast to this keenly sensualised involvement with the icon through devotional *seva*, the 'taste of reflection' is predicated on an autonomous subject that has self-critically distanced itself from its sensory passions, desires and affects, even as sensual apprehension is acknowledged as their basis." She continues, "However, it seems to me that for those of us who try and write about images, loaded as we are with cultural capital and reflective 'taste,' the default approach is still to collapse questions of the image into questions of the visual understood as ocular knowing."[51] Ocular knowing, that is to say, locates knowledge and value in the *mind's* eye—and not in the potentially destabilizing visual and corporeal situation of an involved and interested devotee.

In turning to the second point about the distaste for the messiness of emotions, perhaps even more of a problem for understanding the ways and means in which Krishna's worshipers *see* their god is how they *respond* to what they see. Krishna *bhakti* is an emotionally, physically expressive mode of worship: devotees cry out in joy when they first witness their god at *darshan;* they throw up their arms; push others out of the way for a better view; weep; shout; prostrate themselves; fold their hands together in prayer; toss coins at the altar; give gifts of food, cloth, flowers, and money; dance; sing; and strain to receive the cooling touch of holy water or to taste *prashad.* It's chaotic, loose around the edges, and decidedly interested. For the Kantian theorist, these sorts of actions are morally suspect.

As Jain remarks, such a "performative or embodied response" flies in the face of the Kantian "taste of reflection," descending instead into the "taste of sense." She comments, "To the extent that it seeks to guard against the subject's disintegrative bodily engagements with material objects, this moral correlative of the aesthetic shades into another category that once again attempts to police the boundaries of the locus of value, in order to ensure that it remains within an autonomous, sovereign, productive and reproductive human subject: the fetish."[52] Such an embodied response to art objects might be termed "corpothetics," a solution proposed by Christopher Pinney. He writes, "By corpothetics, I mean the sensory embrace of images, the bodily engagement that most people (except Kantians and modernists) have with artworks."[53]

It is not only in the Kantian framework that we find a suspicion of emotion, however. Within the Indian religious and philosophical traditions, there are some philosophies that valorize emotional and physical self-control. Haberman comments about these traditions that, there, "emotions are to be renounced as problematic forms of conditioned ignorance that lock one into personal and therefore illusory experience."[54] Yoga and other forms of ascetic renunciation have often been held up as answers to the chaos and disturbances of human emotions.

But let us turn to other kinds of images of Krishna—modern paintings, prints, and posters—to pursue further these concerns about the relative value of the art object, sentimentality, and, further, kitsch. Pinney's thoughtful studies about early art education in India help us here. He discusses how in the colonial era "[a] similar disembodied 'absorption' was exported to India and can be seen as an attempt—in tandem with the [Calcutta] Art School's stress

on 'naturalism'—to deny the magical origin of images."[55] And later, "The 'supreme fiction' of the absent beholder becomes—in colonial India—a mark of western 'distinction' and a marker of distance from Hindu idols."[56]

The art that resulted from such a collision of visual cultures was a precarious fusion of European modernism and Indian subject matter. Ravi Varma's (1848–1906) historical-mythological paintings come to mind as perhaps the most emblematic of this phase. Varma's paintings heeded the European prescription that works of art must stay within their frames. Figures in paintings were meant to live within the fictive worlds created by, for, and around them; they were thereupon subject to the disinterested gaze of the educated beholder—the better to mediate a process of psychic exchange and self-identification. Pinney explains, "The internalized absorption of the paintings becomes a means of transferring the beholder's own encounter into the subject of the image in what might be termed the idol that dare not speak its name."[57] Yet, although the disinterested European conventions in Ravi Varma's work ultimately did not take hold in Indian visual culture at large, there were some important contributions, notably in the arena of relative naturalism.

The stress here is on the "relativity" of naturalism as Indian artists came to terms with how to create "modern" images of Krishna, the eminently human god. Even as Indian artists began to reject the imported European fiction of the detached beholder and to imbue their works with a more palpable—in other words, more Indian—sense of engagement and immediacy, the lure of European fictive naturalism remained strong. In such pictures as the renowned Krishna images produced en masse by the famous Nathdwara printers S. S. Brijbasi and Sons in the 1930s, we see how the poster image of the god Krishna easily proffers his *darshan* to the beholder in the manner expected of Hindu divinities (fig. I.2).[58] But the setting is not a temple nor the symbol-laden landscape historically favored in Indian painting traditions; instead, the image is rendered in a European-style romantic idiom: here, the utopian idea of Braj is rendered as a sylvan glade complete with a rushing waterfall upon whose banks rest contented deer and a monkey. The scene is illuminated by a full moon that hangs low in the sky, and the sweetness of nature is further underscored by such details as a diminutive sparrow, a peacock, and a pair of parakeets in the tree beside the god. Krishna is embellished head to toe with jewelry, garlands, and diaphanous scarves, and the decoration of his body—

Figure I.2. Narottam Narayan Sharma, *Murli Manohar.* 1950s offset print of a ca. 1934 image published by S. S. Brijbasi. Courtesy of S. S. Brijbasi & Sons.

indeed, of the entire scene—is pervaded with what Christopher Pinney terms "a surface density and plenitude."[59]

This was the beginning of a genre that continues in full measure today—presenting Krishna as a dewy-eyed, gender-bending poster boy. There are countless popular images of this nature, their style characterized by their contemplative quietude, seamless surfaces, and the softly romanticized and sentimental exploration of Radha and Krishna's love affair. For many, this art is kitsch par excellence: attractive because of its seductive easiness yet spurned because of the "Kantian disdain" for "affective figural intensity."[60] Moreover, the highly feminized (at least to Euro-American eyes) rendition of Krishna also generates, for some, potential concerns about the

history of Krishna poster images may be important

seeming imbalance among taste, gender, art, and religion. The same issues are also encountered in debates about Christian art, as Colleen McDannell explains: "Art was given characteristics that Western culture defines as masculine: strength, power, nobility. Kitsch became associated with stereotypical feminine qualities: sentimentality, superficiality, and intimacy."[61]

Skepticism about gender appropriateness is also an issue when considering the high level of interest in surface decoration and "dressing up" that occurs with the images of Krishna in temples. An inordinate amount of attention is paid to dressing the body of the god and to the housekeeping that comes with attending to a sacred manifestation. A comparison to playing with dolls is constantly—and tiresomely—brought up by newcomers to this material.[62] That this is not unique to Hinduism or to Krishna *bhakti* can be seen in the point made by Morgan that "Christ is also made concretely real through physical interaction between viewer and image. Interacting with sacred images—dressing, praying to, speaking with, and studying before them, changing their appearance in accord with seasonal display—is a common and important way of making them part of daily life."[63] Dressing and ornamentation in India form an integral part of an ancient and deeply felt attitude toward bodily enhancement that merits further exploration; one needs to come to terms with the importance of jewelry and textiles in Indian culture to make sense of their roles in temple decoration. As Aitken explains about Indian jewelry, "Because of jewelry's potency, Indians have developed ornaments for every part of the body, from toe rings, anklets, and rings for the thighs to belts, nose rings, turban ornaments, braid covers, and even pendants for the parting of the hair. Over and above their powerful effects, ornaments flatter the body's forms and motions. They also demarcate a social skin."[64]

The foregoing discussion of excess, spectacle, disinterestedness, the relative value of art and kitsch, and fashion might seem like a digression but for the negative impact such concepts have had on much of the thinking and scholarship about Indian art and religion. In discussing decoration and ornamentation as a topic worthy of analysis, I am aware that there nevertheless remains a strong undercurrent of distrust about the intellectual merit of what might be considered the merely decorative. Among some of the pejorative implications of this term are that decorative things are trivial, afterthoughts, commodities, materialistic, subject to fashion trends, manipulated, and manipulative. And there are further obstacles,

primary among them being concerns about the economics of visual display. I am frequently asked if the level of ornamentation that one sees in the temples under discussion here cannot simply be chalked up to the growing ostentation of India's nouveaux riches. And there is some truth to that observation; things *are* more spectacular than they have been in the past. But before we simply attribute this increased level of visual intensity to too much money and not enough taste, we might pause to consider what the value of such increased visual drama might be for patrons and worshipers. Moreover, what do patrons want to sponsor, and why? What are the systems of value? These are questions worth asking if one is to get at the heart of how Indian visual culture works in a religious context. Again, this is a topic that has also captured the interest of those working in the area of American material religion. McDannell advises: "If we immediately assume that whenever money is exchanged religion is debased, then we will miss the subtle ways that people create and maintain spiritual ideals *through* the exchange of goods and construction of spaces."[65]

Sumathi Ramaswamy has written cogently on the theoretical processes and products of visuality in India. Although she focuses on modern India, what she has to say is entirely relevant for our purposes:

> A hermeneutic of the visible in the modern Indian context also has to be grounded in an understanding of visual objects as inhabiting a public (and political) world—rather than a private hermetically-sealed off domain of aesthetic contemplation—where they are in (contested) dialogue with each other and with other agents of communication, as they jostle for the attention of the beholder-turned-spectator/consumer.[66]

I would especially like to turn our attention to her phrase "beholder-turned-spectator/consumer." As we will see in the following chapters, this usefully underscores the artificial divisions that permeate scholarship on the arts: the divisions between beholding and consuming, and between passively standing outside of an aesthetic experience and being fully immersed in it with eyes, body, and heart.

1 The Radharamana Temple:
Divine Time, All the Time

Sitting amid a heap of vivid pink lotus buds, Lakshmi patiently took each one in turn and folded back its silky petals. As she placed each newly opened blossom to the side, she remarked that there were a thousand lotuses to get through on this stifling late June afternoon. "Even at four rupees apiece, what price is this to pay for the Lord's pleasure?" she mused. Lakshmi and a host of workers were furiously laboring in the Radharamana ("the one who sports with Radha") temple courtyard, preparing a flowery stage set (*phul bangala*) for that evening's special event; it would comprise one presentation in an eight-day series sponsored by one of the Radharamana temple's leading *goswami* families. Up on the stage-like dais in front of the altar, workers were arranging the opened lotuses and twisting long strings of fragrant white flower buds onto the *bangala*'s wooden supports. These window-like frames—along with other shaped wooden skeletons—are studded on their fronts with regularly spaced protruding nails. The strung flowers are wrapped around these nails in intricate patterns reminiscent of the carved sandstone and marble screens (*jali*) seen in the region's Mughal and Rajput architecture. A vivid blue cloth backing set off the trellis-like designs created by the strings of brilliant white flowers and complemented the extraordinary pink of the lotuses. Intensely colored marigold and rose tassels were also hung from garlands that were arranged across the tops of some of the *bangala* frames. As each individual *bangala* frame was assembled, it was fitted into a gradually growing pattern of flowery tiers. Some of the *bangala* frames were arranged so as to create three-dimensional cubbies, balconies, and alcoves.

At center stage, other workers were constructing an arbor of mango leaves and fruits (fig. 1.1). Cherries, bananas, mangoes, and plums were tied among the leaves that were tucked up under a

Figure 1.1. Assembling
a *phul bangala* at the
Radharamana temple

canopied roof topping a small pavilion-like structure. Although
botanically improbable, the effect was of a lush forest arbor (*kunj*)
or open-air pleasure pavilion. The back and the sides of the pavilion
gleamed with cutout floral designs constructed of iridescent white
banana pith. Small brass female figurines dressed in complemen-
tary sheer white dresses were inserted into niches around the cen-
tral pavilion, some bearing fruits in their hands.

Not to be overlooked in the preparations, a miniature *bangala* also
graced a planter for a *tulsi,* or holy basil, plant in a corner of the court-
yard across from the dais. The *tulsi* plant, emblematic of the forest

goddess Vrinda after whom Vrindaban is named, is always found growing in the courtyards of temples dedicated to Krishna, where it conceptually symbolizes the lush forested landscape of Braj.[1] The preparations for tonight's stage setting thus promised to draw upon some of the most symbolically pregnant natural symbols of religious life in Braj: the river Yamuna, the goddess Vrinda in her natural form as the *tulsi,* and the fertility of ripe fruits and flowers.[2] Reminiscent of a crew making stage sets for a school play, the workers frantically scrambled to finish up; and by 5:15 PM, a cloth curtain was pulled across the front of the stage, all the debris was swept up, and the temple was quiet for what was left of the afternoon.

During all this activity, the deities for whom this gorgeous stage set was being designed slept peacefully. Polished silver doors to the temple's sanctum were shut tight against any disturbances while the *svarupa* Radharamana took his afternoon nap. Radharamana is the manifestation of Krishna who revealed himself to Gopala Bhatta Goswami (1503–1578) in Vrindaban in 1542. Originally from Shrirangam in South India (modern Tamil Nadu), Gopala Bhatta came to Chaitanya's notice when Chaitanya was visiting that important temple site during his two-year sojourn around South India, around 1510–1511.[3] Gopala Bhatta was the son of one of the priests of the Shrirangam temple, and although but a young boy, he became Chaitanya's disciple. As the boy matured, Chaitanya asked him to go on pilgrimage to Nepal, where he collected a number of *shalagrama*s, the smooth black river stones that are considered by Vaishnavas to be sacred emanations of divinity. Gopala Bhatta then settled in Vrindaban, bringing with him three new disciples.

According to Chaitanyaite Vaishnava tradition, Gopala Bhatta had the unusual distinction of being singled out by Chaitanya as his spiritual heir, a request Chaitanya made a short while before his death in 1533. Along with this, Chaitanya handed over to Gopala Bhatta responsibility for completing the work of codifying the guidelines and instructions for Vaishnava temple rituals and behavior. These were compiled in the *Hari Bhakti Vilasa* (The Performance of Devotion to Hari, an epithet of Krishna), which many believe was assembled by another of Vrindaban's founding Six Goswamis, Sanatana Goswami (1488–ca. 1555); there are other accounts, however that attribute its authorship or co-authorship to Gopala Bhatta.[4] This manual is still used as a reference for today's rituals, supplying regulations for the appropriate personal and ritual conduct of Vaishnavas.[5]

Figure 1.2. Radharamana Krishna, Radharamana temple. Courtesy of Robyn Beeche, Shri Chaitanya Prem Sansthana Archives

Ultimately, Gopala Bhatta was rewarded for his devotion with his own *svarupa* of Krishna, but it did not come easily (fig. 1.2). Margaret Case relates the story of how Radharamana eventually came to reveal himself to Gopala Bhatta in Vrindaban:

After many years of worship, in 1542, it is said that Gopala Bhatta had become discouraged because Sri Caitanya's promise made years before (he had left the world in 1533) had not been fulfilled. This was the promise that Gopala Bhatta would have his, Caitan-

ya's, darsana (equivalent, in Gopala Bhatta's belief, to darsana of Sri Krishna and Radha themselves) through worship of the salagrama stones. On the eve of Buddha Jayanti, the full moon of Vaisakha (April–May), Gopala Bhatta was reading the sacred story of the young boy Prahlada, to whom Krishna manifested in the form of the man-lion Nrsimha. Gopala Bhatta was overwhelmed by the realization that this young boy had the good fortune to see the Lord himself through the power of his devotion, but that he himself had not been so fortunate. Acutely feeling his own worthlessness, he lost consciousness. A basket holding the precious salagramas was hanging from a branch overhead. When he regained consciousness, he noticed that the lid of the basket had come open a bit. Fearing that a snake had entered, he tried to push down the lid but found it impossible to do so. Then he looked inside and found, instead of the salagramas, a small black figure, his head tipped slightly to the left, his torso leaning slightly to the right from a slender waist, his knees gracefully bent and his right foot crossed over his left. This "triple-bent" (*tribhanga*) boy was holding a flute to his lips with both hands. This is the image whose home is in Radharamana temple.[6]

As noted earlier, Radharamana's self-revelation was but one in a sequence of such miraculous events, and the effect of such potent physical expressions of divinity was to secure Vrindaban's importance in earthly history, prompt the construction of temples around the images, and draw worshipers and patrons to these new manifestations. Because a *svarupa* requires continual care and ritual attention, there arose a need for ritually sanctioned caretakers; to this end, a hereditary lineage was established that was dedicated to Radharamana's well-being. Of the group of Six Goswamis, Chaitanya's singling out of Gopala Bhatta for discipleship meant that, as Case writes, "Gopala Bhatta was the only one of the Six Gosvamis who established a lineage of disciples. As an indication of Gopala Bhatta's position, Sri Caitanya Mahaprabhu sent his own seat (*asana*), his necklace (*mala*), and renunciate's loin cloth (*kaupina*) to this holy man of Vrindaban."[7] She also explains, "Seva in the temple, service to Radharamana, is maintained by members of the group of Gosvami families who trace their lineage to Gopala Bhatta. The first link in the chain of inheritance is spiritual, not physical. Gopala Bhatta never married."[8] It would eventually fall upon the shoulders of one of Gopala Bhatta's disciples to perpetuate the lineage that today still traces its origins to him.

Gopala Bhatta was connected through Chaitanya to Sanatana and Rupa Goswami (ca. 1489–ca. 1564; these dates are not agreed upon

by historians), two brothers from Karnataka who also were part of the Six Goswamis group; also included was their nephew Jiva Goswami (1513–1598). All were handpicked to continue Chaitanya's work in Vrindaban after he departed to return to Puri (Orissa). Rupa Goswami, the most renowned of the group, had already discovered the self-revealed manifestation of Krishna Govindadeva in 1534, and he was also responsible for writing extensively about Vaishnava devotional theory, practice, and aesthetics.[9]

The devotional movement spawned under their leadership, with its special ritual manuals, theoretical treatises, and commentaries, is still maintained by the sect (*sampradaya*) to this day. Known as Chaitanya or Gaudiya Vaishnavas, named after Chaitanya and his association with the capital at Gaud (Bengal), they are distinctive in their elaborate and aesthetically rarified exposition of a specially cultivated devotional approach to Krishna and Radha as illicit lovers. The fact that Radha is conceived as being married to someone else (*parakiya*) makes their love even more pure in its intentions, as it is love that transcends all duty and social strictures. Shashi Bhushan Dasgupta elaborates upon this concept:

> The highest ideal of human love, which is the most intense, is the love that exists most privately between couples, who are absolutely free in their love from any consideration of loss and gain, who defy the society and transgress the law and make love the be-all and end-all of life. This is the ideal of Parakiya love, which is the best human analogy for divine love. It is because of this theological ideal that in none of the legends of Radha-Krishna is Radha depicted as the wife of Krishna, she is generally depicted as the wife of another cowherd, or as a maid just attaining the prime of youth.[10]

Rupa's most influential treatise was the *Bhaktirasamrtasindhu* (The Ocean of the Essence of Devotional Rasa), written and completed in Vrindaban by 1541. David Haberman, who translated and edited this copious work, explains it as a

> detailed and systematic study of human emotions, conducted in terms of the classical aesthetic theory of India, wherein the true object of emotions is God. This brings us to the deeply religious world of Gaudiya Vaishnavism as envisioned by Rupa Gosvamin, wherein the primary aim is an experience of Rasa, a term rich in meaning, but understood briefly as the culminating result of relishing a divine emotion. The *Bhaktirasamrtasindhu* gave definitive form to a religio-aesthetic theory that has shaped many of the cultural productions of northern India from the sixteenth century on,

and gave voice to a way of thinking about the religious life that has had a lasting influence into the present day.[11]

In this work, and in the practices and theology that developed around it, emphasis is placed on the exposition of the different types and hierarchies of aesthetic modes (what he terms *bhakti-rasas*) through which the devotee may experience the joy and love of Lord Krishna and his beloved Radha. In this, Rupa Goswami's work is unique, as "Rupa was the sole writer to create a systematic formulation of a uniquely Vaishnava aesthetic."[12] For the serious initiate, this formulation involved a highly individual program of initiation, meditative practices, creative visualizations, theatrical embodiments, imaginative role playing, and other devotional performative actions tailored to the devotee's interests and abilities.

For Rupa Goswami, however, one particular emotional aesthetic reigned supreme as the one best suited for experiencing the full potential of Krishna *bhakti:* the amorous mode (*madhura-bhakti-rasa*). Here, the erotically charged relationship of Krishna and Radha provides an emotional template for the structuring of the devotee's own particular relationship to Krishna. As Radha and Krishna respond to each other, so too does the devotee savor Krishna as his or her own beloved. Moreover, all the trials and tribulations that plague the divine couple's relationship are also milked for their full affective potential in the worshiper's imagination. In particular, the pain of separation (*viraha*) from one's lover becomes a vehicle for expressing the pain of the devotee when parted from Krishna. Also important is the thrill of the illicitness of Radha and Krishna's passionate union; this creates all the more fuel for the devotional fire. The couple's transgressive relationship is, however, not to be viewed as indulging base sexual lust: it is to be understood as pure desire selflessly directed toward the pleasure of the beloved.

For the current *goswamis* of the Radharamana temple, this web of interrelated historical kinship and continuity with Chaitanya, his followers, and the theology they developed is of paramount significance, and it is actively nurtured through a variety of performative strategies, most visibly in the temple arts. Not only are aesthetics a means for forging connections with the founding religious theorists, but also they remain a vital catalyst for continuing spiritual transformation. The temple arts comprise visual media, in the presentation of exquisite *darshan*s and their accompanying temple decorations and stage sets, as well as performing arts, such as theater, music, song, and dance. The provision of beautifully prepared

food offerings and seasonal delicacies engages other senses. For Radharamana's manifestation is living proof of a connection that extends back almost 500 years, endowing the temple and its hereditary priesthood with a specific historical and religious legitimacy that is never taken lightly.

Even though all of Radharamana's *goswami* caretakers share an equal commitment to serving their god to the best of their abilities, it is not a secret that there have been and continue to be differentiations—and even some competition—in the artistry of the temple *sevas* among the family lines that care for Radharamana.[13] As the genealogy is becoming more complex and fragmented through time, the pressures to sustain this temple tradition in all its dedicated purity and selfless service—in a world so vastly different from almost half a millennium ago—necessarily create friction and challenges. Nonetheless, the most important objective for all the *goswamis* and their devotees is to please and take care of Radharamana and his beloved mistress Radha.

Taking care of Radharamana and Radha is a round-the-clock activity that is immensely demanding and time-consuming. Krishna and Radha's exalted embodiments in the temple are considered to be continuously present—and so they must be fed, bathed, dressed, ornamented, put to bed, and so on every day, every week, every month, every year—as already has been done for centuries and presumably will continue into eternity. These responsibilities unfold in a prescribed manner, as we can see in turning our attention back to the activities that opened this chapter.

During the torrid afternoon hours of that June afternoon, Krishna Radharamana and his beloved Radha were taking a well-deserved rest. The divine couple had already started off with a long, eventful morning, making their first appearance to their devotees at about 4:45 A.M. Thereafter followed a regular cycle of appearances based on Krishna's eternal daily schedule (*ashtayama lila*), part of a system of visualization that was imaginatively elaborated in Chaitanyaite theory. Neil Delmonico explains: "The day of Radha and Krishna is divided into eight periods that act as divisions in their sport, and these periods correspond to eight divisions of roughly three hours each in the day of the practitioner, and thus can be given exact times in the earthly day of twenty-four hours. This allows a practitioner to visualize what Radha and Krishna are doing at any time during the day."[14]

Open Secret: A Day in Krishna's Life

Krishna's schedule in the temple makes visible what every devotee knows—how he spends this day and every day in the eternal Vrindaban. Devotees can easily imagine Krishna's unending routine: he is awakened very early in the morning after a night of love-making with Radha in Vrindaban's groves and forests (usually by Radha's girlfriends who urge them both back to their respective homes); he then slips back into his own bed just in time to be roused by his unsuspecting mother, Yashoda, at sunrise. He goes through his early morning chores and personal duties and finally, after dressing and eating, he heads out to the fields with the cows and his cow-herding companions, where a lot of play and tomfoolery occurs. He then has his midday meal, and afterward, while ostensibly napping for the afternoon, he is instead to be found in Radha's—or perhaps another *gopi*'s—arms in the quiet of the green forests. Although Radha is his true love, and the one to whom he will always return, Krishna is well known for his wayward ways, and his inconstancy causes dramatic tension between the couple that is usually resolved with much exquisitely heightened emotion. After his nap, the rest of the afternoon is whiled away until Krishna returns back home with the cows. Upon his return, he is refreshed with a snack, changes his clothes, and relaxes until the evening meal. Just before bed, he is brought warm milk and is sung to sleep with a lullaby. As the full quiet of the night descends, Krishna slips out of the house in search of his beloved Radha for a night of sensuous passion. The next day, the cycle begins anew, eternally.[15]

The conceptual connections with Krishna's daily schedule as outlined in text and poetry are borne out by Radharamana's physical appearance to his devotees in the temple. His body and ornamentation are prepared by the *goswamis* for the daily rotation of his formal public viewings (*darshans*), and their decorative details reflect the specific time of the day. For the first presentation of the day, for instance, Radharamana greets his devotees in his pajamas. Later in the morning, he emerges fully dressed and decorated, and at lunchtime he might change part of his clothing or jewelry. He often appears in a new fresh outfit for the evening viewing, and by the end of the night, he is attired in more comfortable lounging clothes. Devotees mentally tuck him into bed until the following morning, when they greet him anew, still clad in his bedclothes. In addition to the staged sequence of clothing and ornamentation that reflects his daily schedule, Radharamana's attire is also responsive to the seasons: for example, in the winter, his clothing is heavier,

more luxurious, and covers his whole body—including even mittens and booties. Correspondingly, in the summertime, he wears the lightest of fabrics and the skimpiest of fashions. Krishna's ornamentation and dress allow the worshipers to imaginatively share the same stage with their lord—and connect the divine and the mundane worlds with a common material vocabulary.

Certain details of Krishna's daily activities—especially the amorous ones—are meant to be a secret, but devotees are privy to this knowledge through a bit of divine reportorial leakage. One of the sources is a story in which the sage Narada questions the god Shiva about Krishna's daily schedule. Shiva in turn sends Narada to the goddess Vrindadevi, who answers Narada's query, "Even though it is secret I will tell you, Narada, [for] you are a devotee of Krsna. You, however, should not reveal it; this is the greatest mystery of mysteries."[16] Naturally, the secret was promptly passed on through the eons, but the sense of privileged mystery, now shared by Krishna's contemporary human devotees, has not abated. Access to this intimate chronology puts devotees "in the know": it is an open secret among all who love the god. A sense of shared indulgence thus unites devotees as they gather in the temple: they are all aware of what Krishna has really been up to, and they find it amusing and endearing. This secret knowledge fuels the emotional fervor that is brought to a climax when the worshipers have actual *darshan* of the god. The priests who minister to the god's needs behind the sanctum doors and the devotees who come to witness what the priests make visible are willing collaborators in a collective imaginative drama.

That this drama never ends only adds to its magic; and despite the following of a preset, eternal schedule, the *darshan*s are never routine, at least in theory. This is where ornamentation plays a particularly critical role, as it is ornamentation that makes things special and that contributes to the daily sense of wonder. The staged realm of art and aesthetics creates a space wherein certain things can happen that do not ordinarily occur in the mundane world. Participants in temple *darshan*s cross more than a physical threshold when they enter the temple: they also cross a psychic threshold into a province of the spirit and the emotions. Creative emotional possibilities arise with allowing oneself to be vulnerable and open to the experience of viewing the deity in his splendid domain, a domain that rewards the devotee time and time again with fresh and inspiring visions.

A similar phenomenon of openness to, and immersion in, the fraught deliciousness of emotional response occurs in Hindi films.

Sam Joshi points out in an instructive article that an important objective in some Hindi films is to present events in a manner that allows viewers to viscerally experience the emotions of the characters on the screen. Bollywood's focus on emotion differs from the Hollywood concentration on plot and action: he terms this dichotomy "affective" as opposed to "cognitive" realism. Joshi states, "[T]he viewer of affective realism is not interested in what will happen next, but in how a particular on-screen event *feels*. To experience a depicted emotion in as much depth as possible is the reward for a viewer of Hindi cinema."[17] It follows that to experience an *elicited* emotion in as much depth as possible is the reward for a viewer of an effective temple *darshan*.

A Kaleidoscope of Time

Emotions are elicited by a felicitous conjunction of an individual's emotional preparedness and his or her particular response to and participation in the *darshan* experience. That participation is in turn aided by sensitivity to where the devotee is in time and space—an awareness of which can increase the worshiper's potential for a fully affective experience. The aesthetics of temple *darshan*s are informed, in part, by visual codes that communicate a particular cosmic positioning to the alert and knowledgeable devotee, and these visual codes constantly change in response to the passage of time. The *ashtayama lila* daily schedule, for example, forms but part of a larger temporal matrix in which the divine couple and their devotees are involved. Indeed, the entire premise of time itself is exceedingly complex in India.[18] While the country follows the Gregorian calendar and organizes its business schedules like any other modern country, lying under the surface of this standardization is a riot of calendrical possibilities. There are multiple specialized calendars available, each tailored to one's specific geography, religion, and sectarian affiliation. Even the simplest of bazaar calendars will provide information, spelled out in a cryptic graphic shorthand, about contemporaneous temporal circumstances (such as planetary and zodiacal positions and their timing) for every day of the year. Deciphering a Hindu calendar requires expertise in astronomy, astrology, national and regional particulars, and the numbering systems of ancient eras that connect present time to that of former dynasties. There is an aesthetic of time that extends into the smallest fragments of daily living and that divides each day into ever-smaller units, each individually endowed with its own special

qualities and degrees of auspiciousness or inauspiciousness. These units are in turn bundled into the eight three-hour segments (*prahara*) that form the rhythm of Krishna's daily schedule. Early dawn is considered a peaceful and highly auspicious time, and it is particularly appropriate for worship and going to the temple. Dusk, poetically termed "the hour of cow-dust" (referring to the time of day when cattle are herded back to the village) is similarly religiously potent. Little happens in the mid-afternoons, a time of rest for humans and gods. I discovered that the intersection of real time and divine time was one of the most important factors in understanding the language of ornament; and if one did not know where one was in time, little else made sense.

In addition, in the manner of ever-widening circles rippling out from the center of a pool, different levels and types of time further envelop the temple. Extending beyond the time of day or night, the levels of temporality important for each temple *darshan* draw upon increasingly broader references. These include the specific solar day of the week, its sequence in the biweekly lunar cycle of light and dark halves, the lunar month's position in the lunar year, the lunar month's place in the annual festival (*utsav*) cycle, and the ongoing sequence of the seasons. Richard Davis's felicitous phrase "an oscillating universe" evokes perfectly the way in which these machinations of time are in constant movement, intersecting with one another to create unique chronological moments.[19] Each *darshan* thus occupies a specific temporal niche that is cyclical but never repetitive. Although time is fluid, each *darshan* creates an opportunity for a small fragment of temporality to be briefly framed—allowing it to be held there for a momentary period of rapt contemplation.

The Radharamana temple liturgy is organized around a system of timekeeping in which the days of the week are connected with a presiding planetary deity and its associated gemstone and color: Sunday's planet is the sun, the gemstone is ruby, and the color is red; Monday's is the moon, the gem is the pearl, and the color is white or pink; Tuesday's is Mars, whose gem is coral and whose color is red-orange; Wednesday's is Mercury, emerald is its gem, and the color is green; Thursday's planet is Jupiter, with the gemstone topaz and the color yellow; Friday's is Venus, associated with the diamond and the color white, or a variety of other colors (like the multicolored prisms of a diamond); and Saturday's planet is Saturn, whose gem is sapphire, and black or dark blue is its color.[20] These planets and their associated gemstones have specific apo-

tropaic properties, and while many of the planets have auspicious profiles, it is important to understand that all things that affect time are highly interdependent and entirely relative. Things can go awry at any time; thus, timing is everything. All contemplated actions need to consider the relative positions of a host of astral and celestial conjunctions. For this, one needs a guide, and Indian calendars provide a road map to navigating through the auspicious and inauspicious moments of each and every day.

The temple calendar, a small pamphlet published yearly at its official start in March, also provides a broad listing of the major cosmic alignments and events, coordinating them with the specific rituals and observances that are particular to the Radharamana temple. A major category of cyclic recurrence is the phase of the moon. For Vaishnava temples, four lunar phases are observed each lunar month: the fortnight leading up to and including the dark (new) moon (*amavasya*); the fortnight leading up to and including the full moon (*purnima*); and the eleventh day of each of those fortnights, preceding the appearance of the new or full moon on the fourteenth day. Termed *ekadashi*, the "eleventh," this day (as well as the other lunar phases) is marked on the calendar and is generally observed with certain prescribed behavior, notably specific vows and dietary observances. Each of these lunar phases is also made visible in Krishna's ornamentation.

Daily time and monthly time are part and parcel of the annual cycle of events, which coordinates with seasonal changes. In March, Holi ushers in the spring. The scorching heat of May through July is offset by festivals of flowers, decorated swings, fans, and cooling fountains of water. Krishna's birthday in late August or early September heralds not only the birth of the god, whose skin is colored dark like a monsoon cloud, but the monsoons themselves. The autumnal celebrations of Diwali (dedicated to the goddess Lakshmi), Govardhan Puja (when Krishna is worshiped as the uplifter of Mount Govardhan), Gopashtami (when he is venerated as the divine cowherd), and Sharad Purnima (the culminating October full moon that illuminates Krishna's great circle dance) all revolve around bounty, the harvest, the sacred landscape of Braj, and Krishna's potent powers of illusion. A wide spectrum of other ritual activities and festivities punctuates the calendar as well: the birth and death anniversaries of Chaitanya, Gopala Bhatta, and other important figures and former *goswami*s; the appearance day of Radharamana; and other temple-specific and locally inflected cel-

ebrations. The list goes on and on. It is fair to say there is never a dull moment in the temple's calendar. And all of these observances potentially involve some sort of special decoration and ornamentation that set them within their proper ritual, cosmic, and temporal frameworks. The details for each *darshan* are thus predicated upon a set of complex and deliberate choices, and their aesthetic success is dependent upon the skills, aptitudes, resources, and interests of the particular *goswamis* in charge of the god's care.

The preparations for each *darshan* in the Radharamana temple are performed by the multiple families of descendants who connect back in time to Gopala Bhatta. An intricate system of dividing up the responsibilities throughout the ritual year results in the apportioning of specific segments of time to each of the numerous *goswami* families. Thus, it might be that during the year a particular *goswami* family will be in charge of Radharamana's care (*seva*) for as little as a few days or as much as a month or more. When individual families take their turn in the temple, it is up to them to determine how elaborate or simple the *darshans* will be during their time of service, but first and foremost they must be mindful of staying within the centuries-old ritual strictures governing Radharamana's care.

For the purposes of this book, I will concentrate on select examples from *sevas* sponsored by the family of Purushottama Goswami, the head of a prominent *goswami* family familiar to many scholars in the field of Krishna studies and the arts (and who is most often referred to as "Maharaj-ji"). Margaret Case's excellent book *Seeing Krishna* focuses on the history and contributions of this family, and numerous researchers have benefited from the charismatic wisdom and guidance of Purushottama Goswami and his equally capable son Shrivatsa Goswami. Like these others before me, I have chosen to focus my attention on their *sevas*: I do so because of their distinctive and highly refined commitment to the temple arts and because of the articulateness and generosity of the family in sharing information. Not only are they deeply involved in perpetuating the initiatives set in motion by Chaitanya and his disciples so many hundreds of years ago, but also they are active in trying to keep the temple arts alive through their foundation, the Shri Chaitanya Prem Sansthana. This foundation sponsors conferences and artistic performances, and it has also produced, among other publications, a gorgeous and informative book on the temple arts entitled *Celebrating Krishna*, generously illustrated with beautiful photographs by Robyn Beeche.[21] Additionally, the foundation

is active in promoting greater environmental awareness and in mobilizing sorely needed campaigns to improve the local environmental conditions in Vrindaban and the Braj area.

An enormous amount of preparation goes into staging a longer, more elaborate *seva*. Even in the normal course of events, readying Radharamana for his daily presentations involves a complicated sequence of ritual activities involving many people for many hours. Case provides an informative overview of the daily routine in the Radharamana temple, and she also evocatively describes some of the more special events that have been sponsored by Purushottama Goswami and his family. As she notes, "Maharaj ji's seva is envisioned to create and offer for Krishna's enjoyment the best that the arts of Vrindaban can provide, for the inducement and enhancement of bliss (*ananda*). The temple itself, then, is a continuously changing work of art."[22]

Let us return once again to that June afternoon to see how this process of artistic creation unfolds. After the couple had taken their nap, the time had arrived for them to make their evening appearance. By about 7:30 PM on this sultry evening, the Radharamana temple interior had been transformed from a work-in-progress to a fully visionary work of art (see pl. 1). As worshipers streamed into the temple, they caught a glimpse of the fairytale-like floral pavilion soaring from the stage to the high ceiling. During the heat of the day, the delicate white petals of the strung flower buds (which until they are twisted on the *bangala* frames are kept on ice wrapped in wet burlap sacks) had gracefully opened. Their sweet fragrance was ravishing, the scent beckoning temple-goers even before they stepped across the threshold from outside. The stage set was an artful balance of hot and cool colors, and the vivacious pink of the lotuses, the pristine white of the flowers, the intense liquid blue of the cloth, the iridescence of the banana-pith backing, and the oranges and yellows and reds of the fruits and garlands all came together in an unabashedly romantic spectacle; it was impossible not to be caught up in the playful passion and sheer sensuality of it all. Here, the poetry and myth of Braj was embodied in material form. The stage setting brought to mind some of the more evocative passages from the *Gitagovinda,* or miniature paintings depicting the divine couple making love in a forest pavilion.

Before being granted this vision, however, temple visitors undergo a shift in sensations as they make the transition from the external world to this interior revelation. From the outside, the Radharamana

temple—like so many in Vrindaban—is architecturally unprepossessing. Reached through a walled compound that leads off the street, its nineteenth-century carved sandstone entrance façade is stylistically undistinguished. As other scholars have previously described, this modest exterior draws upon the vocabulary of domestic courtyard architecture, not revealing the fact that beyond its sandstone entryway is a large, covered, marble-tiled interior courtyard fronted by a stage-like altar.[23] What worshipers witness inside this temple courtyard stands in stark contrast to the reality that lies outside its doors. Even this late in the evening, the temperature outside was hovering in the high ninety degrees, and the well-worn path to the temple was strewn with debris and litter, despite erratic attempts to keep it clear. I will revisit this issue of the contrast between real and ideal later, but the dramatic impact of the artistic transformation of the temple's interior was only heightened by this distinction between outside and inside. If the scene setting that happens on such a regular basis in the temples of Vrindaban brings the myth of Braj to life in a way that guarantees its symbolic continuity, there are nonetheless serious threats to Vrindaban's actual, physical survival.

Attendance at that night's *darshan* was high, as the word was out that this *goswami* family puts together particularly beautiful displays and performances. There was a broad mixture of attendees: local folks, young and old; wound-up children; well-off devotees and patrons of the *goswami* family who had come to Vrindaban from New Delhi, Varanasi, Calcutta (Kolkata), and elsewhere for the whole or part of the eight-day duration of this *seva;* ISKCON (International Society for Krishna Consciousness) devotees from the other side of town; worshipers stopping through on pilgrimage; appreciative interlopers such as myself; and so on.[24] Many of the bigger temples in Vrindaban are specially equipped to alleviate the heat such a crowd generates on a hot summer night: for this purpose, jets of water descended from sprinklers suspended above the heads of the crowd, lightly spraying the courtyard where the throng was gathered. Consequently, the floor was slippery, and everyone was still hot and now sticky. All were excited, especially in the charged moments that preceded the opening of the sanctum doors for the first *darshan* of the evening. It was clear that this was a special night, for when the doors were finally opened, the priests performed a particularly lavish *arati* with thirteen lighted tapers (*utsav arati*) instead of the nine that are customary for this time of the evening. Throughout the rest of the night, the mood of rapt atten-

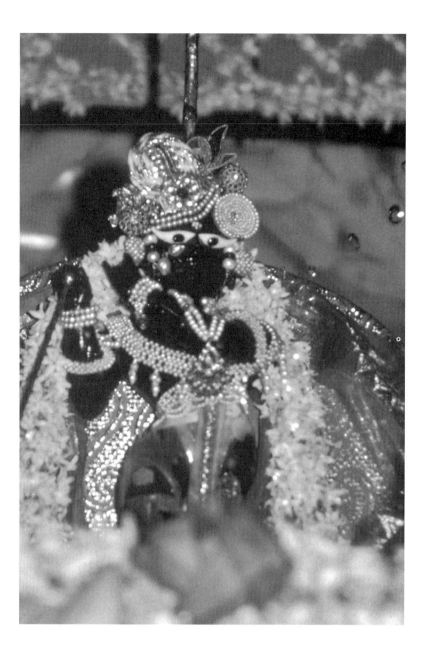

tiveness would be extended with additional ritual offerings, as well as the energetic exposition of devotional chanting, singing, and spontaneous dancing in the temple courtyard.[25]

Adding to the visual drama was the exquisite costuming and decoration of Radharamana, who stood upon a small, gold, box-shaped platform facing his devotees. Since the day was Monday, he wore a sheer lower garment of moonbeam-colored silk, with a vivid orange-yellow scarf echoing the colors of the fruits hanging above his head (fig. 1.3). Radharamana's black skin gleamed through the sheer fabric, and his diminutive figure (he is only about a foot tall)

was embellished from head to toe (or, as we will see, from toe to head): an elaborate confection of minutely detailed ornaments and headdress was balanced on his head; exquisite pearl, diamond, emerald, and gold jewelry decorated his throat, upper arms, wrists, and waist; and on his feet were gold-belled anklets.

To Radharamana's left was a similarly beautifully decorated mound of silk and gems, representing his consort Radha. The early self-manifestations of Krishna did not need to be provided with a separate partner image of Radha, for believers are aware that Radharamana is an incarnation of both Radha and Krishna in the same body. As Jack Hawley explains:

> Krishna and Radha must act out their duality in order to experience their union. . . . In temples this duality in oneness is expressed in the fact that in every sanctuary where Krishna's image stands alone Radha is understood to dwell within him: her throne, which one sees alongside his, and which is served with the same elaborate attention that is lavished upon him, appears empty to the naked eye, for he and she are not so separate as to occupy two distinct places.[26]

This strikes at the core of the important Chaitanyaite concept of *achintyabhedabhedha,* "inconceivable difference in non-difference."[27]

Radharamana, like his worshipers that night, was also cooled down with water that artfully spouted from a small fountain embedded in the stage (called *jal yatra*), and the wet-*dhoti* look was beguilingly suggestive of the power of Krishna's eroticism, bringing to mind a poem from Govindasvami, a sixteenth-century devotional poet from Braj, who wrote:

> Lala—the boy Krishna—O friend! is returning
> home drenched.
> The yellow ornament for his turban incites an excess of love.
> The sky thunders like a kettle drum, the wind
> quickens the rain.
> Glimpsed through the wet cloth,
> the dark body of the boy bearing the mountain
> shines through.[28]

The microscopic attention to ornamental detail lavished upon the petite body of Radharamana is, however, not easily visible. It takes a dedicated effort to see all of the particulars, and it helps that, in the summertime, Radharamana's throne is moved farther forward from within the sanctum than is the practice in the wintertime. Such a

small personal image of the deity was undoubtedly never meant to be enthroned in a large, public temple space; and the god's small size invites scene building on a grand scale in order to effectively fill the space and dramatize the presentation. But Radharamana has such a commanding presence that—when the stagecraft is done well—he does not get lost in the scenery. Rarely, however, is the staging this extraordinary, and in the normal course of events it is not often that such a perfect visual balance is struck.

It is really only with binoculars that the selectively interested viewer—an American art historian, for example, or an avidly committed devotee—is able to see the full extent of the ornamentation. This is what I think of as the "Tiffany window effect": engaged viewers may stand outside the store's plate-glass window and marvel at and desire an arrangement of exquisite jewelry, but they do not have access to the jewels themselves, and many of the most minute details are not easily discernible from a distance. Similarly, devotees are always on the other side of the altar, viewing from a distance the finished effect of the *goswami*'s privileged ministrations to the god. Yet ideally, the appreciation of, and provision for, the finer details of the god's ornamentation is motivated less by the public act of presenting him in the temple at *darshan* than it is a private act of loving service between the *goswami* and the deity.[29] Tellingly, one of the most important gestures in the Radharamana liturgy is when the *goswami* holds a mirror in front of the god so he may appreciate himself in all his finery.[30]

That so much ornamentation can fit on a foot-high manifestation of Krishna is a tribute to the devotion and artistry of the *goswami*s, who—at least in theory—assemble the details through a combination of learned training and divine inspiration; they are thus both caretakers and arbiters of taste. I was told that although particulars of *bangala*s, clothing, and ornamentation were planned well in advance, there is always a level of spontaneity, as Radharamana lets the priests know what he wants to wear. Moreover, it is said, since Radharamana is self-manifested, so too is his ornamentation. All aspects of the god are unique; there is none other like him. For instance, even though there is a pattern of the planetary color of the day that is generally followed, there is a fair amount of variation, and routine is never slavishly adhered to. This openness to uniqueness, inspiration, and spontaneity is an important component of the Chaitanyaite approach to service.

The intense visuality described here is accomplished by virtue of a priesthood versed in the esoteric subtleties of Chaitanya Vaishnavite

theology and its rarified aesthetics. Krishna and Radha are not simply dressed for the day in any ordinary fashion; the choices made for the decorations and for any surrounding stage accoutrements—be they *bangalas* on special occasions or furniture such as thrones, ritual implements, and other thematically appropriate stage props—are guided by special training, manuals, and the temple's own specific customs. The distinction between priesthood and laity is an important one, as it is through the cultivated eye and careful stagecraft of the priesthood that devotees are given access to the distinctive visions of Krishna and his beloved. Moreover, the divine couple's pleasure and comfort are in the priests' hands—a serious task indeed. That nexus between priestly secrecy and public display is where the excitement lies: what is going on behind the closed doors of the sanctum? What does the priesthood see that we don't? Herein lies what David Morgan beautifully terms the "surprise of art."[31]

Another critical aspect of managing the details of service to the deity is approaching the privilege of serving the god with deep sincerity. I was repeatedly told that the "most important thing is honesty." Part of that is doing things by hand and not taking shortcuts. A good portion of each ritual day is taken up with arranging the ornamentation and clothing, organizing the altar accessories, and—during special occasions—the handcrafting of special displays, as well as the offering of live devotional performances of song, dance, and music for the deity, and much else. Shrivatsa Goswami told me that the *goswami* families used to make all of the *bangalas* themselves, as well as the clothing and food, until about twenty-five to thirty years ago.[32] Modernity has changed much about the ways things are handled now: the god's clothing is now most often made by tailors (although I always heard that "handmade is best"), families of craftspeople are hired to make the *bangalas*, and so on. But to the extent that organizing the temple arts can remain the province of dedicated priestly families, the service to the god retains its purity and historical continuity; otherwise, as Shrivatsa Goswami states, "the temple becomes irrelevant." One woman put it this way, "This temple's decoration is the best because it is so personal. The feeling has to be there; otherwise it is prosaic."

Although the priests have done all the work behind the scenes to ornament Krishna, they are not presenting a finished "product" when the doors open for viewing: the resulting vision of the god is ideally only the catalyst in a continuum of love, desire, and devotion on the part of the devotee. Thus, what one sees at *darshan* time

is a conjunction of processes, a cocktail of practicality and emotions. On the one hand, part of what one views is the carefully planned result of priestly training in the ritual texts, immersion in a specialized purified lifestyle dedicated wholly and selflessly to the service of the divine couple, and the stewardship and management of the temple resources—the business of worship, if you will. On the other hand, there is the spontaneity of the emotional moment, the unique spark of that particular fragment of time, and the relative openness to experience that devotees bring to the mixture. Essentially, you get what you give; you see what you want to see. All the elements have been prepared, and it is up to the worshiper to make the most of the opportunity proffered.

Shrivatsa Goswami defined the process of ornamentation as literally that—as a process or an act of love. Radha ornaments Krishna, Krishna ornaments Radha, and devotees in turn personally experience this act of love through viewing their god in the temple—participating in a whole circle of emotion set in motion by the loving act of embellishment. And as this process is repeated anew, again and again, it is fresh, inspired, and different each time. If it, however, becomes routinized, and if the spirit of authentic emotion is missing, then decoration becomes mundane and predictable, reduced to mere window dressing. Shrivatsa Goswami stressed that "the ritualistic activity one sees in Vrindaban's temples is there because love needs a beautiful, decorated environment to thrive." He reminded me that the term *shringara rasa* refers to a state of erotic and amorous emotion. When there is beauty, love and eros will blossom; in the absence of beauty, love will wither. Thus, through a lover's eyes, one gives the best possible for the beloved within one's own capabilities, and service (*seva*) is the ideal way to nurture love. So long as you are *giving*, love is sustained. This theme of continually, joyfully, and selflessly giving to the beloved is critical for understanding the role of ornamentation in Krishna temples.

For most visitors to the temple on that June night, however, it is reasonable to assume that these aesthetic subtleties were admired less for their conceptual particulars than for the overall effect of the decorated stage and Radharamana's splendid attire. Spectators responded with fervent love and devotion to their god, and as mentioned earlier, the spectrum of behavior at the moment of *darshan* is wholly engaged and interested in the extreme; everyone is there, as in the *ras-lila* dance, with their own particular hold on Krishna, and his on them. There are many ways to look at Krishna, but it is

common to hear that the best way is to start at the feet and move up, and the phrase "bottom to top" is frequently used. As one woman explained to me, the worshiper must always start at the feet of the god (Radharamana was referred to here, as he often is, as "Thakurji," or "Lord") or of any other esteemed presence such as a guru.[33] This is because all of the power is concentrated in the feet— and this is why, for example, the notion of the "dust of Vrindaban" on someone's feet is so important, as it means that the person has literally absorbed the essence of Vrindaban. She continued:

> Some people don't let everyone touch their feet—it's selective as to who gets access to that potency. Similarly, with Thakurji, all you could do is gaze upon his feet; you almost don't need the rest. All I need to do is go in for one *darshan* and then I fill in the details in my mind—I close my eyes and visualize the rest. I am a student of dance, and there are times when I see his feet change position. I have to ask people what position Thakurji's feet are really in, because I see something different. Such is the power of my absorption that I really see these things.

And from his toes to the top of his head, Radharamana is a special manifestation indeed, partly because of the preciousness of his small size and partly because of the unique refinement of his features. When they are not overly obscured by dress and ornamentation, one can see that the toes on his feet are individually articulated, and there is a flexible dancer's bend to his crossed front leg. His thighs are smooth and shapely, tapering into tight hips, a narrow waist, and a triangular torso canted to the side that is surprisingly muscular in effect. His arms are energetically lifted across his body, fingers bent in readiness to accept his flute.[34] A full neck supports a lightly tilted square head with round cheeks, upon which is etched a full mouth curved into a smile that just hints at a private joke, or perhaps satisfaction at the world he beholds and the loving attention that is continually lavished upon him. A dimple in his chin is ornamented with a jewel. When particularly delighted, he does show his teeth. A small, perfectly proportioned nose and lightly curved brows frame the curving, cat-shaped enamel eyes that are his special defining feature. In the summer, his skin gleams with the high sheen of a special *itr*, scented oil that is especially selected for its seasonal appropriateness; in the winter, the oil is dampened down to a pleasingly matte surface through which the delicacy of his features becomes somewhat clearer to the eye. The radiant power of this stylish and diminutive body is hard to explain, but it is palpable.

Devotees notice, in particular, the expressive features of their god. In addition to commenting on the beauty of the decoration—usually with such general statements as *mahabhav shringar* (roughly, "ornamentation of great feeling")—the way Radharamana's body changes is most often singled out for notice. Summertime is particularly rewarding, because his lithe black physique is unveiled; as one devotee said to me, "I love all the beautiful ornamentation, but this"—and she indicated the figure of Radharamana, who in the summer is usually stripped down to a light bikini just before bedtime—"I love best." He is said to smile, his teeth gleam, he looks majestic, royal, fat, tall, wholesome, happy, jolly, and his toes and toenails sparkle. His limbs, glowing with scented oil, seem to move. One particular occasion struck me as powerfully emblematic of this ability—or, in my case, inability—to see. At the time, I was stationed in front of the altar and I noticed that the fabric of the sari that was wrapped around the symbolic presence of Radha was surprisingly active. Seeing the skirts move, I immediately leaped to the conclusion that it was a mouse, having observed them scurry across the altar on more than one occasion. Yet, at that moment, a woman next to me turned and delightedly observed, "See, he is shaking! He is dancing!" I stopped and considered: my eyes had seen one thing, but this believer had seen something else. On another occasion, I overheard someone exclaim, "He's looking out of this world!" to which his companion responded, "He *is* out of this world."

judgement [The ability to suspend logic is a critical component of truly learning to see. As Shrivatsa Goswami cautioned me, "Focus less on the grammar and more on the poetry." He narrated a favorite story as an example of the tendency to stay within the bounds of rational, logical thinking:

> Let's say you have a *rasgulla* [a type of Indian sweet], and it is one of the best things you have ever eaten. You naturally want to find out where it is made, what the ingredients are, and so on. What if you learned that it was boiled in cow urine? Wouldn't you get sick and have your experience of its taste completely altered? Better, really, not to know. If you want to be blissfully aware, then don't be aware. It is best to be able to put reason and rationality aside so you can prolong and enhance the taste [*ras*]: this is the difference between knowledge and bliss [*ananda*].

For those who were willing to truly *see*, then, that night's *darshan* provided a guided tour through the most refined of Chaitanyaite

aesthetics: it brought together the themes of the season; the pleasures of the night; coded references to cosmic time; the romance and mythical potency of the Vrindaban landscape; the sensuous triggers of fragrance, color, and song; the magnetic attraction of the god's body; the erotic tensions between the couple; and the earthly demonstration of this particular priestly family's approach to service. And every *darshan* represents the potential for just such a conjunction of divine and earthly concerns; each temple presentation is a unique event in the ongoing continuum of divine time.

That night's *darshan* was the seventh of a series of eight special presentations that were hosted by Purushottama Goswami's family over the course of eight days in June 1999. For every one of those days and nights, the Radharamana temple was made as beautiful and as artful as possible: from the moment the doors opened at dawn until they closed at night, the temple was a vibrant platform for extraordinary visual displays, rapt devotion, heightened emotion, and dramatic song and dance performances. That evening's presentation, for example, capped an already splendid day for the divine couple. It was Monday, the moon's day, and felicitously, the moon was full. Lunar phases are indicated with special ornamentation, colors, or dress; for *amavasya*, the new moon, Radharamana dons black; for the full moon, he wears a distinctive triangular crown capped with a tall leaf- or fan-shaped finial and often wears white. Earlier that morning and until lunchtime, Radharamana had been presented to his worshipers wearing his full-moon crown (fig. 1.4). He has several such crowns to choose from, and that day's was fashioned of gold and gems. Pearls, symbolic of the moon and considered particularly cooling (and thus appropriate for the heat of the summer), dominated his jewelry, which also included his customary diamond and gold nose ring and an emerald and ruby choker at his throat. And most spectacular of all was his outfit, which consisted of a James Brown–style jumpsuit made from hundreds of tiny pearls strung together into a net-like design covering his entire shapely body. Around his shoulders was arranged a scarf made of alternating rows of pearls and small gold beads, all hand-selected and individually fashioned. This was Tiffany's, indeed; Radharamana had a wardrobe rivaling that of the late Princess Diana.

The moon carries multiple associations in Indian art and poetry, and this pairing of pearls on black stone could not but evoke visions of the moon's cool rays gleaming on Krishna's rain-cloud-dark body. "To live with Indian jewelry, then, is to live with an infinite potential for flights of metaphoric fancy and discoveries of hidden

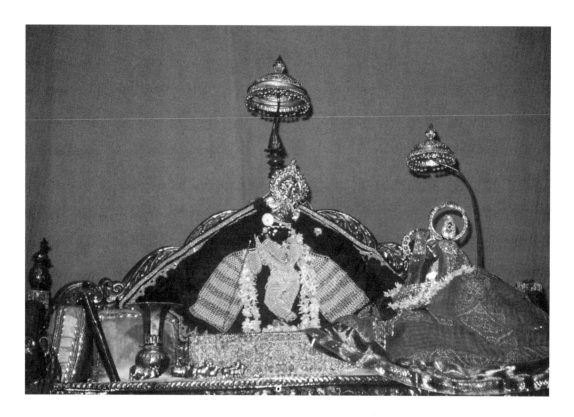

Figure 1.4. Radharamana in pearl outfit and full-moon crown, Radharamana temple. Courtesy of Robyn Beeche, Shri Chaitanya Prem Sansthana Archives

links among disparate things," comments Molly Aitken in her work on Indian jewelry. As Daniel H. H. Ingalls explains, "The moon is love's stage manager," and images of Krishna are inescapably tied in with the night magic of the moon.[35] The moon is also especially associated with the *ras-lila,* the great circle dance that takes place with Krishna and the cowherd maidens under the autumnal full moon. This episode in Krishna's mythology is particularly significant because Krishna was magically able to replicate himself to give each *gopi* the illusion that she, and she alone, was dancing with her beloved Krishna.[36] On full-moon nights, Krishna's ornamentation often includes, in addition to the lunar crown, a full dancing skirt. On the occasion of the autumnal full moon (Sharad Purnima), usually in October, he is luminously arrayed in white clothing, wearing his dancing skirt, his distinctive crown, and multiple strands of necklaces that fan out across his outfit (fig. 1.5). His legs are adorned with the thick, belled anklets that he customarily wears, but this detail has added significance on his dancing nights. The temple is further clad in swaths of shimmering fabric that evoke the intense clarity of the moon on that special night.

Alert devotees are thus, through the visual cues embedded in Krishna's ornamentation, constantly updated to the ongoing passage and particular conjunctions of lunar, planetary, and seasonal time.

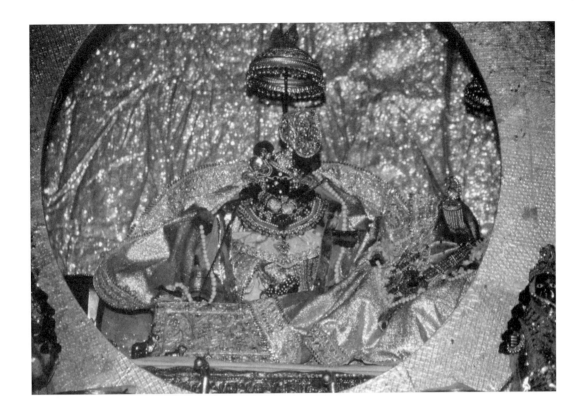

Time's ephemerality informs the choices of jewelry, dress, and stage-craft. One of the most impressive exemplars of the fleeting nature of time was that this night's special floral *bangala*—only just assembled in the heat of that afternoon—would be gone by the next morning, its flowers and fruits tossed into the courtyard for passing cattle to graze on. The *bangala*s on the previous days had all been different, and tomorrow there would be another, entirely new *bangala* on view. It is customary in the hot summer season for flower *bangala*s, with their short shelf life, to go up for only one night. Throughout Vrindaban, many other temples had similar flower pavilions gracing their altars, and in taking a tour through the town's temples on a summer night, the experience of all this fragrant sensuality was enough to make one giddy. Yet the level of craftsmanship and the attention to the purity and authenticity of each and every detail distinguished this family's presentation from many others.

It is increasingly common, for example, for craftspeople to substitute Styrofoam for the background, as opposed to using banana pith. Foil decorations stand in for colored flowers, and gaudy electric light bulbs are frequently resorted to. During other occasions, such as for the autumnal full-moon celebration, I have seen anemic silver Mylar curtains clumsily strung up to simulate the moon's clear light. There have even been reports of a *bangala* made of rupee notes! When tem-

Figure 1.5. Radharamana in full-moon dancing skirt and full-moon crown during Sharad Purnima, Radharamana temple

ple presentations are not controlled by a strong aesthetic conviction, they can range from uninspired to misguided or even shoddy. If the truth be told, the high level of aestheticism described above sets a stylistic paradigm that is rarely achieved on a regular basis. Many is the time when I have witnessed temple presentations that are, for lack of a better description, dispirited. Radharamana frequently has to endure the fashion insults of poor fabric choices, such as the pink satin outfit he wore one recent summer *ekadashi* night. The distinctive curved headdress he wears for that lunar phase looked in danger of falling off, and the evening's *bangala* was limp and tired. The temple was showing its age, shabby, and in need of a good cleaning. Everything about the temple looked old, tired, and dissipated. Yet Radharamana stood tall, despite his indifferent surroundings. I asked a devotee once if the experience of viewing Radharamana was the same to her if the presentation was not beautiful. "Yes," she answered thoughtfully, "but it increases the feeling when it's done right—like a devotional song sung with the right amount of emotion; one gets more of a feeling of satisfaction."

The most important guiding principle for Krishna's decoration is that it be pleasurable for him and his beloved. A premium is placed on freshness and on choosing the best of all possible materials and ingredients. Therefore, the sensual, temporary nature of the flower *bangala*s that are erected and displayed anew in many temples almost every day throughout the summer season—while rarely as complex and visionary as the one described earlier—is deeply tied in to this notion of newness. The fleeting qualities of the season were perhaps nowhere better expressed than during the previous evening's (Sunday, June 27, 1999) presentation. For that occasion, everything—not only the entire *bangala,* but also the deities' clothing and ornamentation—had been hand-decorated with tiny flower buds stitched onto leaf, banana-pith, and fabric backgrounds.

The work took all day, involving a crew of over twenty women and girls who applied floral designs and borders to the lengths of blue cloth—generally about one-and-a-half to two meters' worth—necessary for constructing Radha's outfit and to the saffron-yellow fabric meant for Radharamana's attire (fig 1.6). The floral designs were created by embroidering tiny white buds onto the cloth in delicate geometric patterns, requiring an inordinate amount of patience and skill. Still other craftswomen were sewing buds onto stiffened cloth or leaf backings; these design motifs were destined

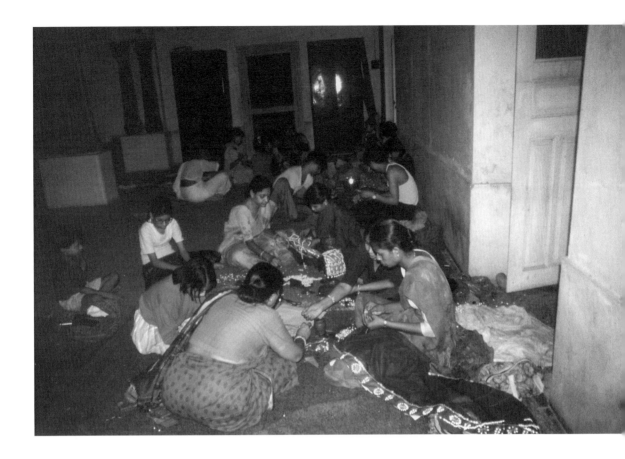

to serve as the jewelry for the couple or were for decorating the
banana-pith and flower *bangala* that was concurrently being con-
structed by the family of *bangala* artisans that is always used for
this family's temple service. Red stitching further set off the pat-
terns. Everyone labored frantically, but congenially, to finish the
flower decorations by the 5 PM deadline. Stacks of designs had al-
ready been made to decorate the *bangala:* lotuses framed with
curlicue tendrils, swans, and other natural motifs. It was mind-
boggling to know how many hours had gone into this display,
which would last but part of an evening (fig. 1.7).

Once the clothing, jewelry, and other embroidered designs had
been handed over to the *bangala* makers, they set to work con-
structing a marvelous pavilion (*kunj mahal*) that brought to mind
the elegant red sandstone structures that once graced the banks of
the Yamuna River, open to its cooling summertime breezes, and
whose crumbling ruins still stand as melancholy reminders of a
time when the river used to be cleaner and closer to the town than
it now is (fig. 1.8). The colors were soothing green and ivory white,
the effect created by varying which part of the banana stalk was

Figure 1.6. Women sewing
flower buds onto clothing for
Radharamana and Radha

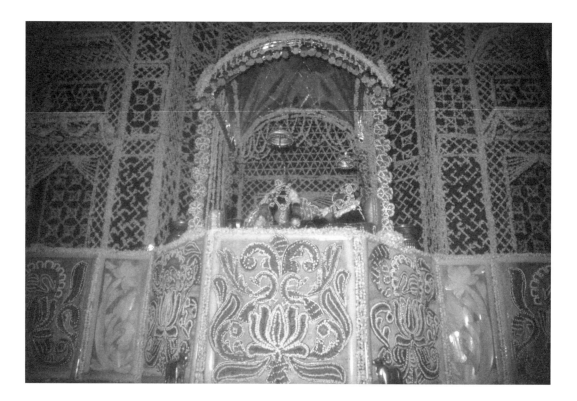

Figure 1.7. Summer *phul bangala* with embroidered panels of banana pith and flower buds, Radharamana temple

used. The banana trunks had been delivered whole to the temple earlier in the day. They were thereupon peeled apart, their concentric rings of flesh ranging in color from darker green on the exterior layers to progressively lighter green and finally to a shining ivory white at their centers.

By 7:15 PM, the usual huge, hot, sticky, keyed-up crowd had gathered, and the *bangala* was unveiled. The divine couple looked cool and composed in their yellow and blue flower-embroidered clothing and ornamentation, and the stage pavilion was restful in its overall effect. Songs were sung that evoked images of the verdant banks of the Yamuna River, and the classical restraint of this evening's presentation was reminiscent of many of the textual descriptions of the couple in just such a setting. Aside from its overtly pleasurable aestheticism, the evening's decor represented an actualization of similarly idealized poetic descriptions of Krishna and Radha, achieving a beautiful synchronism between ideal and real, between text and image.

To what extent are textual descriptions reflected in, and necessary for, such visual expositions? These visual displays are an important part of the exteriorization of a description-obsessed theology, which expends an extensive amount of effort on detailing what the couple, and especially Krishna, looks like. Rupa Goswami's

Figure 1.8. Remains of sandstone pavilions along the Yamuna River, Vrindaban

Bhaktirasamrtasindhu, for example, provides good examples of the standard descriptions of Krishna's beautiful dress and ornamentation. This text lists a series of verses regaling the reader with information about Krishna's decoration: "Hari's [Krishna's] clothing is similar in color to such things as the rising sun, saffron, and yellow orpiment [a mineral], and includes three styles: a two-piece outfit, a four-piece outfit, and a multi-piece outfit" (v. 347). Moreover, "[t]he two-piece outfit consists of an upper garment [long scarf] and a lower garment [*dhoti*]" (v. 348). And, "Mukunda [an epithet of Krishna] wears a yellow cloth over his hips that puts to shame the brilliance of a mound of gold, and a bright red cloth on his upper body. My dear friend, these indeed are the colors associated with the passion of his beloved, Radha. May Mukunda satisfy the desire of my eyes and grant me a vision of this!" (v. 349).[37] Many more verses are devoted to the description of Krishna's dress and ornaments. Emphasis is placed on variety, visual delight, multiple colors, patterns, designs, and top-to-toe embellishment of every sort. Ornamentation is made from fine fabrics, jewels, flowers, and temporary designs painted on the skin (vv. 346–361) and is always attuned to the nuances of season and activity. Verse 360 rhapsodizes about the ornaments Krishna wears: "A multi-colored waistband, a crown of unequaled beauty, two enchanting diamond earrings, a pearl necklace, a shining bracelet, a four-stringed necklace as lovely as the moon, beautiful rings, and two charming anklets— this mass of jewelry, itself made beautiful by the limbs of Krishna, is milking beauty itself." And a particularly evocative passage, reminiscent of the medieval South Indian devotional poetry discussed in the previous chapter, relies on a similar reference to the power of Krishna's body to outshine even the most beautiful of orna-

ments: "O Varangi, the ornaments of Krishna, such as his jewels and earrings, are placed on his body to ornament him, but they are not able to accomplish this in the slightest degree. Instead, they themselves are greatly ornamented by him" (v. 339).[38]

It would be easy to go on and on (and on); the staggering amount of loving description is as boundless as Krishna himself. It might be reasonable to conclude that the temple displays are nothing but three-dimensional realizations of these descriptive vignettes. But it's not that straightforward. What textual descriptions cannot offer is the actual experience of Krishna's ornamented body set within its particular temporal and spatial contexts—and more than that, they do not focus on those specific self-revealed manifestations that carry their unique histories forward with them.

Additionally, it is the living quality of the *darshans* that brings worshipers back to the temple, time and time again. For no two presentations are ever alike, even on the same day. Because each *darshan* represents a slice of Krishna's schedule, modifications in his decoration are made at each presentation. *Darshans* offer privileged glimpses into Krishna's daily routine and reflect his many moods and activities. The most committed of the devotees are alert to these changes, which are sometimes as subtle as the rearranging of the jewels in Krishna's headdress, the substitution of a new flower garland, or an added twist to his scarf. The sense of ever-renewing wonder is encoded in a beautiful poem:

> Today and tomorrow and every day he is different—
> See the suave uplifter of Mount Govardhan
> Every day there is a new picture
> Every day a different decoration;
> What poet could describe the scene?
> The body of the Dark One is the ocean of beauty,
> His different appearances are the waves,
> Millions of gods of love feel ashamed looking
> at the enchanter of the universe.
> Live by drinking the nectar of beauty of the one
> who holds the mountain,
> the lord Catrabhuj,
> and be protected by him always.[39]

As Shrivatsa Goswami's wife, Sandhya, so elegantly noted, "If the day is ordinary, he makes it beautiful."

These adjustments fuel the mental images that devotees have of their god, as I learned from Chandini, a very quiet, spiritual, and

lovely woman visiting from Muzzafarnagar. She noticed the ways in which Krishna's flute is to be found in different places at different times throughout the day, commenting that, for her, the visual changes are accompanied by corresponding internal visions of Krishna's activities. She felt that the purpose of ornamentation was to uplift, to make one joyous. The beauty of seeing such changes over an extended period in the environment of the temple is that they culminate in an overall experience of joy; the accumulated repetition of multiple viewings differs from her daily routine, which is usually limited to one small ritual a day.

Other evenings during that special summer program witnessed several more extraordinary *bangalas*: one featured simple, yet exquisite, flat panels of floral designs constructed from cutout layers of banana pith; another fell on the night of Ganga Dussehra (the festival of the goddess Ganga, held in the bright half of the month of Jyeshta, usually in June) and played up the river references by artfully using the whitest banana pith to create a full-fledged bird-shaped boat for the divine couple's amusement (fig. 1.9). Its side panels (also constructed of banana pith) additionally had small narrative scenes: to the viewers' left was depicted a large tree with a peacock, and to the right was a boy flying a kite, with a Shiva *linga* in a shrine with a bell, another bird, and a pond with flowers, fish, and turtles pictured beneath.

On *ekadashi* night, the *bangala* was overtly flamboyant, with banana pith fashioned into a grand lotus pedestal upon which stood Radharamana; a multiheaded cobra (also shaped from banana pith) reared over his head, illustrating Krishna's subjugation of Kaliya. For the evening presentation on *ekadashi,* which heralds the upcoming lunar transformation every fortnight, Radharamana is specially adorned with a curved, horn-shaped crown (see fig. 1.10). This one sparkled with diamonds and rubies, and its curved shape was further offset by two circular diamond ornaments. Radharamana was also embellished with a pants-like lower garment constructed of a mesh of tiny gold beads. And this formed just one part of that day's options for wardrobe and decoration. One starts to run out of words for all the variations and visual delectations this week of presentations offered.

A mere half year later, Purushottama Goswami's family had a longer time in the temple—this time, a full twenty-one days, spanning the very end of 1999 into the start of the new year in January 2000.[40] Somewhat jokingly termed the "millennium" *seva,* this was

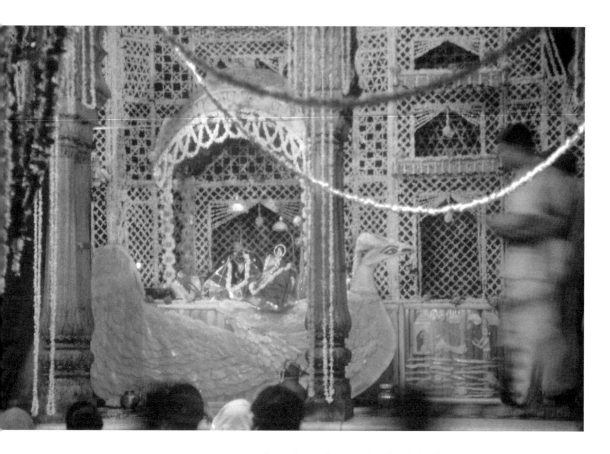

Figure 1.9. Summer *bangala* made in the shape of a bird, Radharamana temple

a major undertaking that took all of the family's ingenuity and resources. A variety of *bangalas*, a whole new winter wardrobe, and new jewelry had to be planned and made, and an extensive program of classical music, dance, and vocal performances by prominent artists had been organized (they called the theme of these performances *rag seva*).[41] Even though the focus of this book is on the importance and meaning of visual practices, by no means would it be fair to say they are the only aspect of significance. Temple presentations are multimedia events: they involve a host of performative activities, some of the most important of which are the food offerings, song, music, dance, and drama. The visual arena contributes yet another aesthetic and sensory dimension to worship, setting its own particular tone while at the same time making concrete the imaginative visions enacted in other media.

Winter *bangalas* naturally need to be constructed of different materials, since the delicate flowers of the summer are long past. The materials most commonly used are cloth, dried fruits, nuts, lentils, seeds, paper stencils, beading, designs cut from the soft core of a dried reed called *shola pith*, mirrors, and so on. Moreover, in the cold season, the *bangalas* tend to stay up a bit longer, as the

Figure 1.10. Radharamana in *ekadashi* crown and gold-bead clothing, Radharamana temple

materials are not as perishable. For this *goswami* family's three-week period in the temple, a more ambitious menu of designs had been initially planned than was ultimately executed; there was a death in the *bangala* maker's family, and he was thus unable to produce the full program of *bangala*s that had originally been envisioned.

Producing these stage sets involves a complex fusion of imagination, planning, collaboration, negotiation, and flexibility. The design and construction of the *bangala*s generally represent a team effort among the priestly family, temple patrons, and the hereditary craftspeople who have their workshops in Vrindaban. For while

only the priests are privileged with the most intimate details of Radharamana's care (and only they may have actual physical access to his divine form), the juncture between priestly secrecy and public display is somewhat permeable in that interested patrons may work together with the priesthood to not only sponsor, but also guide, some of what is placed on and around the body of the god— the clothing, the ornamentation, the *bangala*s. Lakshmi, for example, has been working with Purushottama Goswami's family for over twenty years, and her aesthetics and design ideas are an integral part of how some aspects of this family's *seva*s are envisioned and produced. She is a lovely, deeply sincere woman from Kolkata, a profoundly committed devotee of Maharaj-ji, and an artist herself. She has long taken an active role in collaborating with the family on the development and production of the special *bangala*s when it is their turn for *seva* in the temple. Both before and during this three-week period in December 1999–January 2000, Lakshmi worked closely with the *bangala* maker: they have worked together for so long that he understands what she wants. She told me that the traditional *bangala* makers are very good, and most temples just leave the designs and execution up to the professionals. But she likes to experiment and try out new ideas. She said that some were more successful than others; it was all part of the learning process.

What I found particularly fascinating about the process is the level of imagination and innovation that takes place in conceptualizing the unfolding of all the visual events and details for the *seva*. Quite often, for example, the *seva* has an organizing theme, and it takes some effort to bring the initial vision into alignment with what is available in terms of talent, materials, and skill. This is true for the design and fabrication not only of the *bangala*s, but also of the clothing and jewelry. Lakshmi has also worked with jewelers in Kolkata to fashion some of Radharamana's jeweled outfits, and the learning curve for both jeweler and patron was reportedly steep.[42] Some of the jeweled outfits—the pearl jumpsuit and the gold-bead pants, for example—were highly innovative in their initial designs. They took many tries to get right because Lakshmi's level of idealism demanded that absolutely the best, and only the best, could be given to the god. Nevertheless, it is often easy to lose sight of the heart of the gesture—the deeply felt commitment to offering the best one has—when confronted with the visual pyrotechnics of an absolutely stupendous *darshan*. It can be difficult at times to sepa-

rate surface from substance, or to make the distinction between offerings and ostentation. I was always reminded that the *act of giving*—whether it was one flower bud or a crown of diamonds— was the single most important point to keep in mind.

Aside from the input from their patrons, the *goswami* family it- self is intimately involved with the production of the visual details of the *seva*. Sandhya, Shrivatsa Goswami's wife, is especially tal- ented in designing and organizing the production of Radharama- na's wardrobe. She told me that, in her early married life, it took her a long time to learn the intricacies of how to outfit Radharamana for the family's turn in the temple. After years of experience, she is now very comfortable designing clothing for each program of the service, basing the choices on a combination of old styles, previous ideas, and inspiration from texts and miniature paintings. Fabrics and borders are hand-selected from Jaipur, Varanasi, and Kolkata, and new jewelry is often commissioned, usually by patrons, under the guidance of Maharaj-ji. When new jewelry is commissioned, a to-scale photograph of the divine body is supplied to aid in its de- sign and manufacture. Special tailors, as well as devotees, come into the family home to prepare the wardrobe for the programs, and all fabrics and materials destined for this sacred purpose are reverently handled to ensure their purity. The planning and execu- tion for the programs is a family affair, and now Shrivatsa and Sandhya's two sons have matured to the point that they are actively contributing their own aesthetics and ideas to the service.

Since Radharamana has a wardrobe and accessories to rival most royalty, one might justifiably wonder how he could possibly need more. A combination of factors influences the decisions to provide more ornamentation: it has been customary since ancient times to donate jewelry and ornaments to one's god or temple; cloth and clothing have long been major items of transaction be- tween donors and higher authorities; and there is the overriding concern with giving the best one possibly can, which is generally translated as something new.[43] I heard repeatedly, "God has given me so much; this is the least I can do for him." And, as it has been explained to me, since the god is infinite, there is never an end to the amount that can be offered to him. Clothing and ornamenta- tion (as opposed to something like a building, or land, or a chari- table endowment) have the added benefit of being relatively afford- able, tangible, and publicly visible. Within bounds, patrons can request that an ensemble they have sponsored and commissioned

be worn by the god on a specific day. And, most powerful of all, gifts of clothing and jewelry make their way directly onto the body of the god; they come into contact with him in a way that nothing else does. At some temples, patrons can satisfy the need for such bodily contact by purchasing a flower garland and handing it to the priest, who will place the garland on the god's body for a few moments before returning it—now charged with the god's essence—to the individual.[44]

Some of the god's jewelry belongs to the temple, and it is kept collectively in the treasury, to be used by all the hereditary families who share in the god's care. In addition, individual *goswami* families have created their own personal collections of items that have been donated through time by their specific patrons. When a family takes its turn in the temple, each and every item that belongs to the temple is inventoried at the beginning and at the end of the time of service, a process that reportedly takes hours. The individual collections are brought in and taken out by the particular families.[45] Jewelry types are selected from a broad range of headdress, earring, necklace, armband, bracelet, waistband, and anklet styles; these all have specific names and represent an extraordinary vocabulary of forms derived primarily from Rajput and Mughal royal fashions.[46] Headdress and turban ornaments alone comprise an entire category, and during any given presentation, Radharamana might be sporting a selection of five to six of these at a time. He even has a summertime wardrobe of bikini underwear made of diamonds, pearls, or intricate gold beads—exquisitely scaled down for his physique. I was always astonished at how conversant some devotees were with jewelry styles; if, for example, Radharamana was wearing a particular kind of necklace, most could tell me not only its name, but also the technique by which it was made. Technique was another aesthetic arena: there were inlaid stones (cut and uncut), enamel work, styles from Kolkata or Varanasi or Jaipur or South India. To ignore the fact that at least some devotees are looking this closely at ornamentation is to overlook an important cultural repository of meaning, connoisseurship, and aesthetic appreciation.

When I questioned one of the devotees about such interest in the details of ornamentation, I asked what his associations were with the word *shringar*. He paused a bit, thought, and then said, "it reminds me of a Hindi word, *rijhaanaa*, which I think of as 'wooing'" (lit. to delight, to please, to charm). I told him that, in the Euro-American art canon, "ornamental" or "decorative" are usually considered deroga-

tory terms for a work of art, and that we tend to laud big ideas, structural integrity, fundamental concepts, and a minimalist aesthetic that rejects excess. Indeed, one of the worst things one can call a work of art that is trying to take itself seriously is "decorative." He replied that, in India, they take all those things for granted. *Shringar* is on a level higher than that—it rises above all. Moreover, in India, ornamentation has value in the personal and pleasurable uses to which it is put, especially when it comes to divine delectation. Commenting on this phenomenon with respect to a poem describing the mind-numbingly myriad of details of Radha's decoration as she adorns herself after her bath, Neil Delmonico explains: "the true value of all those priceless jewels and silks is in their expenditure, that is, in the pleasure [they give] to the lover, especially if one's lover is the divine Krishna."[47] Attuning oneself to the culturally affirmative connotations of decoration is critical for coming to terms with the level of spectacle that one sees in temples.

For those unused to or uninterested in the minutiae, all this visual detail might seem like so much trivial excess. But, as with a classical music concert, although the audience is familiar with the base composition, the music is made exciting by each performance's spontaneity or inventiveness. As Girish Karnad put it so cogently with reference to contemporary Indian theater, "The principle here is the same as in North Indian classical music, where the musician aims to reveal unexpected delights even within the strictly regulated contours of a raga, by continual improvisation. It is the variability, the unpredictable potential of each performance that is its attraction. The audience accepts the risk."[48] So, too, the *darshan* experience—the dynamic process of sustained viewing and appreciation of the moods, nuances, and emotions evoked by the vision of the god—is in some important ways similar to the gradual unfolding and revelation of the themes and motifs that occur over the duration of a classical music concert or theatrical performance. Akin is the anticipation, the buildup of mood through aesthetic elaboration, the momentariness of the unique artistic presentation, the surprise of the new, and the living presence of the god made manifest in the hands of the priest-performer. The synergy among deity, priesthood, and devotees creates a potent arena for emotion and devotion—the *bhav* that elevates the *darshan* experience beyond material display. The extra details do matter, and the kind of cultural literacy needed to interpret the intricacies of visual meaning is similar to the ways in which the ears are attuned to music or

language. And, as I learned, each temple has its own idiomatic expressions, its own dialect of a shared visual language.

Thus, in accordance with the language of the season, the winter *seva* opened with a lovely *bangala* featuring a mosaic of floral and organic motifs made from a mixture of lentils—red *masoor dal,* whole green *moong dal,* yellow *channa dal,* whole black *urad dal*—the effect "like stained glass," as one observer remarked (see pl. 2). These dry materials are used in the winter in the same way that fruits and vegetables are used in the summertime. At the front of the stage, elegant streamers constructed from cutout paper-thin strips of *shola pith* (used extensively in Bengal, and a nod to the temple's connections with Chaitanya) covered the pillars, forming an elegant white façade that framed the altar. This winter *bangala* set the tone for the richness of the rest of the displays. For the next twenty-one days, Radharamana was presented to his worshipers in an unending series of winter fashions designed to keep him warm and beautiful in the extreme. Heavy velvets, silks, and rich brocades in saturated deep colors, and thick cloaks, leggings, tunics, mittens, and slippers differed markedly from the ephemeral, delicate, floral ornaments and sheer fabrics he wore the previous summer. To keep things cozier (and because there was a heater inside), his throne was pushed farther back into the altar space than during the summertime, rendering the use of binoculars mandatory for those of us who cared about the minutiae. Yet very few devotees have binoculars. I noticed, however, that even without extra visual aids, the effect of such highly refined ornamentation was to snap all of the details into focus. Perhaps this was due to the stronger colors and more dramatic ornamentation used in this winter *seva.* For whatever reason, everything about the god's presentation seemed clearer, more present, and more visible than on occasions when the decoration is less carefully assembled.

One of the more dramatic presentations during this time period was an evening viewing where the internal reality of Krishna and Radha's unity in duality was expressed externally. To demonstrate their interdependence, they shared each other's colors: Radharamana was clad in a blue tunic, and Radha was in a yellow dress; and in the background, the cloth covering the throne was equally separated into half-blue and half-yellow segments (see pl. 3). An educated observer informed me that Radharamana was also wearing "feminine jewelry."

The new year opened on January 1, 2000, with a fresh *bangala,* this one a spectacular Sheesh Mahal (Palace of Mirrors; fig. 1.11). Con-

structed of white cloth stretched over a firm backing, its surface sparkled with a constellation of large and small mirrors, enlivened by red-, green-, and blue-colored stones simulating gemstones. The effect was breathtaking, especially when the reflective effect was magnified with the installation of a large mirror on the courtyard level across from the sanctum. One devotee helpfully told me that "there is a Sheesh Mahal *bhajan* [devotional song] that says something like 'Krishna and Radha are sitting in the glass palace admiring each other.' Krishna offers Radha *pan* [betel leaf], and then she shares it with him. They admire the way their lips are stained red." The intentionality of the myriad reflections and replicated images also brought to mind Krishna's own illusory omnipresence; it was a clever and effective visualization of Krishna's limitlessness. Beyond the devotional references, the Sheesh Mahal also drew upon architectural prototypes seen in some Rajput palaces in the region.[49] Such structures were also used as spaces for dance performances, the movements of the dancers enhanced by the magical twinkling of myriad reflected lights. The Sheesh Mahal thus conjures up visions of the ultimate in royal refinement, relaxation, and luxury.

The winter 1999–2000 *seva* program thus provided a crystallization of all that is dynamic and creative about the process of ornamenting the god and his temple abode: for three weeks, the Radharamana temple became an ongoing, living theater of the visual and performative arts—all of which came together to create a beautiful, sustained environment for love. And while it was unique for that period of time, similarly potent *sevas* have been presented in the past, and inventive and effective *sevas* continue to be offered today. Indeed, Robyn Beeche described to me the details and visions of a *seva* that took place in the winter of 2006–2007. This *seva* was short (only a week) but was a particularly spectacular one because of the unconventionality of Radharamana's ornamentation: he was garbed, every day for a week, in outfits made entirely of semi-precious gemstones that corresponded to the colors of the days. Because the program of service began on a Wednesday, the first *darshan* of Radharamana was in an outfit of emeralds, as green is that day's color and emerald is its corresponding gemstone (see pl. 4). Beeche reported on the sequence of the outfits: "Thursday followed with yellow sapphire, Friday was turquoise, Saturday blue sapphire, Sunday rubies, Monday white pearls, Tuesday coral, and Wednesday one-half yellow sapphire and one-half emeralds." The visual drama of the *darshans* was heightened by *bangalas* that made thematic reference to the Jagannath temple in

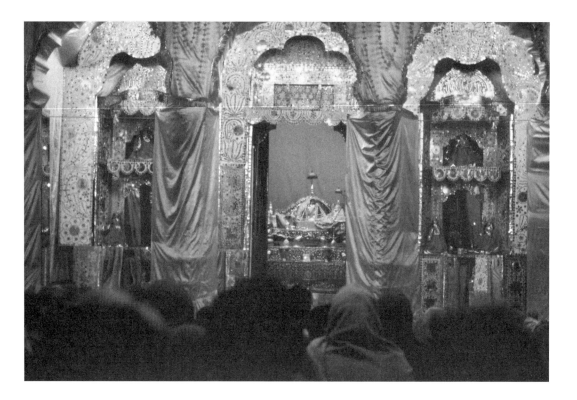

Puri and to the rural Orissan landscape (fig. 1.12). The stage sets
changed over the days, giving the impression that Radharamana had
been transported from Braj to Orissa—or perhaps that Jagannath
Puri and Orissa had come to Braj. The cumulative effect of the inven-
tiveness of the ornamentation and the *bangala*s elicited rapturous
responses from devotees, especially with the first *darshan,* which was
eagerly awaited by all. The comments expressed amazement: "phe-
nomenal, beyond description"; "I don't know if the *shringar* is enhanc-
ing His beauty or He is enhancing the *shringar.*" Beeche's description
of the whole temple environment is so lovely and evocative that I
share large parts of what she witnessed during the *seva* (with some
editing for consistency):

> The temple was jam-packed, and in between the *darshan*s and
> change of outfits for the *aulai* [evening] *darshan,* many different
> aspects of traditional music were sung. If it was classical singing,
> there was rapturous applause when a song of Vrindavan was sung
> by the classical singer Shubha Mudgal; when *kirtan* was sung, the
> temple erupted into gaiety. The overall feeling of joy was abun-
> dant—not only for the *darshan* but also for what was going on in
> between. Music is also a powerful lever on emotions, and this is
> transferred to the devotee. At one particular *darshan,* a middle-
> aged woman was holding on to the front ledge of the altar crying

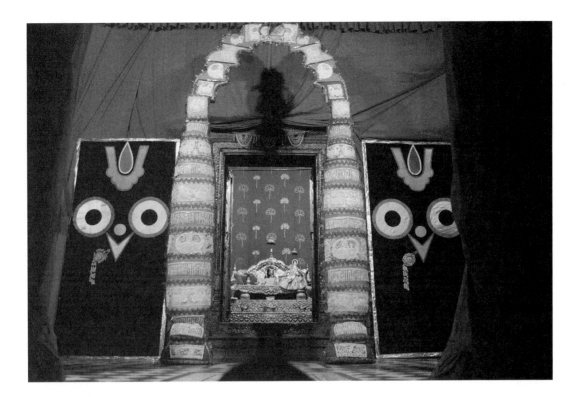

for her Shyama [a name for Krishna]. Some people [could] not control their tears when the songs were being sung about *shringar,* and some [got] up to dance. All of this appears to charge the temple space with different vibrations, but when the curtain opens for yet another chance to have *darshan,* no time is long enough. It seems the longer you look, the larger the imprint on your mind.

Everyone know[s] it is just a week in the life of Shri Radharamanji; everyone knows that again Maharaj ji has excelled in being able to give the deity something new for Him to enjoy; everybody knows that it will happen again in seven months' time (when the family has another turn in the temple); everybody promises themselves to be there again, and so it goes on.[50]

The poignancy of such beauty in the service of the god is that it cannot be held, or owned, or neatly packaged—even given the now-common practice of capturing the visual moments through photography and videography. There really is no value to going back. Instead, each moment is new and fresh and unique, and each moment offers the opportunity to be fully present for the love of the god, and each moment will cycle forward again to be experienced anew. Somewhere between the details, the planning, the artistry, and the actual experience of *darshan* lies the ongoing magic, and at the center of it all is the radiant figure of Radharamana.

Figure 1.12. Winter *bangala* with symbols of Jagannath temple, Puri, at the Radharamana temple. Courtesy of Robyn Beeche, Shri Chaitanya Prem Sansthana Archives

In addition to the creative emotional and aesthetic opportunities that arise during these special *sevas*, the stage settings (*bangalas*) that serve as a frame for Radharamana's decorated body often extend the meanings and messages of the *darshan* presentations in important ways. During Purushottama Goswami's family's *sevas*, there is often some sort of theme that guides the designs and that situates the deity, the temple, and the *goswami* lineage in the past and present history of Vrindaban. At such times, the *bangalas* can provide important opportunities for making visually manifest the intricate links among the mythology of Krishna, the centrality of Braj, the foundational history of the Radharamana temple, and the geographic and conceptual extensions of that temple's connections to sacred sites beyond Braj. All of these themes were creatively interwoven in a series of unique presentations that Purushottama Goswami's family organized for a twenty-one-day winter program that spanned late December 2004 into January 2005 (I was not fortunate enough to see it, but I did review all of Beeche's photographs). The theme centered on representing some of the pilgrimage places to which Chaitanya journeyed in India as he traveled a peripatetic route that led him from Bengal to Vrindaban.[51] In representing these sacred destinations on the Radharamana temple dais, Radharamana himself (and by extension, Chaitanya as an embodiment of the dual form of Krishna and Radha) went on a metaphorical pilgrimage.

Termed the Char Dham Yatra (Journey to the Four Holy Abodes), the first night opened with reference to the Jagannath temple in Puri, Orissa: the easternmost destination of this pilgrimage route, Chaitanya's starting point, and the temple that was the focus of so much of Chaitanya's devotion.[52] The stage in front of the altar had been draped in cloth and its three bays had been ingeniously shaped to simulate the great *rathas* or carts—complete with massive, spoked chariot wheels, pot-shaped finials, flags, and tall fabric superstructures—in which the god Jagannath and his family make their annual journey outside the temple. Another evening was devoted to the recreation of the façade of the Shrirangam temple, near Tiruchirapalli (Trichy), Tamil Nadu, emblematic of the southern leg of Chaitanya's journey, as well as the place where he would meet Gopala Bhatta. This stage set featured a beautifully detailed South Indian temple tower (*gopuram*), its tiered roof lines seemingly sculpted and painted through the artful use of delicate stencils of *shola pith*. The sacred island pilgrimage destination of Rameshwaram was next evoked by banana trees and the "seashore": a swath of blue fabric, sand, and

shells. Next came the westernmost point of the pilgrimage route, located at Dwarka, Gujarat—the city from which Krishna ruled after his departure from Braj—symbolized by a golden, glittering stage set that represented that temple's façade. The elegant restraint that had characterized the previous stage sets was continued into the next pilgrimage site featured—Badrinath, Uttarakhand—but here a more colorful, folksy setting was a delight, as were the simulations of the Yamuna River and the cascades of rounded cloth "boulders" that evoked the Himalayan context. A sprinkling of ersatz snow the next evening transformed the venue into the Kedarnath temple, also in Uttarakhand. The culmination of that journey—and the beginning of another—was Vrindaban/Braj, artfully encapsulated on the stage with sculptural images of lotuses shaped from blue and pink fabric, a "rocky" background to represent Mount Govardhan, a blue swath of cloth representing the Yamuna River, and sculptural figures of *gopis* and *sakhis*. The (literally) crowning touch was seen in two large, glittering, cutout representations of Krishna's and Radha's special headdresses (Krishna's always rakishly tilted toward his beloved) that were suspended to either side of the sanctum doors.

This constant touching base with the Radharamana temple's founding connections to Chaitanya and Gopala Bhatta is also evident in the annual rites that center around the "appearance" day—or birthday—of Radharamana himself. As recounted at the beginning of this chapter, on the eve of the rituals marking Vishnu's incarnation as the man-lion Narasimha, Gopala Bhatta found himself in despair at ever achieving his own personal *darshan* of Krishna in the way that the devotee Prahlada had been granted his own vision of Vishnu. And the very next day, on the full-moon night of the lunar month Vaishakha (generally in April–May), Gopala Bhatta was finally granted the manifest form of Radharamana.

This sequence of events is observed in the Radharamana temple as a two-part ritual process: on the night of Narasimha's manifestation, a unique *shalagrama*—enlivened by special markings and a pair of enameled eyes—is brought to the front of the temple altar and anointed with a succession of sacred substances that are used in what is called the *abhishek,* an ancient ceremonial anointing that accompanies the renewal of such sacred presences as deities or kings. While this anointing of the *shalagrama* is relatively short, it sets in motion the much longer process that follows the next morning. By 7 AM, a special altar has been set up, covered with a canopy supported by four posts. Involving a large crew of attendant *goswamis*, the entire morn-

ing is taken up with an extraordinary hours-long process of sacramentally anointing Radharamana's body with vast amounts of the sanctified five auspicious liquids (*panchamrit:* milk, yogurt, honey, Yamuna water, and sugar syrup) as well as an array of specially prepared herbs, spices, minerals, and other ingredients (some ninety-two in all) that assure his ritual renewal as Gopala Bhatta's personal divinity for yet another year. Radharamana also goes through the same rites in August, when the pan-Indian celebration of Krishna's birthday (*janamashtami*) is observed.[53]

Once the process of renewal for that year was complete, Radharamana made his appearance shortly afterward on a tall tiered throne and in a set of new saffron-colored clothes, and he further received another set of ritual offerings that welcomed his symbolically regenerated and recharged presence. For the evening's presentation, he continued to wear saffron, further augmented by a large floral *bangala.* Saffron—although the color most frequently associated with asceticism, renunciation, and religious militancy—is equally for Hindus an auspicious color, always worn on occasions of rebirth, renewal, and special celebration. Another special addition was a framed fragment of Chaitanya's loincloth, which the saint conferred—along with his seat, rosary, and begging bowl—to Gopala Bhatta upon choosing him as his successor. This stood to the viewer's left side of the altar, on the same side as Radharamana, and was barely visible under the garlands and layers of sandal-paste anointments on the glass surface of the frame. Because this was a full-moon night, I naturally expected that Radharamana would wear one of his full-moon crowns, but that was not the case; evidently, he was excused from the normal temporal adornment on this most special of days.

I have described this in some detail because, while a lack of knowledge would not have detracted from the pleasure of attending Radharamana's *darshan* that particular hot May evening, it would be difficult for the uninitiated visitor—without some prior familiarity with the temple's visual vernacular and of its particular founding narrative—to be aware of the full import of what had happened that day and what its significance was for the temple in particular and for Vrindaban history in general. The visitor would need to know that Radharamana had just been ritually renewed on his annual appearance day and that his ornamentation reflected that potent moment in his ritual calendar. A wealth of cultural knowledge and visual literacy is needed to negotiate all these connections; add to that the particular temporal matrix within which

any given image is enmeshed, and it becomes clear that the visual options and possibilities for interpretation are manifold.

This chapter has established a foundation for understanding the basics about the Radharamana temple and its ornamental traditions; from here, as we consider other temple practices, we will learn that, while much is shared elsewhere, there are many differences in the details and in the stories each temple tells about itself through its visual imagery.

2 The Radhavallabha Temple: One Is Better than Two

"All *darshan*s are alike," I was once assured when I first came to this subject. Armed with this attitude, I headed down to the Radhavallabha (meaning "the lover or beloved of Radha") temple, the residence of the self-manifested image that found its way into the care of Hit Harivansha, the sixteenth-century founder of the Radhavallabha sect. I assumed I would simply be adding a bit of comparative information to the perspectives I had gleaned from the Radharamana temple, but as I was to learn, a great deal would be *not* alike about the *darshan*s I would experience at this temple, and the distinctions would have everything to do with how this temple identifies itself in the interpenetrated continuum of Vrindaban's history and its many ways of worshiping Krishna and Radha. The current temple's exterior does, however, share the same level of architectural modesty and its interior layout is roughly similar to that of the Radharamana temple, although it is larger. Its eighteenth-century exterior and large interior courtyard abut the remains of the original late sixteenth-century Mughal-era red sandstone temple, now in a considerable state of disrepair but still used for some religious functions, such as devotional singing.[1]

The Radhavallabha temple has a front and a back entrance, both reached after one negotiates the warren of small streets that delve into the midst of Vrindaban. Upon entering the temple from either direction, the visitor will step into a large, semi-open interior courtyard (with a retractable roof) and encounter a raised dais in the manner of the Radharamana temple. But two major distinctions exist: the first is that devotees can step up onto the dais, bringing them up to the same level as the sanctum; the second is that Radhavallabha is a physically much larger image than Radharamana, and consequently the impact of his iconic presence is markedly different. We will also see that these physical differences extend to

include many other areas of differentiation, encompassing the sectarian history and viewpoint, aspects of the liturgy, the temple calendar, and the decorative and ornamental traditions.

If the silver doors to the sanctum are open, devotees might at first see a curtain stretched across its opening. When it is pulled back for the deity's public presentations, what they will view is a sturdy black figure, approximately three feet tall, standing in Krishna's familiar posture of right leg crossed in front of the left, arms raised with red-lacquered hands poised to play his flute.[2] His height is extended by a tall turban upon which is overlaid a configuration of crowns. Snaking down the god's left side is what appears to be a long decorated extension of the headdress. Beneath this towering assemblage, the details of Radhavallabha's broad black face shine with scented oil. Most arresting of all are his huge ovoid eyes with their lightly etched pupils, left black and not covered with a white enameled pair as with Radharamana (see pl. 5).[3] Inlaid gold and ruby eyebrows follow the dramatic curved contour of his eyes, accented by a teardrop-shaped gold and ruby *tilaka* set in the middle of his forehead. A slight smile is made more apparent with a narrow strip of red color. Beautiful hand-painted patterns made from light yellow sandalwood-and-saffron paste are traced in loops, dots, and curves across his tall forehead and full cheeks; he is additionally adorned with a pearl and diamond nose ring and a glittering round diamond set into his chin.

Radhavallabha's relatively larger size allows for an elaborate and highly visible schema of ornamentation that cloaks every available surface of his body: multiple strands of beads encircle his neck, a varied collection of necklaces is laid in concentric layers across his chest, and his wrists and upper arms sport an array of cuffs and bracelets. At his waist can be found several belts; chains are draped across his upper thighs; several anklets are arranged in tall stacks that extend from ankles to shins. Not to be outdone, his headdress assemblage also glimmers with embellishment. It is a fairly complicated arrangement, with a base layer of a wrapped fabric turban upon which rests a multipart crown consisting of bifurcated halves joined by a decorative middle section, perhaps framed by a fan or two of peacock feathers. Augmenting this might be crinkly fabric extensions fanning out to the sides, sparkly pendants, or extra rows of beads, all of which provide further embellishment to the extent that it becomes almost impossible to distinguish the individual components. Add to this the embroidered serpentine extension that curves down his left side and his equally ornamental clothing, and Radhavallabha becomes a truly

magnificent sight to behold. To his left side, as in the Radharamana temple, is stationed a similarly adorned mound that serves as a symbolic reminder of Radha.

My first reaction to this visual extravaganza was, I will admit, puzzled dismay and bewilderment: although visually compelling, what exactly was I to make of all this excess and splendor? How did this fit in with the conceptually refined Chaitanyaite aesthetic norms exhibited at the Radharamana temple? Later, as I gained a bit of proficiency in the temple's visual vernacular, it finally came to make fascinating sense, but this involved an extended learning process requiring the able guidance of some very helpful members of the *goswami* families and others. I had to learn how to see anew—or at least with fresh eyes.

Two railings extend straight out from the sanctum's threshold, ending at the edge of the dais and creating a sort of narrow corral in front of the doors (fig. 2.1). Here, women may gather and sit, affording them a privileged viewpoint as they are stationed only a bit beyond the sanctum threshold—literally at Radhavallabha's feet. The rest of the crowd stands to either side of this railing or collects down below the dais; when it is time for *darshan,* huge groups gather in the courtyard space below, all eyes awaiting the vision of Radhavallabha as the curtain is pulled back. When Radhavallabha's image is finally revealed, the men and latecomers who have been standing to either side of the railing literally hang off its edges, leaning in for a closer look. This creates great conflicts when the doors are opened because those standing below and farther to the sides of the stage cannot see their god. People badger each other to move aside, and there is a lot of chattering, shouting, and rearranging—"Hey, you've looked long enough!" "Let me see!" "Sit down! I can't see over you!"

Even for us comparatively lucky women, it's not that easy. The first, early morning viewing (*mangala arati*) is considered the most auspicious, so it is important to arrive at the temple early to stake out a spot in the ladies' section. This *darshan* is very brief, so it is also easy to miss. Once, I had actually managed to get to the temple well ahead of time (somewhere around 4:45 AM) and sat patiently waiting like everyone else. But when the doors finally opened, I was amazed to see how the space I had so carefully carved out quickly disappeared. Two women in particular had me smashed against the railing, and I was stunned to see an ancient old woman turn up at the very last minute and unapologetically burrow her way into the already overcrowded ladies' section.

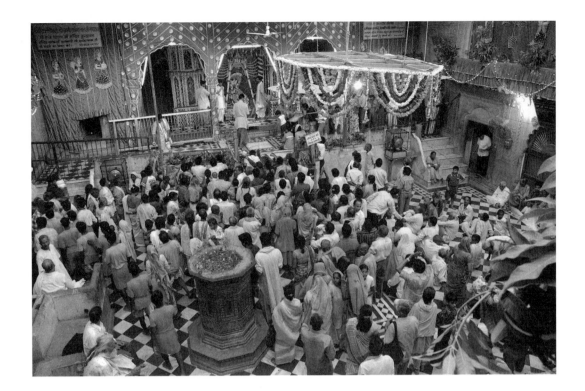

The pattern of presenting Radhavallabha to devotees follows the
ashtayama seva model seen in the Radharamana temple and the
Chaitanya Vaishnava tradition. But there are significant differences
in how Radhavallabha is imagined to spend his day, encapsulated,
for example, in the sequence of *darshan*s I followed particularly
closely during May and part of June 1999 (and little has changed
since). On summer mornings, Radhavallabha's day begins early.
He is awakened from a night spent in his temple bedroom, where-
upon he is prepared for public viewing and then carefully trans-
ported by the temple priests to his throne in the sanctum. At about
5 AM, the doors are opened and he greets his devotees. A small,
concentrated crowd gathers in front of the sanctum, eagerly await-
ing his appearance. The first ritual offering is quick and seductive:
after the door is opened, a short waving of lighted tapers is per-
formed, the curtain is closed, *prashad* is distributed, and that's it
until a short while later when Radhavallabha will briefly reappear
for the *dhup* (incense) *arati,* the second in a series of eight daily
ritual offerings and *darshan*s.

For this first viewing of the day, Radhavallabha is not yet deco-
rated with the full complement of crowns, jewels, sandal-paste deco-
rations, and so on that will be provided later in the morning. But
devotees will be able to see his smooth unadorned black face, reflec-

tive with oil, topped with a turban and crowns—as well as the nose and chin ornaments he wears at all times in public in addition to the long decorated extension to his side (fig. 2.2). At this early hour, his body is obscured by a light summer wrap that comes up under his chin and covers his hands; this simple attire only intensifies the power of his gaze. Most of the crowd moves off after *mangala arati;* having experienced an auspicious start to another day, they emerge from the dark coolness of the temple into already sweltering brightness. Later this evening, many of the same devotees will return to see Radhavallabha in his full summer evening regalia.

Although Radhavallabha's morning (or, more aptly, the day after the night before) schedule echoes that of Radharamana, a core difference lies in how he has been spending his time. While Radharamana has been making romance with Radha or any number of other female companions under the cover of Braj's luxuriant forests, Radhavallabha has instead been entwined in Radha's—and no one else's—arms in a private love bower (*nikunj*) of their own, deep in the mystical heart of Vrindaban. Radhavallabha does not wake up in a cowherd's hut in Gokul, nor does he prepare himself for a day herding cows and playing about in the fields of Braj. He and Radha instead wake up in the company of their closest female companions, the *sakhis,* and go no farther. Indeed, their entire universe is focused on their love for one another, and there is no other destination or activity that would lure them from the enchanted private world they eternally share. Thus, the *ashtayama seva* that the Radhavallabha priests perform each day does not provide worshipers with a reflection of the cowherd Krishna's daily sport; instead, devotees at the Radhavallabha temple participate in a different kind of sport, what the sect terms <u>*nitya vihara*</u> or <u>*nikunj lila*</u> (constant or eternal bower-pleasures or delights), enacted only in Vrindaban's most private and celestial of arbors (*nikunj*). These differences are attributable to the philosophy and teachings of Hit Harivansha, the founder of the Radhavallabha sect.

Hit Harivansha was a poet-saint (ca. 1502–1552) who came to Vrindaban at about the same time as Chaitanya and his followers.[4] He is revered by the Radhavallabha *sampradaya* as an iconoclastic and visionary aesthete and is considered by them to be the "true" discoverer of Vrindaban. The stewards of this sectarian tradition stress that Hit Harivansha was born and grew up in the Braj region, thereby endowing him with a local authenticity distinguishing him from Chaitanya and other "outsiders." Moreover, as his

Figure 2.2. Radhavallabha at the morning's first *darshan*, Radhavallabha temple

hagiography recounts, he was divinely led to Vrindaban by a message from Radha herself.

The first thing that anyone in the Radhavallabha *sampradaya* will make sure a visitor understands is how fundamentally different Hit Harivansha is from the contemporary Chaitanya-centered contingency. This is especially apparent in how fervently members of the denomination tell the story of its establishment. Aside from some standard academic accounts, an interesting source for information on the Radhavallabha sect is found on its website, www .radhavallabhmandir.com.[5] Beginning with his divinely sanctioned birth, Hit Harivansha's hagiography is full of visions and miracles. The generally accepted accounts state, with some variations in the details, that his father, Vyasa Mishra, was a Gaur Brahman who came from the village of Deoband in Saharanpur district, in the vicinity of Mathura. Vyasa was the court astrologer in the service of the emperor; some accounts name the ruler as Sikander Lodi (d. 1517), while others purport it was Humayun (1508–1556).[6] Despite Vyasa's professional success, he and his wife, Tara, had been unable to start a family. Miraculously, Vyasa's ascetic brother had a vision of Krishna, who predicted to him that Vyasa and Tara would have a son; moreover, their son was to be a joint incarnation of Krishna and his flute.[7] Soon thereafter, Tara became pregnant. On *ekadashi* of the bright half of the month of Vaishakha, VS 1559 (Vikrama Samvat is a Hindu dating system, thus 1559 translates to approximately 1502 or 1503 CE; today, the birth date falls somewhere around mid- to late May), while accompanying the emperor's entourage along the Agra road, Tara gave birth to Hit Harivansha in the Royal Army camp at the village of Bad, south of Mathura. The boy grew up in his father's village of Deoband, precociously demonstrating an early affinity for classical knowledge in Sanskrit, the Braj dialect, and religion. His childhood miracles began with a dream-vision of Radha, who directed him to a leaf high on a *pipal* tree outside his door, upon which he found her mantra inscribed. Radha also led him to look in a well in the garden, from which he retrieved a two-armed image of Krishna holding a flute. This he installed and served in a shrine in Deoband, where it is still worshiped. At seven years old, he had his sacred thread ceremony. He was later married to Rukmini, with whom he had three sons and a daughter.

Upon the death of his parents, Hit Harivansha decided to leave his family behind and pursue his desire to move to Vrindaban and devote himself to Radha. But Radha had other plans for him: after

making another dream appearance to Hit Harivansha on his way to Vrindaban, she pointed him toward the village of Charthawal. There, Hit Harivansha was to go to the house of a rich Brahman named Atmadeva and accept the Brahman's offer of his two daughters in marriage. Hit Harivansha was also to accept an important and ancient image of Krishna that one of the Brahman's ancestors had been given by the god Shiva himself as a reward for special penance. As recounted on the website, Shiva offered Atmadeva's ancestor anything he desired, and the ancestor asked for "the most cherished thing of Lord Shiva. Then Lord Shiva gave him the idol of Shri Radha Vallabh Ji Maharaj from his heart and told him the method of its service."[8] Thus, Radhavallabha's image—considered a self-manifestation handed down from Shiva, its location revealed by Radha—came to be in Hit Harivansha's possession.

Pursuing Radha's mandate, Hit Harivansha moved to Vrindaban, and in 1535 he installed the image of Radhavallabha in a shrine believed to have been situated at Madan Ter, a lovely wooded spot on the banks of the Yamuna River; he is also credited with establishing other sacred spots in Vrindaban, including the important Seva Kunj (Bower of Service) garden. He began a new lineage with his two new wives and established himself as an important spiritual leader in the incipient revitalization of Krishna worship in Vrindaban. He is famed for making conversions among some of the seemingly incorrigible bandits who reportedly lurked in the as-yet untamed Vrindaban environs. Hit Harivansha's most important contribution to the emerging religious landscape of sixteenth-century Vrindaban was his resolute fixation on the primary and exclusive worship of Radha as a means to apprehend Krishna. This approach differed markedly from the focus on Krishna and his exploits with the cowherds and cowherd maidens that Chaitanya and his followers were propagating in the Braj region.

In particular, Hit Harivansha did not accept the emotional model of love-in-separation that informs the Chaitanyaite perspective on the relationship of the divine couple. Moreover, adherents of the Radhavallabha sect insist that it was Hit Harivansha—and not Chaitanya—who first truly "discovered" Vrindaban. Additionally, and somewhat controversially, Hit Harivansha claimed that Radha herself was his guru, thus setting himself apart from any existing spiritual lineage or religious leader. Hit Harivansha held that Radha is Krishna's guru: she teaches him the arts of love, dance, flute, and ornamentation. Followers are fond of pointing to

evidence of this in the small, enclosed (and monkey-infested) Seva Kunj garden in Vrindaban. There, as a vivid illustration of Krishna's subservience to Radha in these matters of the body and heart is a painting in a small pavilion that depicts Krishna massaging Radha's feet.[9]

Hit Harivansha's most important work is his *Eighty-four Hymns* (*Chaurasi Pada*), which was written in the local dialect of Braj Bhasha in the first half of the sixteenth century. This collection of devotional poems spells out in gorgeous and loving detail the common themes of Radha and Krishna's relationship: their trysts, the landscape of their love bowers, their physical beauty, their effect on one another, and so on. The work is of fundamental importance for the Radhavallabha community, serving as the main text for the songs that are sung at the various temple presentations and festivities and providing much rich visualization for the devotee to savor. Worshipers are enjoined to learn about Radhavallabha through Hit Harivansha's eyes: his poems are to be considered not as just lovely descriptions, but as a path to deep spiritual understanding.[10]

Other characteristics set the Radhavallabha sect apart from its Chaitanyaite and other sectarian neighbors, and primary among them is that Krishna and Radha are never apart—so conjoined, in fact, that they share one body. Although this two-in-one-body concept is a familiar one and has also been encountered with both the Radharamana self-manifestation and Chaitanya (and similarly figures in the descriptions of other such manifestations in Vrindaban and elsewhere), the Radhavallabha sect makes this belief apparent in certain unique ways. The divine couple's corporeal fusion is manifested most vividly in Radhavallabha's special iconography and in the visual practices that permeate the *ashtayama seva,* themes which we will explore shortly. Of fundamental importance is the concept of love-in-union, which contrasts markedly with the more familiar idiom of love-in-separation that one finds in other sectarian contexts. Krishna is here not an errant playboy; the *gopis* find no place in the narrow spectrum of Krishna's love interests, which focus exclusively on Radha. Consequently, Radha and Krishna (and, by extension, the devotee) never experience the exquisite pains and artfully detailed anxieties that are so important elsewhere and that have fueled so much emotionally fraught imagination in other devotional contexts. Finally, Radha and Krishna are also considered to be wedded to one another; Radha has no other spouse but Krishna; Krishna has no other partner beyond Radha.

The couple is completely bound up in one another, and they never depart from the enclosure of their private love bower. It was repeatedly impressed upon me that the contemplation of *nitya vihara* or *nikunj lila* allows the worshiper the freedom to focus solely on the eternal reality of Radha and Krishna, without the narrative and historical diversions of the Krishna-*lila* as detailed in the *Bhagavata Purana*. A central tenet for the Radhavallabha sect is that Radha and Krishna occupy the eternal here and now; for them, the celebration of Krishna's past is on the whole irrelevant. In keeping with the well-rehearsed trope of Vrindaban-as-cosmic-garden, the thicket within which Radha and Krishna sport is lush and magical, redolent with flowers and creepers, populated by songbirds and forest creatures, and decorated with splendid pavilions from which the Yamuna River's cool breezes can be enjoyed. But the difference is that it is their private abode; it is not a landscape peopled by the other inhabitants of Braj that are featured in other sectarian accounts.[11]

Aside from Radha and Krishna, the only other occupants of this privileged domain are the *sakhi*s. This is yet another critical detail that differentiates the Radhavallabha outlook. The *sakhi*s, the handmaidens of Radha, live only to serve the divine couple. In this respect, they are said to differ from the *gopis*, who not only represent the cow-herding aspect of Krishna's youth in the wider world of Braj, but also represent self-centered desire: unlike the *sakhis*, *is it so diff?* who wish for nothing for themselves but are ecstatically content to attend to Radha's and Krishna's desires, the *gopis* yearn for Krishna, thinking only of their own wants and needs.[12] The closest and most privileged *sakhi* of all is Hit Harivansha himself who, it is believed, disappeared on the full-moon night of Ashvin (Sharad Purnima) 1552 and, transforming himself into a *sakhi*, "entered the bower" (*nikunj pravesh*) and joined the divine couple. There, he resides eternally and symbolically in the form of the sacred flute which, as we will see, plays a prominent part in the iconography and rhythm of the daily service to the deity.

While the founding narrative of the sect is immensely significant to the devotees and current *goswami* families, equally important is one of the central responsibilities of the sect today: the ongoing care of the self-manifested image of Radhavallabha and the sacred flute. For it is in these physical representations of the god and the incarnate form of Hit Harivansha that historical memories and beliefs are literally embodied; and it is upon and around Radhavallabha's body that they continue to be enacted by the *goswamis*.

At present, two lines of descent are connected back to Hit Harivansha, and as was the case with the Radharamana temple, there have been the usual fissures over ownership and management of the temple's resources. As a consequence of past disputes, the operating management of the temple has been divided: the families alternate service for Radhavallabha each month. This division of duties is marked in the printed temple calendar with red ink indicating the month for one family's turn to be responsible for Radhavallabha and with black ink for the other's. One of the families is also designated as the primary custodian of the deity.[13]

I had been directed toward one of the young *goswami*s in the branch that claims official custodianship in the current genealogy of Radhavallabha's caregivers. Mohit—whose full appellation is Goswami Shri Hit Mohit Maral, also termed *yuvraj* (prince)—was to become my patient and generous guide through the complexities of the Radhavallabha visual tradition. I also learned much from his father, the current head manager, who is referred to as the Goswami Shri Hit Radhesh Lal Ji Maharaj (present) Adhikari; he was also extremely generous with his time and knowledge. As Mohit explained, the starting point for understanding the distinctiveness of the Radhavallabha perspective is the figure of Radhavallabha himself. The first clue is seen in the long decorated extension that flows down Radhavallabha's left side—and, upon paying closer attention, the same element is found decorating the emblem of Radha. These are meant to be long braids, an external manifestation of the internally conjoined form of Radha and Krishna. By the same token, the bisected arrangement of the crowns (called *tiparas*) placed on top of Radhavallabha's turban reveals itself to be a two-part, his-and-hers assemblage of elements. Another crucial visual element is the flute; it is not to be understood merely as Krishna's characteristic tool of seduction, but is representative of Hit Harivansha's presence in the love bower. Mohit pointed out that each day the flute always starts off on Radha's side of the throne, resting against the symbolic expression of her presence. The flute travels between the couple at appointed times during the day's ritual services, for it is understood that since Radha is Krishna's guru, she is the one who hands him the flute and teaches him how to use it. This same process is also followed for certain other details of Radhavallabha's *shringar*.

These details slowly began to become apparent to me as I followed the sequences of *darshan*s over many days and months;

knowledge of the temple's unique history is essential for under-standing the subtle variations in the presentations as they unfold during the day. After Radhavallabha has made his first appearances of the day, and shortly after the first *arati* of the morning, there fol-lows a brief incense offering.[14] When the sanctum doors open again at about 8:30 AM, they reveal Radhavallabha in his fully orna-mented state. Here, we can see the full effect of what the temple priests have been working on since the doors were last closed: Rad-havallabha has been bathed, fed, and richly ornamented, and he is now ready for the offering lamps of *shringar arati*. This is also the first of three fifteen-minute interludes in the day's sequence of pre-sentations when he carries the flute in his own hands (the other two occasions are the late afternoon *uttaphan* and the early evening *sandhya arati*s). After these ritual offerings, the curtain is briefly closed, and when it opens again, the flute has returned to its right-ful place beside Radha's honorific presence. The subtlety of this traversing of the flute between Radha's and Radhavallabha's forms is easily overlooked, but it is a critically important detail for practi-tioners, reminding them both of Hit Harivansha's presence and of Radha's supremacy in the balance of the couple's relationship.

From this point on, devotees can have a long, uninterrupted look at Radhavallabha, as the curtains are mostly open all morning until the lunchtime *rajbhog arati*. Throughout this period, a small but dedi-cated group, mostly women, is usually found stationed in the ladies' section just in front of the god. In the summertime, there is often someone standing to the side of the railing, rhythmically pulling on a string that connects to a cloth fan inside the sanctum. When the curtain does close, it generally signals that someone has made some sort of offering—money, food, flowers—to the deity. The *goswami* inside the sanctum takes the offering, pulls the curtain across as he offers it to Radhavallabha, and then reemerges with some *prashad* for the donor. There is constant traffic in devotees asking for *prashad* or some of the sacred water (*charanamrit*) that has been used to bathe the deity. For this purpose, there is usually a small pot available out-side the door, and a splash of the sacred substance is poured into cupped hands. When the pot is empty, it is refilled from within the sanctum. There is a desultory pace to the morning and a decidedly neighborly feeling to the relaxed groupings of devotees who while away the time between *darshan*s.

Every *darshan* is accompanied by certain alterations in decor, dress, or accessories. Preparations for the noontime ritual offerings

and Radhavallabha's subsequent afternoon siesta involve quite visible changes to his attire and decorations. For his midday comfort, garlands and some ornaments are taken off, and his waistband and clothes are loosened. After the rituals are over and the doors are finally closed for the quiet of the afternoon, everything but a lower garment is removed so that he may rest comfortably in his bedroom.

A group of us was once offered a privileged glimpse into his sleeping chamber, a good-sized room with marble walls and a black and white tiled floor located around the back of the temple. Radhavallabha is placed on a silver bed that has twenty-one pillows and is surrounded by posts from which mosquito netting and light-colored curtains are suspended in the summer, replaced by thicker fabric in the winter. As we stood at the threshold (we were allowed to go no further), Mohit came in from another doorway and applied perfume to the curtains from a small bottle; he then offered some of the perfume as *prashad* to a senior member of the group. Depending on the season, there are air coolers, a hand-pulled fan, or heaters. A low covered table stands nearby for the ornaments that have been removed from the sacred bodies, and the room has shelves, vessels, and containers for snacks or any other needs that might arise.

For the duration of the afternoon, the public areas of the temple kick into high gear if there is to be a *bangala* or other special event in the evening. In preparation, teams of artisans labor on the dais, in the courtyard, or under its arcades, and, as at the Radharamana temple, there is a concerted effort to finish everything in time for the evening's *darshan*s. As the afternoon comes to a close, the standard schedule begins with Radhavallabha receiving another short lamp offering at around 5:30 or 6:00 PM, at which time he is handed the flute for the second time. The third and final time that Radhavallabha holds the flute follows shortly with the early evening offerings that occur at around dusk. In the evening, as in the morning, there is then an extended period when Radhavallabha's *darshan* is proffered to the public. The day ends for Radhavallabha at about 9:30 PM, after a final sequence of offerings and a last *darshan*.

A critical component of the offerings to Radhavallabha is a special kind of musical accompaniment, a style of congregational singing known as *samaj*. While congregational singing is equally practiced in other Krishna temples, in the Radhavallabha temple the songs are particular to the denomination. A cluster of temple musicians usually sits facing the altar at the back of the courtyard; during special eve-

ning presentations, they move up to the dais. They perform a corpus of songs that draws upon a large body of the Radhavallabha sectarian literature, including the poetry of Hit Harivansha and other important historical figures. The various annual celebrations and special occasions also have their own particular songs and verses, some of which are found in printed booklets or pamphlets that devotees use to follow along. The music and singing set a rich and intimate tone for the devotional services; in Guy Beck's study on this tradition, one of the performers proclaimed, "Our only activity is to observe the love affairs of Radha and Krishna by singing these songs. Then the divine beauty manifests in different colors, aspects, and forms."[15] The importance of these songs can be seen in the way that priests and devotees alike refer to the important mood they set and to the beautiful visions they evoke.

Priya, a young woman from Kolkata who is a particularly articulate and devout believer and who was of great help to me, told me that she daily reads passages from the *Radhasudhanidhi,* a short text of verses devoted to Radha and attributed to Hit Harivansha.[16] Her sophisticated interpretation of aesthetics and the depth of her faith were truly impressive, visible especially in the earnest way in which she described how she could feel the great power of *shringara rasa* from reading the text's verses. She cited an example of how Radha dons ornaments (*shringar*) not to, as we might expect, decorate herself or to make herself more beautiful, but to tame the potency of her natural beauty—for if she were unadorned, the splendor of her natural form would be too much for Krishna. Since Priya can only occasionally visit Vrindaban, she regularly keeps up with the temple *darshan*s through its website, saving special visions in her computer's Favorites folder. But, as she insightfully noted with reference to the ornamental traditions of dress and decoration, "without *rasa,* it's just clothes."

The *ashtayama seva* schedule sets a daily rhythm to the dizzying succession of annual and special occasion events that keep the temple extraordinarily active most of the ritual year. As at the Radharamana temple, certain colors have particular significance, but at the Radhavallabha temple they are used to signal broader seasonal and temporal changes than are the daily color choices employed at the former temple. The predictable seasonal changes dictate what kinds of colors and fabrics are worn, and lunar progressions also have their iconographic signals, but there are interesting complexities in the way astral and seasonal times interact. For example, on the new-moon night, Radhavallabha wears a Taj crown, named

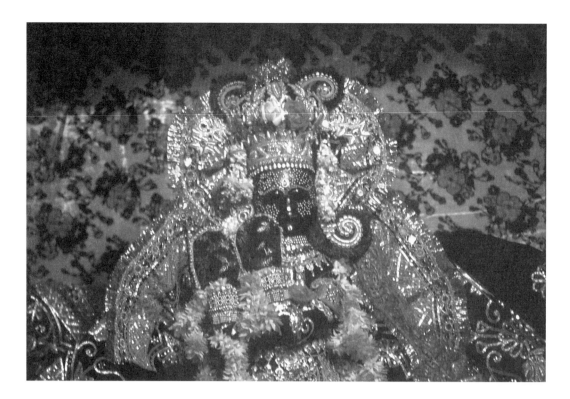

Figure 2.3. Radhavallabha wearing a Taj crown and black clothing on a new-moon night, Radhavallabha temple

for the circular base and tall bulbous finial that evokes that monument (fig. 2.3). He also wears black, a common practice at Krishna temples on new-moon nights. However, on the new moons that fall between or during certain seasonal or ritual junctures, he wears the colors appropriate for those occasions: before Holi, he wears red or yellow; during the period between Krishna's and Radha's birthdays, different colors can be worn; in the *shravan* or monsoon season, he wears green; and during Diwali, he is seen in red.

A broad, leaf-shaped style of crown is worn for both *ekadashi* and full-moon (*purnima*) nights. Radhavallabha wears this crown and a dancing skirt of any hue (see pl. 6), but not before Radha (in her emblematic form) dons the crown first. As with the flute, she serves as Radhavallabha's teacher in the arts of decoration, so she wears the crown for the first half of the day. During the time she wears it, the crown tilts toward the figure of Radhavallabha, and when his turn arrives in the evening, it tilts toward her side of the throne. These elaborate crown assemblages (which are doubly complicated as they also include Radha's crown, plus all the extra headdress extensions) are generally made of intensely worked gold or silver embroidery—stiff, heavy, and grand—but during the summer, they can be recreated in floral embroidery, rendering the crown assemblages gorgeously light and elegant.

The visual signals become more complicated with Sharad Purnima, the full moon in the month of Ashvin (generally October), which is the occasion when Krishna danced the great circle dance with the *gopis*. In general, this event is celebrated in Krishna temples with shimmering white and silver, and this practice is also followed at the Radhavallabha temple. However, Sharad Purnima is also the night when Hit Harivansha disappeared into the innermost bower (echoing Krishna's disappearance from the *gopis* that night); thus, it is considered a night of mourning. The silver and white worn on this occasion thus have an "insider's" significance, evoking both the full moon and the color of mourning. The mood of sobriety is then dispelled two evenings later in a virtual reprise of the Sharad Purnima decoration ("second" Sharad)—but this time the turban Radhavallabha wears under his normal headdresses will be celebratory red and not funereal white.

The Radhavallabha temple's printed calendar is particularly helpful for keeping track of the festival traditions and their allied visual schema. It tells us, for instance, on which new-moon nights the Taj crown and black clothes are worn, and that in the spring month of Vaishakha (April–May), Radhavallabha is decorated with cooling sandalwood paste and sandalwood-colored clothes (this is also observed at other Krishna temples). Hit Harivansha's birthday falls in the same month, and celebratory, fresh yellow clothes are worn after Radhavallabha undergoes a grand sequence of ritual ablutions with the traditional five sacred substances. This event is followed by six days of offering congratulatory songs by the *samaj* as part of a wide spectrum of jubilant observances. The heat of May and June is relieved by "water sports," such as the cooling spray of fountains, floral *bangalas*, or more elaborate constructions simulating boats, which are set into a specially engineered "pool" on the dais. The monsoon is heralded by the color green, and the deity is placed on a series of large swings that are artfully decorated with leaves and garlands and that are physically (and very carefully) swung back and forth by the *goswamis* (fig. 2.4).

Krishna's birthday and Radha's shortly later are denoted by large-scale celebrations. In keeping with the privileging of Radha over Krishna, her birthday is a much grander affair, involving nine days of festivities, the customary ritual ablutions, dancing, singing, street processions, and sumptuous food offerings. There is a particularly messy and energetic free-for-all where copious amounts of turmeric-yellow-dyed yogurt are thrown about in the temple

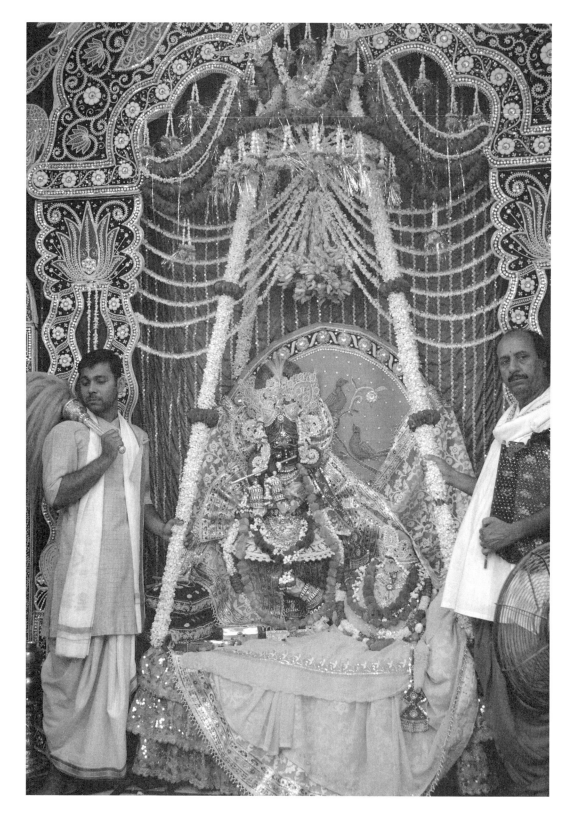

Figure 2.4. Radhavallabha in a swing, Radhavallabha temple

courtyard, covering *goswamis* and devotees alike. The deities are arrayed in auspicious red and yellow clothing. Diwali is also celebrated with red clothing. And each ornamental occasion is accompanied by its own listing of internal details, rules, and guidelines that are too elaborate to go into here. It's easy to become avidly engrossed with every variation, because that is the way this visual language works: its grammar is based upon a succession of common themes that are endlessly varied and embellished upon.

Since the Radhavallabha sect eschews the Braj region's preoccupation with the mythology of Krishna's youth and cow-herding pastimes, it might come as some surprise that the important November events of Govardhan Puja and Annakut (when a huge array of food is offered to the "king of the mountain"), and the somewhat later Gopashtami are observed. But even though such Braj-themed festivals are accommodated in the Radhavallabha calendar, there are always reminders of its sectarian distinctiveness. The temple officially sponsors a wedding ceremony for Radha and Krishna in the evening of the same day that Govardhan Puja and the Annakut festival occur, a day that surely rolls two very different facets of Krishna's personality into one: lord of the mountain and devoted spouse. And just a few days after Gopashtami, when Radhavallabha is provided with the dress, ornaments, and staff of a cowherd, the Radhavallabha temple fetes the day that Hit Harivansha brought Radhavallabha to Vrindaban—known by them as the "festival of the discovery of Vrindaban."

In March, the divine couple is treated to another "official" wedding ceremony on the *ekadashi* day that just precedes Holi. But the temple-sponsored weddings are not the only times that weddings are staged—in fact, Radha and Krishna are married multiple times during the year. Sponsoring a wedding ceremony is one way that temple patrons can demonstrate their gratitude toward their god or mark a special moment (birth, marriage, anniversary, new business venture, construction of a new home, etc.) in their own lives. For these occasions, the god usually receives a new outfit and possibly new jewelry. There are also other types of privately sponsored celebrations (called *manorathas*) that can be coordinated with the temple calendar. Extra weddings are one major category, but also the funding of flower *bangalas* or the gorgeously decorated swing presentations that occur through the summer and into the monsoon season are favorite and highly visible choices—indeed, anything can be paid for or donated by an interested patron.

Since all such occasions involve the ritual donation and display of clothing and ornamentation, I asked Mohit about the logistics of dressing the deities. He took me to a storage room in the upper balcony that surrounds the courtyard, where he proceeded to pull out large bundles of clothes, enveloped in dusty sheets, from one of the many metal cabinets set against its walls. As he unwrapped one of the bundles, he detailed how each of the figures on the throne is dressed in a full array of garments and accessories: for the Radha form, there is a blouse, skirt or sari, and head wrap; for Krishna Radhavallabha, there is a choice of clothing depending on the season. He wears a long, thick tunic or long-sleeved shirt and pajama-style pants in the winter, or a wrapped *dhoti* and light upper pieces in the summer. There is also a selection of shawls and other clothing choices. Hidden from viewers, but part of both Radha's and Krishna's ensembles, is a little drawstring purse, stuffed with cardamom seeds, cloves, a handkerchief, and some coins. Heavy, velvet-type fabrics are used in the winter; cottons and lighter fabrics are for the summer. Synthetics are acceptable provided they are lined with cotton or silk on the inside where the fabric touches the gods' bodies.

Mohit reported that it takes twenty meters of fabric and forty meters of decorative borders for each commissioned outfit. Gold and silver embroidery, pearls, small decorative motifs, and so on can be purchased separately to further embellish the fabric. Patrons may obtain the measurements and have their own tailors make the outfits, or they can go through a local tailor. The process usually takes about four days, and patrons can request a certain day to have their clothing worn by the deities. The throne and bedroom accessories—floor covers, pillow covers, back sheets, curtains, canopies, and so on—represent another category of objects that patrons can donate. And the headdresses and crowns are another arena of purchase and commission, as is the jewelry. On occasion, new gold flutes are provided as well.

If, as was clear from the heaps of clothing that surrounded us, Radhavallabha already has an extensive wardrobe, why do people insist on giving more? What is the value of this visual spectacle? The answer here is no different than in any other temple context: people want to be able to see, and visibly exhibit, the tangible products of their patronage, and they want the personal experience of seeing their gifts directly benefit Radhavallabha himself. But there is an artful tension between the reality of such practices and the ideals upon which they are predicated. For Mohit, the value of such display is that it

brings in devotees on a certain physical, elementary level of under-standing, and he hopes that they may eventually advance to higher levels of spiritual interaction with the divine. As he elucidated, "There are two types of eyes: those in the heart and those in the head. The ones in the heart see the poetry and the truth. The eyes in the head are like cameras. During *darshan*, we capture all the details of the dress and ornamentation of Radhavallabha with our camera eyes and place him in the album of our hearts."[17] This first visual level is the foundation upon which the devotee progresses to the next stage, which is more abstract and is nurtured by chanting, singing, and the poetry and literature of the sect. At this second level, mental images are lodged in the mind and the heart, and the practitioner no longer requires the physical presence of the deity. And finally, the highest level is reached when one is immersed in round-the-clock contempla-tion of Radha and Krishna as they act out their constant rounds of love play (*nitya vihara*), a mental recreation of the *ashtayama seva*. This is an ideal that is also shared by the Chaitanyaite and other Vaishnava denominations. The value of sustained temple visits and repeated *darshans* is that they help the devotee to build a strong foun-dation of experience upon which these higher levels of contemplation can be reached.

Mohit's father addressed these issues more colorfully:

Who do you think this decoration is for? Radhavallabh-ji? No! It's for the devotees to see and appreciate. The decoration is like a fish hook that reaches out and pulls people in—say someone comes to the temple and sees Radhavallabh-ji ornamented in beautiful crowns, necklaces, jewelry, clothes, nice sandalwood painting on the face, and he thinks to himself how beautiful it is. Then he goes to America and one day he thinks of how beautiful Radhavallabh-ji was, and it brings him back here—the decoration has hooked him. Radhavallabh-ji is supreme—he has no need of the kind of decora-tion we can provide—he is beyond that, he is already fully orna-mented. This is for us, not him. First you start out, you give a little money, you sponsor something, give some gifts, etc. But this is just the beginning, a starting place. And when you get to a certain point, you won't need it either.

He gestured toward preparations that were being made for a spon-sored wedding scheduled for that evening and said: "See this? While this may all be beautiful, it is external, as opposed to the internal. You give money, some donation, some kind of gift, you take something. These things are necessary, the first things for en-

trance into the inner side [understanding about the Radhavallabha beliefs]. They are necessary at first, but later are not necessary. I'm not interested in this kind of decoration," he declared as he nodded dismissively toward the *bangala* makers. "This is a showy thing. When you go inside the *nikunj*," he gestured expansively, eyes shining, "you will see such beauty, such decorations. You can't imagine! Oh ho! The *nikunj* outshines everything."

As I noted earlier, this kind of disavowal—and I am not questioning its sincerity—of the motivations for sponsorship pervades the rhetoric about lavish patronage and display. Whether from the perspective of the priest, the patron, or the participant/consumer, temple spectacle serves many culturally viable purposes: it pleases the divine, it keeps the temple coffers full and allows the show to go on, it sustains regular patrons and attracts new ones, and it provides occasions that have entertainment as well as spiritual value. Temple patronage also provides a culturally sanctioned way to display wealth and prestige. To deny this would be naïve; to be overly cynical about it would ignore much about how contemporary Indian society organizes its priorities. Pavan Varma shrewdly comments on a similar phenomenon seen in the single-minded pursuit of power while attempting to elevate the process with a veneer of ideological respectability:

> Indians need to always prove to themselves, and to others, that their relationship with power is "honourable." They like to project that they seek power not for itself, but for a cause separate from themselves. Ideology is the perennially available midwife to deliver "respectability" to the jockeying for power. Ironically, the ability to renounce power is a goal all Indians accept as laudable. It is part of a philosophical tradition that looks to spiritual salvation beyond the finite world. Indians will often cite this tradition to prove their "detachment" from the lure of power. They do not expect to be taken seriously, except perhaps by foreigners excessively taken up by India's "spirituality," and increasingly not even by them.[18]

Let me stress here that I am being neither critical nor cynical; instead, what I hope to point out is that within the parameters of historical practices, religious ideals, and traditional aesthetic norms, there is room for—and positive worth given to—a certain kind of acceptable exhibitionism. And related to this, as the trend for deploying the visual in ever more daring ways continues in contemporary Indian society, is the high premium given to newness

while at the same time being mindful of tradition. As a colleague once commented, nobody really wants the stories and traditions to change, and people are comforted when the myths and narratives of old are delivered with no unexpected plot twists: emotion deepens with each well-worn repetition of the familiar. Yet there is eternal delight in change, and renewal is intimately tied to notions of auspiciousness.

Newness and freshness are, of course, not limited to temple aesthetics. Kajiri Jain notes, with reference to the annual custom of businesses presenting new calendars to their clients:

> [T]he very newness of a calendar is auspicious in itself: not so much as ontological originality, but as a renewal, indexing freshness, fecundity, plenitude. . . . Here "auspicious," *shubh,* is a term of value that becomes efficacious, or gains a material force: the ethical and/ or sacred nature of the representation in a calendar image, as well as its ritualized annual presentation, works to enhance the reputation and thereby the creditworthiness of the firm whose name is printed onto the calendar.[19]

It is a reciprocal relationship: the patron gains value in giving something new. Jain elaborates further in a footnote:

> In this sense, the calendar itself is auspicious in its newness as a gift, which is why it must be re-produced every year. Publishers said that even though clients often demand pictures of the same deity from year to year they cannot repeat exactly the same design, or it wouldn't be "new." So by now thousands of iconic figures have been published with the same iconographic characteristics but varying backgrounds, ornamentation, colour schemes and composition.[20]

If it is in part the novelty factor that keeps people coming back for more, perhaps the most interesting opportunity for witnessing the exposition of newness is during the cyclically occurring extra lunar month known as *adhik mas,* literally "extra month."[21] This, fortunately, fell right during the time I was doing early fieldwork, from mid-May to mid-June 1999, and Mohit informed me that the Radhavallabha temple has a special tradition of allowing patrons to sponsor any festival they desire from the regular ritual year. What this means is that time can be upended, and that year's suspension from scheduled normalcy resulted in a fascinating temporal free-for-all that would teach me much about the temple and its distinctive culture.

Time's Baby: What to Do with an Extra Month

As I noted previously, the phenomenon of time in India progresses along several distinctive trajectories. On the one hand, there is the Gregorian calendar based on solar progression. But equally important is an active lunar calendar with its own system that divides the month into a dark half, when the moon is waning, and a light half, when the moon is waxing.[22] The new moon and the full moon set the thresholds of those lunar fortnights, and as we have observed, those chronological junctures are made apparent in Krishna's ornamentation. Not surprisingly, with all these cosmic gears meshing and turning, interesting things can happen to time when the solar and lunar calendars bump against each other, their rhythms overlapping and intersecting. When this happens, an extra month of time is spawned, a celestial bonus that Shrivatsa Goswami once aptly termed "time's baby."

The reason for the extra month takes some explaining. In India, the traditional Hindu calendar is calculated on the passage of lunar, and not solar, months. The Hindu month thus spans the period from one phase of the moon to the next (and, depending on the region, it can be new moon to new moon, or full moon to full moon) and comprises approximately 29.5 solar days. Twelve lunar months, thus, add up to a total of 354 days, necessitating adjustments to bring the lunar year in line with the solar calendar. This means that approximately every three to four years, there is a buildup of "extra time," resulting in a thirteenth lunar month. This extra time is formalized by an intercalary month for that year. In the years that this calendrical adjustment occurs, there are two months designated by the same name. The process for this is a bit complicated: the "regular" or proper month starts off with its dark half, and after the passage of the new moon, the intercalary month—bearing the same name but with the prefix *adhik,* or "extra" (or sometimes "second")— appears in the calendar in its entirety, picking up the schedule with the ensuing light half of the lunar fortnight that culminates in the full moon. This is followed by the second or dark half of the "extra" month, which concludes on the new-moon night and brings the calendar full circle. Then, the second half of the regular or "first" month picks up where it left off, and the rhythm of the contemporary cosmos is righted once again, at least for the next few years.

Depending on what part of India one is living in, this kind of extra time is considered either inauspicious or auspicious, a gift of out-of-the-ordinary, unique, special time. This extra month is a time, then, for special—particularly religious—action. Many people go on pil-

grimage or attend week-long public sessions of the recitation of important texts such as the *Bhagavata Purana*. Aside from births and deaths, which cannot be rearranged, no regular ceremonies, such as weddings, should be scheduled during *adhik mas*. The Radhavallabha temple solves the problem of what to do with this extra time by opening up the sponsorship of the temple program to the whims of its devotees. As Radheshlal Goswami explained to me, it was an innovation that was adopted about sixty or seventy years ago, perhaps inspired by the Pushti Marg sect which he believed also follows the same practice. The decision to, in essence, market the whole month was based in part on economics: how was the temple to pay for the expenses that were incurred during the "extra" time that fell between the cracks of the ritual schedule? Now, there is an inventive system of patronage that brings people in to finance special celebrations that are normally the province of the temple: in theory, during this month temple-goers may sponsor a replay of anything from Holi to Diwali and a whole lot in between. I was not to be disappointed in the variety and liveliness of the presentations during the three weeks I observed of this month (for its final week, I was in the Radharamana temple and in the Vinodilal temple in Jaipur). These festivals only took place in the evenings, with the normal pattern of ritual services offered in the mornings until lunchtime. As is always the case with such special occasions, final preparations were made in the late afternoon, culminating in the presentation in the early evening. There was usually a sign placed near the edge of the dais announcing the evening's upcoming event.

As expected, a few days into the extra month, a placard appeared announcing "Hori Utsav," using the Braj-language spelling for Holi. The beloved festival of colors is normally held in March, and it is particularly important for worshipers of Krishna and Radha as it focuses so much on their playful aspect, along with strong undercurrents of eroticism and tension between the sexes and the heralding of the spring season. In Braj, Holi celebrations extend over a period of ten days, and the Radhavallabha temple is no exception in the extent and gaiety of its observances: the *samaj* is in full swing many days in advance, there is a street procession with child-impersonations of Radha and Krishna riding an elephant, flags are flown, festive bands march in the street, and there is the requisite throwing of colors (in both liquid and powder forms) and consumption of rich sweets. In the temple, there is similar merriment, and the actual day of Holi culminates in one of the two annual

temple-sponsored weddings.[23] Since I could not be there during the actual Holi season, I was delighted to witness its out-of-time reenactment.

Even though the replicated festival is an abbreviated version of the normal program—it only lasts one evening and there are no elephants or street festivities—nevertheless there is a convincing amount of jubilation and merrymaking. I had arrived at the temple a bit later than I had expected, delayed by one of the fierce dust storms that periodically beset Vrindaban in the summertime, and by the time I got there the courtyard floor was already a mess of rose-colored, slippery water. The curtains—made of some sort of silver lamé with ruffles—were closed, and many people were cheerfully waiting around, already drenched with color. On summer evenings, Radhavallabha's throne is moved forward of the sanctum doors, taking up the space where the women usually sit. A barrier is erected across the dais, separating the god and the *goswami*s from the populace and creating a narrow lateral strip of space in front of the sanctum. Onlookers can lean over the railings that extend out from the sanctum door, just as they do normally. Radhavallabha is physically closer, but is visible only from the side or from the courtyard below. At times, the *samaj* is positioned on the dais in front of the god, and the *goswami*s move freely back and forth, dispensing *prashad* and engineering the ritual offerings and the viewings.

I ran into the family—father, mother, son, daughter—that was sponsoring the evening's festivities; I had met them earlier in the day at one of the morning viewings. When I asked them where they were from, the father told me they were from Nakpur, making it into a joke by pointing to his nose (*nak*) and then saying *pur* (city); he was clearly in a jovial mood, covered from head to toe in color. I asked him why he chose to sponsor the Holi festival, and he replied that "it is a time of people giving to one another, embracing, no struggle and strife." He told me that I would never forget this experience and that it would always remain in my heart. "Our country," he declared, "is the land of *yogi*s [that is, simple]; your country is the land of *bhogi*s [enjoyers, consumers]." While I was puzzling that one out, the curtain opened and a lamp offering ensued. Radhavallabha was dressed in sheer white clothing with silver borders that had been stained judiciously with color by the priests, who stood behind their railing. In front of Radhavallabha was stationed a large silver pot filled with liquid color; in it rested silver syringes (or water guns) designed to dispense color over the

crowd. To my unprepared surprise, the *goswamis* started tossing powdered color from behind their barrier right onto me, onto my camera bag, and in my contact lenses—I ended up covered with color. People took pictures of me, and I took pictures of them, all the while trying to protect my camera. Then, the nice man from Nakpur directed me and his family to stand under the sprinkler that descended from the ceiling, and after we all got thoroughly soaked, more photos were taken. His final words of wisdom were that, while "the exterior color may wash away, the interior color will always be there in your heart." He was right.

A number of days later, there was yet another Holi festival. This time, Radhavallabha appeared in brilliant, brand-new white clothes bordered with silver, offset by a bright red sash at his waist (fig. 2.5). Some orange and red color had been decorously sprinkled on the divine couple's clothing, at their feet could be seen a smaller version of the vessel that held the liquid color, and two small silver syringes were provided for Krishna and Radha's personal entertainment. One important detail betrayed the out-of-sync timing of this festival: the couple was surrounded by a flower *bangala,* a seasonal feature not available in the "real" Holi season. The *samaj* was singing verses appropriate to Holi, and the sprinkler was rendering the powdered colors being thrown by the *goswamis* into a multicolored puddle on the courtyard floor. The *goswamis* were also dipping their syringes into the saffron-colored liquid in their larger pot, and I was almost drenched again by underestimating their range. Having learned my lesson from the previous Holi celebration, I decided to take refuge in the upper balcony; from that vantage point, the dais was almost obscured in the clouds of green and red colors that were being dispensed with great abandon. These kept being replenished with big bags of color: first yellow, then green, then red (which makes an amazing chromatic cloud), then white.

My retreat to the balcony had the great benefit of allowing me to meet another of its occupants. Her name was Neha, and she was one of the extended *goswami* family's daughters; she was to be of great help to me in deciphering much of what I would see in the next few weeks, and she remains a good friend. This balcony is where the *goswami* family's females view the *darshans,* as they are meant to be in *pardah*—shielded from public view. When the wives or mothers of the *goswamis* leave their home to go to *darshan* at the temple, they need to be completely swathed with an outer wrap, and only their eyes are visible (they say they are thus dressed like

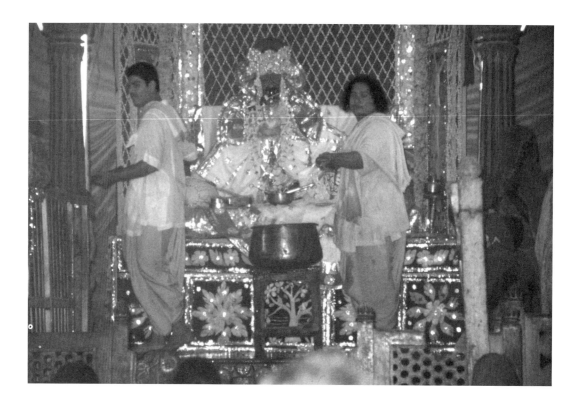

Figure 2.5. Radhavallabha playing Holi during *adhik mas,* Radhavallabha temple

Radharani). The balcony allowed Neha, who was young and un-married at the time (and consequently less constrained by convention), a freer viewpoint. Indeed, witnessing the festival from the safety of the balcony was far preferable to being caught in the mayhem occurring on the slick color-stained courtyard floor below. Neha told me that Sukrit, her younger brother, was born on Holi, so this was a particularly evocative day for the family. Neha also helpfully pointed out a few details: the red sash tied around the waist is only worn on Holi, and the kind of yellow-orange color that was being sprayed is what she termed "edible color," made from seasonal flowers available only at Holi time.

The themes of Diwali and Sanjhi were selected for another night. Although the events were coupled together for that particular evening, Diwali in fact occurs in the month of Kartik (October–November) and Sanjhi precedes it in the month of Ashvin (September–October). For Diwali, Radhavallabha always appears in a magnificent silver pavilion, wearing auspicious red clothing. During the evening, the *goswami*s play *chaupar,* a dice game, in front of the divine couple, just as they would in the properly scheduled enactment of that ritual occasion. Small clay *diya* lamps (made from miniature saucers filled with oil and a hand-rolled cotton wick) illuminated the temple balcony with their flickering lights; only the

floral *bangala* betrayed that something was seasonally unusual. At the back of the courtyard, on the floor under the arcade where the *samaj* singers usually sit, was a small octagonal platform—its eight sides emblematic of the eight *sakhi*s who assist the couple with their trysts—with what looked at first to be a painting of Radha and Krishna on a swing, enjoying the summer breezes in the forest (fig. 2.6). Upon closer inspection, it became clear that this lovely image was made entirely of the finest grains of colored sand, applied to the surface of the platform with stencils. It took hours and hours to complete, and would be brushed away by the next day. These productions are called *sanjhi,* and they are made anew every evening for the two weeks' duration of the dark half of Ashvin.[24] They can be made of colored sand or flower petals and are breathtakingly intricate—somewhat reminiscent of Tibetan sand paintings. This one had been created by Sachiko, a talented young Japanese woman who was in Vrindaban for a while and who contributed much to the spectrum of Radhavallabha temple arts.

The radiant splendor of Sharad Purnima was featured on a subsequent evening, replete with its characteristic white and silver colors. But this was not to be a simulation of the "first" Sharad Purnima, the day of mourning when Hit Harivansha left his mortal body to enter the innermost bower. Instead, this was the "second" Sharad, signaled by the festive and auspicious red turban amid all the shimmering silver-white decor and ornamentation (see pl. 7). Monsoon-season swings made the list of requested "extra" celebrations several times. The swings are physically large affairs, made of silver, and for the swing festivals, they are profusely decorated with thick hanging floral garlands and pendant strings of seasonal leaves. Also requested was a simulated boat constructed on a bamboo scaffold and decorated with banana pith. It appeared to float on an imaginary Yamuna River, the illusion artfully supplied by some clever plumbing on the dais and a sprinkling of lotus flowers. And along with all this excitement, Radhavallabha and his beloved were married three times during this bonus month.

Priya and her family were the sponsors of one of these weddings (termed *vyahula*). I asked if she would tell me all about how the process worked, and she readily agreed. First, she said, the wedding outfits were made in Kolkata by Muktar, a famous embroiderer who makes ten to twenty outfits a year for the neighboring temple of Banke Bihari in Vrindaban. She had taken some old clothing as a sample, and it took him two months to prepare the new clothes.

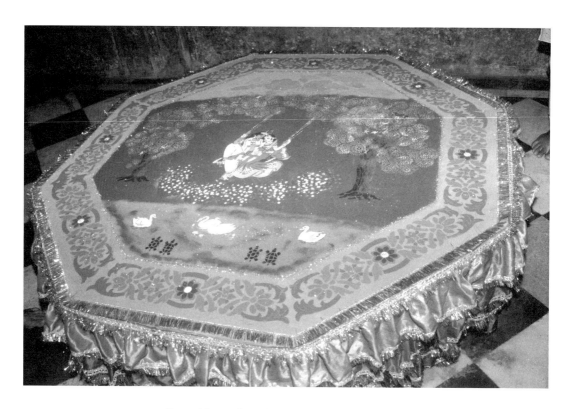

Figure 2.6. Colored-sand *sanjhi* image of Radha and Krishna on a swing, Radhavallabha temple

She told me that she had chosen a light mauve color—just because she likes it. This initial phase cost 50,000 rupees (at the time, roughly $1,150); the minimum cost for clothing was about 20,000 rupees (around $460). The family also needed to furnish the temple priests with two scarves that would be tied together during the wedding ceremony, symbolizing the union of the couple.[25] Radhavallabha holds one scarf in his hand and Radha's emblematic form wears the other scarf around her neck. The scarves cost another 5,500 rupees ($125), but the family will get them back afterward as *prashad*. Then there was a whole series of financial transactions, with money being distributed to the family's guru, to the assistants who help the *goswami*s, to the *samaj* singers, for the special food that is distributed to the various *goswami* families (along with small accompanying cash payments), and so on. She estimated that all this would total between $2,500 and $3,000. Priya's whole family, both her husband's and her own, would come for the wedding celebration (as far as they are able—her brother was not able to come because somebody died in his fiancée's family). And, even more special is that the sponsoring husband and wife sit, with the *samaj*, in the area in front of Radhavallabha that night. Priya was married in March 1995, and they marked the occasion by sponsoring a temple wedding ceremony the following September. At that time,

they also donated new clothing, gold bangles, and anklets; this year, they are giving gold bangles as well.

It is not necessary, however, that everything sponsored be a big-ticket item like a wedding or Holi festival. Many of the evenings featured the floral *bangalas* that are so emblematic of the summer season. Curious about the process, and urged on by Priya, I decided to ask about sponsoring a floral *bangala* myself, which I learned would only set me back about $125. I met with Radheshlal Goswami, and we selected a date and made the preliminary arrangements. Both he and Priya were at pains to tell me that, just because one has the money does not mean that Radhavallabha will accept one's offering. But, as is commonly said to those who find their way to Vrindaban, I had been called, and it was through Radhavallabha's grace that I could make this offering and that it would be accepted. As I was to learn, sponsoring a *bangala* could provide a valuable lesson in how the personalization of one's relationship to the temple can be made tangible and more meaningful through material display.[26]

On the day that "my" *bangala* was scheduled, I went down to the temple in the morning to watch the preparations. There was already a sign on the dais announcing that there would be a *phul bangala* that evening. It was only 9 AM, but there were about ten people working on the flower ornaments that would adorn the couple's bodies (fig. 2.7). After a while, I sat down and was taught how to make one of the ornaments. First, I was instructed, I must wash my hands. I was then provided with a needle and thread, and next I was to take a black fabric template from a selection of stiff, prepared, cutout designs that had already been hand-decorated with a silver chain-stitch border. All around me were women expertly filling in their templates with beautiful designs, the flowers chosen from broad clay bowls filled with cool water upon which floated tiny white buds with slender green hollow stems; brilliant long red buds were suspended in another container. I was to stitch each individual flower bud in a spoke design, arranging them one by one while not allowing them to exceed the edges of the design template. I was hopelessly clumsy at first, causing much giggling and polite attempts to correct my wayward stitches. I completed a couple of designs before I conceded the rest of the preparations to the artisans.

After the noontime ritual presentations to Radhavallabha, I was invited to have lunch with Priya and her mother at their home in town. They proudly showed me their home shrine to Krishna and Radha, its bronze images beautifully ornamented and dressed.

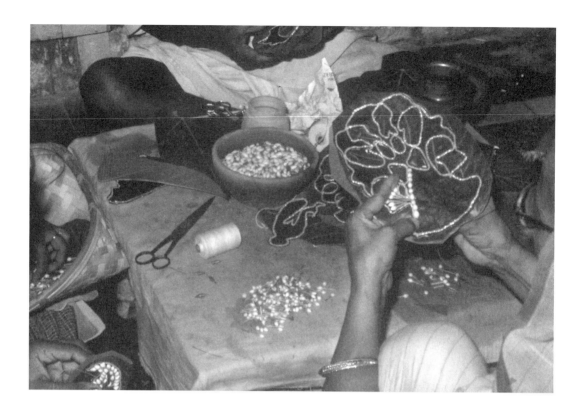

Figure 2.7. Embroidering flower ornaments, Radhavallabha temple

These domestic deities were given some food and then, after having their clothes changed, they were put to sleep in a perfect replication of what was happening in the Radhavallabha temple. Priya had already been in Vrindaban three weeks, and I asked her why she was spending so much time here: Vrindaban is certainly not the easiest place to be in May and June. She confided to me that she was troubled because she was not having any luck conceiving children after almost four happy years of marriage, and while she normally goes to see her mother in Gauhati for this month, they were here because of *adhik mas*. However—and she was firmly insistent about this point—she was definitely *not* here to ask Radhavallabha for help, nor did she believe in vows or any other special ritual actions (these are eschewed by the Radhavallabha sect, which feels there is no need to look outside of the grace of Radhavallabha) to fulfill her desire for children. It was her deep and abiding faith—come what may in her personal life—that brought her here; *adhik mas* presented a particularly auspicious opportunity to single-mindedly immerse herself in her devotion. The Radhavallabha sect makes much of this notion of single-mindedness (*ananya bhava*), and in Priya I found a vibrant, warm, profoundly generous person who radiated an enviable sense of inner peace and conviction.[27]

After lunch, I went back to the temple and watched the flower *bangala* being assembled (fig. 2.8). I had left the design up to the artisans, and they had come up with a backdrop of the usual beautiful geometric interlacing of strung white flowers and had provided banana-pith cutouts depicting auspicious full pots, lotuses, and *svastika*s. I learned that it takes over fifty pounds of strung flower buds to construct such a pavilion. Meanwhile, the floral jewelry for the deities continued to be made, and I watched how the long garlands were assembled: by pushing a sequence of white buds and rose petals onto an extra-long skewer that terminates in a long thread. The motifs for the waist girdle were made on prepared round black templates or on doubled-over *pipal* leaves that have been soaked, softened, and folded in half. I was extremely impressed with the level of intricacy and the extraordinary delicacy of these decorations and found myself wishing they were not temporary; I had to remind myself that what was important was the *process* of giving and not its products—in other words, the poetry and not the grammar. As the ornaments were finished, they were put aside in a basket in a cool storeroom, although by this point in the scorching afternoon "cool" was a highly relative term.

Finally, I decided that I would allow for an element of surprise, so I left for the rest of the afternoon. By the time I returned, shortly before 7 PM, the temple was already very full, as the varied pageant of *adhik mas* displays always draws extra spectators. The *bangala* was finished: fresh, bright, and fragrant (fig. 2.9). As I made my way toward the front of the temple, a few people called out "Congratulations!" or told me "See, he is looking at you and smiling!" I unaccountably felt like the mother of the bride—or, in this case, the bride-and-groom. I stayed until the bitter end, and when the *samaj* wrapped up their program for the night, I paid them the preset amount of 201 rupees (financial transactions ending in the number one are considered auspicious), and then I went down the line and paid all the *goswami*s a token amount of 21 rupees apiece; finally, 101 rupees went to the deity. Fortunately, Priya had been my guide to the appropriate amounts and the correct decorum for their presentation; I had already paid the artisans and other expenses. The final moment arrived, and I received some of the flower jewelry as *prashad*. As it was ceremoniously handed out to me by the *goswami*s from behind their barrier, others around me eagerly reached for the ornaments, first reverently putting them to their eyes before passing them around. I was told that I should put

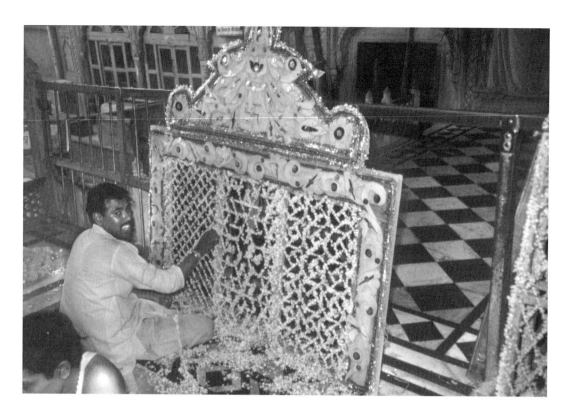

Figure 2.8. Artisan assembling flower and banana-pith *bangala,* Radhavallabha temple

them under my pillow that night and I would have a vision of Radha and Krishna. Once they were dried, I could have them stitched onto a background and framed. There were many admonitions that I must get this done right (and no, I won't tell you what I dreamed that night).

Aside from Priya's family's wedding, there were two others scheduled, one of which fell on the full moon of the *adhik mas.* This timing compounded the multiple levels of auspiciousness possible—and the multiple levels of visual complexity. I learned that many people had already performed special circumambulations of Vrindaban and other holy sites in Braj, notably Mount Govardhan. The temple was especially crowded that night as well, with a lot of uncharacteristic pushing and shoving as people jostled against each other in the teeming courtyard. For this occasion, a hired wedding band in full dress uniforms serenaded attendees as they streamed through the front entrance, which was dressed up with a glitzy temporary gateway made of Styrofoam and foil decorations. From the ceiling hung chandeliers wrapped with rich marigold garlands. Topping this off (and, as Dave Barry would say, I am *not* making this up), a mechanized peacock stood on one of the *tulsi* planters in the courtyard, blinking lights flashing on its sides, while an internal motor slowly lifted and lowered its tail.

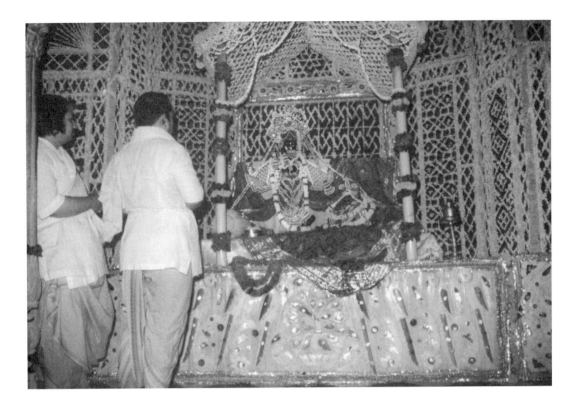

Figure 2.9. "My" *bangala,*
Radhavallabha temple

A wedding celebration involves extended coordination between
the evening ritual offerings and the ceremony itself. It was rela-
tively early in the evening, about 7:30 PM, and visitors were initially
presented with a vision of a sumptuous floral *bangala* framing the
divine couple, who were surrounded by a glittering, yellow, floral-
patterned background cloth with deep, shiny, red and gold borders.
Radhavallabha was wearing a gold full-moon crown over an orange
turban, and over his tunic and leggings (made of the same vivid
cloth as the background) he wore a beautiful tiered dancing skirt
that spread away from his body in layers of deep red and dark green,
elegantly embellished with gold embroidery. The standard stacks
of jewelry cascaded down his front and garnished his body and
limbs. I am uncertain of the exact sequence, but at some point
shortly afterward, the curtain was closed. After a short interval, the
divine couple reappeared in their full wedding regalia, the most
visible features of which are the floral veils (*sera*) that cover their
faces and the two long scarves that are tied together in a knot and
stretched between them (see pl. 8). For tonight's presentation, Rad-
havallabha held a yellow cloth—Krishna's color—while Radha's
blue cloth was wrapped around her symbolic form. The customary
auspicious coconut, wrapped with colored thread under which
some rupee bills were secured, and a clay pot filled with mango

leaves were also part of the wedding accessories. By 9:30 PM, the couple had gone through the enactment of their vows (partly behind closed curtains), and when they were presented anew, the flower veils were lifted and the knotted scarves were untied. As visual spectacle goes, this one would surely win the contest for the most number of conjunctions (*adhik mas,* full moon, summer, wedding) going on at the same time.

As I observed some of these proceedings from the balcony with Neha, she told me that these days, especially in the last ten years, there are far more weddings and there is a noticeable increase in attendance. She recalled that, twenty years ago, they used to have weddings only three to four times a year, and they never used to have *prashad* every day. She also mentioned that it is the practice to give the clothing worn by Radha's symbolic form as wedding gifts within the *goswami* families. There is enough fabric in Radha's clothing that it can be altered and recycled into something that could be worn at one's own wedding (Radharamana's old clothing, by contrast, is sometimes gifted upon the birth of a baby). She also repeated what I heard many times: only a select few are "allowed" into the temple; she said that not everyone is so fortunate as to be here.

Divine Deception: **A Rogue's Gallery**	The examples cited here from that extra summer month do not exhaust all the possibilities for special sponsorships; they are merely representative of the types of celebrations I witnessed that year.[28] Another ritual occasion in the regularly scheduled Radhavallabha temple calendar offers a similarly extensive vista of the unique practices of the sect. This festival is known as Khichri Utsav, which falls between the winter months of Paush (December–January) and Magh (January–February).[29] More than any other festival in the temple calendar, Khichri Utsav brings to the fore important issues about the Radhavallabha temple's sense of sectarian distinctiveness, but this is neither immediately apparent, nor did anyone within the tradition with whom I spoke forward (or would necessarily agree with) the conclusions that I will propose about its significance.

Khichri Utsav is best known for the special food (*bhog*) that is prepared for the god and later distributed to his devotees as *prashad.* January and February are miserable months in Vrindaban—the weather is cold and dank and foggy; the landscape is devoid of any foliage—and it is a quiet time in most temples as far as special occasions go. Thus, the richness and exoticism of the ritual offer a wel-

come diversion for both deity and devotees alike. *Khichri* is normally a comfort food, a sort of porridge of lentils and rice, but at the Radhavallabha temple during this month it is enriched with lavish amounts of clarified butter; numerous luxurious spices such as cloves, cardamom, and pepper; dried fruits, nuts, and coconut; and so on.[30]

The sumptuousness of the food preparations mirrors the complex visual fare that will be presented in the temple this month, for this festival is also renowned for the parade of playful disguises (*chadam vesh*) that Radhavallabha will adopt in order to woo Radha out of her palace or forest bower. It was explained to me that this is a time for everyone, including Radhavallabha, the *goswamis*, and the devotees to have a bit of fun. Every morning for the month, directly following *mangala arati*, devotees are treated to a parade of costumes drawn from a spectrum of divine and human personalities. The panoply of impersonations from this world and others provides fascinating insight into the Radhavallabha temple's sense of how it fits into the larger history of Krishna devotionalism in Vrindaban as it took shape in the sixteenth century and as it continues today.[31]

The mornings predictably unfold along the pattern I observed over a number of days in January 2000 and have continued to follow through the years via the temple's constantly updated website. As I had experienced previously, finding a place in the ladies' section proved next to impossible; and if the women were stingy about space during a regular *mangala arati*, they were downright hostile now. Space was clearly at a premium, and I had to fight my way in, which hardly presented an auspicious start to my mornings. The temple musicians performed the special verses that accompany Khichri Utsav; many others followed along in a pamphlet printed for the occasion. The sense of anticipation was high, although it appeared we were in for a wait as it was already past 7 AM. Finally, the temple gong rang, the curtain was opened, and Radhavallabha made his long-awaited appearance. He was attired in a richly embroidered heavy cape (*phargul*) and matching tall headdress, its shape somewhat reminiscent of a papal crown, which is customary for winter; for Khichri Utsav, there is a new cape each morning (see pl. 9). On a normal day, after *mangala arati* is performed, the curtain would be closed and devotees would leave to start their daily routines. But during Khichri Utsav, there is an extended period of extra visual presentations immediately following *mangala arati*. They begin with a process of gradual unveiling, termed "whole body" (*sarvang*) *darshan*. Somewhat akin to emerging out of bed

on a cold winter day, Radhavallabha is gradually unveiled to his devotees: after *arati,* the curtain is briefly closed, and when it is opened again, one mittened hand is seen protruding from under the cape. A few seconds later, the curtain is closed again, and when next opened, a second mittened hand is visible. This sequence of unwrapping is performed bit by bit, with the god's slippered feet uncovered one at a time, then half the length of his body, and, finally, *darshan* of his full body is offered, now attired in a thick skirted tunic and leggings. The gradual uncovering has the crowd thoroughly awakened, and each step in the sequence is accompanied by loud cries of "Jai ho!"

Then, the real fun begins. By this time, most of the crowd has started to leave, but a committed group will remain for the next session. For now will commence a prolonged and extensive program of disguises and costume changes (termed *jhankis,* or glimpses), augmented by all manner of stage props, artificial hair, headdresses, and so on. Between costume changes, the curtain is closed for a few minutes, and when it is opened again, it is not always immediately apparent what figure is being represented. Frequently, a bit of conferring and guesswork goes on as participants try to puzzle out identities, a process that is also a calculated part of the fun: for Krishna's disguises not only fool Radha, but they also befuddle his worshipers.

When I was in attendance, the first day's costume session began with Radhavallabha dressed in a pure white cloth covered with a light patterned scarf frequently associated with learned holy men (fig. 2.10). On his head was a white turban, a *tulsi*-bead rosary (*mala*) was dangling from his hands, and a tall twisted walking stick was placed at his side. The initial guesses were *panditji* (holy man), but finally it was decided that this was meant to be Svami Haridasa, a contemporary of Hit Harivansha who discovered the self-revealed manifestation of Krishna as Banke Bihari and established a temple for his worship. Like Radhavallabha, Banke Bihari is also considered a joint form of Krishna and Radha, and the Haridasi sect is equally focused on the exclusive relationship between the lovers in eternal union.[32]

The next disguise was of Radhavallabha dressed as a woman. Garbed in a skirt, bodice, and shawl; decorated with a nose ring and a crown; and equipped with a cardboard *vina,* she was identified as Lalita *sakhi,* one of Radha's eight main girlfriends and confidantes who reside in the innermost bower along with Hit Har-

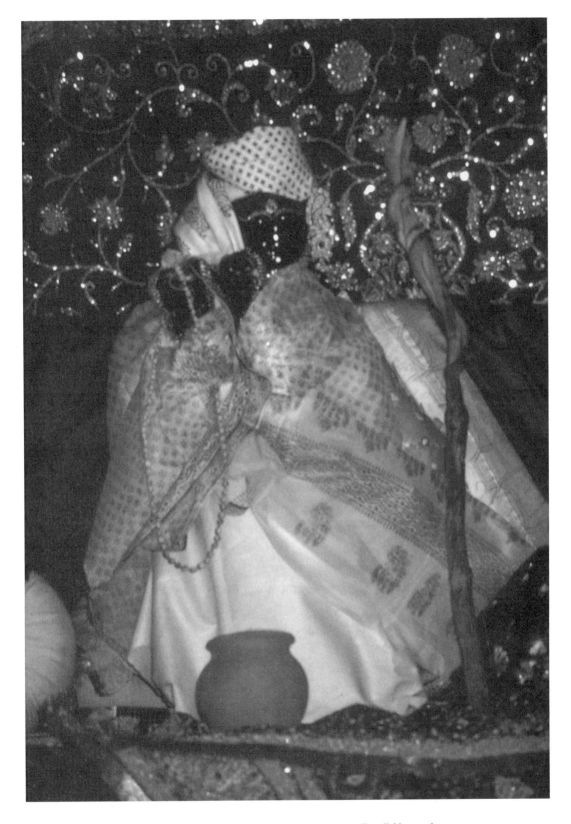

Figure 2.10. Radhavallabha disguised as Svami Haridasa during Khichri Utsav, Radhavallabha temple

ivansha in his flute incarnation.[33] The following transformation had Radhavallabha outfitted as a Shaivaite ascetic, wrapped in an orange cloth and provided with a mop of long wild black locks, a rosary, a silver pot, and a trident (see pl. 10). Next was Radhavallabha in the guise of an ordinary Vrindaban woman, or perhaps a *gopi,* going down to the banks of the Yamuna River for a bath (fig. 2.11). She was dressed in a silvery-blue dress and shawl, and at her feet rested a plastic basket with a change of clothes and a silver carrier of bath accessories. This scenario was immediately followed by the same figure with a blue cloth stretched across her at knee height, representing her immersion into the river (fig. 2.12). The morning's session was (literally) wrapped up by a final vision of Radhavallabha covered up, only face and hands visible, with a heavy quilt. This convention signals the end of each day's pageant. The curtain closed, and the disguises were over for the morning. The rest of the day was devoted to the normal pattern of ritual presentations.

The next morning's program started with the unveiling process, and then proceeded with Radhavallabha dressed like a bride with an identifying streak of vermilion (*sindur*) along the part in her hair and a nose ring. After this came a woman who was selling the sixteen items of decoration necessary for a wedding, including bangles, black eye makeup, forehead decorations (*bindi*s), combs, oil, flowers, a mirror, perfume essence, henna, ribbons, powdered vermilion, and so on. An impersonation of a bird seller followed, with the god dressed in a pink Rajasthani-print outfit, with two colorful clay birds perched on her mittens. After a short period behind the curtain, the same figure was shown, this time with a ball-shaped sweet called a *laddu* and a rose petal balanced between her mittens. (At that point, one of the officiating *goswami* members in the sanctum handed out a basket of *laddu*s that had been placed on the altar to one of the devotees gathered outside, triggering a virtual riot as people mobbed her to get at the *prashad.*) A "princess" appeared next, with pink outfit, blue fan, a crown, and a gold necklace. The final disguise was termed Hit Sajhni *sakhi,* featuring a female figure with a fly whisk. She represented one of the *sakhi*s who, along with Hit Harivansha, are allowed unique and intimate proximity to Radha and Krishna in their love bower. She is considered the one most qualified to understand the divine couple's needs, and she intuitively knows best what Radha desires—even when that desire is unspoken.

Another morning brought the disguise of a bangle seller, with strings of bangles dangling from above and baskets full of her wares

Figure 2.11. Radhavallabha disguised as a woman going to take a bath in the river during Khichri Utsav, Radhavallabha temple

at her feet. Next was Radhavallabha as Hit Harivansha himself, with a large manuscript (obviously something from the temple library) stacked in front of him and a page arranged between his hands; I was told that he was reading the *Bhagavata Purana*. The next scene had him finished with the reading, with gifts placed at his feet. A fruit and birds *sakhi* came next, followed by, I was informed, a *sakhi* who enters Radha's palace (there appears to be a cast of lesser *sakhi*s who float in and out of the picture).

Through the years, I have observed parts of Khichri Utsav and followed it on the website. I have also been told about special *darshan*s and been sent copies of photos and digital images. The list of disguises is extensive, and I include many of them to give a sense of just how broad the spectrum is. In order to make sense of the panoply of forms, I will categorize them by type: Krishna-*lila* disguises, general activity-type human disguises, and special transformations that impersonate other deities.

The Krishna-*lila* disguises include Radhavallabha dressed as young Krishna about to steal butter: he is armed with a stick and a clay pot of butter dangles above his head. He is also featured in the *kadamba lila*: in the first scenario, he is surrounded by branches of the *kadamba* tree and miniature doll-like cowherd maidens (*gopis*) are placed at his feet; in the subsequent scene, the *gopis* are just

Figure 2.12. Woman bathing in the "river," Radhavallabha temple

visible behind a blue cloth representing the river, and their clothes are now dangling from the tree branches. Radhavallabha is also sometimes shown as a boatman, in a miniature bird-shaped boat; as the vanquisher of Kaliya, complete with a many-headed cobra prop; as a peacock, with a peacock cap and peacock tail fanning out behind and miniature peacocks arrayed at his feet; and as a cowherd, with cardboard cutout cows and a crook. He also plays Holi, for which he is provided with a silver basin of color and syringes.

All of these little scenes come with a range of props and fancy dress, and the variety of effects and transformations is wonderfully inventive and delightful. The human disguises he adopts include him dressed as a woman churning butter in a big clay pot (possibly as Yashoda); as a woman on her way to the well with a pot on her head, a pot on the end of a rope, and a painted well; as a young child flying a kite; as a member of the Chaitanyaite sect, with a triple strand of beads, a bag for the rosary, and the appropriate identifying forehead mark; as a lady "going shopping" in a colorful outfit with gold Lurex pocketbook; as a *goswami*; as a *goswami*'s wife swathed from head to toe in a white covering cloth; as a schoolboy with a bag and a slate upon which is written "Shri Radha"; as a teacher instructing, with a blackboard on which is inscribed "Shri Harivansh"; as a man in a

printed vest and *dhoti*; as a female proprietor—complete with a large sign and a selection of cricket bats, balls, and other equipment—of "Radhavallabha Sports"; as a cricket player in uniform with bat and wicket; as a wrestler in short pants with his weights; as a woman with a frilly baby-doll frock and a pointed hat; as a princess with luxurious garments and a crown; and as a king with the special Taj crown, cape, and staff. Then there is a whole lineup of merchants and their wares: a dried-fruit seller, with scales; or purveyors of vegetables, fruit, flowers, or cosmetics. When shown as a betel-leaf seller, Radhavallabha holds aloft a leaf, half-filled with areca nuts or other aromatics for *pan*, and has a basket of prepared *pan* and accessories at his feet. He is often portrayed as some sort of female musician with castanets ("like Mirabai [a devotional poet of the sixteenth century], but not her"), or as a holy man with an instrument. The contemporary world is increasingly represented: in January 2009, Radhavallabha appeared as a merchant of kites, deity ornaments, clothing, plastic baby toys, and Krishna music CDs. And this list is not exhaustive; there are many more and details always change.

Radhavallabha also takes on the special forms of divine assistants and other divinities. For instance, Chitralekha, the painter *sakhi,* is provided with an assortment of art supplies and a drawing of Radha and Krishna. In the subsequent tableau, a painting of the divine couple is substituted for the drawing. Sanwari *sakhi,* the one with a dark complexion, is represented, and Saraswati, with her *vina,* is often dressed in white. Radha herself is impersonated as Mansarovar-vali Priyaji, who sulks at the banks of Mansarovar Pond, usually dressed in red for this occasion.[34] When Radhavallabha masquerades as the goddess Lakshmi, the outfit is white, or yellow to denote the prosperity of gold, as well as to coordinate with her day's (Thursday) color. Radhavallabha takes on the identity of Vamana, Vishnu's dwarf incarnation, and is supplied with a yellow wrap, a rosary, a pot, and his identifying parasol. He also appears as Kamadeva, the god of love, with his flowered bow and arrow.

Shiva is only represented on his special day, Monday, and is always ingeniously arrayed. He is clad in a mock-tiger or leopard-print animal skin and has long black hair and a stream of blue cascading from his crescent-moon-decorated topknot. Pseudo-snakes are twisted around his body, and his emblematic trident and drum stand at his side. In Vrindaban, Shiva is known as a great devotee, becoming a *gopi* so that he too can have access to Krishna. In terms of the Radhavallabha temple's history, Shiva is also the source of the *svarupa* Rad-

havallabha. Immediately following his representation is that of his wife Parvati, wrapped in a blue dress that covers her body and head.

Closer to home, and only on the two *ekadashi* days that fall within the month, Radhavallabha is dressed as his sectarian cousin the *svarupa* Banke Bihari, identifiable by the arrangement of multiple crowns, thick braid, and elaborate long gown that spreads across his body, always covering his legs and feet. Only once a year, on Akshay Teej (in April), are Banke Bihari's feet made visible to his devotees, and so the next glimpse in the fashion show displays his feet uncovered. This appearance is usually followed by Banke Bihari with his head wrapped with a veil, identified as taking on the form of a *sakhi* and called Biharin. On the new-moon and full-moon days of the month, Krishna's raucous older brother Balarama is impersonated in his form as Dauji (who is worshiped in a village of that name) with the full array of his identifying attributes: crowned with a grand tier of multiple headdresses, pleated scarves fanned out to his sides, snakes twisting around his body, holding a silver plowshare, with a big metal pot of milky *bhang* (mixed with marijuana) in front of him. Arrayed at his feet are platters of *bhang laddu*s and *barfi* (a dense milk sweet); these are the day's *prashad*. Revati, his consort, ensues with a yellow cloth covering her head and body.[35]

Perhaps the most theatrical of the costumes is the *yugal,* or joined, form of Radhavallabha, where he displays outwardly on his body the signs of his permanent union with Radha. For this special form, Radhavallabha's body is neatly divided into two halves: on his left, he is dressed as Radha; on his right, he is garbed as Krishna. Radha's half is dressed in a blue skirt and head cover, and she wears elaborate jewelry and carries the flute. Her crown is usually in the identifying paisley shape and often of silver, and under it she wears a turban that departs in color from Krishna's half. In addition to the differing turban color, Krishna's half wears a larger, frequently gold, crown. A peacock ornament complements the Krishna side, as does a crook and his yellow clothing. Radha's hair is shown loose; Krishna wears a braid. Even the mittens and booties that keep them warm are different colors.

The parade of disguises comes to an end on the final day of Khichri Utsav. This is signaled by a succession of blankets, capes, and shawls that are rapidly put on and removed in lieu of costumes: Radhavallabha is invisible under his multiple shawls that wrap his head turban-style, and he can be seen wearing up to seven blankets at a time on his body.

What is the ultimate point of this rogue's gallery of deception and disguise? I was told that this is all part of Krishna's playful inventiveness; it makes everyone feel happy and affectionate. The youthful Krishna is renowned for the amusingly deceitful ways in which he tries to gain entry to Radha's presence, and the Radhavallabha temple acknowledges this during Khichri Utsav. It is also a time for Krishna to have a bit of the attention focused primarily on him; this period represents a brief shift of focus away from Radha. I suggest, however, that along with all the obvious fun, there is a more complex agenda that deserves attention.

First of all, Khichri Utsav is the only time during the Radhavallabha temple's ritual year in which Krishna literally stands apart from his beloved Radha: he is separated, if only for a short period of the morning, as he dons a sequence of distinctive personalities to trick Radha into allowing him access to her. Additionally, even though Govardhan Puja and Gopashtami are observed during the regular ritual year, at no other time do certain aspects of the Braj *lila*—Krishna as cowherd, as butter-stealing child, as mischievous thief of the *gopis'* clothing, as subduer of Kaliya, and so on—play such a visible role in the temple culture; significantly, these are restricted to quick appearances that are mixed in with everything else. Moreover, Khichri Utsav, although not restricted in any way, is basically for committed insiders, for those who are knowledgeable about the sect's history and theology. It takes place during a normally quiet time of year and of day—for a month in the winter, following *mangala arati*—and it is looser, more spontaneous, and more interactive than any of the more stately, organized presentations that characterize the rest of the ritual year.

Finally, and most important, Khichri Utsav provides an opportunity for the Radhavallabha sect to make manifest, in visual terms, its own distinctive history and theology. In featuring the impersonations of Hit Harivansha, Haridasa, Banke Bihari, Shiva, the *yugal* form of Radha and Krishna, and numerous *sakhi*s, the Radhavallabha temple proclaims its singular place in the complicated story of Vrindaban's reemergence in the sixteenth century. Not only does the Radhavallabha sect take ownership of a founding narrative that reaches back to mythological time with Shiva, it is a narrative that is divinely presaged and directed by Radha. Moreover, it is local: in other words, it is not related to Chaitanya, his designated successors, nor other sectarian movements that were active in the region at this fertile time in Braj history. Hit Harivan-

sha, we are told, was born near Mathura, and his family was positively connected to the Mughals, who seemed to give everyone else trouble. Hit Harivansha is credited with rediscovering Vrindaban and was sent there by Radha herself. Hit Harivansha's relationship with Haridasa (and his personal deity, Banke Bihari) further allies him with another local visionary who also shared his belief in the joined form of the god and in the primacy of Radha.

Making History Modern: www .radhavallabhmandir .com

Khichri Utsav can thus be viewed as part of an overall—if subliminal—strategy of the Radhavallabha sect to lay claim to a primary place in the mapping of Vrindaban's history. These concerns are also transparently represented on the Radhavallabha temple's website (www.radhavallabhmandir.com). As noted above, a recurrent theme for the *sampradaya* is the recounting of its establishment as a specialized sect among the many that developed in Vrindaban from the sixteenth century onward. More to the point, a dominant issue is its preoccupation with authenticity—indeed, primacy—among the many concurrent sectarian developments in medieval Vrindaban. This concern surfaces in the website's organization and in the selective nature of the information presented. It is not my intention to either substantiate or refute any of the claims or data included; what I instead will attempt to do is navigate through the site on its own terms, understanding it as yet another kind of document—a contemporary text worth translating.

Let's begin with the architecture of the website.[36] The home page opens with a visually stimulating banner at the top, announcing "Destination Sri Radhavallabh Vrindavan Introduction." Along the top of the page, there is a small portrait of Hit Harivansha, the founder of the Radhavallabha *sampradaya,* and an image of the elaborately decorated black stone sculpture that is the self-manifested image of Krishna as Radhavallabha. Accompanying these are the standard visual tropes of Vrindaban and Braj: a peacock, a large sacred tree, and an idyllic view of the *ghat*s and red sandstone architecture along the riverbank. A representation of a somewhat surrealistically shimmering sunset over the Yamuna River is overlaid with a small image that nicely summarizes the important signifiers of the sect: Krishna's fan-shaped crown, Radha's paisley-shaped crown, and a decorated flute. The introductory text provides a précis on Krishna, Radha, Vrindaban, and the practices of *ras-bhakti* from a decidedly devotional perspective, and a menu on the left side provides access to more de-

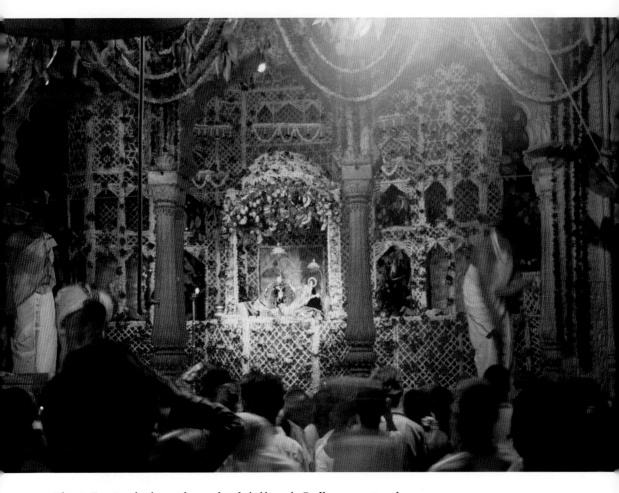

Plate 1. Evening *darshan* with completed *phul bangala,* Radharamana temple.
Courtesy of Robyn Beeche, Shri Chaitanya Prem Sansthana Archives

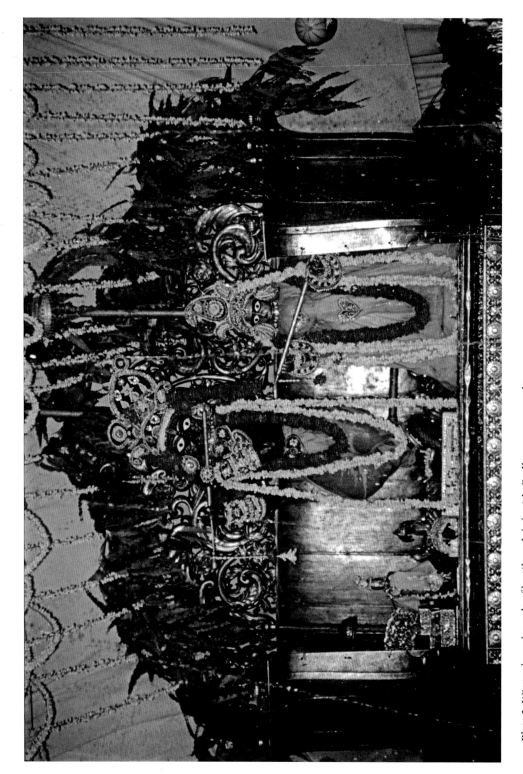

Plate 2. Winter *bangala* made of lentils and *shola* pith, Radharamana temple

ERRATUM

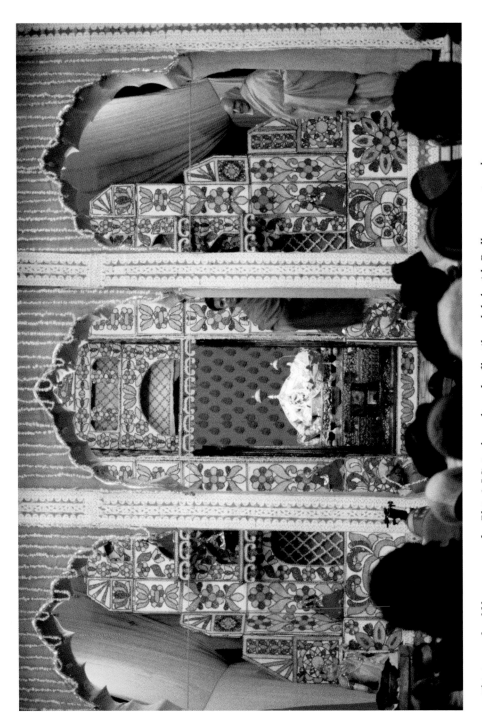

This image should have appeared as Plate 2, Winter *bangala* made of lentils and *shola* pith, Radharamana temple.

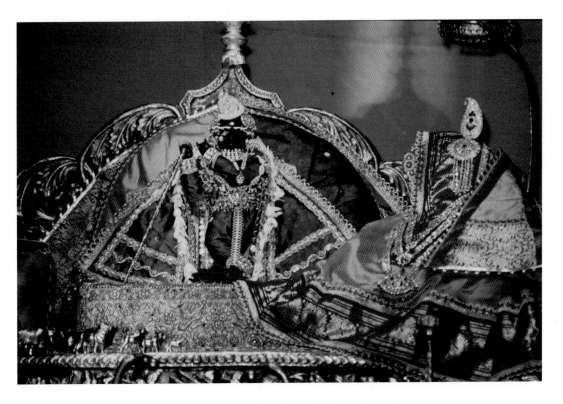

Plate 3. Radharamana in winter adornment, with yellow and blue background to
symbolize the union of Krishna and Radha in one body, Radharamana temple

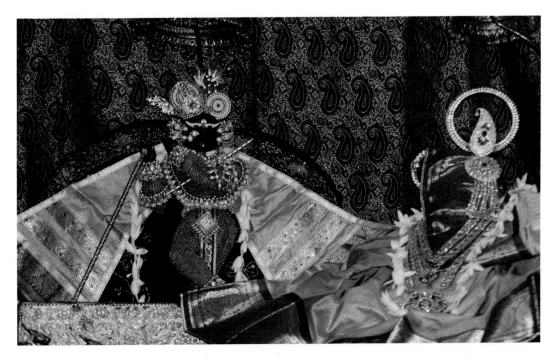

Plate 4. Radharamana in emerald outfit, Radharamana temple. Courtesy
of Robyn Beeche, Shri Chaitanya Prem Sansthana Archives

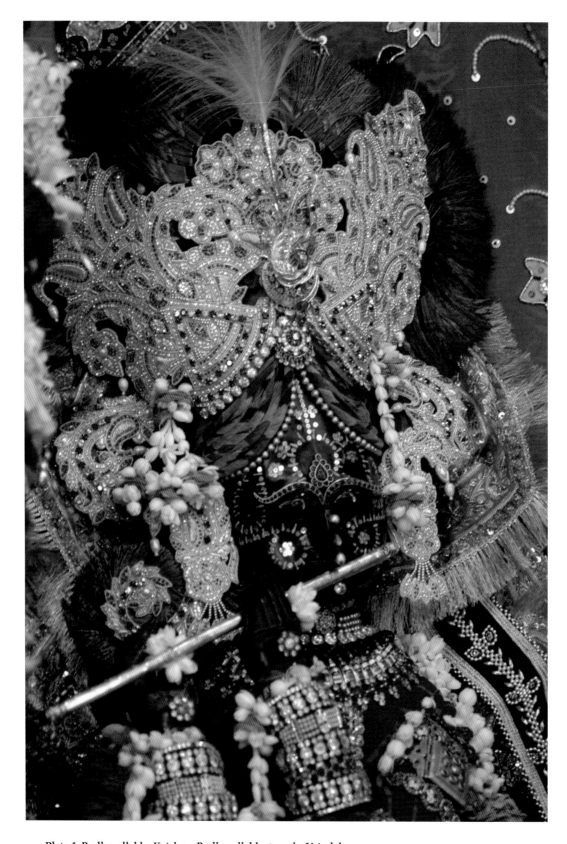

Plate 5. Radhavallabha Krishna, Radhavallabha temple, Vrindaban

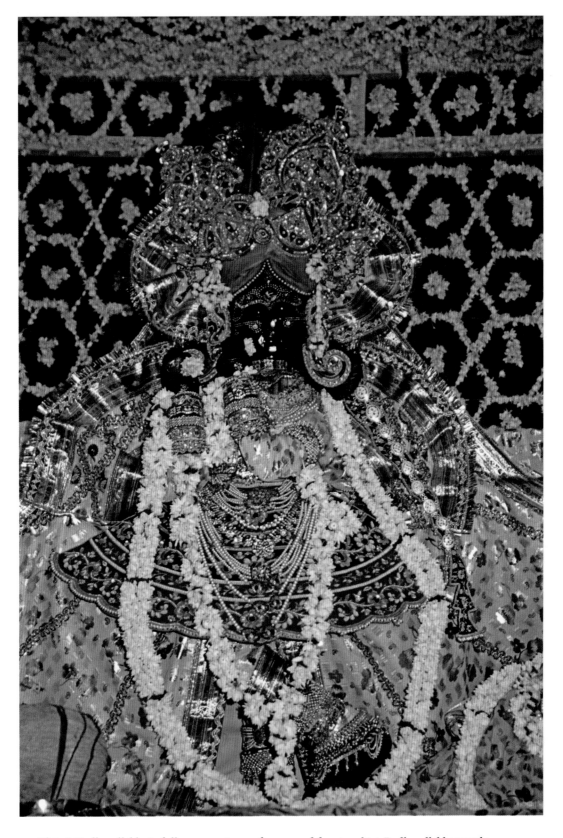

Plate 6. Radhavallabha in full-moon costume of crown and dancing skirt, Radhavallabha temple

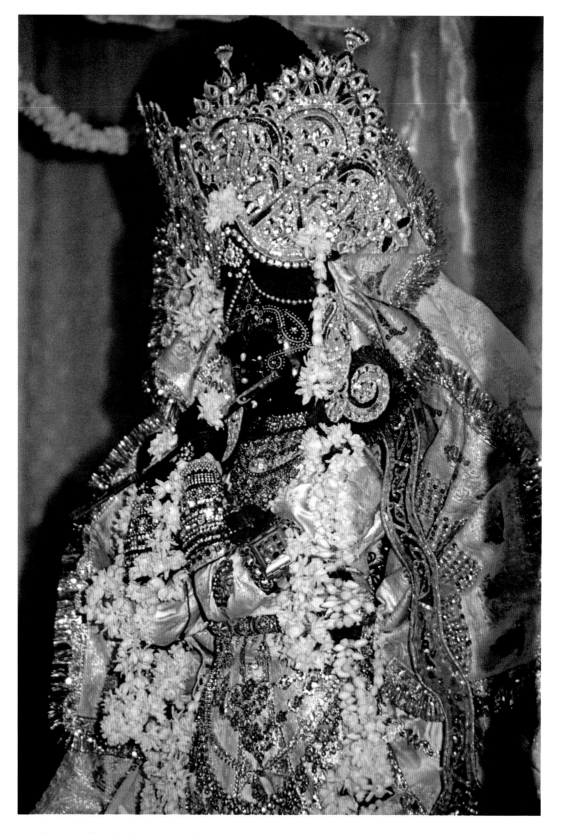

Plate 7. Radhavallabha at "second" Sharad with red turban during *adhik mas,* Radhavallabha temple

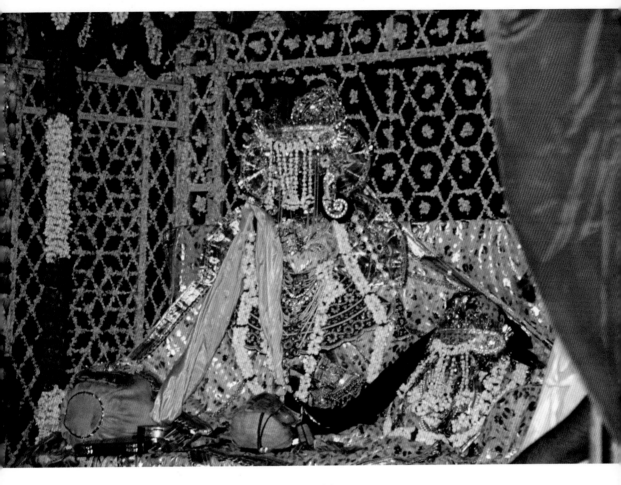

Plate 8. Radhavallabha with face covered with a floral veil during a summer
wedding ceremony on a full-moon night, Radhavallabha temple

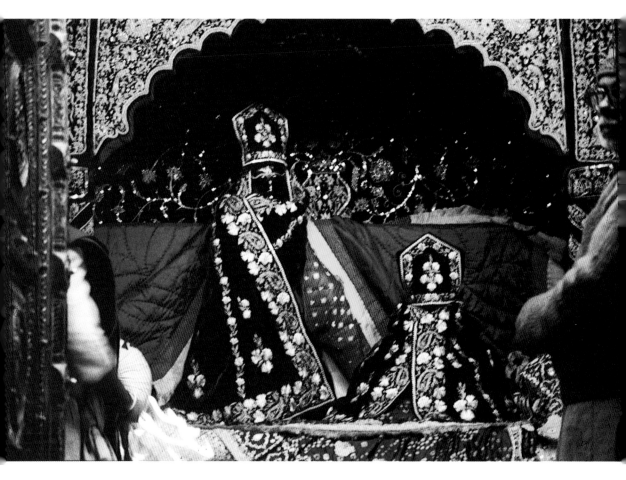

Plate 9. Radhavallabha at *mangala arati* during Khichri Utsav, first viewing, covered with crown and cape, Radhavallabha temple

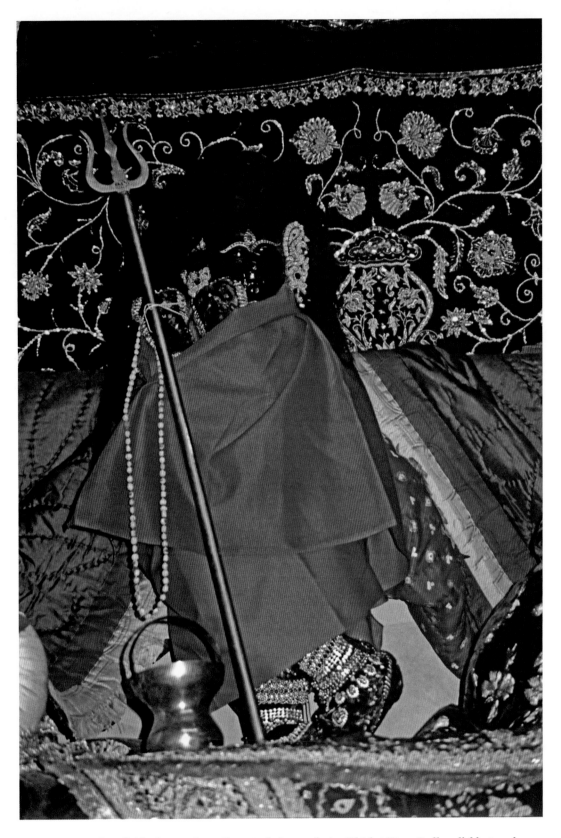

Plate 10. Radhavallabha disguised as a Shaivaite holy man during Khichri Utsav, Radhavallabha temple

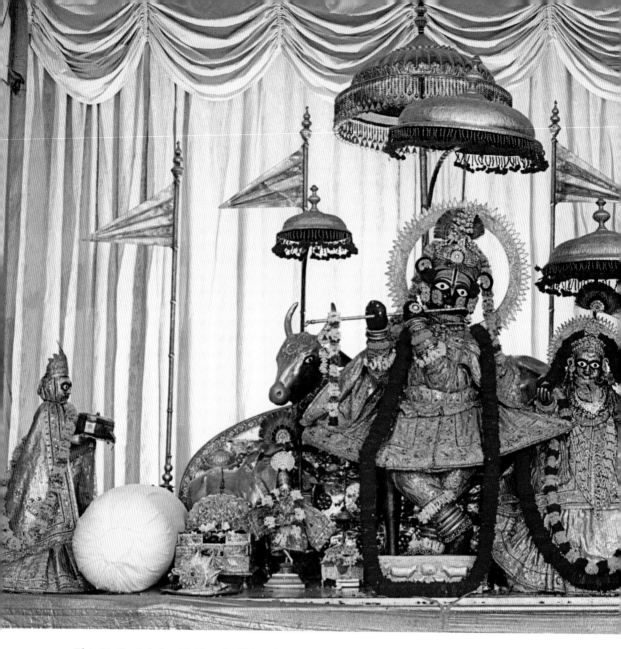

Plate 11. Govindadeva Krishna, Radha, and attendants, Govindadeva temple, Jaipur.
Courtesy of RG Photoflash, Jaipur

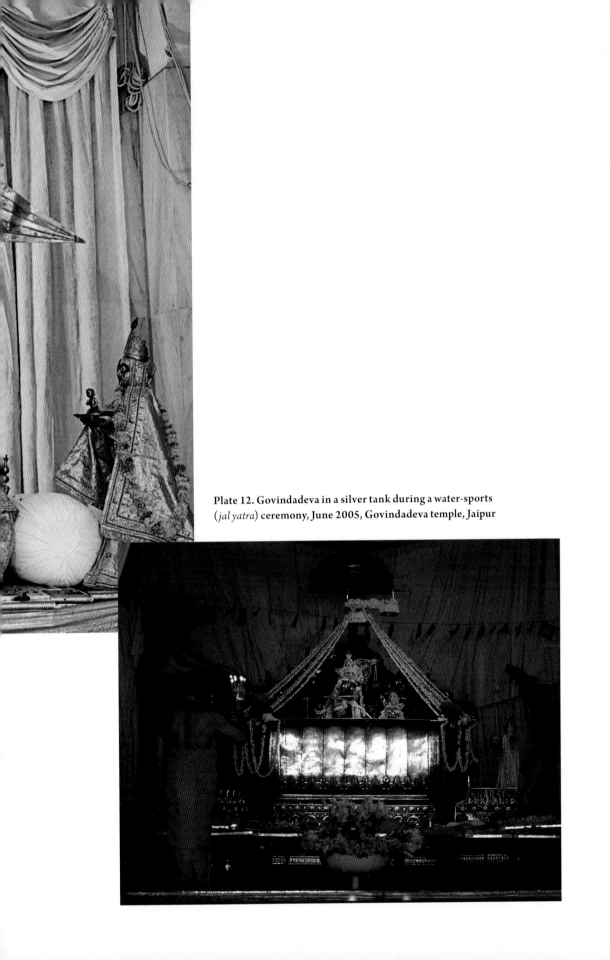

Plate 12. Govindadeva in a silver tank during a water-sports (*jal yatra*) ceremony, June 2005, Govindadeva temple, Jaipur

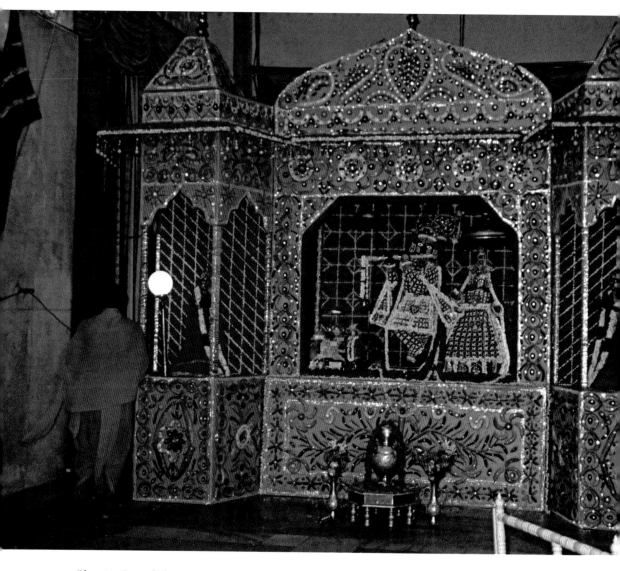

Plate 13. Govindadeva in a vegetable and fruit *bangala*, Govindadeva temple, Jaipur

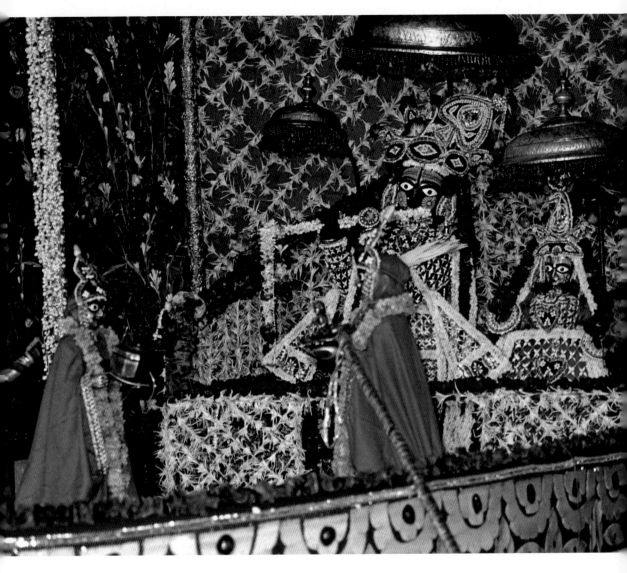

Plate 14. Govindadeva and Radha in a boat *bangala,* Govindadeva temple, Jaipur

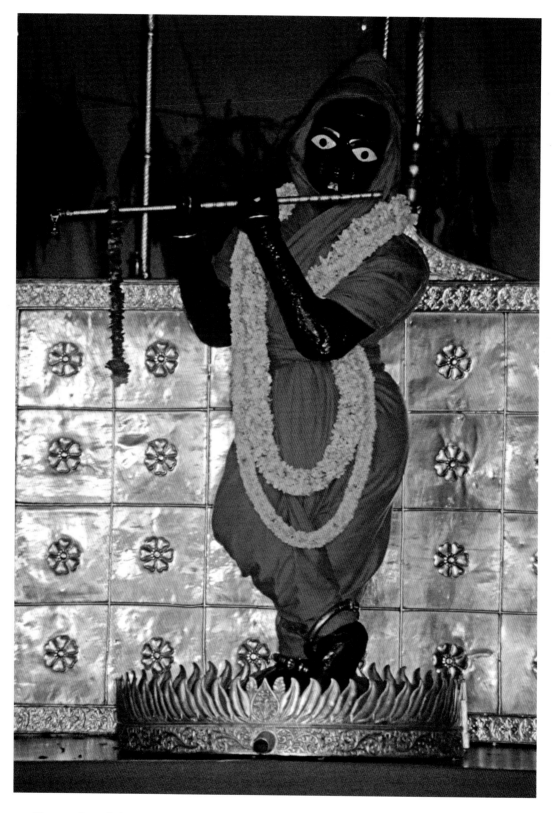

Plate 15. Govindadeva ready for his birthday *abhishek* ritual, Govindadeva temple, Jaipur

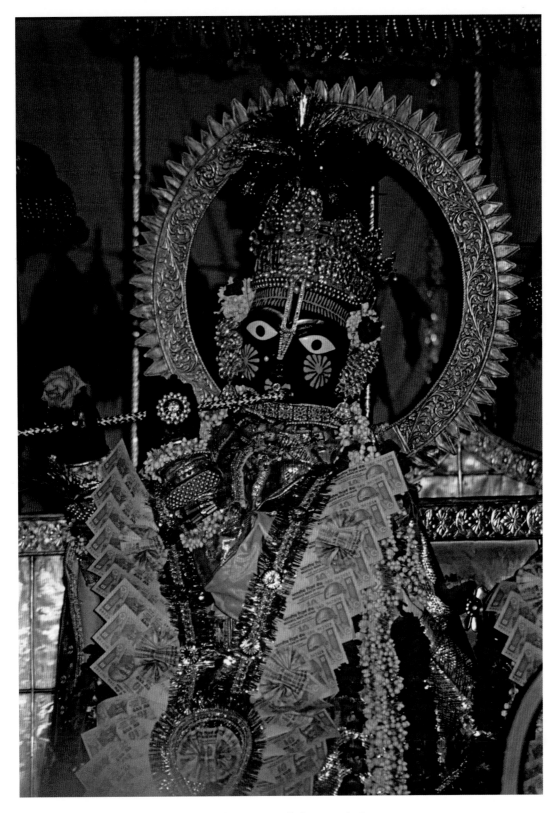

Plate 16. Govindadeva dressed for Nandotsav, Govindadeva temple, Jaipur

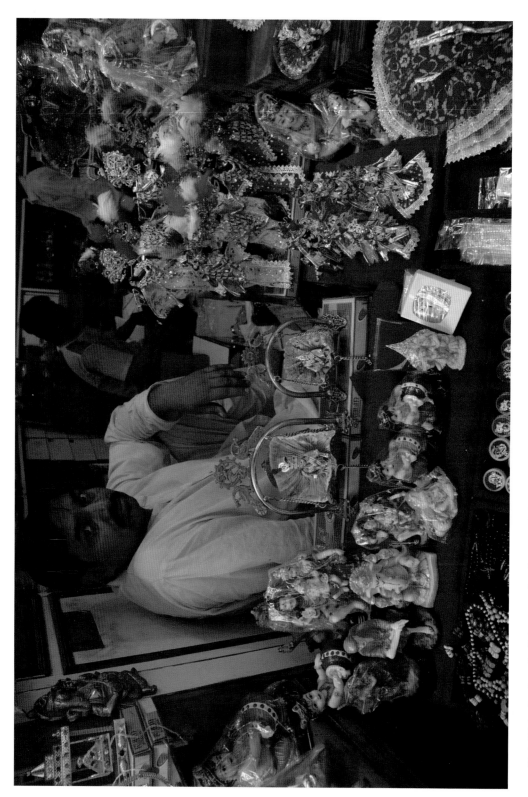

Plate 17. A selection of religious merchandise, Vrindaban

tailed information, with the links cleverly framed on leaves. The links are captioned Home, About Us, History, Ashtayam Sewa, Online Sewa, Gallery, Downloads, Contact Us. There is a separate process to navigate to the "Picture for Daily Darshan," "News and Events," and a place to sign up for newsletters.

Hit Harivansha's biography is recounted under the history section, and although most of the details were summarized earlier, I would like to point out a few features that do not always find their way into scholarly analyses. The first is that, on the occasion of Hit Harivansha's birth, his father was singled out for special attention and honors by the emperor himself. We are told that when Hit Harivansha made his predestined and auspicious appearance on this earth, Emperor Humayun "celebrated with pomp and splendor heralding the incarnation of [the] sacred flute of the Lord." Authoritative texts are cited that purportedly describe the ensuing ten days of lavish celebrations, royal recognition, and courtly gift-giving, all sponsored by the emperor. Additionally, it is reported that Emperor Humayun decreed that the celebrations were to be vegetarian and alcohol-free. Moreover, readers are informed that the birth site—at the Royal Army camp near Mathura—was subsequently memorialized and no longer used as a military campground.

The history section continues by providing the well-known account of the child prodigy Hit Harivansha's unique spiritual prowess and special connection with Krishna: his retrieval of an image of Krishna from a well while chasing a ball, and his first dream-*darshan* of Radha, during which she gave him her mantra under a *pipal* tree. Thus far, we have a beautifully blessed account of Hit Harivansha's birth appearance and subsequent conduct: his family and the populace are feted lavishly and in pure Vaishnava fashion by the Mughal emperor, and he is directly initiated and guided by Radha herself. Later in life, Hit Harivansha became obsessed with devoting his life to Radha, whereupon he left everything and made his way toward Vrindaban. As he enters the next phase of connection to Radha, yet another divine figure appears in Hit Harivansha's life story: the god Shiva himself. The treasured manifestation of Radhavallabha that is enshrined in the temple today thus possesses a powerful divine pedigree that reaches through Hit Harivansha back to both Shiva and Radha.

The history of Hit Harivansha's eventual establishment of a temple for the image follows, and under the heading "Shri Radha: The Main Deity," there unfolds a conceptual discussion of the rela-

tive importance of Radha as the main focus of worship. The reader is admonished that the "conception of Shri-Shri Radha is completely misconceived by most people, and Shri Hit Harivansh Mahaprabhu has shown the path," and later, we are reminded that he "adored Radha first and after her Krishna."

The Ashtayam Sewa section provides a fascinating and in-depth description of the type and schedule of services that Radhavallabha receives every day. Here, the lineage head is introduced, with an overview of both his and his family's duties. The reader is afforded a rare behind-the-scenes detailing of the entirety of Radhavallabha's day, and is educated as to what he does, what he eats, and how he is bathed, dressed, and entertained. Included in this section is a mouth-watering litany of special foods that are prepared and served to the deity on a daily basis and during certain annual festivals. Stress is placed on the artfulness of the ingredients, the culinary skill of the *goswami*s, the uniqueness of the cuisine, and the healthfulness and purity of the ingredients and techniques of preparation.

Another link takes the visitor to the Maha-Mahotsavas category with even more detailed discussion of the history and meaning of the various "grand festivals" celebrated throughout the Radhavallabha temple's ritual year. Of these, Hit Harivansha's birthday receives elaborate attention as a "main grand festival," and the process of celebration and veneration of the holy flute and image of Radhavallabha is described. Then follows an account of how Radha's birthday is celebrated over nine days. Also listed are the other *utsav*s, including Krishna's birthday and widely observed festivals such as Sharad Purnima, Diwali, Govardhan Puja, Annakut, and Gopashtami. Holi is accorded a great deal of attention; noted too are Vasant Panchami (celebration of spring), summer swing festivals, and water sports, along with such season-specific installations as flower *bangala*s and *sanjhi* (colored-sand) decorations. Wedding ceremonies also punctuate the sequence of festivals.

Significant among the celebrations is the Patotsav, or crowning of the deity. This festival commemorates the occasion of the "discovery of Vrindaban" by Hit Harivansha. The website informs its visitors, "Till then, [the] Holy town of Vrindavan remained disappeared amongst dense forests and cliffs, and it was Sri Hit Harivansh Mahaprabhu who discovered it."[37] The Radhavallabha sect is insistent that Hit Harivansha, and not Chaitanya or others, saw the true Vrindaban first; they also maintain that his elevation of Radha over Krishna constitutes a higher plane of spiritual understanding.

An overview of some of the important sectarian literature ensues under the Literature category, which also includes some more historical information and an explanation about the *samaj,* which is the Radhavallabha temple's special musical tradition. There is a short section on Related Places: special holy places that are important to the sect, including the first place in Vrindaban where Hit Harivansha established himself, and information on the original temple. The Calendar section outlines the sequence of festivals and plots the regular pattern of lunar phases and other dates that keep the ritual year on track. A brief section entitled "About Us" outlines the family tree of Radheshlal Goswami's and Mohit Goswami's lineage that descends in an unbroken line from Hit Harivansha Mahaprabhu, but no dates are provided. It also places the Radhavallabha temple in the context of its value to the local community. Mention is made of how *prashad* is distributed and how the ongoing needs of the temple generate employment and support for individuals in the neighborhood. Outsiders also find a modest place on the website under the "About Us" heading, where we read, "This all provides a wide spectrum not only to the orthodox devotees but also to modern day research scholars for whom it is no longer fashionable to limit to textual studies, and have an urge to study a living tradition." That struck a resonant chord!

The "Picture for Daily Darshan" link is active and current. Taking into account the vagaries of technology, the images of the deity are updated on an almost-daily basis, and through the years the quality and scope have become increasingly inventive and thorough. Generally, a digital photograph of the deity is taken at one of the main *darshan*s, most often in the early evening when the deity is arrayed in his full splendor, but occasionally photographs are taken earlier in the day and labeled as such (*mangala* or *shringar arati,* for example). Several other photographs augment the picture of the day, providing more context for that day's presentation. For instance, there may be additional shots of the *prashad* being prepared for distribution, the day's sponsor might be featured, a close-up view of the decorations may be provided, or a view of the courtyard full of ecstatic devotees may appear. Occasionally, there are glimpses of something special: Radhavallabha's bedroom; the yogurt-covered celebrations at Radhashtami; *sanjhi* decorations; or one of the many weddings of the deity. These images are archived for several months at a time, so one can go back and get caught up if one has missed any presentations. This is indeed a remarkable service and resource for the virtual visitor.

The Radhavallabha Temple 121

The interconnections and links that the website makes possible thus give the contemporary visitor a full, if selective, overview of the sect's history and practices. But the site certainly cannot provide the whole story, and moreover, much remains that only regular participation in, and attendance at, the temple can supply. For the digital picture of the day—as wonderful, welcome, and special as it is—can only give a static glimpse. The performance and sensory aspects of *darshan*—its ever-changing nature, the multiplicity of viewings throughout the day, the singing, the music, the lamp offerings, the texture and fragrance of summer flower *bangalas*, and so on—are necessarily missing. Moreover, the special iconography of the image, the changing details of dress and embellishment throughout the day, the seasonal shifts in attire, and the ephemeral nature of festival decorations cannot be fully appreciated online. Thus, even in this modern era when the form of Radhavallabha is accessible through one's laptop, in the end, one must still have a real *darshan* in order to experience the full physical reality of his presence.

The Govindadeva Temple: From the King's God to the People's God

Ask anyone in Jaipur "Who is the king of Jaipur?" and the unhesitating answer will always be "Govindev-ji!" and not Sawai Bhawani Singh, the current *maharajah* of the Rajput kingdom. "Bhawani Singh is only a man," I am admonished. "Govindev-ji is Lord Krishna; there is no comparison." Most are aware that Govindadeva is a self-revealed manifestation of Krishna who made his way to Jaipur from Vrindaban and that he was installed as the city's main deity by Sawai Jai Singh (1688–1743) in a converted garden pavilion at the center of his new royal city in the early eighteenth century. Sawai Jai Singh was also responsible for the royal pronouncement that he found shelter at the feet of his god; and in the twentieth century, his descendant Sawai Man Singh II (1912–1970) announced publicly that the kingdom belonged to Govindadeva and he was but the deity's minister.[1] Thus, people are also fond of pointing out that the *maharajah*'s official residence, the Chandra Mahal (Moon Palace), looks upon Govindadeva's temple, originally designated the Surya Mahal (Sun Palace, also known as the Govinda Mahal; figs. 3.1–3.3). That architectural connection is an important visual testament to the long history that exists between the rulers of Jaipur and their tutelary god. It also obscures the complexity of the current relationship among god-king, mortal king, and the populace of Jaipur.

Today's Govindevji Mandir, as it is known in contemporary parlance, still preserves some sense of the original openness, cosmic centeredness, and verdant serenity of its original garden setting, but it is gained at a price. Visitors to the temple have to fight their way through Jaipur's chaotic traffic and vibrant street life to enter through one of the boundary gates that once clearly defined the walled perimeters of the City Palace, newly established early in the eighteenth century as the nucleus around which the rest of the city of Jaipur was oriented. The temple is at the center of a south-north nexus of built compo-

Figure 3.1. Plan of Chandra Mahal and Surya Mahal (Govindadeva temple), Jaipur. Courtesy of Jue Yang

nents uniting the Chandra Mahal, the Surya Mahal, and the Jai Niwas, an elegant planned garden that lies behind and to the north of the temple. Those interrelationships are now, however, obscured by the current jigsaw of spatial uses and abuses.[2]

We will soon consider more fully the historical circumstances for this original configuration of structures and their place in the history of Jaipur, but for now our concern is with the present temple. Once one has successfully negotiated the maze of obstacles between the city streets and the temple gates, there are further transitional moments that tell us that we are in a more diverse milieu than what was previously encountered in Vrindaban. Not only are there a couple of Hanuman shrines and a Shiva shrine, but also the shops in the street and in the small plaza in front of the temple compound's entry gate offer a broader selection of ritual paraphernalia and souvenirs than is available in Vrindaban. The merchandise ranges from Shaivaite *rudraksha* beads to pocket-sized plastic Ganeshas, glow-in-the-dark religious stickers, lucky

ornaments to suspend from car mirrors, and a hodgepodge of
other items. A modest array of Krishna and Radha figurines and
accessories from Vrindaban shares space with framed photo-
graphs—in small, medium, and large sizes—of Govindadeva.
Cassettes and CDs with the latest popular religious tunes can be
purchased, along with pamphlets of devotional songs and prayers
for Durga, Ganesha, Hanuman, Shiva, and Parvati, and guides for
observing *ekadashi* vows. On their way into the temple, devotees
can also pick up an offering packet, comprising a set of three mari-
gold garlands: one for Govindadeva, one for his consort Radha,
and one for his flute. There is also a tiny dairy with a cow and a calf
or two tethered nearby.

Some sense of the formality and expansiveness of the temple's
original setting can be gleaned upon entering from the main eastern
gate, which affords a vista of the Chandra Mahal to the south (or left;
fig. 3.2) and the Surya Mahal (now the Govindadeva temple) to the
north (right; fig. 3.3). These days, a fence separates the two struc-
tures, and there are barrier walls, ongoing construction, and recent
additions that confuse their original relationship. The architectural
typology of the Govindadeva temple is also unusual and unexpected:
as its original designation as a palace structure or pleasure pavilion
(*mahal*) and not as a temple (*mandir*) indicates, it is shaped like the
royal halls of public audience seen in Mughal and Rajput architec-

Figure 3.3. View of Surya Mahal (Govindadeva temple) porch from east side

ture, departing from the courtyard (*haveli*) or tall temple styles that one expects of a Vaishnavite religious structure.[3] The original architectural configuration is centered on a square building that encloses the sanctum of the god. Silver doors on its south side provide access to the sanctum for the priesthood as well as affording a view of the deity for devotees; in front of the sanctum doors is a low marble dais now fenced off with guardrails. A covered circumambulatory passageway wraps around the building, its roof supported by a series of carved marble pillars between which spring cusped, lobed arches. These were originally open on the north and south sides, while along the east and west sides are enclosed rooms that serve as the kitchen and other functional spaces for the temple's administrators.

In the 1990s, a campaign of expansion of the temple was initiated, altering the original sense of direct, open access to the temple. A spacious covered patio was added to the front of the south side (covering parts of the once-open area between the Chandra Mahal and the temple), extending portions of the original plan into a public space for the large numbers of devotees that now gather for Govindadeva's *darshan*. Until these renovations were completed in the mid-1990s, the original experience of *darshan* was, as Margaret Case nicely observes, experienced "under the sun or stars."[4] While

care has been taken to replicate the architectural style and details of the original building, there were some fountains on the south side that were unfortunately covered over to make room for the new porch. The renovated porch is also connected to the circumambulatory passage that envelops the sides and back of the temple. Govindadeva still resides in the original structure's sanctum, facing south toward the Chandra Mahal, an unusual arrangement, as normally most divinities face east. The spatial experience here thus differs dramatically from that of the enclosed courtyard temples of Radharamana and Radhavallabha: here, devotees await their god's *darshan* in an airy but protected outdoor space. As the augmented porch allows for far greater numbers of worshipers, so too is the physical distance from the deity correspondingly greater.

On an early evening in July 2009 I attended a *darshan* that nicely encapsulates a typical experience. The doors were scheduled to open at 6:30 PM, and the crowd of worshipers had started to assemble in earnest about twenty minutes earlier. Some of the devotees pressed themselves against the railing set across the perimeter of the dais; others stood in clusters at the back of the patio, facing the sanctum; still others chose to stand outside the covered section, in the open. In the center is usually found a small, informal group of devotees who animatedly sing and dance in anticipation of seeing their god. There is always a stream of people making a clockwise circumambulation of the sanctum, and as they move around the temple there are special places—such as the side doorway to the sanctum or its back wall— where they touch or press their bodies against them, evidenced in part by the dark, worn smudges on the wall. A Ganesha temple high up on a rocky hill in the old capital of Amber, approximately eleven kilometers from Jaipur and visible to the north from the back of the temple, also received reverential attention as worshipers made their circumambulations.

As *darshan* time approached, a ritual assistant (*pujari*) dressed in bright orange robes began to bang a gong, and the crowd joined together in a long, ragged rendition of "Om Jay Govind Hare [O Lord Govinda]," the words of which are in a cheap pamphlet available in the stalls outside the temple. There was plenty of out-of-tune expressiveness, and the devotees formed a wonderfully vibrant mosaic of the colors for which Rajasthan is so renowned: the women were in vivid chili-pepper red, mustard, magenta, lapis, lime, and mango skirts, shawls, and saris, and some of the older men still wore traditional twisted turbans of varying hues. There was the after-work

crowd and the normal spectrum of people from all walks of life. I noticed a large proportion of deeply devoted older men at this time of the day, perhaps made more apparent to me because of the contrasting preponderance of older women in Vrindaban. Quite often, these grandfatherly types took it upon themselves to make sure I had a good view of the god, asking people in front of me to move aside and ensuring that I got some *tulsi* as *prashad*. Despite the numbers, there was a lovely community atmosphere as everyone joined in song and patiently waited. Once the door was opened for *darshan* and the lamp ritual was enacted, the crowd started another cycle of songs; and after the *charanamrit*—the water that has bathed Govindadeva's body—had been poured from its silver conch shell and sprinkled across the crowd, most broke off and did a circumambulation of the temple before departing. There is a station where one can purchase sweets as *prashad,* and many buy a bag and distribute bits of it to all the eager hands that are thrust in front of them.

Govindadeva, the vision they had all been awaiting, is a large, black, stone figure of Krishna, standing with crossed front leg and raised hands. Not only his stature, but also his energetic stance and slightly raised chin endow him with a magnetic presence, apparent even though he stands a fair distance back from his worshipers. Differing markedly from Radharamana's petite suaveness or from Radhavallabha's shapely elegance, this figure instead has a rough, dense power that is undeniable and curiously affective. From his large flat ears to the enormous enameled eyes set on his broad face to his thick hands and trunk-like sturdy legs, he is every inch a commander. Jaipur is said to have never been defeated—its name means "city of victory"—because it has Govindadeva at its helm; and the city is clearly in good hands. Dressed in shimmering fabrics, adorned with handcrafted floral ornaments, and with his face painted with bright sandalwood-paste designs, Govindadeva fulfills well the role of an expansive king surrounded by his court. This is in part due to a striking difference between this temple and others we have considered: with the god is found an ensemble of other images (see pl. 11). Govindadeva shares his large silver throne with a golden figure of Radha, who stands to his left side; to his right, at his feet, is stationed a small image of Krishna donated by Chaitanya and considered to be homologous with the saint's presence. There are also two flanking attendant *sakhi* figures, also made of metal, and both donated by former rulers: Lalita, who is Radha's attendant, bears a bottle of *itr,* perfumed oil made from the con-

densed essence of seasonal flowers; Vishakha faces her on the other side of the altar and carries a *pan* box.[5] All of these figures are important components of the biography of this temple. The sanctum space and throne are embellished further with golden umbrellas over the three central figures, pennants, and a large silver cow—donated a number of years ago by a Jaipur businessman—that normally stands behind Govindadeva.

The silver cow is a visual reminder of the miracle of Govindadeva's self-revealed manifestation, and the account of Govindadeva's discovery and his eventual arrival in Jaipur is fundamental for understanding the visual practices and preoccupations of the contemporary temple and its administrators. As with Radharamana and Radhavallabha, the story begins in Vrindaban in the early sixteenth century. Govindadeva chose to make his presence known to Rupa Goswami, who was one of Chaitanya's most able and prolific followers and a member of the seminal group of the Six Goswamis. As we saw earlier, Rupa's *Bhaktirasamrtasindhu* (ca. 1541) set the terms for much of the aesthetic expression of devotion that we have been exploring thus far. He had been in the Braj area since 1517, and like several of his compatriots, he too was destined to be divinely granted his own particular *svarupa* of Krishna, but not until he had reached the point of personal despair at ever experiencing this. Divine grace intervened, and in 1534, it is reported, a beautiful boy appeared to Rupa and led him to a mound called Goma Tila, upon which, the boy pointed out, a mother cow had been seen repeatedly dispensing her milk.[6] Rupa, with help from the neighboring villagers, thereupon unearthed from the mound a tall and comparatively archaic black stone form of the lord, who was recognized as a special form of Govindadeva, the "lord of the cows." When Chaitanya received the news, relayed to him in Puri, of the miraculous appearance of Govindadeva, he sent a small metal image of himself in the pose of a fluting Krishna to Rupa Goswami. Known as Gaur Govind, it was meant to be in every respect his representative, and it was duly consecrated and placed beside the newly discovered manifestation of Govindadeva; that image is the one that stands today at Govindadeva's feet in Jaipur.[7]

Of further significance is an important account of the sacred origins of this self-revealed image of Govindadeva, which was, it is believed, recognized as one of a trio of sculptures that was personally commissioned by Vajranabh, Krishna's great-grandson—an interesting variation on the "self-manifestation" theme, as even though these

particular figures are understood to have been carved by ancient sculptors, they were created by a process of divine proxy and thus have an intrinsic power that differs from the usual sculpted image. The motivation for creating this trio of images was that Vajranabh, as the successor to the throne of Dwarka, was seized by a desire to "see" Krishna's manifest form. But, it is commonly recounted, there was no previous model to work from. So, "Vajranabh searched for a resource person, still living, . . . one was Uddhav [Krishna's friend] and the other was Uttara, Abhimanyu's [son of Arjuna] wife and [King] Parikshit's mother. When the sculptors failed to replicate Krishna satisfactorily, they sought the help of these eyewitnesses, and prayed to the Lord to manifest. That grace came in the form of a triad: Govind Dev, Gopinath and Madan Mohan."[8]

This collection of figures thus represents three separate attempts to replicate Krishna, each one succeeding in some ways and falling short in others. No single figure fully encapsulates Krishna's form: Govindadeva's face, it is said, looks the most like Krishna, but the rest is not perfect; only Gopinatha's chest and arms work; and Madan Mohan's lower legs and feet are the portion that best matches Krishna's. Despite their shortcomings, each of these images would henceforth become an important object of worship in its own right, although, like other self-manifested images, they disappeared for a long time before their rediscovery. Gopinatha and Madan Mohan were, for example, also destined to re-manifest themselves in the sixteenth century, and we will re-encounter all three of them relocated from Braj to their present locations in or near Jaipur. These figures would form part of a whole emigration of important religious images that had to be moved away from the Braj region in the politically tumultuous period that would occur about a century and a half later. The connections of this trio of sacred images to Vajranabh, Braj, and subsequent Rajasthan history continue to be kept alive through the religious actions and imaginations of contemporary devotees.

Power, Prestige, and Piety

In addition to its importance as the spot where the deity was found, Goma Tila was no ordinary mound. David Haberman informs us that "Vrindaban tradition has it that the spot revealed to Rupa is the Vrindaban *yoga-pitha,* literally a 'place of union,'" the very spot where Radha and Krishna meet every evening for their romantic encounters.[9] Hence, Goma Tila is considered to be the literal and figurative center of Vrindaban. During Rupa's lifetime, Govin-

dadeva was worshiped in a simple shrine erected on the sacred site, and after his death around 1564, his nephew Jiva Goswami (1513–1598) was entrusted with the god's continued service.[10] At the same time that Vrindaban was physically and figuratively emerging from the overgrowth, the Kachchwaha kingdom of Amber to its west, in what is now known as the state of Rajasthan, was jockeying for lead position in the matrix of regional power intrigues between the newly ascendant Mughals and the preexisting mosaic of native Rajput kingdoms. Vrindaban would soon become very important to both the Kachchwahas and the Mughals as a venue for proclaiming not only new religious developments but also new political alliances. As the fledgling Mughal kingdom, ruling variously from nearby Delhi, Agra, and Fatehpur Sikri, grew in power and scope, it initially encountered resistance from many of the region's native Rajput rulers, who were threatened by the Mughal incursions into their territories. The Kachchwaha clan that ruled Amber, however, seems to have recognized an opportunity where others perhaps saw oppression. As is widely observed, its ruler, Raja Bharmal (r. 1548–1573), had early opened the door to Mughal-Kachchwaha relations in 1562, when he negotiated a treaty with the young Emperor Akbar that allowed the Mughal ruler easy passage through Rajput territory to the important Muslim pilgrimage destination of Ajmer and to regional centers of trade. After securing this alliance, Bharmal also presented his daughter in marriage to Akbar, thereby inviting further positive relations between the two powers.[11]

Subsequently, Bharmal's nephew the crown prince, Man Singh (1540–1614), and his father, Raja Bhagwan Das (r. 1573/4–1589), actively cultivated and acknowledged Mughal suzerainty while facing the disdain of the other Rajput kingdoms. There are different interpretations of their motivations: was this intelligent and opportunistic, or, as is often heard, were they "sellouts"? Sachdev and Tillotson state, "The Kachchwaha rulers of Amber are best remembered for their close association with the expansion and governance of the Mughal empire. Whether they are seen as the servile dupes of an alien imperial regime, or as far-sighted princes who helped to build a new order within India, naturally depends on the view that is taken of the Mughal period more generally."[12] Hand in hand with their increasing prestige and success within the Mughal court, the Kachchwahas also began to broadcast their presence outside of their Amber base. Man Singh avidly sponsored a variety of religious projects that spread far and wide across his

kingdom and beyond, encompassing Vaishnavite, Shaivaite, and goddess temples as well as Muslim structures.[13] But the most highly visible locus for his religious sponsorship, and the one for which he is best known, was the construction in 1590 of a grand new temple for Govindadeva in Vrindaban. This prominent act of patronage directed interest not only toward Rupa Goswami's self-manifested deity, but also to Vrindaban.

Indeed, during the previous twenty-five years, Vrindaban had been gradually growing in importance, becoming a target for conspicuous patronage by Man Singh's forebears as well as for others associated with both Rajput and Mughal authority. Vrindaban started to take on the shape of a pilgrimage and temple town, purportedly coming to the direct attention of Akbar himself. Its proximity to the Yamuna River, Mathura, Agra, and Fatehpur Sikri, as well as its congregation of powerful holy people, attracted donors, sponsors, and—in the time-honored practice of Hindu kings—royal temple patrons and builders. Furthermore, the attention paid to Vrindaban can be in part attributed to its potential as a revenue source for the early Mughals. Nalini Thakur comments: "Even as Vraja was taking shape as a sacred land in popular consciousness, the Mughal administration was confirming its jurisdiction over the area. The power of imperial rule was consciously solidified by establishing or reviving urban settlements as centres of trade and administrative control."[14] Thus, although it was never a royal city, Vrindaban received its share of high-level interest; attesting to this was a growing collection of red sandstone temples and a string of elegant residences and pleasure pavilions lining the banks of the Yamuna River. Although today these are little but crumbling ruins amid the decay and chaos of the contemporary town, their remains are testimony to the poetic accounts of Braj as an idyllic playground for gods and mortals alike.

The King's God

Within this context of deliberate revivification, the image of Govindadeva garnered an impressive amount of imperial attention: already in 1565, it is recorded, Emperor Akbar donated land for the Govindadeva temple, which we can presume was as yet a relatively modest structure. While it is tempting to attribute this gesture to Akbar's religious broad-mindedness, it was undoubtedly in part also a business decision based upon Akbar's earlier agreements with Man Singh's predecessor, Raja Bharmal. In 1568, Akbar's Hindu minister Todar Mal "recognized Jiva [Goswami] as rightful man-

ager of the temple and granted him all claims to the court offerings," thus further legitimating the temple in the eyes of the Mughals.[15]

Govindadeva increasingly attracted overt demonstrations of Rajput piety while also providing the Mughals with an available project upon which to lavish imperial largesse. Moreover, Govindadeva was not the only deity enjoying this kind of attention, as it is reported that, by 1580, a number of other temples in the area were also receiving land revenue grants, and there is evidence that Akbar's Brahman minister Birbal was involved with the Vaishnavite Vallabhacharya sect and patronized Shri Nathji's original temple at Mount Govardhan.[16]

Although Vrindaban may have been initially portrayed as a jungle, it was not long before the spires of ornate, architecturally and stylistically experimental temples were punctuating its skyline. By the late sixteenth century, there was a building boom—spurred on by Akbar's other architectural developments in the region—and it makes sense that Govindadeva would eventually be seen as needing a home worthy of the imperial favor being showered upon him. But, while it was common practice throughout Indian history for rulers to erect monumental temples in honor of their favorite deities, conspicuous construction of large-scale temples had languished for centuries in this area of northern India. Appropriate models were therefore not readily at hand, and much of the scholarship on this era focuses on the unique, hybrid nature of the temples that began to be built in Vrindaban in the late sixteenth and early seventeenth centuries. It appears that builders utilized new materials and came up with an innovative fusion of architectural styles, evidenced in their choice of the red sandstone used so extensively by Akbar's builders in combination with an unusual and perhaps central- or eastern-Indian-inspired design of an octagonal sanctum supporting a tall, conical superstructure.[17]

Thus it was that, in 1590, Govindadeva was moved into a sumptuous new red sandstone temple erected upon the *yoga-pitha* (fig. 3.4). This temple was unequaled in its size and grandeur and was renowned for its ambitious architectural plan. Most sources attribute Govindadeva's relocation to the successful outcome of a vow made in 1571 by Man Singh, then the crown prince of the Amber kingdom. Like his father Raja Bhagwan Das, Man Singh was a devotee of Govindadeva, and he had pledged to build the god a magnificent temple if he defeated the southern Rajput kingdom of Mewar. His eventual victory in battle purportedly earned the god his new home, although

Figure 3.4. Govindadeva temple, Vrindaban

there are arguments that Man Singh may have had other, more personal reasons for overseeing the temple's construction.[18] Whatever the motivations, the refurbishment of the Govindadeva temple created a highly visible beacon for broadcasting Kachchwaha prominence and its enjoyment of Mughal endorsement. The new temple was architecturally grandiose and financially well-endowed; all that remained was for Govindadeva—who had manifested himself as a single deity—to find his true partner, which occurred in 1632 when he was joined by a golden image of Radha sent to Vrindaban by an Orissan king. In 1633, these figures of Radha and Krishna were united in a celebratory wedding ceremony.[19]

A generous level of support for and interest in Vrindaban and its temples continued to be maintained well into the seventeenth century by Akbar's successors and the Amber Kachchwahas, whose ruler Mirza Raja Jai Singh I (1611–1667) served the Mughals during the reigns of Jahangir and Shah Jahan, as well as during Aurengzeb's early years.[20] Both Jahangir and Shah Jahan continued to recognize and endow the temple, and during Shah Jahan's reign the Amber Kachchwahas were formally entrusted with its revenue and management.[21] The mutually beneficial arrangement between the Kachchwaha Rajputs and the Mughals lasted just over a century until political intrigues and policy changes during Aurengzeb's rule (r.

1658–1707) eroded the Rajput kingdom's favored status. By the time Mirza Raja Jai Singh I died in 1667, the era of Mughal indulgence was effectively over.[22] Also over was the relative peace that had been enjoyed between Hindu and Muslim rulers: in 1669, Aurengzeb ordered the demolition of temples in Mathura and Varanasi, a result of both his growing religious orthodoxy and his vindictiveness in the face of what he felt was political betrayal by his Rajput vassals.[23]

It is commonly accepted that the destructive raids on temples in nearby Mathura prompted the hasty exit of a number of Braj's most important sacred manifestations, including Shri Nathji from Mount Govardhan and Madan Mohan, Gopinatha, Vinodilal, Radhadamodar, Govindadeva, and Radhavallabha from Vrindaban; only Radhavallabha was to return (and Radharamana never left). Whether Aurengzeb was entirely responsible for this emigration is open to debate. George Michell speculates, "Though Aurengzeb never issued a decree ordering the destruction of the Vrndavana temples, it is generally believed that it was raids by his followers that persuaded the authorities to remove the holy images for safety."[24] In fact, what damage was done to structures in Vrindaban—including to the Radhavallabha and Govindadeva temples—was selective and limited and appears to have been perpetrated some time after the launching of Aurengzeb's aggressions.[25]

Real or perceived, however, the threat to the images was enough to propel Govindadeva and his compatriots far afield: Shri Nathji found his way to Nathdwara in Mewar, and the rest eventually made their way toward the Kachchwaha Amber territory. Govindadeva and his partner Radha were thus launched upon a long, peripatetic journey, ultimately aimed at delivering them to the relatively safe haven of the Kachchwaha realm—specifically to those villages and territories that had been issued to the deity in the form of land and other grants.[26] Over a span of close to fifty years, Govindadeva was moved steadily westward from Vrindaban toward Amber, residing in a series of temporary, at times makeshift, shrines and temples (and perhaps a fort) in various villages. It is not entirely clear what the ultimate intentions were for the god's final resting place, as some of the temples that housed Govindadeva appear to have been more permanently conceived than others. While much has been made of the fear that prompted and sustained this exodus, the point has been made that, by the end of the seventeenth

**Idols of the King:
The Holy Trail**

century, the Mughals were too busy plugging the leaks in their crumbling empire to pay much attention to a traveling icon; indeed, one has to wonder if they ever really cared.[27] The decision was finally made to bring Govindadeva fully into the Kachchwaha orbit, and in 1713, in a highly visible gesture, the deity was installed in a splendid new temple (his eighth) near the Amber fort. The temple was placed in a setting designed to evoke and even surpass Vrindaban in its beauty. The construction of this temple marked the "turning point," Monika Horstmann argues, "in the relationship between [Govindadeva] and the Kachavaha house."[28]

Govindadeva's penultimate residence became known as Kanaka (or "golden") Vrindaban, and it was directly sponsored by Mirza Raja Jai Singh I's namesake, Jai Singh II, who had earlier assumed the throne in 1699 at the tender age of eleven. Initially, Jai Singh II (later known as "Sawai"—meaning "one and a half"—Jai Singh) continued the Kachchwaha policy of supporting the Mughals, but there were significant and continuing political challenges and tensions.[29] Upon Aurengzeb's death in 1707, the youthful Jai Singh II made a poor choice that was to cost him the temporary loss of his Amber capital:

> [W]hen the death of Aurengzeb led to a war of succession between his two sons, Shah Alam and Azam Shah, Sawai Jai Singh backed the latter, who turned out to be the loser, at the battle of Jajau on 8 June 1707; and as a punishment for this tactical error, Amber was invested by Mughal troops. The dispossessed young Raja turned to other Rajput leaders for assistance, and particularly to Jodhpur, which had suffered a similar fate, and Udaipur, which had reserved its position and so was better placed to be of help.[30]

Late in 1708, with assistance from Udaipur (Mewar) and the newly recovered Jodhpur (Marwar) kingdoms, Sawai Jai Singh fended off a Mughal attack, and by 1710, after a series of negotiations, Sawai Jai Singh had his land again.[31] Both the recovery of his ancestral capital and the concurrent waning of Mughal power—which gradually became less and less essential and meaningful to the Rajput rulers—thus emboldened Sawai Jai Singh to think creatively about his own status in the matrix of political relationships between his domain and others', most notably the other Rajputs.

It was within this shifting political context that Sawai Jai Singh brought Govindadeva out of exile to reside in the splendid new temple at Kanaka Vrindaban in 1713.[32] Although the weakening of Mughal power set in motion the final process that brought Govin-

dadeva closer to Amber—the historical seat of Kachchwaha power—that process was, most believe, motivated less by personal piety than by royal hubris and ambition. Already in 1708, while hardly back on his political feet, Sawai Jai Singh had a powerful Vedic ritual performed that only the most ambitious of kings would consider. And his boldness in asserting his paramount sovereignty would continue later in his reign to encompass the further enactment of other potent Vedic kingship rituals that proclaimed his sense of his elevated status.[33]

But the most overt and conspicuous declaration of this outlook was in the planning and construction of his new capital city of Jaipur—not to be formally dedicated until 1727—in which the image of Govindadeva was ultimately to play a leading role. For all intents and purposes, however, it initially appeared that Govindadeva's installation in Kanaka Vrindaban in 1713 was meant to be a permanent relocation. At the same time, Sawai Jai Singh was occupied with laying out a terraced formal pleasure garden, named the Jai Niwas, a few kilometers south of Kanaka Vrindaban, and within the Jai Niwas he constructed a hunting lodge and the Tal Katora, a small artificial lake. As Sawai Jai Singh proceeded with planning his new city, he had many practical considerations to keep in mind—existing trade routes, geography, topography, the relationship to Amber and other settlements—but one of the foremost was that it be a city that was cosmically aligned and fit for royal dominion. Yet it was important to him that the pleasure gardens and hunting lodge also fit within the city's plan, and this requirement ultimately prompted the decision to center the royal palace within the Jai Niwas garden compound.

It thus comes as somewhat of a surprise that in 1715, barely two years after being moved into his new home in Kanaka Vrindaban, Govindadeva was once again relocated—this time into the Jai Niwas gardens.[34] Even more puzzling is the fact that the historical record is unclear where exactly the god was sheltered; it seems that the deity had no specifically designated space to move into, prompting some to speculate that Govindadeva's first residence within the gardens may have been in the hunting lodge itself, or perhaps in one of the garden's subsidiary buildings.[35] Provisions were made for the god's upkeep, but it would take some time—between ten and twenty years, depending on what dates are used—before Govindadeva was properly installed in the Surya Mahal some time between 1727 and 1735.

What would prompt Sawai Jai Singh to seemingly suddenly shift gears in the planning process by importing Govindadeva into the center of his new royal city, especially when he seemed already to have set the wheels in motion for establishing Kachchwaha prestige with the construction of the new Kanaka Vrindaban temple, and when he did not, at least at first, seem prepared to protect the deity in the same splendid fashion? Most scholars attribute this change of plan both to Sawai Jai Singh's political ambitions and to his increasing piety and interest in Chaitanyaite Vaishnavism, although he also held a broad view of religious efficacy.[36] Indeed, religion and its role in politics were already important motivating factors in the initial layout of the city. Sawai Jai Singh had ensured the cosmic alignment of his new capital by constructing temples in strategically important quadrants of the city: a temple dedicated to the sun god, Surya, was built high in the eastern hills above the city in Galta, aligned with the city's main west-east thoroughfare. Two Vaishnava temples—built in an older architectural style associated with centuries past—still anchor the western and eastern boundaries of the city; the one to the west is dedicated to Rama and Sita, and the eastern temple is dedicated to Lakshmi-Narayana. "Thus," conclude Sachdev and Tillotson in their study on the building of Jaipur, "is declared the presence at the heart of the city of the god Vishnu, with both regal and mercantile associations."[37] The historical records suggest that the god was officially installed in the Surya Mahal by around 1735, although this may have occurred earlier with the 1727 founding of the city.[38] Additionally, some aspects of Govindadeva's whereabouts in these intervening years are complicated by references to the god possibly being back in Kanaka Vrindaban during at least parts of 1719–1720.[39] Whatever the chronology, and however formally or informally he was being worshiped, Govindadeva's physical presence in the city's center—what would be the palace precincts—was established as early as 1715. His presence, moreover, endowed the north of the city with another cosmic axis, establishing the apex of what Sachdev and Tillotson call "a ritual triangle" composed of three Vaishnava deities.[40]

It seems reasonable to assume that, at some early point in his plans, Sawai Jai Singh came to realize the full political and religious potential of what he had in the image of Govindadeva: here was at hand a venerable manifestation of the god Krishna who carried with him connections to Vrindaban's *yoga-pitha*, Krishna's great-grandson Vajranabh, Chaitanya, Rupa Goswami, Jiva Goswami, and Sawai Jai

Singh's illustrious Kachchwaha forebears—Raja Man Singh being most prominent among them. As he took up the reins in the first quarter of the eighteenth century, Sawai Jai Singh's overt patronage of Govindadeva became yet another potent tool with which he could—as his title suggests—one-up his Rajput rivals. While there is no question that Sawai Jai Singh, like his predecessors, was an ardent devotee of Govindadeva, he must have been aware that his Rajput rivals had also installed their own tutelary Krishnas and that these deities were directly, albeit symbolically, involved in state politics. In the southern Rajput kingdom of Mewar, for example, the self-manifested form of Shri Nathji enjoyed imperial patronage by the Udaipur rulers after he was resettled in Nathdwara in 1671–1672; these are the same Mewar Rajputs who bailed out Sawai Jai Singh in 1708, when they helped him to regain Amber. There were several other important manifestations of Krishna in circulation in western India that were related to the Vallabhacharya sect, and a number of these Krishnas were intimately connected to the histories of some of the royal clans and, by extension, to the persons of their kings.

More pertinently, in 1719, a few short years after Sawai Jai Singh had ferried Govindadeva from Kanaka Vrindaban to the Jai Niwas gardens, Maharao Bhim Singh (r. 1707–1720) of the kingdom of Kota had his portrait painted in attendance upon his tutelary divinity, Krishna as Brijnathji.[41] The Kota Rajputs had connections with the Vallabhacharya sect, to the extent that the kingdom had played host to Shri Nathji for a few months in 1672 during the rainy season. But for the Kota Rajputs, as Norbert Peabody explains:

[O]ne deity has come to be especially associated with Kotah's ruling dynasty: the image of Shri Brijnathji . . . which was given to Maharao Bhim Singh I during his initiation into the practice in 1719 shortly after his audience with Muhammad Shah in Delhi. Since that date, Shri Brijnathji has been the kingdom's tutelary deity, and possession of this deity has played an important role during civil wars and succession disputes in establishing the legitimacy of rival claims to the throne.[42]

The portrait depicts a smaller-scaled Maharao Bhim Singh standing in attendance upon the much larger image of Krishna—identified by his dusky skin, but otherwise looking every inch the earthly ruler—who sits upon the king's throne while enjoying veneration from his royal devotees.[43] Maharao Bhim Singh I dedicated his kingdom to Brijnathji, the deity thus becoming the titular sov-

ereign of the Kota state.[44] In similar fashion, Sawai Jai Singh symbolically elevated Govindadeva to the status of state ruler: his seal bore the formal declaration that "the feet of Sri Govindadeva [are] Savai Jaya Simha's shelter."[45] From this, scholars have deduced that Sawai Jai Singh ritually ceded his kingdom to the deity; this critical interpretation will be revisited later with reference to the current situation at the temple.

One might wonder why Govindadeva was never returned to his presumably rightful home in Vrindaban once the worst of the political upheavals were over, and it has been suggested that, once Sawai Jai Singh established the god as the sovereign of his state, he effectively—and, one presumes, deliberately—joined god and kingdom in an inseparable bond. As Richard Davis comments in his study on the appropriation of images, "Alive to the identities and mythic backgrounds of the figures, royal looters dislodged select images from their customary positions and employed them to articulate political claims in a rhetoric of objects whose principal themes were victory and defeat, autonomy and subjugation, dominance and subordination."[46] Although Sawai Jai Singh may not have been a looter per se, both the timing and the singling out of Govindadeva as a special object of royal piety were clearly part of a calculated decision made by Sawai Jai Singh to make his own special mark in the complicated pastiche of eighteenth-century regional politics and religion.

The gesture, moreover, of physically bringing Govindadeva into the palace precincts, into the most intimate milieu of the king's domain, makes the connection between god and king at once overtly public and manifestly private. The god is no longer physically distant and spatially associated with the old Kachchwaha capital of Amber, but now presides at the heart of Sawai Jai Singh's new Jaipur. It is not as though Sawai Jai Singh's Kachchwaha ancestors were lacking for deities to worship: at Amber, for example, is the important temple of Shila Mata, a figure of the goddess brought back from Bengal as part of the victory spoils from Man Singh's defeat of an important rival in 1604.[47] But new cities and new reigns need new deities, and Sawai Jai Singh made a very clear architectural, ceremonial, and personal statement that his was to be a new era, one that both looked to the past for legitimacy and established legitimacy on its own terms. This personal mode of worship was in essence a pronouncement of a different order, one that was meant to supplant the old deities and the old history of the clan—a history that was in some respects tainted by the Kachchwahas' former

close association with the Mughals. It is abundantly clear that the establishment of a proper royal capital and the investiture of Govindadeva as its tutelary divinity were one and the same process.[48]

The choice of the Surya Mahal in the Jai Niwas gardens as Govindadeva's new home appears to have been motivated by both Sawai Jai Singh's need for personal proximity and a desire to situate the god within a definitively public, royal architectural context. As Cathy Asher has written, "Installing the image in a temple that evokes an imperial public audience hall was a conscious choice, for in this setting Govinda Deva's dual role as ruler and god are understood."[49] The current temple custodians also narrate the popularly held account that the Surya Mahal was originally designated as Sawai Jai Singh's personal residence, but the ruler had a dream in which he was instructed to present it to the god instead, and the king thereupon took up residence in the Chandra Mahal. Thus, whether by design or by divine guidance, the Surya Mahal became Govindadeva's final destination, one befitting Jaipur's new divine ruler. Its typology as public audience hall was a common one in imperial Mughal architecture and was appropriated similarly by the Rajputs as a semi-public venue for the ruler to display himself and to meet and impress the various courtiers and visitors to court.[50] Generally fashioned as large, open, pillared pavilions that are, in essence, permanent tents, these spaces were gorgeously designed shells that were plumped out with carpets, cushions, curtains, and temporary floor covers when in use.[51] For the Surya Mahal to become a temple, the large—normally open—central space under the flat roof had to be enclosed and made into a sanctum. The sanctum doors face south, directly on axis with Sawai Jai Singh's Chandra Mahal palace, an orientation that has been interpreted as an outcome of the charged physical and devotional relationship between deity and earthly ruler, ostensibly providing Sawai Jai Singh with an unobstructed view of the god as he looked out into his gardens.[52] Contemporary accounts describe Sawai Jai Singh's extreme devotion to Govindadeva, and the story is frequently told that the king prostrated himself every day between the palace and the temple, until he was too frail to do it himself. He thereupon deputed a Brahman to perform prostrations in his stead.[53]

In Sawai Jai Singh's time, a pattern of devotional service to Govindadeva was established, and while related in most ways to practices in the Chaitanyaite temples of Vrindaban, certain modifications were made to accommodate for the differing personal, geographic, religious, and administrative circumstances that had

transpired over the course of 200 years. Some of these practices are preserved in the *Sri Govinda Varsikadvadasakam* (Twelve Verses on the Yearly Festivals of Sri Govinda), a text dated to 1734, during Sawai Jai Singh's reign, and are illustrated in a later set of eleven miniature paintings, most probably dating to around 1777.[54] These two textual sources provide complementary and valuable information on aspects of the annual program of festivals, food, ornamentation, and entertainment of the god and his consort.

While I have never been able to track these paintings down, Chandramani Singh has worked with the paintings and vividly describes how they picture Govindadeva and Radha receiving a succession of offerings on a number of different ritual occasions. Also pictured is the *sakhi* Lalita, a figure of whom had been donated in 1727 by Sawai Jai Singh to serve Radha, as well as various female attendants and priests. The "atmosphere they depict," writes Singh, "is very simple and serene. The priests are dressed in white dhotis and dupattas, and the deities are also dressed in simple clothes, not brightly colored."[55] This simplicity and serenity are less evident in the contemporary temple's more vivid—and at times flamboyant—visual presentations.

After Sawai Jai Singh's death in 1743, later rulers continued and, on occasion, augmented the deeds and grants already in place. Sawai Jai Singh's grandson Sawai Pratap Singh (r. 1778–1803) gifted the figure of a second *sakhi,* Vishakha, in April 1803.[56] Horstmann's detailed study of the documents relating to the maintenance of the Govindadeva temple finds that "[t]he revenue grants which were made by the Kachavahas survived into the period when the Jaipur State merged with the State of Rajasthan (30 March 1949). These titles were eventually transformed into an annuity, which the State of Rajasthan pays to the temple of [Govindadeva]."[57]

In the face of the great changes in Indian history and politics in the twentieth century, the worship of Govindadeva, formerly primarily the domain of the royal family and the *goswamis*, gradually became more open to the public and more democratic in its patronage base. In former times, Anjan Kumar Goswami (the current head priest of the Govindadeva temple) explained, worship at the temple was beholden to the ruler's schedule. The king's routine was to get up in the morning and first see (have *darshan* of) a cow and calf in front of the palace; only then would he send his guard to the Govindadeva temple and, then, the temple would be open to the public.[58] There was evidently no specified time for *darshan;* it just

depended on when the guard was sent. Moreover, the first and last viewings of the day (*mangala* and *shayan arati*) were reserved for the royal family, the priests, and their assistants. Additionally, the court and *goswami* women were strictly segregated and veiled when they came to the temple. Anjan Kumar Goswami also noted that, in times past, the rulers told the *goswamis* what to do; the priests had no power except for enacting the rituals for the god. But the times changed, and so did some of these customs. Reportedly, some of the democratization and consequent opening up of the temple to the public came about in 1947 under Gayatri Devi, best known for her popular memoir *A Princess Remembers*.[59]

With the diminishment of private royal patronage and as the temple's administration ultimately came under the umbrella of the government of the newly formed state of Rajasthan, tensions surfaced over who exactly was in charge of the temple, its services, its schedules, and its resources. An important point for the *goswami* family is that Govindadeva, although he is elevated to the status of ruler of an earthly domain, is yet a perpetual minor: Krishna is an adolescent, and hence he needs guardians to manage his affairs. In legalistic terms, Horstmann explains, "[t]he *adhikari* (custodian), or to use a more common term, the *sebait* . . . is the human caretaker and legal representative of the juristic person that the deity represents, and he handles the deity's property. In the case of important shrines such as that of Sri Govindadeva, the custodianship was invested with considerable economic power."[60] A critical distinction must be made here, however, between *ownership* and *custodianship* of Govindadeva's estate. I was cautioned that, lest this economic power be misinterpreted as greed, it was fundamental to understand that the *goswamis* do not personally own any of, nor do they have access to, the riches of the temple; it all belongs to the god, and the human caretakers are but managers who turn the temple's resources back to the deity and his community of worshipers. Disputes have been ongoing since the late 1960s between competing members of the priestly families who claim genealogical legitimacy for running the temples in Jaipur and Vrindaban: even though Govindadeva now physically resides in Jaipur, the connections back to his original temple in Vrindaban are still maintained there by members of the priestly lineage at the Govindadeva temple. Additionally, there are disagreements between these priestly families and the current royal family in Jaipur; even though the erstwhile rulers no longer hold real power or claims to authority, nevertheless the connection between the Jaipur royal

house and the temple is still active—albeit mostly symbolic—and integral to their shared sense of historical continuity. While none of this is a secret, and conflicts such as these pepper the entire spectrum of Indian history, art, and religion (indeed, all of human history), the most interesting aspect of these altercations lies not in the disagreements themselves but in the effect they have had on the growth and visibility of the Govindadeva temple and on the population of Jaipur.

If You Build It, They Will Come

Even as there were divergences in interpretation over the terms of Govindadeva's management after Indian independence, the temple itself went into a decline. The new accessibility set in motion after independence did not effortlessly translate into the sort of public attendance upon the deity that one witnesses today—in fact, I have heard more than once that "hardly thirty people attended *darshan*," and at times the number hazarded was as low as ten. A colleague of mine, who visited the temple while doing research at the City Palace in the mid-1980s, wryly commented that the temple itself seemed hardly more than a modest piece of decorative "lawn sculpture": interesting in a general kind of way but hardly noteworthy. To achieve the level of popularity that the temple enjoys today required a concerted effort, one that was initiated in the early 1970s by Purushottama Goswami of Vrindaban's Radharamana lineage with the cooperation and active support of the late Pradyumna Kumar Banerjea Goswami, then the hereditary custodian of the Jaipur Govindadeva temple (and the father of Anjan Kumar Goswami). Shrivatsa Goswami told me that the process began in 1972, when his father, Purushottama, had a dream directing him to develop and expand the Jaipur temple. Similarly, Anjan Kumar Goswami related to me that his father shared this grand vision. Thus, in a fashion reminiscent of the late sixteenth- and early seventeenth-century revivalists in Vrindaban, there was a conscious decision made to nurture the growth of the temple, but now the audience was not the royalty and aristocracy of old, but the residents of Jaipur who lived beyond the royal enclosure: Govindadeva was to truly become the king of all Jaipur.

To begin with, Purushottama Goswami annually offered public readings of the *Bhagavata Purana* during the period of Kartik Purnima, the auspicious full moon that falls in October–November and the occasion of Krishna's great circle dance, the *ras-lila*. According to

Anjan Kumar Goswami, his father also organized large open religious programs, filling the gardens behind the temple. The most decisive changes came, however, in the 1990s, when the temple began to be physically refurbished and the porch was added to the front of Sawai Jai Singh's original Surya Mahal. Margaret Case provides a vivid account of the month-long celebration in 1995 that accompanied the dedication of the new, almost-completed temple porch. The month of festivities opened with a week-long reading of the *Bhagavata Purana* and included numerous rituals, discourses, and performances—notably, an *ashtayama lila* play that dramatized the life of Krishna as it unfolds over the eight time periods of a day (and, hence, eternity), just as it does in the temple on a daily basis.[61]

All this has successfully worked to bring the people in, and as the temple has increasingly gained in popularity in the ensuing years, such special events have become a regular part of the schedule. Aside from these occasions, however, visitors who worship the deity almost always have something interesting to look forward to during the *darshan*s. The temple has published a short, but extremely helpful, booklet entitled *Govind Darshan* (2004; written by Anjan Kumar Goswami's eldest son, Manas Kumar Goswami).[62] With an attractive cover depicting Govindadeva resplendent in shining golden clothes, standing on a brilliant silver throne flanked by Radha, the two *sakhi*s, and Chaitanya's image, and liberally illustrated inside with color reproductions, this small guide not only gives valuable information about the details of the clothing, ornamentation, and annual schedule, but it also provides fascinating insights into the way in which the temple's story is told by its contemporary curators. Its first page declares:

> [T]oday though HE physically resides in this Temple, Practically HE is in the Breaths of The People. HE is Their Faith, Their Inspiration, Their Shelter!!! HE is Their Friend, Philosopher & Guide! HE is not only a Sacred Image of Worship; but HE lives in them and The People Live in HIM. In HIM Somebody finds his Brother, Somebody his Friend [*Sakha*], yet Somebody else his Medicine and So On!!! The number of Devotees visiting the Temple daily runs to Thousands *and* to Lakhs [hundreds of thousands] on Festive Days.

This sets the tone for the rest of the booklet, whose first section is entitled "The Divine Arrival of Thakur Shri Radha Govind Devji to Jaipur" and which includes an abbreviated synopsis of the history detailed earlier. This background chapter also supplies the story of the gifting of the Radha image, provides a brief summary of Govin-

dadeva's peregrinations, discusses the circumstances of the provision of the *sakhi* figures, and explains the background of some of the smaller objects of worship arranged on the throne, such as various sacred *shalagrama* stones belonging to previous *goswami*s.

At this point, it is worthwhile to quote several passages from the pamphlet; we will revisit them later when we come to terms with their larger significance. The reader is next informed, "The present Grandeur of The Temple was attained during the period of Revered His Holiness Late Shri Pradhyumna Kumarji Goswami, the [curator] just preceding Sole Sebait. . . . Exemplary was his life. He devoted himself to the cause of the Temple and to the service of the Devotees" (13). *Govind Darshan* explains that, since September 1972, the current arrangement for the management of the temple is that it "is a Registered Public Trust with the Devasthan Vibhag, Govt. of Rajasthan, Jaipur. . . . This is a self-sustained, Independent Thikana (ENTITY)." Additionally, we are instructed, "The Trust is Governed and managed by its Sole Trustee. The Glorious Heritage finds its Origin from 1008 [an auspicious number here used as an honorific] SHRI SHRI CHAITANYA MAHAPRABHU, the founder of the MADHVIYA GOURIA SAMPRADAYA. Right Since the Times of Akbar the Great, the Heritage in its chain, descends now to the present Sole Trustee, SHRI ANJAN KUMAR GOSWAMI, Tikai [eldest son] of Late Shri Pradhyumna Kumarji Goswami" (15).

The second section outlines a genealogy of the temple's custodians, beginning with Rupa Goswami, and we are assured that it is "well defined, ratified and decided in the court of law" (19). A list of names, but no dates, is presented in what appears to be an unbroken line of succession descending straight from Rupa Goswami to the present custodians. Some scholars have raised questions about the fact that the sequence is not as uncomplicated as this presentation might suggest, but that is not our concern here.[63] A listing of different properties managed by the Govindadeva managers follows in the ensuing section, including numerous temples and shrines in Jaipur and others in nearby areas of Rajasthan, Braj, and Vrindaban.

Robes, ornaments, crowns, and makeup comprise the next two sections. Readers of the booklet are educated as to the different fabrics required for winter and summer, and the major cyclical occasions for special ornamentation are noted. On *ekadashi*, Govindadeva wears "blood-red" clothing and is dressed as a cowherd: wearing a special, curved, conical headdress canted to one side, bearing a tall staff, and carrying aloft a curved bugle-like horn in

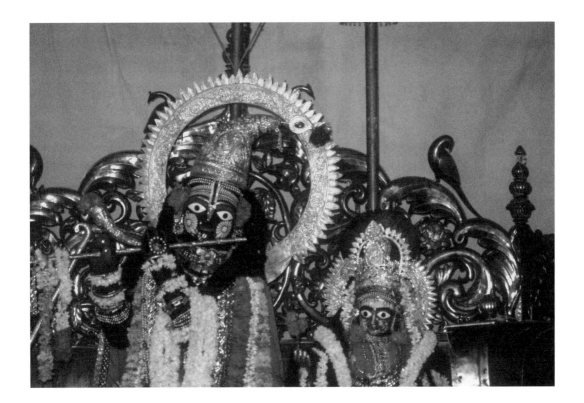

addition to his flute (fig. 3.5). A detail not included in the booklet is that, on *ekadashi* and *purnima,* Govindadeva and Radha also don hair extensions of long flowing black tresses that spill down over the fronts of their robes, an innovation Anjan Kumar Goswami credits to his father. Lunar phases have special crowns, and for the full moon the god also has his cow-herding staff. On full moons, the clothing is usually white (except for the month of Ashvin, when he wears silver, and Kartik, when he wears golden clothing); for new moons, it is customarily black; and for the summer month of Chaitra, the god's clothing is often constructed from embroidered flower buds and he is framed within flower *bangala*s.

Figure 3.5. Govindadeva on *ekadashi,* with curved crown, horn, staff, and long hair, Govindadeva temple, Jaipur

The makeup section leads readers through the basic steps taken on a daily basis to prepare the deities for presentation in the temple after the first morning ritual. This includes bathing their bodies with holy water, dressing them, applying saffron and sandal painted designs to all the deities' faces, and adding ornaments and floral garlands. Differing from both the Radharamana and Radha-vallabha temples, once Govindadeva is ready for the day his ornamentation remains relatively constant (with the exception of the freshening of the floral garlands) until the night's final presentation. Not included in the booklet, but related to me in conversation

by Anjan Kumar Goswami, is that after the lunchtime *darshan*, Govindadeva's ornaments are removed, and, together with his flute and Radha's ankle bells, they are placed under a pillow in his bedroom as it is too impractical—given Govindadeva's size—to place the whole figure there. The morning and evening *darshans* feature the god in simple pajama-like clothing, with all sandal decoration removed from his skin, wearing a simple cap or flat turban and a bare minimum of jewelry.

Govind Darshan next devotes several pages to detailing the annual festival cycle. The booklet concludes with some information on the Chaitanyaite practices to which the temple subscribes, including the sequence of mantras uttered when religious initiates mark their bodies in twelve places with sandalwood paste as part of their devotional practice.[64]

This handy reference to the main patterns of the temple hardly does justice to the ongoing visual spectacle one encounters during the daily and festival presentations. That this is not an entirely new phenomenon can be gleaned from the historical records. While the eighteenth-century paintings noted earlier depicted a somewhat restrained vision of Govindadeva and his retinue of companions and attendants, the written descriptions in the 1734 *Sri Govinda Varsikadvadasakam* certainly make clear that luxury and all the right accessories have always played an important part in the god's worship. Permeating the historical accounts of the festivals are references to all manner of gorgeous seasonal accoutrements, such as those alluded to in verse 10:

> (v. 10) I recall the dual deities, Radha-Govinda, [receiving] abundant services [as ordained] by the celebrated king of kings with endless decrees, by means of the products of this season or that, [such as] various kinds of fruits, leaves, and pure bunches of flowers, [and] with many types of adornment, chiefly pearl ornaments, in the finest royal palace in the superb pleasure garden called the fortunate Jayanivasa.[65]

Similarly, today's daily services find Govindadeva and his companions outfitted in an astonishing array of clothing and ornaments, but nowadays most of the clothing is donated by worshipers and not by the ruler. And since there are no particular rules for the decoration of the clothing except for the seasonal dictates of style and fabric and the special colors and ornaments used for the lunar cycles, there is consequently a fair amount of variety on a daily basis. Anjan Kumar Goswami explained:

[E]very day Thakurji wears new *poshak* [clothing]. Devotees give it to the temple, even though it is not needed, and most of it probably won't be worn unless it is specifically organized. Every person who gives clothing gets a reference number that is entered into a ledger. All donations of clothing are kept at the temple, in 500 or 600 cupboards that are in the clothing storage room, full of clothes. Thakurji has 3,281 sets of clothing listed in the ledger [as of the April 1999 inventory]. People can request that their outfit be worn more than once: they go to the ledger, find the number, and reuse it. The clothing is not redistributed, and the temple keeps it until it disintegrates, or is chewed by rats or bugs. The *goswamis* say, "It's not necessary to clothe Thakurji in rich garments. Govindadev-ji is a cowherd. Why don't you instead donate money for serving utensils, or the refurbishing of the porch?" But people think, "If you do this for me, God, I will give you *poshak*." They fulfill their promise to God, and express their thanks by donating clothing. The main thing is that he wears it on his body.

As with the Radhavallabha temple, donating clothing involves the financing of many separate pieces: the winter and summer outfits are composed of thirteen items, and the monsoon season calls for eighteen. These numbers hardly differ from historical practice. Grants and deeds from the seventeenth century provide a fascinating perspective on the economics of earlier temple patronage. No different than today, the upkeep of the temple—part of which included food and the payment of income to the *goswamis* and custodians—was clearly very costly, and support came from a wide variety of sources and donors.[66] The historical records also highlight the important role of clothing and ornamentation for the deities and the occasions for which they were worn. For example, a deed dated to 1660, during Govindadeva's and Radha's original residence in Vrindaban, lists five festivals (Holi, Phuldol, Rakhi, Dashara, Diwali) for which specific items of dress and accessories are mandated. The god and his consort received full wardrobes, the details of which are enumerated in a translation by Monika Horstmann.[67] In this grant alone, instructions were issued that, for each of these five occasions, Govindadeva was to be provided with twenty items of clothing, including brocaded tunics and *kurtas*, sashes, gowns, brocaded turban pieces, and trousers. Radha was outfitted with "saris of cotton from Burhanpur," satin skirts, silk taffeta blouses, and gold trimmings. The styles of clothing, types of fabric, and yardages of each were also specified. A subsequent decree in 1670 noted that the offerings of new clothing were a year in

arrears because the court factory was apparently behind in providing the fabrics.

Aside from the normal requirements for ornamentation of the deity, it should also be borne in mind that, historically, textiles in India were not simply worn to clothe the body. They comprised an elaborate language of their own: fabrics and styles of decoration were encoded with information about status, provenance, and levels of rarity and craft specialty. In particular, the Mughal courts were deeply interested in acquiring, collecting, displaying, controlling, and gifting gems and textiles. In the early sixteenth century, Ritu Kumar informs us, the first Mughal emperor, Humayun, "took up the daily ritual of choosing the colour of his royal robes in accordance with the movements of the planets. This practice was similar to the Indian custom of choosing colours according to the season and wearing prescribed colours on auspicious days—yellow in spring, burgundies and olives during the monsoons, etc."[68] Gavin Hambly, in his study on "robes of honour" in Mughal India, introduces the reasons that certain objects of clothing had such esteemed social status: "Garment-giving as a ceremony binding donor and recipient can be documented across much of Eurasia. . . . In traditional Islamic society, however, the traditional exchange of articles of clothing known as *khil'at* (pl. *khila'*) between a superior and an inferior, was virtually ubiquitous."[69] Mughal court paintings, especially those from the mid- to late seventeenth-century *Padshah Namah*, attest to an avid interest in the details of textile and gem presentation, ornamentation, and display that borders on the obsessive.[70]

This was a climate in which refined categories of aesthetics mattered: specialized fabrics were woven with gold, elaborate weaving was admired, varieties of brocade or embroidery were sought after, and rare types of cotton, patterns, and motifs were paid attention to. Robes of honor, famous gemstones, the proper accoutrements for court attendance and gift giving, and luxurious textile environments created by tents and furnishings were favored as carriers of meaning. The Kachchwahas' intimate connections with the Mughal court undoubtedly educated and involved them in this elaborate code of refinement, and it appears that other Rajput courts were also attuned to the language of power inherent in what might appear to be simply personal and decorative objects. For example, James Tod, in speaking of Nathdwara in the early nineteenth century, noted that there was a distribution of *prashad* from Shri Nathji's temple to certain devotees:

[In addition to food,] at the same time are transmitted, as from the god, dresses of honour corresponding in material and value with the rank of the receiver: a diadem, or fillet of satin and gold, embroidered; a *dugla,* or quilted coat for the cold weather; a scarf of blue or gold; or if to one who prizes the gift less for its intrinsic worth than as a mark of special favour, a fragment of the garland worn on some festival by the god; or a simple necklace, by which he is inaugurated amongst the elect.[71]

It is unlikely, however, that current devotees of Govindadeva are actively mindful of these historical contexts, participating instead in a generalized pattern of patronage that has become almost reflexive for a broad spectrum of devotional venues. Gifting clothing and textiles, for instance, is an automatic gesture for many who attend goddess temples, where one frequently finds entire preassembled outfits with full decoration (*shringar*) available for purchase outside the temple gates. Depending on one's budget, this can include a head scarf, miniature skirt and blouse or sari, bangles, *bindis*, makeup, and so on. And this example can be multiplied and extended for numerous different devotional frameworks. All this is to say that there is a broadly understood cultural familiarity with presenting clothing and other textiles, as well as ornamentation, to temple deities.

An especially celebratory and inventive time of year arrives with the scorchingly hot months of May–June (Vaishakha and Jyeshta). It is also a period when material presentations and gifts to the god are overtly seasonal in nature. Commencing with the full-moon day of Vaishakha and ending on the full-moon day of Jyeshta, a month-long program of "water sports" (*jal yatra* or *jal vihara*) enlivens the temple calendar. Designed to create a cool and pleasurable environment for the deities, a series of festive water-themed presentations are staged for the public to view and enjoy, usually scheduled as an extra *darshan* in the early afternoon. This is not a new practice, as seen in the following selection of verses from the *Sri Govinda Varsikadvadasakam,* which supplies a lovely description of the enactment of some of these water sports in the eighteenth century:

Bathing Beauties

> (v. 6) In the hot season, I recall the dual deities, Radha-Govinda, having the services of the munificent King Jaya, with falling streams of water from the many water machines [*vari yamtra*] [that make] a splashing sound as if it were Caturmasya [the rainy

season]: the two are placed in a fragrant grass [*usira*] house open to [the circulation of] the wind [where they are] sprinkled with water fragrant with sandal, produced by mixing usiram, camphor and kubja.

(v. 7) I recall the dual deities, Radha-Govinda, being served according to the orders of King Jaya, wrapped with clothing moistened with fragrant substances, with extremely fine, pure, pearl necklaces, with the best, whitest pearls [for their] ears . . . [and] with the best cool offerings [consisting of a mixture of] curds, sugar, and dried fruits, and a large quantity of beverages [made from] grapes, mangos, and so on.

(v. 8) Deep within the heart, I recall the dual deities, Radha-Govinda, both being sprinkled with much love, immersed [that is, completely occupied] in playing in the water within a tank of silver pure as the heart of King Jaya, under fragrant water falling in a thin stream, [their] each and every limb is an aggregate of beauty and they are ravishing [with] their eyes constantly roving about.

This last verse mentions a "tank of silver," a version of which I witnessed in use during just such a playful water-sports session on June 18, 1999, and subsequently saw again in 2005 and 2006. The 1999 occasion was scheduled for 1:30 in the afternoon, outside of the usual sequence of *darshan*s. Despite the heat, great numbers of devotees had gathered, seated under the porch roof in companionable clumps and trading gossip while noisy children careened around and between them. One old, toothless woman danced with her face covered by her sari, while others sang in groups in the corners. The Govindadeva temple does not employ the system of ceiling sprinklers found at the Radharamana and Radhavallabha temples, and there were only a few inadequate oscillating fans to dispel the sultriness of the afternoon—their ineffectiveness apparent by the way small birds were bold enough to take rides on them. As we sweated and waited, temple assistants carried numerous covered trays of colorful cut-up seasonal fruits into the sanctum. The silver doors to the sanctum were open, but a double set of curtains prevented us from seeing what was going on until one of the outside curtains was finally pulled aside. What followed was quite charming: the interior white curtain began to get wet in certain spots as a system of fountains inside the sanctum was turned on, and the shapes of the priests and temple assistants were visible as they crossed back and forth behind it.

By now, the worshipers were on their feet, and when the interior curtains were somewhat dramatically pulled aside, there presided

Govindadeva and Radha, dressed in sheer, filmy white clothes, adorned with jewelry and headdresses constructed of floral embroidery and garlanded with roses (fig. 3.6). Green leaves bunched behind the throne created a cool atmosphere, and a lovely canopy of woven strings of white flowers and roses was suspended from the ceiling of the sanctum. Govindadeva's powerful torso and thick arms were bare except for his ornamentation, the deep black surface of his skin gleaming with oil and water droplets. Behind the couple, and placed atop the ornate silver throne upon which they usually stand, was an enormous, silver, bathtub-shaped shell, its upper edges rising in lotus petal–like points. At the base of the throne, in a slightly sunken space on the marble floor, lay a rectangular pipe with about ten tall slender pipes rising from it, each capped with a finial and spouting a delicate jet of water; something like this must have similarly served as a "water machine" in the eighteenth century. As the plumes of water sprayed the deities and their clothes became progressively drenched, the fabric was suggestively plastered against their bodies; amusingly, Radha's embroidered floral necklace fell against her figure in such a way that it looked as if she were wearing a bikini bottom. Both of them carried the traditional Indian equivalent of a water pistol in their arms—a long, thin, brass water pump—and Govindadeva's was cleverly positioned as a substitute for his usual flute. Each of the two *sakhis* bore a whole melon in her arms. After a short interval, the curtains were closed, and when they opened again, the trays of fruit were arranged on low tables fitted in between the fountains. Finally, a lamp offering was performed, and after all the normal rituals of offerings and distribution were completed, the water sports were over for the afternoon.

The culminating Snan Yatra, or bathing festival, takes place on the full-moon day of the month of Jyeshta (May–June). It is in most respects similar to the *jal yatra,* with the exception that it includes an elaborate ritual bath involving much more than cooling jets of water. *Govind Darshan* lists the event as follows: "Jyeshta Sudi 15 (Poornima): Snan Yatra; A [holy] bath is given [*abhishek*] with Saffron + Rose Water + Cow Milk + Honey + Curd + Ghee + Boora [powdered sugar] + Itra [perfumed oil]. Thereafter Bhog [sacred food] of various dishes is [offered]." Fortuitously, one of the eighteenth-century paintings described by Chandramani Singh records just this ritual, and I was fortunate to witness its contemporary enactment on June 22, the full-moon day of Jyeshta 2005 (see pl. 12).

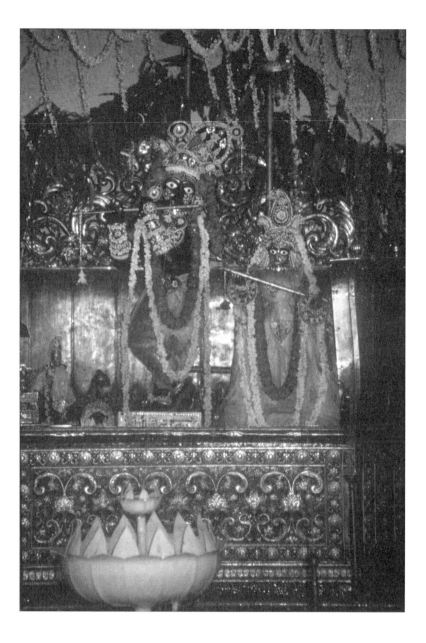

Figure 3.6. Govindadeva and Radha during water-sports celebration, June 1999, Govindadeva temple, Jaipur

On this occasion, there was a group of VIPs invited up to the dais area in front of the sanctum. Normally, this section is separated from the general public with a guardrail, but under special circumstances, a select few are invited inside, seating themselves on the floor space to the left and right of the sanctum doors. Only the priests stand in front of the deities and use the space in front of the doors. Invited guests may lean in from the sides and take a very close, privileged look at Govindadeva, something I have been fortunate enough to do myself on a number of occasions. (In fact, quite often, right after the regular services are performed for daily *darshan*s, the *pujari*s will

allow a few devotees from the general crowd to slip inside the gates so they may have a quick, thrilling, closer view of their god.) As the temple assistants directed traffic, leading the dignitaries to the inner section and monitoring the gates, a videography crew and several photographers recorded the events. This was clearly a big deal, and when the ritual began, the priests conveyed an extra-serious concentration in their ministrations.

The deities were garbed in the same kind of clothing and ornamented with beautiful floral jewelry as they previously were for their water sports. Bunches of green leaves behind their heads were supplemented with slender banana plants flanking either side of the sanctum, and strings of white flowers stretched across the top of the throne and dangled down its sides. Fountains on the floor lightly drenched gods and priests alike. The ritual commenced in exactly the same manner as before, but this time the curtains were closed shortly after an initial viewing of Govindadeva and his companions as they stood on their throne with the silver bathtub-like shell behind them. After the curtains were re-opened, all of the figures were now seen to be fully enclosed within the silver tub (tank), the sides of which reached to about mid-chest on Govindadeva; Radha's face was just visible over its upper edge. This was accomplished by adding matching silver panels to the front of the tank's shell and creating a completely sealed environment for the next series of liquid offerings. In addition, rising on tall slender pipes behind the tank were more water machines; these had ingenious whirling blades at their tops that sprayed water over the deities' heads, in a fashion reminiscent of a lawn sprinkler. Two tall stepladders had also been set up behind the tank, upon which climbed the head priest, Anjan Kumar Goswami, and his assistant. Thereupon commenced an extended series of anointments using various substances, bringing to life the description accompanying an eighteenth-century painting which portrays the black stone body of Govindadeva clad in a white lower garment (*dhoti*) and shawl: "Five priests assist him in bathing: one pours water, one helps him, one stands with dry clothes . . . one takes water from a pitcher, and the fifth holds a pot and bowl."[72] As each substance was successively poured over the god's head, it ran down his face, mixing with the sandalwood painted decorations, which progressively became less and less visible. At long last, the ritual ablutions were completed, and a concluding lamp offering was performed.

What is different between the eighteenth century and the twenty-first? Having established the historical background of the Govindadeva image, the circumstances and motivations for its arrival and patronage in Jaipur by Sawai Jai Singh and his descendants, and some of the links between past and present practices, it is now time to consider in what other kinds of ways the god has indeed become more "the people's" than "the king's." And it is with the performance of another ritual anointment—during the celebration of Krishna's birthday—that this evolution will be made most vividly apparent.

In the buildup of events leading to this occasion, in the staging of the ritual itself, and in its aftermath can be found a wealth of information about the competing claims to Govindadeva's guardianship. Those competing claims reached a head in January 2001, I was informed by Anjan Kumar Goswami, when Bhawani Singh (full title: Brigadier H. H. Maharajah Sawai Bhawani Singh, MVC, of Jaipur, who is the current royal descendant) brought a court case against the *goswami*s claiming that he, as erstwhile ruler, "owned" the temple. "How can this be?" the priest pointed out:

> How can a single man be in charge of Govindadev-ji? This temple and its property has been in the care of the *goswami*s since the time of Jai Singh; even in Akbar's time, the land it stands on was donated by Akbar as a grazing spot for cows. In the *farman*s [grants and deeds], it states that the Jaipur king is the ruler *on behalf of* Govindadev-ji. Govindadev-ji is the true king of Jaipur.

Whatever the historical veracity of these claims, it still stands that there are major differences of interpretation. This is where the emphatic rhetoric of *Govind Darshan* finds its place, for the paragraph that makes the point about Anjan Kumar Goswami serving as "sole trustee" is also laying historical claim to stewardship of the god as far back as the era of Chaitanya. In 1977, I was told, Pradyumna Kumar Goswami was legally registered as Govindadeva's guardian with the Rajasthan government. Thus, his son and successor's repeated restating of his proper title, "Mahant—Sebait and Manager—Sole Trustee," takes on added meaning in the face of the ongoing disagreements between royalty and priesthood. Finally, it is through and upon the body of Govindadeva that these conflicts are at least symbolically resolved for the devotional public, as it is the head *goswami* who is very much in charge during the annual rites of renewal that take place during Krishna's birth celebrations in the monsoon month of Bhadrapad (August–September).

While the observance of Krishna's birth is conducted in much the same way as it is in many other Krishna temples, the level of intensity—and the amount of public engagement—at the Govindadeva temple is markedly higher. I was in Jaipur for this celebration in August 2001 and again in 2006. I will concentrate here on the 2001 birthday rites, which were scheduled for midnight on Sunday, August 12. Annually, for close to two weeks in advance of the birth celebration date, an extensive program of festivities is organized, constituting a massive undertaking for the temple; lay patrons are also closely involved in working with the temple authorities to organize and finance the events. The first indicator of what was to come arrived in the form of a large, hand-lettered billboard in Hindi that devotees encountered immediately as they passed through the entrance gate into the temple precincts; another sign with the same information was posted near a major city crossroads. It announced that, for the great festival of Krishna's birthday, from July 31 until August 13, various groups would offer a series of cultural programs, including devotional singing, dramatizations of the life of Krishna (Krishna-*lila*), and chanting of the names of Krishna; there would also be several swing displays and numerous attractive *bangala*s. Included was a daily listing of all the activities and the institutions sponsoring and performing them.

Thereupon began a whirlwind succession of spectacular nightly displays. In comparison to the Radharamana and Radhavallabha temples, the Govindadeva temple sanctum is much larger: the god is set within a spacious marble room with a very high ceiling. This, coupled with his larger size and the greater number of attendants who share his throne, makes the visual impact of the *darshan*s consequently much more arresting and dramatic; adding to this is the fact that Govindadeva is basically on the same level as his devotees. By the same token, the sense of intimacy and privileged access that devotees experience in the Vrindaban temples (although those deities are elevated on stages) is physically harder to achieve in the Govindadeva temple. But even though Govindadeva's stagecraft and ornamentation are writ large, almost on a corporate scale, his worshipers are no less emotionally attuned to their god than are their Vrindaban counterparts; the impassioned responses to Govindadeva in his magnificence are testimony to the high levels of connection and emotion (*bhav*) experienced when devotees lay eyes upon their god.

July 31 was an *ekadashi* night, which saw Govindadeva dressed in red with his cowherd accessories, sporting his long hair. Supplement-

ing this (to me, slightly eccentric) vision was an enormous silver swing, parts of which had been overlaid with panels decorated with sequins and colored fabric. The swing's platform carried Govindadeva's throne and all of its occupants, and its supports rose high toward the sanctum's elevated ceiling. (Anjan Kumar Goswami mentioned that this display is always a bit "risky" but that the god is stable.) Part of the extensive collection of temple accessories accumulated through the long period of royal patronage, the swing's imposing size and portal-like shape accommodate a wealth of sculptural and decorative details, ranging from large flying celestial attendants with peacock fans hovering at the top of its frame to elephant finials extruding from its crossbar to rows of small female attendants arranged in niches to the sides. Not easily visible to the observer, unless one is very close, is an ornate crowning finial with figures of peacocks and the emblem of a full radiant face of the sun flanked by two winged *putti*; this motif is here featured because the Kachchwahas, as a Rajput clan, claim descent from the sun god (fig. 3.7).

An even more dramatic scene was unveiled the following evening, which celebrated *pavitra dvadashi* (twelfth day of the lunar fortnight) and memorialized the anniversary of the disappearance of Rupa Goswami, a decorated, painted portrait of whom hangs in the circumambulatory passage. On this day, devotees offer *pavitra*, sacred threads, to their god. Govindadeva was again on the same massive swing, but this time its supports were dressed up with long panels of neatly arranged gladioluses, carnations, and roses (this presentation was advertised simply as "flower swing"; see fig. 3.8). A regional inflection was particularly apparent in the god's vividly colorful outfit, made of Rajasthani five-color, diagonal-striped (*lahariya*) fabric with gold trimmings (*gotr*). The sandal designs on his face were particularly bold, and on his head was a huge gold crown with sparkling gems and surrounding gold halo; it seemed like every single inch of his body carried some sort of ornamentation. Festooning the sides of the swing were masses of colorful sacred threads, and numerous extra altar accessories—silver vases and perfume bottles—crowded the display. The following evening again featured the swing in a display entitled "arbor swing" (*nikunj jhula*), and the decor was a lovely assemblage of leaves with fruits tucked into them, artfully serving as background greenery for the swing. In this case, simple strings of white and red flower buds garnished its edges, and Govindadeva was garbed in a yellow outfit and a turban in lieu of a crown.

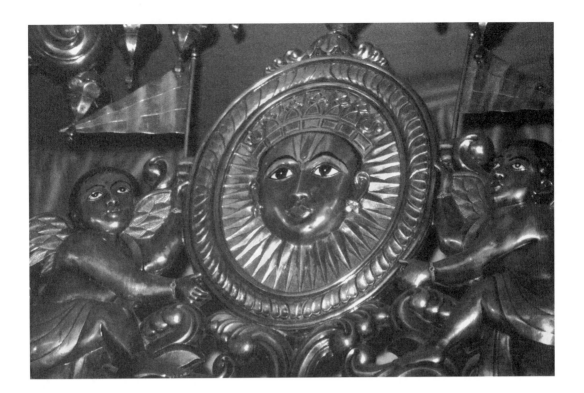

The occasion of the full moon on the subsequent day, Friday, August 3, drove the visual drama to unparalleled heights (see fig. 3.9). This full moon also serves as the time in the year for the celebration of Raksha Bandhan, when sacred threads (*rakhi*s) are tied around the wrists of gods and humans alike; sisters tie these bands on their brothers' right wrists. Nowadays, *rakhi*s can be extremely elaborate affairs, with sequins and beading and tinsel fringe, and that night several large exemplars dangled from Govindadeva's right arm, and others were affixed to Radha's and Chaitanya's figures, the railings, and the outside doors of the sanctum. Govindadeva also bore a sheaf of dry *kevda* stalks (an aromatic plant used for perfume and flavoring) in his arms. And because this was a full-moon night, Govindadeva was accessorized with an elaborate conical crown encircled with a band of miniature peacocks topped with the broad, leaf-shaped finial characteristic of many full-moon crowns, in addition to an encircling gold halo and his flowing black lunar locks. As if that were not enough visual information, Govindadeva was dressed in a brilliant peachy-gold costume, densely roped with thick rose garlands, and packed from head to toe with gold jewelry. And all of this was set upon the swing, which was additionally embellished with panels of magenta fabric adorned with mosaic-like floral designs made from variously hued lentils (this one was called a *dal jhula*).

Figure 3.7. Top of silver swing with emblem of Jaipur royalty, Govindadeva temple, Jaipur

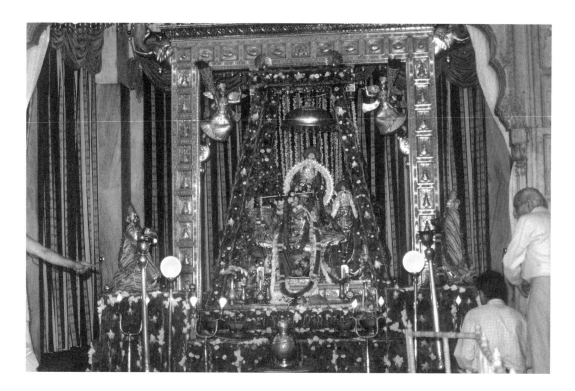

Figure 3.8. Govindadeva
on a silver swing decorated
with flowers, Govindadeva
temple, Jaipur

Friday's arresting display was extended into the next day, with
some minor adjustments: the bunch of *kevda* stalks was removed,
and the legume-mosaic panels were replaced with new ones; these
had a bright pink background and a lovely pattern of gleaming
white floral motifs cut from banana pith. Sunday's presentation was
relatively modest: the swing was gone, and the deities were back in
place, now set within a *bangala* fashioned as a niched space and
surrounded by a boxy stage set. This was created from blue fabric
panels supported by silver posts at the corners, and the blue panels
were delicately overlaid with a trellis of feathery white flowers and
bordered by bands of deep crimson roses. At its base, extra panels
below the deities' feet bore representations—made from artfully
garnished banana pith—of the god Vishnu in his tortoise and fish
avatars. Govindadeva and his retinue were brilliantly garbed in co-
balt blue, the simplicity of their attire offset by elaborate crowns.

The rest of the temple was actively under preparation. Lights
were beginning to be strung along the roof lines. A stage had been
set up between two of the pillars on the western edge of the porch,
and the first of several dramatic performances reenacting parts of
Krishna's childhood and adolescence (Krishna-*lila*), commonly
held during the days leading up to the birth festival, was getting
under way. The temple was packed to the rafters. Tonight's enter-
tainment, scheduled to begin right after the 8 PM *darshan,* was by

Figure 3.9. Govindadeva on a swing decorated with lentils on Raksha Bandhan, Govindadeva temple, Jaipur

a lively group, led by a smoothly practiced master of ceremonies who conferred a stamp of authenticity on the troupe by announcing that they were from Vrindaban and Mathura. The performers really whipped up the crowd, leading them in enthusiastic chanting of "Shri Radhe Gopal, Radhe! Radhe!" An exceptionally adorable and amazingly well-behaved small boy played the part of the baby Krishna, and when the actors who portrayed the adolescent Radha and Krishna arrived on stage, the crowd went wild: clapping, singing, moving forward en masse to have a better look. Some women started to line up to give money to the actors, but were stopped in the interest of temple decorum. When there were particularly

meaningful scenes, such as the one depicting the Seva Kunj (arbor of service), where Krishna pays homage to Radha with the humble and unusual act of massaging her feet, all assembled exultantly cried out, "Jai Jai Shri Radhe!"[73]

It should be clear by now that the Govindadeva temple was the destination of choice for much of the city's populace during the weeks leading up to the birthday. And the extravaganza just got bigger and better. From Sunday on, *bangalas* supplanted the swings, and it would be no exaggeration to say that each day's visual theater was progressively more dramatic. Monday, August 6, showcased one of my favorite displays—a *bangala* shaped like a pavilion, embellished with cut-up vegetables and fruits tacked onto a beautiful saffron cloth background and decorated with small silver-foil motifs (see pl. 13). Vertically cut green bananas; creamy yellow wedges of pumpkin; pale-green discs of melon; long serpentine-shaped summer squashes; halved red apples; wine-colored jujube berries; a spectrum of green limes, cucumbers, and bitter gourds; and deep purple eggplants, both narrow and round, were artfully arranged in gorgeous swirls and tendrils and clusters, jewel-like in their aggregation. The deities were provided with white flower-bud outfits, and the impression of freshness and sparkling delicacy was heightened with effective lighting.

Each of these *bangalas* had a mere one-day shelf life, and the ongoing preparations for each successive display were apportioned to various craftspeople both on and off the temple premises. Near the temple entrance was a workroom that housed teams of artisans, and much of the flower decoration for the deities was produced in the passageway that ran behind the sanctum; there were also parts being produced in various places in the neighborhood. Because many of the *bangalas* were usually designed as flat, separate pieces, they could be decorated before they went into the sanctum. Tuesday's *bangala* was entitled the "English flower *bangala*" and consisted of a somewhat funereal, but nevertheless striking, arrangement of masses of gladioluses, lilies, dahlias, and ferns that created an arbor-like setting for Govindadeva and his consort, who were thematically attired in floral vestments. And even though the evening's program was more reminiscent of Bollywood than Braj, the performers were nevertheless very sincere, announcing, "We are happy to do this *seva* for the first time for Govindadev-ji's birthday."

Next in the lineup was Wednesday's cleverly constructed "boat *bangala*," where a large boat prow protruded from the sanctum; colored a vivid pink, it was garnished with banana-pith decorations

along its sides (see pl. 14). The divine figures were arranged inside it in such a way as to simulate a river outing: dressed in flower-bud outfits, Radha and Govindadeva were upon a flower-bedecked "seat," and the *sakhi*s were moved forward and supplied with silver oars. The slightly sunken floor of the sanctum was, moreover, filled with water. Outside the sanctum, the porch ceiling had been criss-crossed with red, green, and yellow banners with silver *svastika* designs; marigold and leaf garlands had been draped over the dais railings; and two massive silver elephants flanked the sanctum doors, bearing flowers on their backs.

Wednesday evening's staged performance featured the god Shiva—comically played by a beefy man with a printed tiger-stripe loincloth—who, having heard about the impending birth of Krishna, desires to have a glimpse of the newborn. After a lot of back and forth, where Krishna's foster mother, Yashoda, does her best to keep Shiva away ("No! Don't get near my baby! You're dark, you wear snakes"), she finally relents and allows him to see the boy. Thursday evening's performance was a bit more sedate, with some lovely dancing and singing. A nice *bangala* had been unveiled, its designs created from bits of packaged *supari* (betel-nut mixture), which has a pebbly tex-ture and was ingeniously used as a filler for designs outlined with gold thread. Govindadeva was resplendent in gold clothing, and a *chappan bhog* feast was arrayed in front of the sanctum, with fifty-six different kinds of special delicacies laid out on platters that were stacked on a gradually ascending series of plank-like steps.

Friday brought with it a spectacular Sheesh Mahal (Mirror Pal-ace) *bangala* and a culminating Krishna-*lila* performance. Most col-orful and ambitious of all the presentations thus far, the Sheesh Mahal gave the illusion of a glimmering multistoried pleasure palace, created from a myriad of sparkling mirrored pieces, colored pearls, and gold and silver threads. Not simply restricted to the sanctum, the stage settings extended out to either side of the sanctum doors; simu-lated arches framed pastel paintings of scenes from Krishna's child-hood, while niches on the lower level housed the large silver elephants. The divine figures wore full-body suits of netted (plastic) pearls, sim-ilar to, and inspired by, Radharamana's pearl jumpsuit but on a much grander scale. In the evening, the final Krishna-*lila* performance was a full dramatization of Krishna's life from birth to adolescence, put on by a local celebrity and his company, and they generated much inter-est; the audience was the largest yet. The play was extravagantly and gorgeously put together, clearly the most "professional" of the week's

events, and garnered an enthusiastic response from the crowd. The final *bangala* on Saturday (called "embroidered stars and sequins *bangala*") consisted of a clean, graphic façade made from motifs cut out of "velvetized paper," which has a soft, velveteen-like surface. The color scheme of a white backdrop with applied floral and vegetal designs in rich red, dark green, and sapphire blue accented with silver star-like sequins was restrained and elegant; Govindadeva and Radha, however, made their appearances in a jazzier magenta wardrobe shot through with gold threads, complemented by the richly embroidered gold crowns that are a specialty of Vrindaban workshops.

As the days progressed, not only had the visual presentations and displays and dramatizations been gradually ramped up, and the temple become more and more decorated, but another feature prominently came into play: virtually nonstop recorded announcements were broadcasting that a special auspicious procession would be taking place on Nandotsav, the festival that is celebrated on the day after Krishna's birth. Accompanying these announcements were more large hand-painted billboards providing the details of the procession's departure from the Govindadeva temple at 4 PM and outlining its planned route through all the main bazaars of the city, eventually terminating at the Gopinath temple. Jaipur city was also blanketed with advertising, flyers, and hand-painted billboards. Most visible were square saffron-yellow banners, printed with a motif of an auspicious pot with leaves flanked by red *svastika* motifs and bearing the words "Festival at Govindevji temple, Jaipur." These ubiquitous banners, along with loudspeakers, were affixed to lampposts throughout the city streets: there was no doubt that the Govindadeva temple's birth celebration was *the* show in town for the week, even though Jaipur has many other Krishna temples.[74]

Augmenting the printed and other announcements were visual images of the god, which became increasingly available as the week wore on. Tiny photographic reproductions of the week's *bangala*s were passed out as special *prashad,* and many photographers were there each night to record the displays for the local newspaper and television station (fig. 3.10). Govindadeva's and Radha's brightly colored pictures, showing them resplendent in their various special outfits, emblazoned the front page of the *Rajasthan Patrika* newspaper on several occasions during the week. Photographs were also widely available for sale in small shops in the market around the temple, the most important of which was R. G. Photo Flash. The

main photographer's card reads "Roop Kishor Goyal, Photographer / Personal Photographer of His Highness and His Family / City Palace, Jaipur"; additionally, he takes photos of Govindadeva on a daily basis. Because access to the podium near Govindadeva's sanctum was to be restricted on the evening of the birthday, those of us who were privileged enough to be invited inside the guard-rails were issued special laminated "press badges" with a photographic image of Govindadeva in his birthday outfit, standing in a shallow, silver, lotus-petal basin, holding his flute, with a bright orange cloth wrapped around his body and head.

Tempers started to fray the closer it got to the big day: on the evening that I arrived at the temple office to pick up my pass, I encountered some uncharacteristic obstinacy from one of the office personnel, who didn't realize what my connection with the temple was. As he determinedly tried to shoo me out, the head priest's eldest son, Manas Goswami, fortunately saw me and corrected the situation. Getting to the temple became progressively more difficult as well, and I had to ask my rickshaw drivers to park some distance away, outside near the City Palace or the Jantar Mantar. Police barricades were set up outside of the temple to control the flow of visitors; hawkers selling toys and cheap religious pictures spread their blankets outside the temple grounds; and loudspeakers blasted popular devotional music from the lampposts along the city streets: the temple was unapologetically taking over the city.

While all this activity can undoubtedly be attributed to the size of the temple and its importance for the city of Jaipur, there was an edge to it—an additional degree of public display that, in the final analysis, went beyond the merely celebratory. Prominent in this careful buildup of momentum was the constant repetition of the head *goswami*'s name (Anjan Kumar Goswami) in the announcements. Moreover, on all of the printed materials detailing the events was the *goswami*'s name followed by the title "Sole Manager of the *Seva* [service to the god]." Anjan Kumar Goswami is first and foremost a hereditary priest—but he has had to step into such a public role because of the conflicts between the temple and the palace. This situation is complicated even further because, above and beyond the competing claims over Govindadeva's stewardship, the terms of royal patronage have changed considerably. Some fear that Govindadeva will not be properly cared for if the royal family takes control; and some claim that even though the god still faces the Chandra Mahal, he no longer likes what he sees there. Parts of the Jaipur City Palace have been

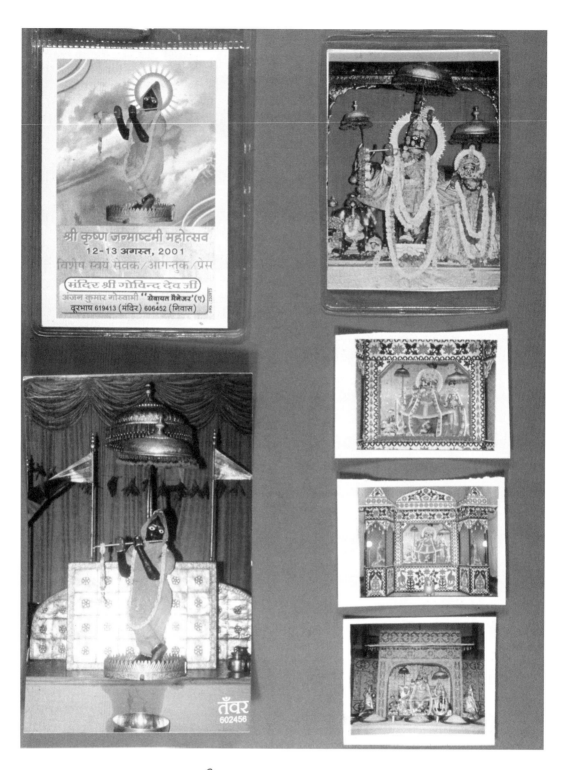

Figure 3.10. *Prashad* photographs and a press pass for entry to the Govindadeva temple's *janamashtami* ritual

converted into a luxury hotel, and there are charges that Govindadeva no longer gazes upon the home of a devoted king-patron but instead looks out from his sanctum upon a pricey party space where all manner of drinking, meat eating, and other sinful activities goes on. This has stirred up some heated feelings.[75]

The ruler does, however, still have a part to play during the birth ritual, which took place at midnight on August 12. On that night, about an hour or so in advance, he was one of the many dignitaries already gathered on the dais in front of the sanctum. He was dressed in a simple white *kurta;* did nothing to identify himself as a ruler, patron, or ritually significant person; and was seated on the left side of the doors, literally just outside the sanctum's threshold. As the ritual preparations unfolded, the *goswamis* did include him first, but it is clear that he played a diminished symbolic role. The general public was already assembled in huge numbers, densely gathered in front of the podium, divided down the middle by gender, and cordoned off from one another with metal barriers. Huge TV screens were set up outside the porch for those who could not find a place under its roof. At 11 PM, there was a lamp ritual offered to Govindadeva and Radha, both dressed relatively simply in auspicious yellow clothing with gold borders and placed on their customary silver throne—tonight polished to its utmost—with their entire retinue of companion figures. Govindadeva's torso was bare, and he wore the low decorated cap (*topi*) in which he usually appeared for the first and last offerings of the day. A vertical marking (*tilak*) of painted sandalwood, inlaid gold eyebrows, wide enameled eyes rimmed above with a broad stroke of red color, and the red of his mouth were his only facial decorations, and he carried his flute in his thick hands, which too are always colored red. His jewelry was limited to simple gold bangles ringing his wrists and a pair of anklets. The sanctum was decorated simply with the banana stalks that are traditionally found in rites of renewal, and garlands of auspicious greenery were strung across the top of the sanctum.

I caught this presentation only after battling my way through the crowd, brandishing my press pass, and struggling onto the dais at last with camera bag crushed against me, crumpled sari unraveling all the while. Other outthrust hands waving press passes were being shoved into the faces of the Govindadeva temple staff, recognizable by their white clothing, their badges, and their special yellow scarves; palpable was a barely controlled hysteria as they worked out who was to be let in the barrier gates and who was to be held

back. The sanctum doors were then closed while final preparations were made. From my privileged and relatively protected perspective on the dais, I gazed in amazement at the surging crowd in front. The situation was totally chaotic; I've never felt more frightened at the potentially destructive power of a gathering of excited people, who, despite their benign intentions, were seemingly close to rioting as they strained to get closer and to fit more people on the porch. Loudspeakers drowned out the voices of the devotees, and the combination of too many people and too much noise was electrifying and exhausting. I was in complete admiration of the ability of Anjan Kumar Goswami and his assistant priests to calmly and stoically go about their ritual duties amid this pandemonium.

Finally, at midnight, the sanctum doors were opened to reveal Govindadeva standing alone, with the exception of the two attendant *sakhis* (Anjan Kumar Goswami had explained to me earlier that Radha is removed "for modesty" and placed behind the curtain that is strung behind the throne), in the middle of the special shallow silver basin used for this ritual of sacred ablutions (see pl. 15). From its front protruded a short silver spout, from which the liquid offerings that are poured over Govindadeva's head flow into a tall silver vessel stationed beneath it. These sacred substances, charged with the power of contact with Govindadeva's body, were collected and distributed as *prashad* at the conclusion of the ritual. I was unprepared for the sheer, raw impact of his presence—with his large, rough body minimally clad in wraps of orange cloth and dense white flower garlands, his thick hands holding his flute, which had a small garland dangling from its end. This was the most direct and unadorned view I had of the god. Moreover, I was really close to him—so close I was shaking and having a hard time taking pictures. This response not only was unexpected and uninhibited, but also jolted me into a fuller understanding of just what it means to have even a limited connection with such a potent and historically meaningful manifestation of the divine. I thought: *this god has been in constant worship since the sixteenth century, and I am incredibly blessed to be this close to him.*

Govindadeva was ritually renewed in a lustration ceremony many hundreds of years old. He is prepared for this ritual with an extensive list of sacred substances, including sixty-four types of Ayurvedic medicines, cow urine, cow dung, and so on. A number of offerings are poured over the god during the public ablutions: honey, sugar syrup, clarified butter, milk, and yogurt (not necessarily in that order)

(fig. 3.11). The whole process is finished up with a bath of rose water, taking about two hours to complete. Once the yogurt offering—the final substance that was publicly poured over the god's body—was finished, the gathering began to disperse. The VIPs were handed baskets of special *prashad,* wrapped in block-printed cloth scarves that are given out by the temple on these special occasions, on top of which they carefully balanced plastic containers brimming with the milky liquid mélange from the ceremony. The general public consumed their liquid *prashad* from stainless steel tumblers they had brought along, or from plastic bags that were being filled by temple assistants from huge cauldrons.

It would be easy to assume, as I initially did, that these rites are the most important and culminating moments of the birth ceremony; but I learned that the following day is just as important, although for different reasons. The day after Krishna's birth is called Nandotsav, meaning "the celebration of Nanda," and it is the occasion when Krishna's foster father celebrates the arrival of the boy by distributing gifts to the community—not unlike the proud father who hands out cigars in another cultural context. Prior to the public celebration, Govindadeva—in his renewed form as the newly born Krishna—was protected against harmful influences, such as the evil eye, by the performance of special prophylactic rituals. The god was fed special foods and dressed in a new, auspiciously hued, saffron-yellow outfit (the color yellow is always used for occasions denoting beginnings, rebirths, and renewals) (see pl. 16); this is donated annually by the same devotee who has vowed to provide the clothing for the *janamashtami* and Nandotsav presentations every year until he leaves this earth. Govindadeva was further ornamented and decorated beautifully from head to toe: adorned with an antique crown encircled with turquoise peacocks (reserved for such special occasions), a large gold halo placed behind his head, and draped with a garland of rupee notes.

All cleaned up and ready to weather another year[76] in the most propitious framework possible, Govindadeva was revealed to his devotees late the next morning. The crowd control had tightened even further, in keeping with the heightened sense of barely controlled delirium. From my relatively sheltered station on the dais, the reason for this shortly became clear as bags and bags of gifts—mostly dried and fresh fruits, sweets, plastic toys, and clothing—were brought into the enclosed dais area and presented to the god. The bulk of these were thereupon ritually returned to the individuals who

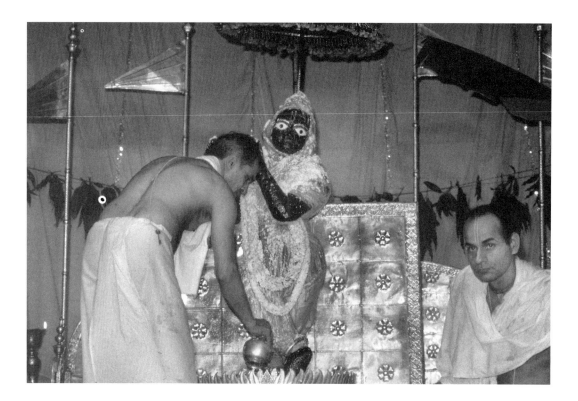

Figure 3.11. Govindadeva covered with sacred substances during *abhishek,* Govindadeva temple, Jaipur

had donated them, presumably to be redistributed in other contexts now that they had been blessed. The remainder, in addition to coins, was tossed out to the crowd—amid thunderous roars of excitement—by the temple personnel; this went on for a good forty minutes of joyful mass abandon. The highlight of the celebration was when Anjan Kumar Goswami and his wife clambered up on stools and threw out two special—tied with auspicious threads and garnished with 100-rupee notes—coconuts to the crowd. One went to the male side of the divider, and the other was lobbed to the female half of the congregation; the winners then came up to the dais and received special gift packages of 101 rupees, special *prashad,* and a sari for the woman. As Anjan Kumar Goswami explained to me earlier, this practice began in the mid-1990s, as new traditions are always being developed to keep up with the times. His son Manas Goswami added that "nobody lives a routine life any more; people like change. New ideas add to the enjoyment of this festival."

Power and Piety

As important as what went on *in* the temple that day was what was scheduled to go on *outside* of it. Thus far, a calculated statement of public participation and ownership had been enacted in the expansive decoration of the temple, the staged dramas, the elaboration of

the image with beautiful adornment and fancy swings and *banga-las*, and the enormity of the public rituals and advertisements surrounding the birth celebration and Nanda's festival. Of yet further significance was the procession scheduled for the afternoon of Nandotsav. As the signboards had announced, there was to be a "great grand procession" (*vishal shobha yatra*) that would make its way through the streets of Jaipur from 4 PM onward. Its major focus would be a large, new, sanctified photograph of Govindadeva that would be placed on a decorated jeep and venerated as a processional representative of the god (fig. 3.12). The flyers and posters had advertised a procession that would include devotional song and dance groups (*samaj* and *kirtan*) from Kolkata, Vrindaban, Radhakund, and other locales; representatives from different sectarian traditions; Jaipur residents who had all seen (had *darshan* of) the three deities Govindadeva, Gopinatha, and Madan Mohan in one morning; various local bands; elephants, horses, and camels; and special floats. En route, flower petals would be distributed from atop elephants, and there would be special fireworks. Joining the procession with displays would be numerous school and performing arts groups, religious organizations, neighborhood associations, and many others. There was also information that citizens could climb aboard the cart with Govindadeva's image so they could perform individual *arati*s and offer special prayers, so long as there were no more than two individuals at a time and the offerings would be performed quickly. A sticker with the times and places of *janamashtami*, Nandotsav, and the procession also exhorted, "If you stay with the procession from beginning to end, you will receive religious merit."

Every year, Anjan Kumar Goswami explained, the photograph of Govindadeva is a new one: everything is auspicious and fresh. Moreover, the opportunity for individuals to make their own personal offerings and prayers to the god is very special, as normally people do not have this kind of proximity to the god's representation. But there is more here than what literally and figuratively meets the eye. This tradition, I learned elsewhere, was initiated by Purushottama Goswami about twenty-five years ago, its purpose unambiguously about power and visibility and its message proclaiming "we can take over the streets of Jaipur for hours." Processions such as these have become increasingly common in Jaipur in recent years, and while their purposes range from religious celebrations to expressions of a variety of community solidarities, many

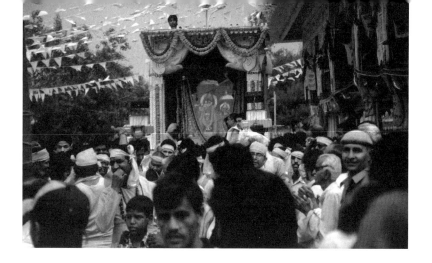

have the added effect—as this one surely did—of snarling the already troubled traffic flow in the heart of the city.

By 4 PM, against a backdrop of seriously threatening dark monsoon clouds, the vehicle with Govindadeva's large photographic likeness was still under preparation in the temple precincts. The conveyance underneath the float had been cleverly transformed into a sort of chariot, its sides covered with cloth panels and draped with garlands of marigolds and auspicious greenery. A platform had been constructed on top to resemble a temple sanctum and porch, replicating the designs on the Govindadeva temple itself. Govindadeva's photograph—heavily garlanded and with its ornamental details touched up with gold paint—was inside the "sanctum," and a carpeted and covered space on the "porch" protected the temple officials and dignitaries. The beginning of the proceedings was finally signaled by the arrival of Bhawani Singh, who ascended via a set of steps that had been built onto the front of the chariot. The *maharajah* made his prayers, he anointed the protective glass surface of the photograph with an auspicious sandalwood marking, and then he and his wife performed an abbreviated ritual offering of lighted tapers under the guidance of Anjan Kumar Goswami. After being presented with one of the white flower garlands that embellished the picture frame, he pressed it to his eyes and departed, his royal ritual duties completed. After this first *arati* was performed, one of the temple functionaries offered around a silver tray bearing the sacred flame, consecrated water, and a marigold garland to the crowd expectantly waiting at the base of the chariot. Devotees passed their hands over the flame as a way of connecting with the presence of divinity.

The parade was ready to start: it was now the god's turn to take over the town in a very physical sense. A large group of attendants

accompanied the chariot, highly visible because they wore brilliant saffron-yellow clothing and head scarves. The vehicle slowly began to make its way out of the temple courtyard, stopping once or twice to take on worshipers, who performed their "express *aratis*" and received saffron scarves as *prashad* (called *prashadi duppatta*). It had started to drizzle by then, and the other floats and groups waiting to join the procession outside the temple gates were getting soaked. Once it reached them, Govindadeva's chariot took up the rear, acting "like a bodyguard," as Anjan Kumar Goswami quipped. The procession gradually wound its way through the city streets, ultimately ending the journey at the Radha Gopinath temple, which is tucked into the depths of the old city. The following day, the photograph was returned to the Govindadeva temple, and approximately ten days afterward, a reception with gifts and *prashad* was held at the Kanaka Vrindaban (now known as Shri Radha Madhava) temple to thank those who gave financial and physical help to the festival preparations.

The mapping of the parade route and its culminating moments at both the Radha Gopinath and Kanaka Vrindaban temples highlight a vital interchange between present and past. The current practices that surround the Govindadeva temple's *janamashtami* celebrations continually and pointedly make reference to the foundational history of the temple and its deity, while also responding to the changed circumstances of today's Jaipur. In particular, the connections to and inclusion of the Kanaka Vrindaban and Radha Gopinath temples overtly reinforce the important mythological and historical connections among the three temples. The Kanaka Vrindaban temple, of course, was the penultimate home for Govindadeva before he was finally located in the Surya Mahal as Sawai Jai Singh's personal and his kingdom's tutelary deity. The Gopinath temple is important for a different reason: it houses the image of Gopinath-ji, one of the sacred triad of sculptures believed to have been commissioned by Krishna's great-grandson Vajranabh in his three attempts to capture Krishna's likeness. Long after Gopinatha's production, and after a sustained period of disappearance from memory, his image was rediscovered in the sixteenth century by a man named Paramananda Bhattacharya. Found in the area of Vrindaban near Bansibat (the tree where Krishna played his flute on the night of the great circle dance), Gopinatha was thereupon installed in a temple that was patronized by one of Akbar's courtiers and overseen by Madhu Pandit, an associate of the Six Goswamis.[77] Like Govindadeva, Gopinatha was one of the

many images that emigrated from Braj in the aftermath of the political turmoil of the late seventeenth and early eighteenth centuries. Devotees are quick to affirm that various body parts of these three manifestations are "best," pointing out that Gopinatha's chest and arms most resemble Krishna's, just as Govindadeva's face is said to be the closest replication.

The final member of this triad is Madan Mohan, who was also commissioned by Vajranabh, and whose legs and feet are thought to best approximate those of Krishna. This figure was miraculously rediscovered in Mathura by Rupa Goswami's brother Sanatana and installed in a temple.[78] This image, too, later found its way into the Kachchwaha territories, eventually to be re-enshrined in the Madan Mohan temple in Karauli, a small town approximately 180 kilometers southeast of Jaipur. Followers of Chaitanya Vaishnavism believe that one is especially blessed if one has *darshan* of all three of these deities by sunrise on the same morning; in accomplishing this, it is said that one has seen Krishna's whole body, and it explains why successful devotees are recognized in the Nandotsav procession. I think of their interconnection as a cumulative "bodyscape," or composite map of sacred images that constitutes a geography of historical and contemporary devotion.

In order of priority, however, Govindadeva is most important because he is believed to incorporate all of these other manifestations in his body. I was informed by a devotee, "He is the sum, and more than the sum, of them all." Additionally, there are other deities in Jaipur who came from Vrindaban and who participate less formally in this conceptual bodyscape. The interrelationships among them are neatly reified in an illustrated chart on the wall of Anjan Kumar Goswami's office at the temple. Manas Goswami explained that "the head of the Gaudiya *sampradaya* is Govindadev-ji," and he pointed out how the god is featured at the center of the chart. To the left of his image is a representation of Gopinatha; to the right is featured Madan Mohan. Above this row of deities is an image of Vinodilal and Radhadamodar, two other self-manifested figures that were relocated from Vrindaban and who are now worshiped in small *haveli*-style temples in the city of Jaipur. Below the central row is a picture of Chaitanya on the left, followed by images of the deities Radharamana and Shyamsundar, both manifestations of Krishna still in Vrindaban; and finally, on the far right is a representation of the god Shri Nathji. Through time, as Govindadeva was joined in Jaipur by Gopinatha, Vinodilal, and Radhadamodar, and with Madan Mohan established

in a nearby kingdom, Govindadeva became the central figure in a confederacy of images that are related to him in intricate ways. More-over, the amassing of this collection of venerable manifestations ri-vals anything the other Rajput kingdoms had access to. A network of historical associations thus powerfully binds these temples and their sacred images together, their individual potencies bolstered by their collective pasts and marshaled toward their collective presents.

4 Krishna to Go

Up to this point, we have centered our consideration on the experiences temple-goers have when they behold special physical manifestations of Krishna, all of which originated and are rooted in the sacred domain of Braj. We have explored the visual vernaculars of various temples and connected them to their sectarian histories. In all cases, we have seen that decoding the language of ornamentation allows access into culturally specific notions of time, place, and space. In addition, we have examined the central role of the *goswami* as arbiter of taste and curator of aesthetic and ritual traditions. But what happens when visual imagery is not bound by the specificities of temporality, history, hagiography, or locality?

In fact, most images of Krishna inhabit a visual universe free of such constraints, an open, and increasingly global, domain that is decoupled from such concerns. The world we live in is dominated by images and multiple types of media, and the visual universe is changing and expanding at a dizzying pace. There is a new generation of worshipers poised to have a dramatic effect on how Krishna is visualized and venerated, and innovative visual media are indisputably changing the face of Krishna worship.

The most recent case of such a challenge to convention was the fall 2007 release of *Krishna: Aayo Natkhat Nandlal,* the first 3-D animated film on Krishna. Sold in a colorful blue box with a winsome cartoon image of the young god on the front, the film narrates the story of Krishna's birth and adolescence through his slaying of Kamsa. The animation takes its cues from Disney in its soft-focus, dreamy, westernized aesthetic, and its visualization of the Indian religious landscape is equal parts *Bambi* and *Aladdin.* Background music is provided by Bollywood singers, there is an overt appeal to a young, contemporary audience, and there's now an English version available.[1] The cover of the DVD quotes the *Times of India* as saying, "Take Your Kids. They'll love it, even as they get acquainted

with Indian mythology." Animated cartoons of Hanuman and Ga-nesha have also been highly successful, in large measure because the gods do cool superhero things that today's kids can relate to. The *Washington Post*'s Foreign Service reported from New Delhi in an article entitled "In India, Gods Rule the 'Toon' Universe" that filmmakers "take a revered Hindu story line, tweak it, put it in a 21st-century context and bring the gods down to earth."[2] The gods play guitars, ride snowboards, speak "Hinglish" (Hindi-English), and are transported to other countries and cities. For today's parents interested in having their children learn about the classical Hindu gods and goddesses, such "mytho-cartoons" are filling a much-needed educational niche.

How Krishna looks, dresses, and acts is changing. The privileged sense of historical continuity and aesthetic control that we have followed in the Radharamana, Radhavallabha, and Govindadeva temples fade far into the background once one takes up the larger issue of popular practice and the widespread availability of Krishna imagery in every sort of material and medium. Can the visual traditions that we have considered thus far continue to have meaning in today's 'toon universe? What happens when Krishna is worshiped and visually adorned outside of his sacred homeland; put another way, if you take the boy out of Braj, do you also take Braj out of the boy? This chapter reviews some of the ways in which people can take away a visual reminder of Krishna from his homeland and further considers what can happen when images of Krishna and Radha are recontextualized outside of Braj: in people's homes, on their televisions, and on their computer screens. We will also briefly review other kinds of re-situations by looking at some new temples, not all of which are dedicated to Krishna, that have been built in India and in the diaspora.

Temples and home shrines need images to worship, and a popular place for purchasing representations of deities and their appropriate decorative accoutrements is Vrindaban's bazaars. In addition to its historical centrality and its importance on the pilgrimage circuit, Vrindaban is the economic center of a well-developed and highly fluid art and souvenir market for Krishna images and paraphernalia. New shops are continuously springing into existence, fueled by a seemingly inexhaustible appetite for fresh and inventive merchandise destined to be transported by pilgrims to their home shrines

Stylists for the Gods

and altars, or commissioned for display in temples in Vrindaban, other places in India, or abroad. Part of the process of packaging "Krishna to go" necessarily involves adapting traditional practices and aesthetic norms to new ritual, physical, and cultural contexts.

When patrons are making personal choices and are not constrained by a particular traditional temple or image, the primary guide for the god and his consort is no longer the temple priest. Instead, devotees—in partnership with purveyors of religious merchandise—contribute their own senses of style and vision to the process of ornamenting Krishna. A large selection of ready-made deity accessories is available in Vrindaban's bazaars for the day-tripping visitor or pilgrim to purchase on the spot. Alternatively, patrons can commission specific outfits and decorations from local tailors and *mukut-walas* (makers or vendors of crowns; fig. 4.1). These shops specialize in fashions and accessories for Vrindaban's temples and also for an increasingly widespread and wealthy domestic, international, and diaspora clientele. One such *mukut-wala* is Bipin, who manages one of Vrindaban's oldest and most prosperous family businesses. I paid several visits to his shop, which includes a large window display facing onto Loi bazaar's main thoroughfare. Behind this is tucked a small private showroom where Bipin and his family preside over an extraordinary inventory of clothing and ornamentation not only for Krishna and Radha, but also for a wide array of other deities and holy figures. Bipin recounted that the business was established 150 years ago by his great-great-grandfather, a Marwari who came from Rajasthan. For the last 25 years, they have had two shops in Vrindaban, and they employ well over a hundred workers—some in sales and management and others in their factory-workshops—in Vrindaban and Mathura.

Their main focus is on clients who have temples in their homes, and Bipin noted that approximately seventy percent have sculpted or cast-metal images of Krishna Gopal-ji installed on their personal altars (see fig. 4.2 and pl. 17). Gopal is the form of Krishna as a baby (Bal Krishna), crawling on his hands and knees with one hand uplifted, playfully grasping the characteristic ball of butter. Bipin told me that many of his clients spend a large amount of money on these small Gopal-jis: the image of the god is treated as a child and a family member, and Bipin's customers buy many outfits and accessories for him, just as they might do for their own children. Accoutrements for paired images of Radha and Krishna comprise the other thirty percent of the Krishna-related wardrobe and decoration business, but

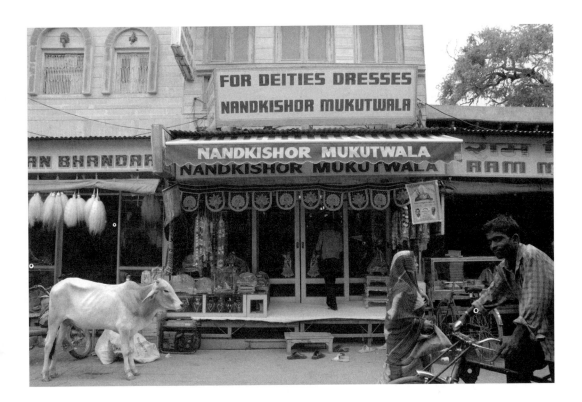

Bipin observed that "theirs is a more difficult *seva*, with more rules and regulations; Bal Krishna is easier, as one can treat him as a child." People usually start by providing their deities with three to four embroidered outfits and simple crowns and jewelry, and then they might purchase something special once a year. He noted that, for particular days, specific colors are needed: for *ekadashi,* the clothing is red, with silver jewelry; for *janamashtami,* the color is yellow-orange; Holi is fluorescent yellow or pink; Hariyali Teej is green; Diwali is red or maroon; *purnima* outfits are sometimes white, but since they are easily soiled, there is not a big demand (even gods have to be practical); and *amavasya* is blue or black.

Figure 4.1. Shop selling deity accessories, Vrindaban

Other clients purchase items for some of the big temples in India and abroad; the members of ISKCON account for a large proportion of his business. The ISKCON temple in Vrindaban, for example, advertises the possibility (a practice common at other temples) of sponsoring "Your Day in Vrindaban," whereby a devotee can choose to provide, on an annual basis, the clothing and other items for a particular day's *seva.* This in turn generates numerous orders for outfits when devotees are in town. Bipin serves as a knowledgeable guide and fashion consultant for their commissions, commenting that there are a lot of rules for the ISKCON temples: "they stick to the book because they are not Hindus originally."

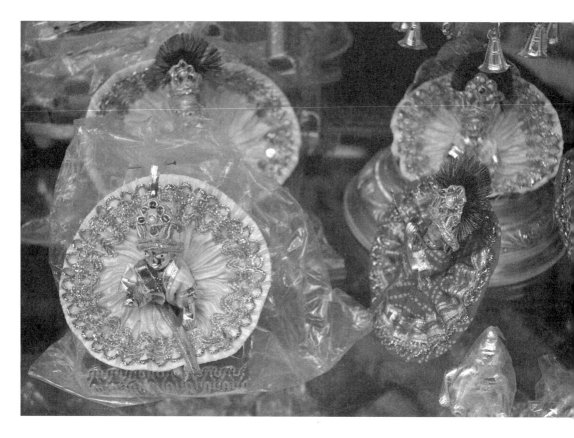

Figure 4.2. Decorated images of Krishna Gopal-ji for sale in Vrindaban

He also provides clothing and accessories for temples dedicated to Rama and Sita, as well as for those with groupings of other deities. Bipin explained that there are generally groups of ten to twelve deities in the big temples: for example, Lakshmi-Narayana, Rama and Sita, Ram-Lakshman-Hanuman, Durga, Shiva and Parvati, Ganesha, and so on might be assembled together. Approximately three outfits a year are provided for special occasions, such as Krishna's or Rama's birthdays or a temple's anniversary. Bipin's family has a database with the measurements of particular deities, which they obtain by either going to the temple—even if it is distant—or extrapolating from to-scale photographs.

Different deities wear different characteristic crowns: Rama's crown is bulbous like the dome of the Taj Mahal; and Krishna's is usually canted to one side and leaf-shaped, a style Bipin termed "Brajratan," as Krishna is a "son of Braj." Around twenty years ago, Krishna's crown would have been assembled from five to six separate pieces (each with its own name) that would be arranged on the deity's turban. Now, however, people find it too difficult to arrange all these pieces on their own and want everything consolidated and arranged as a complete, preassembled crown. Still, different temples

have their own preferences: patrons ordering items for the Rad-haramana temple, for example, tend to prefer the traditional designs and have them copied from older pieces.

All of the workers in Bipin's factory-workshops are Muslim males. Bipin jokingly proclaimed that "Muslims are good workers. Hindus are lazy; they can run their minds but not their hands!" Embellishing and embroidering textiles is a hereditary profession, and the workers are skilled in a wide spectrum of traditional and more popular types of embroidery work—a large variety of different techniques exists from which to select. Shopkeepers have to make the new styles and trends translatable to their workers, and they parcel out the commissions according to who might be most talented in a particular category: some embroiderers, for example, do peacocks better than others. Everything is done by hand, and Bipin stated that "machines are expensive, and labor is cheap." He outlined the many steps that go into creating a finished piece of embellished fabric for a deity's wardrobe: first, a pattern is drawn on tracing paper and then pinpricked all along its lines. The fabric is then spread on a table and the drawing is transferred by pouncing (sprinkling or rubbing chalk along the pin-pricked design until it is visible on the cloth). Thereupon begins the labor-intensive process of embroidering and decorating. Several workers might participate at the same time in outlining the design areas with gold thread, and then the "inside work" is completed. Embroidery, sequins, and beading—or some combination of these—is applied to the fabric in a myriad of extraordinarily beautiful designs. Patrons can select from pattern books or submit their own designs for interpretation; Bipin said that he has more than 40,000 drawings for crowns sketched out on tracing paper.

Not surprisingly, Bipin's business is subject to the vagaries and dictates of current trends. He informed me that, prior to the last ten to fifteen years, there were only three or four varieties of crowns; now, there is an explosion of styles. Fashions are changing rapidly, and his customers insist on variety; they continually want new things. This emphasis on newness is itself new. "Devotees want to see something new and attractive; if not, why should they come back? Some customers even have their deities' outfits designed by Paris designers!" he exclaimed. An article in the *Sampradaya Sun* quoted dress designer Anil Khandelwal, who commented on the international market for deity clothing made in Vrindaban: "The dresses are exported to New Jersey, Washington DC, Houston, Kenya and Italy. In India, the dresses are supplied to several tem-

ples such as Birla temple of Calcutta, ISKCON . . . temple in Bombay and even Vrindavan."[3] The styles resulting from such creative conjunctions of patron and designer can be inventive and eye-catching: I was shown a lavish peacock-embroidered, gored skirt for Radha that strained the boundaries of good taste; an outfit with large sunflowers contributed an unexpected flavor of van Gogh to the traditional visual vocabulary of Krishna's ornamentation.

Bipin also informed me that Vrindaban has become the central market for deity decorations, but the work used to be spread out farther in Varanasi, Mathura, and Nathdwara. Embroidered silver and gold crowns and headpieces, intensively stitched with silk thread, certainly do appear to be an area specialty. Some patrons from outside of Vrindaban still, however, prefer to take the measurements they need back to their home tailors and have the outfits sewn there; additionally, Kolkata, Varanasi, and Jaipur are still favored venues for commissioning jewelry for one's chosen divinities.

On the more economical and populist level, inexpensive small-scale outfits and accessories—primarily for variously sized figures of Gopal-ji, Radha, and Krishna—are available everywhere in Vrindaban, and it is common to see them being stitched up right on the premises of the many shops that sell them. Since I initially began my research in 1992, there has been a steady increase in the number of such shops, and the styles and patterns of even the least-expensive merchandise are always changing. In addition, miniaturized, delicate silver items are especially attractive and popular accessories to bring home from one's visit to Krishna's homeland, ranging from cunningly crafted cows, elephants, peacocks, rattles, and toys for baby Krishna to serving utensils, incense holders, and even tiny silver fans (that can actually be plugged in) for cooling the gods during the heat of the summer. Elaborately decorated swings of all sizes and styles are widely available in the weeks leading up to Krishna's birth festivities. Vrindaban is clearly a pilgrimage boomtown, and there is something to suit everyone's pocket and taste.

The focus of much of this decorative attention is on personal deities who are not self-revealed manifestations, differing from the unique historical images considered in this book. But the altars and shrines for these domestic deities can be quite elaborate and luxuriously appointed, with all manner of ritual accessories (quite often made of silver or gold) and special textile furnishings, such as curtains, backdrops, pillows, and bolsters. The deity's needs may be attended to by the devotees themselves, but some home shrines

have their own dedicated priests and attendants, and at least one of the devotees of the Radharamana temple has replicated details of the Vrindaban temple in miniature for her own home shrine. Occasionally, these domestic gods will leave home and themselves go on pilgrimage to Vrindaban and other holy sites in India, a practice that the saints of old performed with their own personal deities. The power of holy places thus confers added sanctity upon such personal divinities.

Intriguingly, one common category of souvenir—photographs and printed reproductions of Vrindaban's major temple deities—is not well represented in the marketplace. While it is possible to procure photographs of many of Vrindaban's deities from vendors, by comparison with the ubiquitous take-home sculpted and cast figures of the gods and their associated decorative accessories and clothing they form a very small portion of the souvenir business. This might be explained by the fact that, in many of Vrindaban's temples and shrines, photography and filming are allowed, and Radharamana and Radhavallabha are major examples of temples with permissive policies toward photographers. In fact, the Radharamana temple had a temple photographer—recently passed away—who was also a member of the Radharamana *goswami* lineage. This allowed him unparalleled physical access and proximity to the god, and his photographs serve today as a valuable archival resource. Similarly, one of the sons in Purushottama Goswami's family is a talented photographer who has been able to use his access both to the god's inner sanctum and to high-quality photographic equipment to beautiful advantage: his intimate documentary images of Radharamana are exquisite in the ways that they highlight details of the god's radiant beauty not normally visible to the devotee, even those outfitted with good binoculars.

The Radharamana temple has also benefited enormously from the extraordinary abilities and dedication of Robyn Beeche, an Australian whose photography once graced the covers of the world's leading fashion magazines. Beeche has tirelessly documented, over the course of well over a decade, the innumerable *seva*s, *utsav*s, theatrical performances, special ceremonies, pilgrimages, and devotional activities of Purushottama Goswami's family and the Radharamana temple. Some of her work—representing only the tip of the iceberg of her output—can be seen in the beautiful book *Celebrating Krishna*, produced by her and Shrivatsa Goswami. The rest is stored in an archive at the Shri Chaitanya Prem

Sansthana, comprising a collection which has been of enormous benefit to the numerous scholars and visitors who make their way there. My own work would have been impossible but for the enormous generosity of the SCPS and Beeche in allowing me access to this treasure trove of images. For a less specialized audience, however, the photographs that are available in Vrindaban's bazaar fall more appropriately into the category of inexpensive pilgrimage souvenirs, and there is no real rhyme or reason to their coverage. What is available is somewhat eclectic and not arranged or organized in any particular fashion. One simply browses through a shop's available images to make a selection.

The situation in Jaipur is somewhat different. As in the case of the Radharamana temple, the Govindadeva temple has a long-standing relationship with a dedicated photographer, who maintains a small shop just outside the temple gates. There is a large inventory and archive of high-quality images from which to select, and the detail is astonishing. But for most visitors to the Govindadeva temple, it suffices to pick up an inexpensive framed photograph (available in small, medium, and large sizes) from one of the stalls stationed at the temple entrance. The most ubiquitous image is of Govindadeva attired in the same golden outfit that is pictured on the cover of the *Govind Darshan* pamphlet. These framed photographs are quite restrained and tasteful, not succumbing to some of the tricks and gimmicks that one sees at certain other pilgrimage sites: holographic keychains, or photographs with embedded flashing lights simulating garlands around the figures, or cheap calendar-style posters. This is partly attributable to the careful supervision of the Govindadeva temple management, which has periodically had to make a sweep through the vendors' ranks to weed out the more egregiously commercial merchandise. Moreover, as noted in the previous chapter, images of Govindadeva are available in the newspaper and on television and are given away on special occasions (in miniature form) as *prashad* at the temple.

Now You See Him, Now You Don't

In a universe populated with so much available imagery, what happens when photography is prohibited at a given temple? Interesting things can result when visual access to the deity is controlled and restricted. One important temple that does not allow photography is also one of Vrindaban's most popular pilgrimage destinations: the Banke Bihari temple, which also claims custodianship of a his-

torically important self-manifested image of Krishna. This figure of Krishna, the "Crooked Lover," was miraculously discovered in the gardens of Nidhi Bandh by Haridasa in the sixteenth century. Like his contemporary and colleague Hit Harivansha, Haridasa was a visionary who elevated Radha to a position of supremacy. Thus, the self-manifested image (said to be made of black wood and not stone) of Banke Bihari is similarly conceived as a dual manifestation of the divine couple, and as with the Radharamana and the Radhavallabha temples, the exteriorized symbol of Radha is a decorated mound on Banke Bihari's left side.

For many pilgrims, visiting the Banke Bihari temple is the highlight of their visit in Vrindaban, while for others it is a strain, as the temple is in a perpetual state of frenzied chaos. In large measure, this is because visual access to the deity is controlled and manipulated by the temple functionaries in such a dramatic fashion that it is impossible for deity and devotee alike to have a fully satisfactory visual experience. Visual access to the deity is restricted because, it is said, Banke Bihari loves his devotees so much that he tends to steal out of his sanctum in order to spend more time with them. Because Banke Bihari is so emotionally vulnerable to the vision of his adoring devotees, the priests limit the amount of time he is allowed to see them and, in turn, worshipers are allowed but a fleeting glimpse of their god. I have never been to this temple when it was not extremely crowded and, unlike other temples in Vrindaban, the entire experience—from where to leave one's shoes to how to get in and out—is fraught with excitement or anxiety, depending upon one's perspective. Once one has successfully managed to penetrate into the temple and enter its large open courtyard, one faces toward the image of Banke Bihari on his elevated stage. But the visitor does not then necessarily see the god: the temple priests and assistants ensure this by interrupting any kind of sustained *darshan*. This is accomplished by employing what others have termed a "peek-a-boo *darshan*" strategy: the curtain that secludes Banke Bihari from view is regularly, but rapidly, opened and closed, and, with this constant revealing and concealing, full meaning is given to the term *jhanki*, or "glimpse." The only way to get any sense of what one is seeing is to stay for a long time, but this is almost impossible because of the pandemonium of the crowd, with everyone pushing and shoving and straining for their own glimpses. Men in charge of crowd control herd pilgrims through barriers that cordon off the sexes, all the while exhorting visitors to move things along. All this tension only serves to charge the viewing

experience, and devotees cling for dear life to the fencing so they can spend just a bit more time having a proper *darshan*. There are other practices that also make viewing this god different from *darshan* in other temples: the public is not allowed access to *mangala arati,* and the deity's feet are always covered, to be unveiled but once a year in April or May on Akshay Teej. *Darshan* thus comes at a special price for the devotee—since it is not easily obtained, it becomes eagerly craved and sought after. Photography is strictly prohibited, but embossed and embellished graphic images—showing Banke Bihari with his feet uncovered—are easily and inexpensively available in the bazaar.

A similarly negotiated viewing experience awaits pilgrims who journey to Nathdwara in southern Rajasthan to have *darshan* of Shri Nathji, the main deity of the Vallabhacharya or Pushti Marg sect. The Pushti Margs are renowned for creating elaborate, highly artistic visual presentations for their deities and for producing a wide variety of painted images of Shri Nathji in his various ornamented modes throughout the ritual year. Tryna Lyons explains in her excellent study of the artists of Nathdwara that "Pustimarg seems to have taken far more seriously the need for physical staging and tangible props in order to work the alchemy of *rasavada* (aesthetic relish or "tasting") in the heart of the connoisseur/devotee. This accent on the physical properties required to stage the Krishna *lila* provided the motivation for the sect's fervent patronage of the visual arts."[4]

The Nathdwara temple is extensively supported by the Marwari Gujarati merchant community, and the visual displays are lavish and of the highest aesthetic order. The *darshan*s are exquisite and far more concentrated in terms of their stage settings than what we have considered in Vrindaban and Jaipur; the overall effect is more studied and calculated than that of the Gaudiya or Radhavallabha Vaishnavas. Shrivatsa Goswami commented that the Pushti Margs are "more by the book" in terms of organizing their *seva*s than his own more spontaneous and individual Chaitanyaite tradition, and the literature on the sect supports the contention that there are many guidelines to follow in creating the perfect *darshan*.[5] For our purposes, it is notable that, as with Banke Bihari, photographs are not allowed of Shri Nathji. The enormous popularity of the deity coupled with devotees' desires to drink in all the details of the extraordinary visual displays contribute to a similarly fraught viewing experience. On the occasions in 2005 and 2007 that I had *darshan* of Shri Nathji, I felt in constant danger of being swept away by

the frenzied crowd; it was nigh impossible to fully enjoy the spectacle, but the vision was so seductive and elegant that it was ultimately worth the trouble.

Nathdwara's souvenir market is fully stocked with a large and artistic selection of deity and altar accessories. Moreover, there is an emphasis on painted or printed likenesses of Shri Nathji in various ritual settings, both on paper and on cloth (called *picchwais*). These represent a continuity of the Rajput painting tradition as well as the contemporary presence of a productive community of artists who supply images to the hordes of pilgrims that visit the town. This intense visuality is not a practice seen in the Braj area, where fewer paintings are produced and where the objects of worship tend to be sculptural. In lieu of three-dimensional images of Gopal-ji or Radha and Krishna in Vrindaban's bazaars, Nathdwara's marketplace primarily sells two-dimensional reproductions of the god, as well as accessories for framing and decorating the paintings. In the same way that Vrindaban's visitors can come away with a varied wardrobe of accessories for their sculptures, so too can Shri Nathji's devotees purchase an array of fashions for their paintings that can be changed on a regular basis. Especially interesting is the way that these images can be decorated and dressed like sculptures in all manner of embroidered finery. The pilgrim first buys a "foundation" painting or printed likeness of Shri Nathji at his simplest—depicted as the basic black stone form that manifested itself at Mount Govardhan—and slips it under a sheet of glass that is cradled by a frame. From there, devotees can select an embroidered frame cover, a full wardrobe of flat, cutout, miniaturized clothes (a bit like paper-doll clothes, but these are made from real fabrics), and accessories that are affixed to the frame with bits of sticky wax. The picture is thus transformed by ornamentation into a portable and pocket-sized version of Krishna as Shri Nathji, suitable now for intimate and personalized *seva*.[6]

In considering the various ways in which devotees interact with and experience the various forms of their gods, it is abundantly evident that the decoration and ornamentation of the deity are integral to the devotee's full experience. But who does the decorating depends on the context for worship. Once one steps outside of the traditional temple with its specific, dedicated manifestation of divinity, there are many different ways of packaging Krishna-to-go. These range from small-scale personal images and their accessories to bazaar souvenirs, photographs, and painted likenesses and their accessories—all part of a constantly circulating and escalating market of visual forms

that satisfy various devotional needs outside of the context of traditional temples and their stationary images. These forms participate in a very different aesthetic domain, one that is personalized, eclectic, often fashion-conscious, and essentially untethered to the standards and norms of traditional canons of ornamentation. And once the decoration leaves the hands of learned *goswamis*, new and creative visual conjunctions can occur.

Virtual Vaishnavism

Hindu deities have always inhabited a virtual as well as a visual realm in Indian belief. Thus, it comes as no surprise that television is a common and, some would claim, practical way to have *darshan* of a god. Religious television networks (such as Sanskar TV) regularly broadcast an ongoing roster of devotional songs, festivals, and preaching by holy men and women. Sandwiched between advertisements for gemstones and testimonials proclaiming their astrological benefits, the televised religious programs are generally rendered in a brightly lit, but soft-focus romantic style. With invocations or devotional songs playing in the background, the viewer-devotee is visually led through a series of dreamy meditations on pristine images of a variety of divinities. Scenes of loving worship, idyllic landscapes, close-ups of the deities' faces and bodies, images of lamp offerings, slow-motion pans of rapt devotees—all these narrative and visual strategies create a sanitized, wholesome, safe, intimate environment for private worship in the comfort of one's own home. Some of the programs evoke a kitschy "village" rusticity with devotional singers seated in ersatz village huts complete with thatched roofs, mud walls, folk paintings, and clay household accessories, especially suitable for evoking a sense of pastoral authenticity appropriate for Krishna worship. Verdant fields and sparkling pools of water are often glimpsed through the windows of these huts, and the deities can be placed on swings so they can enjoy the cool breezes of the "countryside." The convenience of having this kind of cozy domestic *darshan* is appreciated by the modern devotee, for whom a common sentiment is "I am too busy these days to go to the temple." Efforts are made to be inclusive; hence, short programs are individually dedicated to Shiva and Parvati, Ganesha, Rama and Sita, Vishnu and Lakshmi, Krishna and Radha, Durga, and so on. There is the occasional air-brushed pilgrimage to a special holy destination, and Vrindaban, including the Radharamana temple, is featured prominently.

Additionally, as we saw with the Govindadeva temple in Jaipur, specific temples broadcast their ritual performances, often live, allowing wide access to the event. This was the case with the Govindadeva temple's water-sports festival and birth festival, which were aired at the same time, or shortly after, they occurred. In other instances, footage of the nightly ritual is used repeatedly, as it is every evening on the Jaipur religious channel; there, a regular evening slot is reserved for the final (*shayan*) *arati* at the Govindadeva temple. What strikes me as particularly fascinating about this televised evening *darshan* is the manner in which it provides a distinctive visual experience of Govindadeva not normally available to the worshiper who actually shows up at the temple for the same ritual. Although the overall physical context of the temple and its ritual are pictured, the camera spends much of its time providing lingering and highly detailed close-ups of Govindadeva's face, hands, body, feet, ornamentation, and altar companions. This televised *darshan* thus offers a framed and edited devotional experience that, while it may lack texture and immediacy, rewards the viewer with an unusual sense of physical proximity to Govindadeva.

At this point, it might be tempting to dismiss the Krishna images discussed earlier in this book as interesting anachronisms: important for the traditions they preserve, but not particularly relevant for what is happening in the larger domain of today's Hinduism with its new technologies and growing sense of individualism. This, however, is hardly the case. For while each of the temples covered in this book is doing its part to preserve and maintain the specialized and unique aesthetic canons established centuries ago, their priests and custodians nonetheless recognize that devotees have choices, and their worshipers live in an increasingly complex, modern, and interconnected world. Traditional visual culture needs to neither eschew nor compete with contemporary visual culture; indeed, the Radharamana, Radhavallabha, and Govindadeva temples have all, to some extent or another, joined forces—or made their peace—with technology. As Krishna's image is increasingly dispersed through photography, television, and the internet, the god has, in various forms and media, moved outside of his sacred homeland to new domestic and public domains in India and the international diaspora. The differences in setting, aesthetics, and patronage of images and temples outside of Krishna's birthplace bring to light new priorities and imperatives for today's devotee.

What can an understanding of religious images, visual aesthetics, and ornamentation mean for those coming to terms with contemporary India? India is increasingly in the news as a global force to be reckoned with. *Time* and *Newsweek* have both graced their front covers with brilliant photographs of beautiful—and extravagantly ornamented—women who stood for "The New India" and "India, Inc."[7] That new India is a growing economic powerhouse, renowned for clever and opportunistic outsourcing (from the United States, mostly) ventures, fluid identities, wealthy nonresident citizens who are plowing investments back into the subcontinent, and a growing infatuation with conspicuous consumerism.

Those same Indians are not only building fortunes, but they are also building temples. Many of these reflect a general refashioning of the Hindu temple—both in India and abroad—from a singular, priest-dominated, geographically specific sacred structure to an all-purpose educational and community center and religious entertainment destination. There is a boom in construction, much of it of the super-size variety: enormous temples are springing up, rivaling shopping malls as the newest tourist attractions. Overt references to Disneyland were, for instance, deliberately factored into the planning of the Akshardham temple complex in New Delhi, which earned an entry in the *Guinness Book of World Records* as the "World's Largest Comprehensive Hindu Temple."[8] The *New York Times* ran a feature on the temple on June 8, 2006, appropriately entitled "The Disney Touch at a Hindu Temple." The correspondent, Jonathan Allen, quoted the temple's chief public officer, Jyotindra Dave, as saying: "There is no doubt about it—we have taken the concept from Disneyland. . . . We visited five or six times. As tourists, I mean. And then we went away and worked out how they did everything."[9] "Everything" includes "several features not commonly found in Hindu architecture, including an indoor boat ride, a large-format movie screen, a musical fountain and a hall of animatronic characters." One of the temple's noteworthy attributes is the massive sculptural program, which was "carved by 7,000 sculptors out of pink sandstone and white marble" and features a frieze of nearly life-size elephants in various morally "inspirational" poses, underscoring the Swaminarayan emphasis on social harmony and community values. An article from the *Hindu* chronicled the grand opening ceremonies in November 2005:

> The main monument, depicting ancient Indian "vastu shastra" and architecture, is a marvel in pink sandstone and white marble that

is 141 feet high, 316 feet wide and 370 feet long with 234 ornate pillars, over 20,000 sculptures and statues of deities, eleven 72-foot-high huge domes (mandapams) and decorative arches. And like a necklace, a double-storied parikrama of red sandstone encircles the monuments with over 155 small domes and 1,160 pillars. The whole monument rises on the shoulder[s] of 148 huge elephants with [an] 11-foot-tall panchdhatu statue of Swaminarayan presiding over the structure.[10]

The organization that sponsored the Delhi temple, the Gujarat-based Bochasanvasi Shri Akshar Purushottam Swaminaryan Sanstha (BAPS), also built a similarly grand temple in 1995 in Neasden, London; this bears the distinction of being the largest Hindu temple outside India. The organization has an informative website (www.mandir.org), and the London temple has the added benefit of a link to its "Daily Murti Darshan." It is kept extremely current, and we are informed on the website that "Daily Murti Darshan is now uploaded at 8:15 AM daily (BST) after the Morning Shangar Arti. This is today's Darshan if you were to visit the BAPS Shri Swaminarayan Mandir, Neasden, London."[11] There, one beholds gorgeous pictures of the marble and brass sculptures of the founder, Swaminarayan, with various other important historical and divine personages. Ensconced within elaborate, gilt, canopied pavilions and set against an ever-changing array of painted scenographic and decorated textile backdrops, the glowing white marble deities are theatrically presented in the most fashionable and densely embellished attire. The array of costumes and accessories is simply extraordinary in its opulence, inventiveness, and extravagance; it is clear that there is not only an extensive patronage base but also suppliers for the floral garlands, clothing, backdrops, and accessories. A "Guest Book" on the home website (www.swaminarayan .org/GuestBook) provides insight into the importance of the website for followers, with some poignant testimonials to the sense of peace and joy visitors have when viewing the daily *murti darshan*.

Aside from such large, organized temples with their elaborate educational and outreach strategies, other big-bang, quasi-religious, "infotainment" ventures are in the works. The Sagar Theme Parks company, for example, is planning to build a series of Hindu mythological theme parks in India and the Indian diaspora. The first phases of the Sagar World project will consist of building hotels and a resort near its planned Sagar-NDTV Film City, in the new area of Navi Mumbai. Spearheading the project is Shiv Sagar,

the grandson of Ramanand Sagar—of the hugely influential TV series *Ramayana* fame—and the "mission statement," we are informed, is "[t]o Re-acquaint Indians with their great spiritual heritage and Philosophy of their ancestors using the absolute modern spiritual software and technology."[12] To this end:

> [The next phase will] be the theme park area spread on another 10 acres of land alongside the hotel blocks consisting of animated mythological rides from the famous serials like Ramayan, Shri Krishna, Ganga, Vikram Aur Betal and more recently Sai Baba and Prithvi Raj Chauhan. This phase will also include amphi-theatres for live performances, food courts serving Ayurvedic food, One-Stop-Shops selling spiritual items, Miniature Temples of India etc. Also as newer serials and films are churned out at the nearby Sagar-NDTV Film City, the sets of those can double as attractions for the theme park [or] could incorporate those themes into rides. Once it has been popularized this concept can be franchised all over India and eventually all over the world in pockets where there is [a] large Indian population base and/or interest in Indian culture and spiritual knowledge like Bali, Los Angeles, London etc.[13]

When I questioned Shrivatsa Goswami about these new developments, his answer was that there are "different technologies for different times."

As but one of many more possible examples, and in a more traditional vein, a temple renovation project at the source of the Cauvery River in Karnataka in South India is proposing to replace two older temples with ambitious new structures designed to attract more religious tourists. The emphasis, not unexpectedly, is on monumentality: "The temple [at Talacauvery] will have exquisite woodwork and copper cladding for the roof, and will be one and a half times bigger than its present size when completed," reported an article in *India Today*.[14] Such incremental leaps forward in growth, scale, and vision are, however, not new to Indian religiosity. The medieval temple complexes at Khajuraho, Konaraka, and Mount Abu were undoubtedly grand statements in their own eras, and Phil Lutgendorf has analyzed the complex motivations for a series of increasingly monumental Hanuman images established in various spots in India.[15] All over contemporary India, bigger is better, it seems, when it comes to building or renovating religious monuments.

Behind the move toward more accessible, theatrical, entertaining, and monumental new Hindu temples and religious-tourist destinations lies, in part, a new middle-class desire for a different kind of

temple experience, one that matches more closely the expectations that urban, bourgeois Indians otherwise have in their daily lives. This topic is admirably taken up by Joanne Waghorne who, in her study on modern temples in India and the diaspora, repeatedly came across the sentiment that new temples were in some ways preferable to older ones. In one exchange with devotees during a deity installation ceremony at a new temple in Madras (Chennai), Waghorne noted, "The long conversation ended with a theme I would hear frequently through out the year. Unlike the ancient temples, which 'are so cramped,' devotees praised the new temple for its spacious, open design and cleanliness."[16] Similarly, in discussing the atmosphere and aesthetics of two Hanuman temples in Chennai, she notes:

> Both temples had the same openness, both social and spatial—clean architectural lines, open proportions, sunlight shining on polished floors, and no "Hindus only" signs outside the sanctum. I saw such design elements repeatedly in many of the new suburban temples. The [temple] trustees venerate old authorities, but their new temple conforms to another unwritten "code" of modern temples in Chennai—revere cleanliness (a prize is given for the best-maintained temple in the city), foster a serene atmosphere, and create openness in a broad space that welcomes a wider public.[17]

Not only do modern devotees seek a different kind of aesthetic transparency in their new temples, but also they often conceive of these temples in different ways than in the past. For instance, Waghorne reports, "The most prevalent story of the origin of a new temple begins with a group of 'like-minded' people, often neighbors, meeting in each other's homes for prayers or discussion and then collectively deciding to build a temple."[18] Such temples rely upon a collective planning process, committee management, and a democratic patronage system as opposed to the hereditary religious authority embodied in the *goswamis* that we have encountered in the Krishna temples of this book.

The cooperation and creativity needed to get new temples off the ground are admirable. For some time now, I have been following the progress of the Hindu Temple and Cultural Center of Iowa (established in 2005). As is the practice in many such temples in the diaspora, it is not dedicated to any particular divinity, and its interior houses a number of sub-shrines containing a wide spectrum of Hindu gods and goddesses, albeit with a distinctive South Indian emphasis. The temple was constructed in a modern style which is currently undergoing "Indianization" by imported South Indian craftspeople;

having completed the interior, they have since built tall *gopurams* to mark the exterior (see www.iowatemple.org under the "Virtual Tour" link for photographs of the construction). A democratic approach to managing the temple is abundantly evident, beginning with its name. No single divinity is focused on, the temple's mandate is very inclusive, and there is a full, ongoing roster of ceremonies, rituals, and festivals that punctuate the ritual calendar.

An increasingly visible part of what the HTCC offers is a Weekend Food Service Program. This began as a modest volunteer operation to raise funds by making a vegetarian menu available to Saturday visitors, with proceeds going back to the temple; it was so successful that it has now expanded to include Sundays. Weekly emails are sent detailing the weekend's menu, and it is clear that this form of patronage is an important part of the community building to which the temple aspires. The emails state, "Food service at the temple is a great opportunity for you, your family and friends. You can showcase your culinary talent and at the same time you can have an outing with your family and friends at the temple."

The temple board also organizes cultural and educational programming, some of which is meant to raise funds. A detailed listing of income and expenses that is included in its newsletter, *Iowa Archana,* provides a fascinating tour through the inner operations of such a venture. Everything from the rental price of a helicopter for the opening Kumhabhishekam ceremony ("donate $1,001, get free helicopter ride") to the price of coconuts is included. Listed too are expenditures for deity clothing, garlands, and flowers, as well as a host of other practical needs, such as landscaping and the water bill. On the website, the "List of Items for Poojas" provides detailed shopping lists for many special ceremonies that can be performed at the temple or at a patron's home. You know you are in America when the shopping list helpfully notes that the yardage for a blouse can be purchased at Wal-Mart.

Braj outside of Braj

The Iowa temple follows the model that many temples in the United States have chosen, and its construction and growth point to the success of its management strategies. The transplanting of ceremonies, rituals, and some of the visual vernacular of South Indian temples also makes the temple more recognizably Indian. For all such temple builders, the task of "charging" or investing a new structure with a sense of sacredness is a challenging one, and there are various ways in which this is being addressed. In her work on

how Hindus (in particular, Vaishnavas) sacralize the American landscape, Vasudha Narayanan writes:

> There have been at least four different ways by which the Hindus have made the land of the Americas ritually sacred and to some extent, ritually contiguous with the land of India. These are (a) adapting Sanskrit Puranic [sacred texts] Cosmology by identifying America as a specific "dvipa" or island quoted in the texts; (b) composition of songs and pious Sanskrit prayers extolling the American state where the temples are located; (c) physically consecrating the land with waters from sacred Indian rivers and American rivers; and (d) literally recreating the physical landscape of certain holy places in India, as in Pittsburgh, or Barsana Dham, near Austin, Texas.[19]

Narayanan's outlining of these various techniques for endowing specific American topography with a religious potency that resonates with Hindu ideals helps to address one area of concern that Waghorne raises. In reviewing the difference between traditional Hindu temples and their modern, middle-class counterparts, Waghorne notes that many of the latter have been "denatured"; in other words, they are not geomantically or topographically situated in a landscape that is imbued with sacred meaning:

> [M]issing are the features of nature—the mountains, the confluence of rivers, forest groves—that marked ground as intrinsically suited for a sacred structure. Missing also is the later fifteenth- to seventeenth-century sense that temples center a city and command crossroads of all other activities. This may explain the increasingly elaborate consecration rituals now, which sacralize both the temple and its land. Emphasis falls on the work of devotees to make a place, to build a home, to locate deity in a space that conforms to their own lifestyle.[20]

And further, "When devotees 'transplant gods'—a perhaps inappropriate metaphor commonly used by academics and devotees—into the milieu of a heterogeneous urban community, they construct a new kind of bounded space for the gods that is ironically more global and less universally natural."[21]

The Iowa temple seems to fall into this category of geographically re- and dislocated modern, middle-class temples. Plunked in the midst of corn country off the highway, there is not a whole lot in the flat, endless landscape to be oriented toward. Somewhat closer to the concerns of this book is Barsana Dham, a relatively new Radha temple (dedicated in 1995) which is a short distance outside of Austin,

Texas. This temple fits into Narayanan's last category in very specific ways, as it advertises itself as being situated in a geographically literal recreation of Barsana, Radha's birthplace. The temple's tall, traditional North Indian, multispired roof soars over the 200 acres surrounding the temple, and a simulation of the sacred landscape of Braj has been carefully inscribed and mapped out in its expanses (a "virtual tour" is available at www.barsanadham.org).

Although there have been many testimonials to how closely matched the Indian and Texan landscapes are, the reality is somewhat different. The American version of the Braj pilgrimage can be comfortably fit into an afternoon: dotted about the land are streams ("Yamuna") and ersatz lotus ponds ("Radhakund"), a simulation of Govardhan mountain (actually a modest bump of a hill, complete with little clay cows tucked into its crevices), and a scaled-down version of Barsana hill (Radha's birthplace). Peacocks stroll the grounds, and there is a large round "dance pavilion" and various other buildings. A sense of peace and openness pervades, and the grounds are especially beautiful when the flower gardens and the native wildflowers are in bloom.

When I first visited this temple in the late 1990s, I was fresh from fieldwork in Vrindaban, and I have to admit I was skeptical of the whole enterprise. My stance has since changed, but my initial impressions were informed by a somewhat unfair comparison with "the real thing" in India and what I felt was a sweet, but misguided attempt at an Americanized Hindu temple experience in the United States. I was particularly critical of the interior of the temple, and I will share here some of those early thoughts in order to reveal how some of my thinking has evolved since then.

The interior of the temple is much more overtly modern in its sensibility than the Indianized exterior. Visitors enter into a cool (air-conditioned), hushed, clean reception area where they can read literature about the temple and watch a short educational video. There is a large community hall with a generous stage for *lila*s and performances, the room topped with a ceiling simulating a cloud-studded blue sky. An intensely ornate "South and North Indian" decorative program embellishes the walls and architectural zones of transition. The temple is dedicated to Radharani, with a prayer hall for the worship of her image. *Darshan* times are posted, and once the doors to the air-conditioned prayer hall are opened, visitors can sit and behold a large white marble sculpture of Radha standing on a low stage while a taped message and devo-

tional chanting are broadcast on speakers. Beside this image are two other sculptures of Radha and Krishna standing together. While the images are beautifully dressed and meticulously decorated, at the same time the atmosphere is completely still and devoid of any living or sensual quality. Behind the figures is painted a diorama-style landscape vista that draws upon a whole repertoire of romantic associations specifically designed to evoke the paradise-like arbors (*nikunj lila*) in which the divine couple plays: waterfalls, deeply forested mountains, crystal-clear lakes, cascades of flowers, and celestial architecture (Raja Ravi Varma reincarnated in Texas!). Artificial flowers and a large fake tree contribute a three-dimensional sense of the enchanted arbor to the *darshan* experience. The figures themselves are syrupy and girlish in their affect, a trait characteristic of the visual vernacular of ISKCON religious tableaux and of contemporary Krishna *bhakti* in general.

With the Radharamana and Radhavallabha temples in particular as my most recent frame of reference, I reacted to this scenario with impatience: where was the action? the responses of the devotees? the engagement of all the senses? the messiness of emotion, the unpredictability of the *goswami*'s offering, the surprise and enchantment of art? The setting was, I felt, more reminiscent of a stage set from *Lost Horizon* or a funeral parlor with its artificial flowers than it was evocative of a living Hindu temple. The studied sincerity of the place, the pristine calm, the earnest architectural quotations, and the well-behaved devotees all contributed toward an atmosphere of eerie conventionality. What I ultimately felt was missing was the sense of contrast, of excess, and the undistilled charge of myriad individual devotional practices. Mostly, I missed a real sense of place and divine presence. Shrivatsa Goswami once told me that "if you go into a temple and it's organized, calm, and collected, that's not a real Hindu temple—it's a Christian Hindu temple."

But I was soon humbled to learn that Indian devotees—not just Americans, but those visiting from India—reacted positively, even glowingly, to these images and to the temple in general. "Yes," replied one Indian man who was in Austin visiting relatives, in response to my question about what his *darshan* experience was like, "it is different from India. But it is beautiful, and so well done. It's a very peaceful place." My friend Neha from the Radhavallabha *goswami* lineage married and moved to Texas. Her reaction was also absolutely positive: "Such beautiful *darshans*!" she exulted. I was brought up short once again by my inability to see. I have since learned that these kinds

of settings and aesthetics are completely consonant with the new middle-class values and expectations of such a temple and that this more narrative and representational norm is what defines much of international and diaspora Hinduism, particularly with Krishna *bhakti*. Moreover, Barsana Dham contributes much to the community: its lively calendar of festivals, educational programs, volunteer opportunities, meditation and yoga workshops, and food service involves the larger public in much the same way as has been discussed for other diaspora establishments.

I questioned a colleague of mine who regularly attends a Hindu prayer gathering in Burlington, Vermont, about what they do together as a group. She explained that they pray, sing, and have discussions, but a large part of what they do together is social service, particularly for immigrant populations. Social work is, for this group, a meaningful way of coming together as a community; moreover, it instills important values in their children. Since she has relatives in Austin, I also queried her about how she responded to the temple and deities at Barsana Dham. She told me that, while it is always a nice experience to have *darshan* of the deities, it is no longer a priority for her: "It is a beautiful place to get lost in," she replied, "but ultimately I feel I can make more of a contribution in other ways."

The Real and the Ideal

Barsana Dham promotes itself as being a literal recreation of Braj—so much so that, if a person cannot make the journey to Krishna and Radha's sacred land, a pilgrimage to Texas can take its place. Indeed, Barsana Dham more closely matches the ideal of Braj than the reality of Braj itself, by virtue of its serene perfection and idyllic physical context. The expansiveness and natural beauty of the place, the controlled and static predictability of the *darshan* experience, the carefully crafted symbolic equations with Braj topography—all conspire toward a lovely, peaceful environment that might indeed bring to mind some of the rapturous poetry so endemic to the worship of Krishna and Radha. What does it mean, then, when the *idea* of a place potentially substitutes for the place itself?

It seems to me that the tension between the "real" and the "ideal" lies primarily in the differing connections between *place* and *presence*. Radharamana, Radhavallabha, and Govindadeva all manifested themselves in Braj at a particular historical moment to particular historical figures. Since then, they have each—in their own ways—been magnets and anchors for sacred activity. Never does the priest or

devotee forget that the gods' presences in our human time frame are acts of sacred benevolence and self-will: all of these deities made a choice to be (re)discovered. The power of place and history is thus delivered to humanity through their bodily presences; their bodies—originating in the sacred domain of Braj—metaphorically bring the sacred past forward with them, and their bodies are living testimonies to many hundreds of years of ritual attention. Thus, the Radharamana, Radhavallabha, and Govindadeva temples each have, at their cores, a sacred manifestation that validates their fundamental reason for being; everything else works around the deities' presences. The architecture is secondary, and even the grander, more formalized Govindadeva temple is but a refurbished version of an original garden or pleasure pavilion. The Govindadeva temple served as a point of orientation for the fledgling city of Jaipur only after Govindadeva was installed there and made the place meaningful with his divine presence. Moreover, Govindadeva himself brought Braj to Jaipur.

In contrast, Barsana Dham works, as it were, from the outside in. The temple's story is different: its establishment is attributed to the work of its founder, Swami Prakashanand Saraswati, who envisioned it in 1988. After looking around in a number of different states, he decided on the 200-acre property in Texas and purchased it in 1990.[22] The resonances in topography are thus the driving force behind its existence, while the images of Radha and Krishna are but symbolic place-markers—an attractive focus for prayer and meditation, but not the point of the temple's reason for being. Barsana Dham is thus about the power of place and not about the original enlivening presence of a sacred manifestation.[23]

Are the Radharamana, Radhavallabha, and Govindadeva temples relevant if Barsana Dham exists? Will the new community-based, middle-class diaspora no longer feel the need to physically connect with the soil of Braj? Will jazzy new technologies and the easy portability and adaptability of images render a visit to Krishna's homeland an antiquated idea? Having experienced many ways of seeing Krishna, both in India and in the diaspora, I personally believe that there will always be a need to touch base with the actual self-manifestations and original witnesses to sacred history. No matter how skillfully Braj or anywhere else is "recreated," the power of place is made far more meaningful by the presence of divinity. But, as we will consider in the conclusion, Braj itself is in serious danger of being once again lost to human consciousness.

Conclusion: All Dressed Up
and Everywhere to Go

Where have all this looking and talking about looking taken us? Moving far beyond my initial bewilderment at "all *darshan*s are the same" and "the god was dressed elaborately," I found instead that the rich visual practices of the Radharamana, Radhavallabha, and Govindadeva temples reward the interested viewer with a fascinating profusion of meanings. Especially intriguing are the many ways in which individual temples employ related yet divergent visual strategies for telling their stories. We have seen how each temple centers its narrative on a specific self-manifestation of Krishna that revealed itself to the temple's founder; and we have also explored how those self-manifestations—the bodies of all those expressions of Krishna's presence—in turn variously constitute the meeting places between divinity and humanity, past and present, priesthood and worshipers. The synergy created by the interactions of each temple's history, identity, and sectarian distinctiveness with contemporary ritual and visual practices keeps them alive and meaningful for the present generation of worshipers. Temple traditions continue to be relevant because they are not wedded to a single mode of presentation: they are instead dynamic, adaptive, evolving, and responsive to the culture at large. What we learn from the specific temple displays explored in this book is that ornamentation is never neutral; instead, ornamentation comprises a continuum of calculated visual messages that broadcast each temple's ode to its own history and that are continuously calibrated to have maximum effect on contemporary audiences.

These visual messages are relayed through the ever-changing presentations that each temple organizes on an ongoing basis throughout the ritual year. Central to these visual spectacles is the elaboration and beautification of the deity and the temple, his sacred domain. We have learned that such ornamentation constitutes

a language unto itself, consisting of numerous complex codes that demand some level of cultural literacy in order to interpret what is being communicated. I have been especially struck by how critical is some understanding of the machinations of time for coming to terms with much of what one sees in temple display; and I have been equally struck by how understudied this notion is in most analyses. At any given time, multiple codes of signification may be layered atop one another, reflecting events occurring on the macrocosmic level of the universe at large while at the same time making reference to the microcosm of the individual temple and its specific and unique self-manifested body of god.

In addition, while each of the temples cited in this book rotates on its own temporal, historical, and contemporary axis, each also asserts its unique place in the larger matrix of Braj devotionalism and sectarian history. An important theme for those lineages and temples that connect themselves back to the sixteenth-century rediscovery of Vrindaban is their relationship to Chaitanya, be it direct or by association. No discussion, for example, of the Radharamana temple is complete without noting the vital links that are actively forged—most notably through the temple arts—between the present and the past and that keep the sixteenth-century biography of the temple and its self-manifestation of Radharamana meaningful for the twenty-first century. The Radhavallabha temple, by contrast, bases its narrative on a non-Chaitanyaite founding figure and a correspondingly divergent vision of Vrindaban's rediscovery. In so doing, it sets itself apart from the Chaitanyaite version of history, and its visual traditions reflect its unique sectarian practices and perspectives. For the Govindadeva temple, the deity's original discovery in Vrindaban is further interwoven with the founding narrative of Jaipur. References to Chaitanyaite and Kachchwaha meta-histories converge in Govindadeva's sacred body: the miraculous biography of the god's self-manifestation, its association with one of Chaitanya's followers, its connection back to Krishna via Vajranabh, its patronage by Kachchwaha royalty in Vrindaban, its flight westward, and finally the refashioning of Rupa Goswami's lord of the cows into the lord of Jaipur. The current head custodian keeps the deity's complex historical narrative alive through the visual performances of regular *darshans* and periodic *utsavs*. Managing a large city temple with such a freight of historical significance is a tall order, and the weaving together of all these multiple strands requires constant care and attention, particularly in the face of the changed circumstances of Govindadeva's patronage.

Could all of this information or these analyses have been gleaned from texts? Assuredly not, for it is only through the temples' visual cultures that the rich mixture of historical circumstance, sectarian distinctiveness, temporal positioning, interested patrons, and priestly authority fully and simultaneously comes to life. The temple arts not only make publicly visible the main traditions and accepted practices of the individual temples, but they also serve as barometers of the concerns and priorities of contemporary priests and patrons. Khichri Utsav at the Radhavallabha temple, for example, incorporates themes and disguises from the world outside the temple's doors, while the newer practice of *adhik mas* provides a potent illustration of what can happen when devotees are invited to participate in the temple's scheduling of visual displays. Innovations and adaptations, far from being threats to the established order, can thus provide important information about how these temples negotiate between the present and their pasts in ways that could never be recovered from written texts or by privileging the histories of their art and architecture.

The role of ornamentation in all of these cases is an active one. As we have seen, the decoration of the god and his environment might be variously understood as expressions of loving service, sectarian individuality, political reclamation, public accessibility, or priestly exclusivity—and this is not an exhaustive list. Yet the invisibility or seeming triviality of ornament as a category worthy of analysis has usually prevented such an expansive reading of its potential cultural significance. The presumed ordinariness of ornamentation can lead to a sort of cultural blindness; coming to terms with the actual significance of visual display instead demands that we look closely and approach the material from a different perspective than is customary in most academic practice. In this vein, the anthropologist Grant McCracken notes in an article about "clothing as language" that "we may ask whether material culture as a means of communication works in more understated, inapparent ways than language." He continues:

> The inconspicuousness of material culture gives it several advantages as a means of communication. First of all it makes material culture an unusually cunning and oblique device for the representation of fundamental cultural truths. It allows culture to insinuate its beliefs and assumptions into the very fabric of daily life there to be appreciated but not observed. It has to this extent great propagandistic value in the creation of a world of meaning.

Furthermore, the inconspicuousness of the messages of material culture also permit them to carry meaning that could not be put more explicitly without the danger of controversy, protest, or refusal. Particularly when the message is a political one and encodes status difference, material culture can speak sotto voce.[1]

Indeed, the very ephemerality of ornamentation and display renders them all the more interesting and valuable for analysis: they are constantly refreshed, they are dynamically representative of the historical and cultural moment, and their message is generally relatively transparent, if perhaps subtly so. If we think about adorning Krishna's body as an ongoing series of meaningful artistic events—and not as the seemingly meaningless dressing up of a stationary image-as-art-object—then we get closer to the real significance of the visual arts in the kind of religious contexts we have considered in this book.[2] The transitory, ever-renewed sequences of visual embellishments that make their way on and off the body of the god alert us to the important idea that we—at least within the context of this particular aesthetic tradition—need to loosen our constraints about what does and does not constitute "real art." Additionally, the importance given to renewal and change points to a deeply felt cultural impulse toward newness as an expression of auspiciousness and religious efficacy. The continual provision of material abundance for one's chosen deity has positive connotations of providing the best one has to offer for the beauty and enjoyment of one's beloved. Ideally, beautiful ornamentation in the form of exquisite clothing and accessories and the creation of an aesthetically pleasing and seasonally attuned environment for Krishna and Radha should be understood as an act of love and not as a showcase for material ostentation.

A cautionary note: I say "ideally," for it would be misleading to purvey the notion that all temple displays are exquisite assemblages of refined and rarified visual choices. In fact, much, if not most, of what one sees in contemporary temple decoration is of questionable taste—at least if one is using the classical aesthetic canon as a measuring rod. And here is where it becomes even more important to come to terms with what exactly hereditary temple priests trained in the Chaitanyaite and allied sectarian traditions are meant to be doing when they adorn the body and the environment of the self-manifested god who is in their care: they are the curators of a highly aestheticized ritual tradition that equates beauty with religious devotion. To their hands is entrusted the continuity—or the disintegration—of centuries of refined classical training in the

worship, care, feeding, and multiple-times-daily ornamentation of Krishna's manifestation.

The elevated aesthetics maintained and cultivated, for instance, by Purushottama Goswami's family and their interested patrons are intended to serve as the highest expression of selfless devotion to Krishna in his Radharamana form. The level of refinement seen in this *goswami* family's marshaling of the best of the temple arts also reflects deeply embedded notions of traditional religious training and education: elegant restraint and careful attention to aesthetic subtleties are part and parcel of Chaitanyaite practice, and the *goswami*s are committed to keeping these centuries-old traditions alive and relevant. It bears repeating that, in this religious milieu, the cultivation of "good taste" is less about manifesting the skills of the god's human caretakers and more about making choices that are pleasurable for the god and his consort. Visual practices that might, however, be considered in "bad taste" are telling in the ways that they disclose the fissures, departures, and misguided notions that can and do surface when money, desire, prestige, competition, and the opportunity for public display converge and conflict with such pure aesthetic ideals.

A controversy involving the Banke Bihari temple in Vrindaban vividly elucidates the problems that can surface when new ideas run up against long-standing traditions. In August 2006, the congregation at Vrindaban's most popular temple witnessed something unexpected: the figure of Banke Bihari was dressed in jeans and a T-shirt and carrying a mobile phone (some say it was a toy; others say it was a new model of a popular brand). Amid cries of outrage, threats of protests, widespread media coverage, opinion polls taking place via text messages, and a looming court case, the *goswami* responsible for the display countered with the explanation that the outfit was placed upon Banke Bihari's body as a favor to a wealthy patron. The Kolkata newspaper the *Telegraph* quoted one of its sources as saying, "The *sevait* [patron], a wealthy businessman, had bought a pair of jeans for his sick, six-year-old son and asked that the clothes be put on the idol before he took them to the boy. He said he believed the clothes, hallowed by contact with the god, would cure his son."[3] And further, "For good measure, he also asked for the toy mobile [phone] he had bought to be put in the god's hands." The beleaguered and chastened *goswami*, for his part, claimed that such an act was not sacrilegious. It was merely a part of Krishna's bag of playful tricks: "A new face and a new trick every

day, that's the hallmark of Krishna. What sin have I committed?" he asked. This case brings to the forefront many important issues that will continue to be increasingly important as India modernizes. That this controversy was sparked by what was placed upon the god's body only underscores how highly charged the language of ornamentation is to Krishna's devotees. It also makes unambiguously clear the power of visual traditions: even though freshness and innovation are welcomed, there are important boundaries that seemingly should not be crossed. The closest analogy with this situation might be Khichri Utsav at the Radhavallabha temple, but there these types of costume occur only as part of a very specialized moment in the temple calendar.

The ongoing theater of multiple daily *darshans* is thus sustained by the connections forged among divinity, temple priests, and the audience of worshipers who arrive at the daily performances primed to respond to what is offered. That the terms of the *darshan* displays can be inconsistent and are dependent upon an organized, yet not entirely unified, priesthood brings to mind Stephen Greenblatt's comments on the social energy of Shakespearean theater:

> For the circulation of social energy by and through the stage was not part of a single, coherent, totalizing system. Rather it was partial, fragmentary, conflictual; elements were crossed, torn apart, recombined, set against each other; particular social practices were magnified by the stage, others diminished, exalted, evacuated. What then is the social energy that is being circulated? Power, charisma, social excitement, collective dreams, wonder, desire, anxiety, religious awe, free-floating intensities of experience.[4]

Ornamentation, then, is a potent cultural category that has emotionally and spiritually transformative—and not simply descriptive—value. The embellishment of the god and his temple draws upon a vast repertoire of imagery stored in poetry, song, drama, dance, painting, sculpture, architecture, and the cosmic and natural worlds. The landscape of Braj is made divine, embodied, and given shape; references to the rivers, mountains, forests, flowers, and a whole spectrum of natural forms find their ways onto and around the body of the god and his consort. This is deeply mined for every possible nuance of emotion and sensuality. The images under consideration in this book thus take up their stations in a larger symbolic universe, aspects of which are communicated through a complex and multivalent visual vocabulary. To consider

them and their temple frameworks in isolation would be to miss the point: it is within the whole context of life-and-worship in Vrindaban—the theater of the place itself—that visual displays become wholly meaningful. One has to be tuned into the mythology, the cosmos, the landscape, the calendar, the patronage, the *goswamis*, the temples' own stories, and the many levels and layers of emotional investment to fully understand what these visual productions "mean." Critical to this process of understanding is emotional and devotional surrender: to truly be able to see, one needs to be vulnerable and open to possibility. As Mohit from the Radhavallabha temple gently reminded me, "You need to see with your heart, and not just your eyes."

A Dying Utopia

Krishna's ornamentation draws its inspiration and visual vocabulary from a deeply sedimented and affective notion of the unsullied, pure, celestial Braj. The blue god's homeland is envisioned as a productive and seductive domain of sacred ponds and rivers, verdant forests, fragrant flowers, abundant wildlife, contented cows, lovely changes of season, and playful inhabitants who while away their days in love games.[5] But the contemporary terrestrial Braj has taken a beating, and the centuries have not been kind to Vrindaban. For all its vitality as a pilgrimage destination, today's Braj, and Vrindaban in particular, is profoundly—perhaps irrevocably—threatened with environmental degradation and overpopulation, both of humans and animals. The circumambulatory pathway (*parikarama*) that surrounds the holy town is now paved, blocking access to the sacred ground and obstructing proximity to the river. Vehicular traffic clogs the pathways and threatens pilgrims on foot. Splashy billboards advertise high-rise condominium developments with images of impossibly pristine swimming pools and landscaping more reminiscent of Las Vegas than Vrindaban. These appeal to wealthy pilgrim-consumer fantasies of living the peaceful, spiritual life in Krishna's playground, and they exhort passersby on the highly modern Mathura-Delhi Road with enticing promises: "Radha Puram: Where Luxury and Peace Reside"; "Sri Ji Garden: 24-Carat Precious Look at Life!"; "Bai Kunth: The Modern Side of Spiritual Living." Gleaming new temples, ostentatious guesthouses, and a myriad of other construction projects line the road into Vrindaban, gradually encroaching upon the open fields that once epitomized the idyllic pastoral homeland of Krishna.

Shrivatsa Goswami, who is an environmental activist deeply committed to the salvation of Vrindaban, decried the ways in which rapid development is overtaking the town and its outskirts. Likening the process to everyone building their own private Taj Mahal, he commented that people are no longer "satisfied with Vrindaban itself. Everyone has to construct his own temple and appropriate sacred space to create their own sanitized version." In an interview for the *Religion News Service,* he elaborated: "It is a painful subject. . . . In those [old] days, this place had the most beautiful riverside architecture in India's history. It was like a miniature painting come alive."[6] And further, the interviewer reported: "Goswami notes that previous generations of temple authorities understood the importance of holy places and took responsibility for their maintenance. Today, he says, that sense of stewardship is absent."[7]

Let us briefly revisit the theme of nostalgia, utopia, and the myth of Braj to which I made reference at the beginning of this book. The sacred landscape and the seminal role of historical visionaries in re-establishing it in the sixteenth century and later have been dominant threads in our discussion of the roles of specific temples and their gods; this motif looms large in each temple's ongoing project of constructing and maintaining its self-identity. We saw in the previous chapter that the myth of Braj is so compelling that it has prompted at least one replication in Texas, at the Barsana Dham temple, and ISKCON temples worldwide purvey a similar sanitized notion of Braj-as-utopia. We might wonder if this is indeed the future of the past.

Up to this point, the temple arts and ornamentation have been discussed in terms of their aesthetic, religious, cultural, and historical significance. Much has been made of the rarified ideals, the beautiful materials, and the idyllic visionary world that the divine couple occupies and that temple presentations make visible. But, as I noted in passing earlier, that visionary world begins and ends at the temple threshold. Once one steps outside of the temple, the visitor will very soon encounter the complete and utter breakdown of public sanitation, mountains of trash, clogged sewage drains, crumbling architecture, hideous new construction that is instantly a ruin, a filthy and poisoned Yamuna River, and predatory monkeys that are bold enough to steal glasses off the faces of passersby and food out of the hands of babies. It would be irresponsible of me to ignore this; I cannot turn a blind eye to the fact that Vrindaban is suffering from overuse, over-population, and municipal chaos. The town is groaning under the weight of the centuries and the constant use and abuse of its natural

and architectural features. It is easy to see how the idealized interior world of the temple thus becomes a refuge from the environmental degradation that threatens to overwhelm the outside world.

That threat is imminent and urgent, and I expect that many would argue that lavish temple displays are simply an arrogant denial of this much more compelling reality; temple priests and patrons alike might be accused of fiddling while Rome burns. Indeed, the concurrent process of cultural construction in the face of natural destruction is reminiscent of what Jared Diamond describes in his book *Collapse: How Societies Choose to Fail or Succeed*. Using the Vikings as a case study, he details how they left Norway and resettled in Greenland, only to self-destruct 450 years later because they could not adapt their heavily livestock-oriented diet and farming practices to the very different geographic and climatic realities of their new home. Even at their lowest moments, when they resorted to eating their household pets, the Norse Vikings held out. They could not bring themselves to follow the native Inuit practice of drawing from the bounty of the sea; ultimately, they starved to death. In a review of Diamond's book, Malcolm Gladwell summarizes the real issue: "Why did the Norse choose not to eat fish? Because they weren't thinking about their biological survival. They were thinking about their cultural survival."[8] So, too, might lavish temple displays represent holding on to culture while ignoring the collapse of nature. It is entirely reasonable to ask "why is money going into temple displays?" instead of, for example, civic improvement or charitable causes.[9]

It is easy to be critical, but I would submit that temple displays make real the ideal in ways that will be as meaningful and relevant for the future as they have been in the past. Beautiful temple *darshans* physically create, and continually recreate, aesthetic and material visions that have meaning and power because their visual vocabularies are rooted in the hallowed soil and deeply sedimented sacred history of Braj. The ephemerality, fluidity, and constant renewal of the visual presentations that circulate around and on the body of Krishna endow them with the ability to always be responsive to the present while still perpetuating tradition. In closing, I recall the words I often heard when people learned about my research: "No one comes to Braj by accident. You have been called by Krishna, and you are very blessed."

Notes

<div style="display:flex">

<div>

Prologue

1. Goswami, *Srimad Bhagavata Mahapurana*, 646.

2. Kapur, "Deity to Crusader," 88.

3. John Cort has written extensively about art and religion in the Jain traditions; see especially his *Jains in the World: Religious Values and Ideology in India* and his "Bhakti in the Early Jain Tradition." Joanne Waghorne piqued my early interest in the language of ornament with her "Dressing the Body of God." Richard Davis discusses the affective aspects of Indian religious works of art in his *Lives of Indian Images*. The most recent and highly relevant study is Dehejia's *The Body Adorned*, esp. 25–74; her sensitive study only just became available as this book was going to press.

4. These images are not merely sculptures, or icons, or idols, as they are frequently named. Instead, they are considered special representations or manifestations of Krishna; they are embodiments of divinity requiring round-the-clock care and devotion.

5. See *The Baseball Almanac*.

6. There is an extensive body of literature on the related and extremely lavish visual traditions of the Vallabhacharya—also known as Pushti Marg—denomination, which is most active in southern Rajasthan and Gujarat, but there is nothing comparable for the visual practices of the Gaudiya (Chaitanya) or Radhavallabha Vaishnava traditions. For the Pushti Margs, see Bennett, *The Path of Grace*; Ambalal, *Krishna as Shrinathji*; and Lyons, *Artists of Nathadwara*.

7. Shukla, *The Grace of Four Moons*, 169–170, describes the same sorts of stores and merchandise in Vishvanath Gali, Varanasi.

8. Morgan, *Visual Piety*; McDannell, *Material Christianity*; and especially articles by Kajiri Jain, Christopher Pinney, and Sumathi Ramaswamy in Sumathi Ramaswamy, ed., *Beyond Appearances?* See also Kajiri Jain's *Gods in the Bazaar*.

9. Some believe that Hit Harivansha was one of Gopala Bhatta's devotees, but they parted ways over certain theological disagreements.

</div>

<div>

Introduction

1. Shiva, for example, must don the garb of a *gopi* to gain access to Krishna. See Haberman, *Journey through the Twelve Forests*, 21–23.

2. For a discussion of these, see Burton-Page, "The Early Vrndavana Temples," 123–127.

3. There is an extensive bibliography on the history of this region. See especially Vaudeville, "Braj, Lost and Found"; see also her "The Cowherd-God in Ancient India"; Growse, *Mathura*; Srinivasin, "Vaisnava Art and Iconography at Mathura." For an alternative reading of the relationship between ancient practices and the later domination of the Krishna cult, see Sanford, "Shifting the Center."

4. Vaudeville, "Braj, Lost and Found," 199: "the city of Mathura itself is not central to the Cowherd god's legend: it proves but an entrance and an exit."

5. Haberman, *Journey through the Twelve Forests,* is wonderfully evocative and informative.

6. Ibid., 126. The *tulsi* plant—ubiquitously enshrined in planters in temple courtyards—is circumambulated and its leaves are often offered as a form of *prashad*. Tulsi, a form of the goddess Vrinda, is emblematic of the forests of Braj and, by extension, emblematic of the natural world of Krishna.

7. Chadwick, "Geography of Heaven."

8. Ibid., Nov. 1, 2005.

9. Vaudeville, "Braj, Lost and Found," 199–201. Vaudeville details the litany of loss and recovery that continues to be put forth today.

10. Haberman, *Journey through the Twelve Forests*, 54–55.

11. Ibid., 54. Vaudeville, "Braj, Lost and Found," 199, explains:

> [T]he whole of Vaisnava sectarian literature, from the sixteenth century to this day, asserts that the *lila-sthalas* had all but totally disappeared long before the two great Reformers, Vallabha and Caitanya, arrived in Braj at the beginning of the sixteenth century. By that time, but for Sri Giriraj (the Govardhan Hill) and Sri Jamna Ji (the river Jamna)—both, as we have seen,

</div>

</div>

reckoned as *svarupa*s of Sri Krsna—all the famed *lila-sthala*s were "lost" or had become "invisible." For a good summary of Chaitanya's biography, see Case, *Seeing Krishna*, 64–66.

12. Haberman, *Journey through the Twelve Forests*, discusses Chaitanya's Braj itinerary and rediscoveries, 64–66.

13. The notion of the Six Goswamis as a single group was not consolidated until after the production of the *Caitanyacaritamrita*, a hagiography of Chaitanya written by Krishnadas Kaviraja; see Rosen, *Six Goswamis*, 29–30. For the *Caitanyacaritamrita*, see Dimock and Stewart, *Caitanya Caritamrita of Krsnadasa Kaviraja*.

14. David Haberman explains this development well in his *Acting as a Way of Salvation*, 30–39. Haberman also provides a good synopsis of historical developments in his translation of *The Bhaktirasamrtasindhu of Rupa Goswami*, xxx–xxxv. See Case, *Seeing Krishna*, 157n4, on the advisability of using the term "Chaitanyaite" instead of "Gaudiya."

15. Haberman, *Journey through the Twelve Forests*, 120. Hardy, in *The Religious Culture of India*, 318, writes that the physical re-mapping of Vrindaban was an aberrant and possibly unnecessary project, but the end result was to recreate in quite literal terms a heaven on earth: "One is pulled, as it were, upwards in an upside-down funnel, into the eternity of heaven. The trees, stones, rivers, flowers, and the grass of the earthly Vrndavana make up a physical 'poem' which yields *bhakti-rasa* to the devotee, providing the force that pulls him into eternity."

16. Davis, "Religions of India in Practice," 33, contextualizes the term as follows:

> The term *bhakti* is usually translated as "devotion," but its meaning is more complex than our English equivalent would suggest. *Bhakti* comes from the verb root *bhaj*. In its earliest usage, *bhaj* means to divide or share, as one divides and partakes of the sacrificial offerings. *Bhaj* can also denote experiencing something, as one enjoys food or relishes music. It signifies waiting upon someone, as an attendant serves a king. It can mean to make love in a very corporeal sense and to adore in a more disembodied, spiritual manner. As its Indian adherents define it, *bhakti* partakes of all of these shades of meaning.

17. Nelson, "Bhakti-Rasa for the Advaitin Renunciate," 2. See also Dehejia's helpful discussion of ancient Indian aesthetic theory in *The Body Adorned*, 12–14.

18. Miller, *Love Song of the Dark Lord*, 15.

19. Nelson, "Bhakti-Rasa for the Advaitin Renunciate," 4: Aesthetic theory helped the theologians of Krsnaite devotion deal with several important problems. How, for example, could the devotees actually realize the emotions experienced by other persons who were actors in a sacred drama that was, whether temporally or metaphysically, removed from them? And, particularly perplexing, how could one, if they wished to enjoy the bliss of the highest *bhakti*, experience the love cherished by the cowherd women of Vrindavana [the *gopis*] for the male character Krsna? Fortunately, almost identical questions had already been explored in depth by the writers on Sanskrit aesthetics, using especially the idea of transcending personal temporal limits through aesthetic generalization. . . . Moreover, the aestheticians had developed the theory of *srngara-rasa*, the erotic sentiment, to a high level of complexity and detail. . . . This made the *rasa-sastra* well-suited to the needs of the Gosvamins, who were above all concerned with explicating the nuances of the ecstatic love-relationship of Krsna and the *gopis*.

20. Case, *Seeing Krishna*, 76. It should be noted that self-manifestations abound in Indian religion; the ones considered in this study garner special attention because of their specific connection to the past and their continuing importance today.

21. Case, *Seeing Krishna*, 76.

22. See Pika Ghosh's fascinating discussion about the seventeenth- to eighteenth-century temple town and pilgrimage center of Vishnupur, West Bengal, which was believed to be a "hidden or invisible Vrindaban," as symbolically potent as its Braj prototype. Ghosh, *Temple to Love*, 24; and her "Tales, Tanks, and Temples."

23. Haberman, *Acting as a Way of Salvation*, 74.

24. Case, *Seeing Krishna*, 3, comments on the power of stories of Krishna's life for devotees: "They are for millions of people the spiritual 'glue'—as well as 'lubricant'—that holds together individuals and families and eases the frictions of family life."

25. Huyler, *Meeting God*, 36. The classic reference work on seeing is Eck, *Darsan: Seeing the Divine Image*.

26. Pravina Shukla's discussion of the gaze and the importance of ornamentation is a welcome corrective; see her *The Grace of Four Moons*, 26–38, 169–172. Another exception is Joanne Waghorne's work on South Indian *utsav murti*s; see her "Dressing the Body of God." John Cort also writes in "The Jina as King," 47, that "scholarly discussions of *darsana* have been largely phenomenological in approach." See also the interesting work being done on *darshan* and new media, as in Hawkins, "Bordering Realism."

27. Nayar, *Poetry as Theology*. And seeing the god repeatedly is similar to the ways in which poetic appreciation works; see J. L. Masson's discussion of the "poetic universe" in *Aesthetic Rapture*, 20, where he cites the theorist Abhinava: "Unlike other forms of communication, we read a poem over and over again: 'Aesthetic relish is seen (produced) by the repeated recitation . . . of words, which constitute poetry. For we find that the sensitive reader reads the same poem over and over again (and thereby) enjoys it (all the more).'" Vijay Mishra also observes, with reference to Jayadeva's *Gitagovinda*, "the poem thus has a kind of stilled dramatic structure," in his *Devotional Poetics and the Indian Sublime*, 117. Finally, there is a helpful discussion of the context of these same poets in Dehejia, *The Body Adorned*, 138–144.

28. Davis, *Lives of Indian Images*, 41.

29. Nayar, *Poetry as Theology*, 195.

30. Hopkins, "In Love with the Body of God," 45.

31. Dehejia, *The Body Adorned*, 144.

32. Rosen, "Introduction," *Journal of Vaisnava Studies*, 1.

33. Sanford, *Singing Krishna*, 61.

34. Coomaraswamy, "Ornament," 252.

35. Harlan, *The Goddesses' Henchmen*, 206.

36. Aitken, *When Gold Blossoms*, 9.

37. While I will put off a discussion of devotees' responses to temple *shringar* until later, here I will simply say that the classical definition of *shringara rasa* (the erotic sentiment) plays a background note to how *shringar* will be discussed in the following pages. Priests, of course, think in highly theoretical terms, but the populace in general does not.

38. Hopkins, "In Love with the Body of God," 30, in discussing the South Indian devotional context, explains: "The terms used by both the poet and his scholastic commentators for such an ecstatic, limb-by-limb seeing of God's body . . . are all cognates of the Sanskrit word *anubhava*: 'experience,' 'perception' and, in Srivaisnava theology, 'enjoyment.'"

39. Snell, "The Nikunja as Sacred Space," 64. Carroll, *Through the Looking Glass*, 95.

40. Doniger O'Flaherty, "Impermanence and Eternity," 83–85. She continues:

> The material traces of ritual art must vanish in order that the mental traces may remain intact forever. It is as if a choice were made, somewhat like the choice that one makes when viewing a beautiful scene in a foreign land: If one photographs it, one has preserved it (more or less) forever, but the act of photographing it may interfere not only with the full experience of it at the moment but with one's own power to preserve it in memory.

41. This dichotomy, termed "commonplace" versus "cosmic," by Kenneth E. Bryant in his *Poems to the Child God*, 34n34, is not always as polarized as it seems: it can also be used to produce a dynamic creativity that he calls an "epiphany."

42. Haberman, *Journey through the Twelve Forests*, 163.

43. Davis, "Introduction," in *Religions of India in Practice*, 30. See also his *Lives of Indian Images*, 27–29.

44. Sanford, *Singing Krishna*, 16.

45. See Vasudha Narayanan's useful discussion on the topic of material manifestations of divinity, "Arcavatara: On Earth as He Is in Heaven."

46. A similar apprehension plagues the studies of Christian religious objects. In her important work *Material Christianity*, 4, Colleen McDannell asserts that "[o]ne of the reasons why the material dimension of American religious life is not taken seriously is because of how we describe the nature of religion. A dichotomy has been established between the sacred and the profane, spirit and matter, piety and commerce that constrains our ability to understand how religion works in the real world."

47. Varma, *Being Indian*, 61.

48. Waghorne, *Diaspora of the Gods*, 36.

49. Morgan, *Visual Piety*, 24–25.

50. Ibid., 26–27. See also McDannell's chapter on Christian kitsch in *Material Christianity*, esp. 187–188.

51. Jain, "More than Meets the Eye," 56.

52. Ibid., 60. In some sense, if the images of Krishna that we consider in this book were to be (re)categorized as fetishes, and not as the important religious manifestations that they are, then the response to them might be more easily explained as capricious behavior occasioned by a special category of image that resides outside the category of "art."

53. Pinney, "A Secret of Their Own Country," 116.

54. Haberman, *The Bhaktirasamrtasindhu of Rupa Goswami*, xxvix, states:

> With this in mind, past scholars have often characterized the whole of the religious traditions of Hindu India as involving disciplined spiritual paths that aim to suppress the emotions. This view is limited, however, for besides the emotion-negating philosophies we find in India traditions that, while agreeing that emotions are problematic if left in their ordinary state, go on to maintain that under the right conditions they have the ability to be supremely useful in the spiritual life.

55. Pinney, "A Secret of Their Own Country," 115.

56. Ibid., 116.

57. Ibid.

58. Reproduced in Pinney, *"Photos of the Gods,"* 93, fig. 69, where he notes that this 1934 offset print of Krishna as *Murli Manohar* by the famed Nathdwara artist Narottam Narayan Sharma is "[r]eputed to be the biggest-selling image in the history of the industry."

59. Pinney, *"Photos of the Gods,"* 93. Contrast this to the more Indian miniature traditional-style painting, although with clear Western inflections, seen in Neumayer and Schelberger, *Popular Indian Art*, 102, pl. 88. See also Kajiri Jain's insightful comments on the sources and transformations of painted landscape backgrounds in her article "New Visual Technologies in the Bazaar," 55.

60. Pinney, "A Secret of Their Own Country," 118.

61. McDannell, *Material Christianity*, 164; see also her remarks on gender anxiety and religion, 194–195.

62. Hawley and Goswami, *At Play with Krishna*, 17: "The Vaisnavite tradition, then, is totally unembarrassed about the role imagination plays in the religious life. If the worship of images sounds like playing with dolls, let it: it is the spirit, the affection, the *bhav*, as they say, that counts; and it is the dramatic situation that makes this flow of emotion possible."

63. Morgan, *Visual Piety*, 50.

64. Aitken, *When Gold Blossoms*, 9.

65. McDannell, *Material Christianity*, 6.

66. Ramaswamy, "Introduction," in *Beyond Appearances?* xv.

1. The Radharamana Temple

1. Haberman, *Journey through the Twelve Forests*, 14, discusses further the meaning of Vrinda, *tulsi*, and Yamuna.

2. Schweig, *Dance of Divine Love*, 125–130, reviews some of the most enduring tropes about Braj as a pastoral paradise.

3. Rosen, *Six Goswamis*, 18–21; Goswami and Beeche, *Celebrating Krishna*, 66–67.

4. Shrivatsa Goswami pointed out to me that Sanatana Goswami's commentary on the *Hari Bhakti Vilasa* says that the author is Gopala Bhatta.

5. Rosen, *Six Goswamis*, 74–76. See also Valpey, *Attending Krishna's Image*, for a detailed discussion of the Radharamana temple and its Chaitanyaite practices.

6. Case, *Seeing Krishna*, 75. See also Rosen's account, *Six Goswamis*, 77–79.

7. Case, *Seeing Krishna*, 75. Goswami and Beeche, *Celebrating Krishna*, 67, also note that Gopala Bhatta received Chaitanya's begging bowl.

8. Case, *Seeing Krishna*, 76.

9. Haberman, *Journey through the Twelve Forests*, 32–33, provides a beautiful rendition of the discovery by Rupa Goswami of Govindadeva.

10. Dasgupta, *Obscure Religious Cults*, 124–125.

11. Haberman, *The Bhaktirasamrtasindhu of Rupa Goswami*, xxx.

12. Ibid., xxxv.

13. I base this comment on extended personal observations and on conversations with Shrivatsa Goswami and other *goswamis* in the Radharamana and other temples.

14. Delmonico, "How to Partake in the Love of Krishna," 247. This practice of visualizing the day in eight segments as expounded in Krishnadas Kaviraja's late sixteenth-century *Govindalilamrtam* (Ambrosia of the Sport of Govinda) most probably pre-dates the Chaitanyaite theorists; see Delmonico's discussion of the sources and inspirations on 247–248.

15. There is a lovely summary of Krishna's day in the temple in Hawley and Goswami, *At Play with Krishna*, 7–9. For a translation of a version of this daily schedule from the *Padma Purana*, see Delmonico, "How to Partake in the Love of Krishna," 263–268. Other Krishna devotional sects, such as the Pushti Margs and the Radhavallabhis, also follow variations of the *ashtayama lila*; see Hawley and Goswami, *At Play with Krishna*, 275–276n34, for an extended discussion of the similarities and differences between *sampradayas*.

16. Delmonico, "How to Partake in the Love of Krishna," 263.

17. Joshi, "How to Watch a Hindi Film," 23.

18. Some of this material has appeared previously in my "Time and Time Again."

19. I admittedly use the term in a different way than Davis does. See Davis, *Ritual in an Oscillating Universe*.

20. Untracht, *Traditional Jewelry of India*, esp. 305–307; Patil, *Celebrations: Festive Days of India*. Both provide useful charts and diagrams.

21. Goswami and Beeche, *Celebrating Krishna*.

22. Case, *Seeing Krishna*, 92; see also Hawley and Goswami, *At Play with Krishna*, 6–7: "The *gosvamis* in the temple of Radha Ramana and the other great temples of the city facilitate this learning to see. At Krishna's bidding they assist him, in his image, in his daily round[s]."

23. Case provides a very good description of the Radharamana temple in *Seeing Krishna*, 78–82.

24. There is some misperception that Vrindaban is a quaint medieval pilgrimage town eternally preserved in the mythic past, but Vrindaban has all the hallmarks of a global religious destination and is populated by a wide range of visitors—from long-term ISKCON residents and other westerners who have sought spiritual guidance from the area's multitude of gurus to day-tripping NRIs (nonresident Indians) from Delhi.

25. A short while later, there was another *arati*, this time with nine tapers. Case, *Seeing Krishna*, 89, describes in great detail the daily liturgy of the Radharamana temple.

26. Hawley and Goswami, *At Play with Krishna*, 17.

27. Haberman, *Acting as a Way of Salvation*, 38. Case, *Seeing Krishna*, 39, explains, "For Caitanyaites, truth is a matter of 'both/and.' Krishna is transcendent, but he is also immanent, universal, and multiple."

28. Goswami and Beeche, *Celebrating Krishna*, 134. The source of the poem is not noted. Govindasvami is one of the eight *ashtachaps* (seals), who were poet-saints and followers of the Pushti Marg teacher and saint Vallabhacharya (1479–1531).

29. In fact, it is said that only Radha's girlfriends, the *sakhis*, are allowed access to the divine couple. A priest thus mentally takes on the performative role of a *sakhi* when attending to them (termed *sakhi bhav*). See Haberman, *Acting as a Way of Salvation*, 84–85. See Molly Emma Aitken on the dynamic role of jewelry and ornament in shaping a resplendent *darshan* experience in *When Gold Blossoms*.

30. So Krishna instructs in the *Bhagavata Purana* that his devotees should, if they have the means, do some or all of the following:

> Offering a brush (made of a small green twig with one of its ends crushed) for cleansing My teeth; giving perfumed oil for anointing My body; a paste of saffron and camphor powder to be rubbed on the various parts of My body to cleanse it from dirt; bathing My image with a preparation composed of milk, curds, ghee, honey and sugar as well as with scented water; clothing Me with costly silk and adorning Me with jewels, sandal-paste and wreaths and putting a mirror before Me (to show Me how I look); offering Me food which can easily be swallowed (without chewing) as well as that which needs chewing (together with fragrant water, betel leaves, a bed of flowers, etc.) and [also] the singing of songs and dancing. (Goswami, *Srimad Bhagavata Mahapurana*, 646)

31. David Morgan quotes from Stuart Hall. See Morgan's *Visual Piety*, 32–33n34.

32. Shrivatsa Goswami told me that it takes six months to prepare for twenty-two days of *seva*. In his family's tradition, all the clothing is made by hand. Additionally, his wife, Sandhya, does all the shopping for the fabrics and embellishments, often going to Jaipur, Varanasi, Kolkata, and other far-flung destinations for the materials.

33. Babb, "Glancing: Visual Interaction in Hinduism," 394–395, discusses the power of witnessing and venerating the feet of a sacred person, presence, or image of divinity. Steven P. Hopkins also describes the sensuous, erotic potential of such limb-by-limb beholding in his "Extravagant Beholding: Love, Ideal Bodies, and Particularity," 40–41.

34. Case, *Seeing Krishna*, 73, explains that, "in fact, those hands are never seen to hold a flute. Radharamana's right hand always holds a cowherd's staff, by which he is seen to support himself."

35. Ingalls, *Sanskrit Poetry*, 200.

36. Graham Schweig, *Dance of Divine Love*, 198–199, discusses the significance of the *ras-lila*. He also notes the interconnections among the moon, Krishna, and aesthetics.

37. Haberman, *The Bhaktirasamrtasindhu of Rupa Goswami*, 211, v. 349.

38. Ibid., 209, v. 339.

39. Goswami and Beeche, *Celebrating Krishna*, 106; the source of the poem is not given.

40. As opposed to the traditional reckoning of the new year as commencing after Holi.

41. Themes in the past have focused, for example, on flowers, the headdresses, or the natural materials in the *bangalas*.

42. My deepest thanks go to Robyn Beeche for sharing some of this background information with me and for keeping me updated on the *sevas* that I have unfortunately missed.

43. See Untracht, *Traditional Jewelry of India*, 193, 195; and Aitken, *When Gold Blossoms*, to understand the context of gift giving to temples.

44. This is the practice, for example, both at the Radharamana temple and at the Govindadeva temple in Jaipur. On very special occasions, clothing that has been worn by the deities is given as a gift, especially upon the birth of a child. The sacred garments have a protective charge. See the chapter "Krishna to Go" for a consideration of what can happen when certain boundaries are crossed with respect to deities and their wardrobes, as was the case with the Banke Bihari temple.

45. Untracht, *Traditional Jewelry of India*, 192–193, discusses temple treasuries as does Aitken, *When Gold Blossoms*, 55.

46. A helpful survey of some of these can be found in Kumar, *Costumes and Textiles of Royal India*.

47. Delmonico, "Radha's Bath," 82.

48. Karnad, "In Search of a New Theater," 96.

49. For but two examples, see Martinelli and Michell, *Palaces of Rajasthan*, esp. Nawalagarh, 22, and Amber, 67–68.

50. Personal communication from Robyn Beeche, Dec. 7, 2006. Again, I am grateful to Beeche for so generously sharing her insights, observations, and images.

51. See Sen Gupta, *Chaar Dhaam*.

52. As noted above, visual references to Jagannath, Puri, and Orissa were also featured in the winter 2006–2007 *bangalas*.

53. See the beautiful description by Hawley and Goswami in *At Play with Krishna*, 62–71.

2. The Radhavallabha Temple

1. Entwistle, *Braj*, 403–404.

2. Practitioners will not reveal or discuss Radhavallabha's exact size nor the material he is made of (probably stone, or even wood, as some have suggested), insisting that it is not dignified to discuss a self-manifestation in terms of mundane measurements ("how can you measure a god?") and substances (Banke Bihari, Radhavallabha's sectarian cousin, is reportedly made of wood). The evasion about measurements is somewhat belied by the fact that tailors are able to construct the clothing with which he is so often gifted, but this is not shared public knowledge.

3. Old photos show that his eyes were once white, and were presumably painted in.

4. Snell, *Eighty-four Hymns*, 19, 30–34, discusses controversies in Hit Harivansha's dates.

5. See Brzezinski, "Hit Harivamsa and the *Radha-rasa-sudha-nidhi*," which discusses Hit Harivansha's biography and written corpus. See also Rosenstein, "The Radhavallabh and Haridasi Sampradays." Guy L. Beck has written a very clear summation of the important issues in his "Krishna as Loving Husband of God," 65–90.

6. Similarly, Rupa and Sanatana Goswami held political appointments in the court of Nawab Hussein Shah, the emperor of Gauda (Bengal), when they met Chaitanya. See Rosen, *Six Goswamis*, 86.

7. His name is literally *hari vansha*, "Krishna's bamboo flute," although many of the transliterations commonly convert *vansha* to *vamsha*.

8. Found at www.radhavallabhmandir.com in the "History" section.

9. Another account states that Hit Harivansha began his spiritual training under Gopala Bhatta, but that Hit Harivansha was eventually rejected by Gopala Bhatta because he was so unorthodox; see Brzezinski, "Hit Harivamsa and the *Radha-rasa-sudha-nidhi*," 23–30. On the importance of Radha and Seva Kunj, see Haberman, *Journey through the Twelve Forests*, 18.

10. Snell, *Eighty-four Hymns*, 2; and his "The Nikunja as Sacred Space," esp. 67–68.

11. Snell, *Eighty-four Hymns*, 3, gives a synopsis of the main tenets of the Radhavallabha sect. See also his "The

Nikunja as Sacred Space," 74, where he elaborates, "The commentators' lexicon is replete with images of a divine majesty, the grove taking on the character of shrine and throne-room combined."

12. Snell, "The Nikunja as Sacred Space," 68.

13. Snell, *Eighty-four Hymns,* 4, notes:
The main centre of sectarian activity is the Radha-vallabha temple in Vrindaban, which is in the authority of the Gauda Brahmins who claim patrilineal descent from Harivamsa through his eldest son Vanacandra, and who assume the title *goswami* as their family name. Since the latter part of the seventeenth century this *goswami* dynasty has been split into two branches, following a disputed succession to the *acarya*-ship of the *sampradaya.* The historical origins of this rift are obscure, but the tension between the two branches (called the *Rasa vamsa* and *Vilasa vamsa* after the two rival claimants, Rasadasa and Vilasadasa) is still in evidence today and has been the subject of protracted litigation in recent years; rights to *seva* in the temple have sometimes been allocated by an officially appointed receiver.

14. See the website for fascinating details about the *ashtayama seva.*

15. Beck, "Samaj-Gayan for Radha and Krishna," 85.

16. Snell, *Eighty-four Hymns,* 5.

17. I was delighted to read in Waghorne's *Diaspora of the Gods,* x: "I later discovered that the gods are ornamented precisely to entice us toward devotion. . . . passion begins with the eye and then moves the heart."

18. Varma, *Being Indian,* 43; Lutgendorf, "My Hanuman Is Bigger than Yours."

19. Jain, "More than Meets the Eye," 46.

20. Ibid., 46n8.

21. Many thanks to Shrivatsa Goswami for the apt phrases "time's baby" and "bonus" (see below). Parts of this description have previously been published in my "Time and Time Again."

22. For good explanations of Indian time systems, see Freed and Freed, *Hindu Festivals in a North Indian Village,* 17–25; Babb, *Divine Hierarchy,* 123–176; Fuller, *The Camphor Flame,* appendix, 263–266.

23. Haberman, *Journey through the Twelve Forests,* 174–175, describes the riotous play that is let loose in Braj at this time.

24. Dasa, *Evening Blossoms.*

25. Normally, the groom's scarf is tied to the bride's sari.

26. Waghorne, *Diaspora of the Gods,* 117, gives an example of a similar process with members of a small local temple in Chennai.

27. I luckily found Priya again at the temple in May 2005, and she told me that she had since had two sons. But she was quick to remind me that, even if she had not been able to bear children, she was sincerely fulfilled in her devotion to Radhavallabha and was content to live within his grace.

28. Another *adhik mas* was in July 2004, and I witnessed a similar parade of festivities via the website.

29. Much of this material has previously been published in my "Web of Deceit."

30. For a full listing, see the description under the "Bhog" link at www.radhavallabhmandir.com.

31. I am grateful to several members of the Radhavallabha *sampradaya* who were extremely helpful to me. I'd like to thank Goswami Shri Hit Radhesh Lal Ji (Tikayat Adhikari), his son Goswami Shri Hit Mohit Maral (Yuvraj), and Neha Goswami Tripathi for their patient answers to all my questions and their willingness to share resources.

32. Rosenstein, "The Radhavallabh and the Haridasi Sampradayas," 5–6, neatly outlines the relationship and devotional approach of these two figures. She states that the Haridasi and the Radhavallabhi sects "were united in their attempt to assert their identity as *rasika sampradaya*s, so that they might co-exist with larger and more popular sects like the Vallabha, the Gaudiya and the Nimbarka *sampradaya*s."

33. See Haberman, *Journey through the Twelve Forests,* 176–177, where he identifies the eight main *sakhi*s and their respective villages in Braj.

34. This is described ibid., 208.

35. Haberman describes Dauji ibid., 209–211.

36. It is always being updated, so the following description is accurate at the time of my writing this in May 2009.

37. This is found under the subheading "Patotsava" on the festivals (*utsav*) page.

3. The Govindadeva Temple

1. Bahura, "Sri Govinda Gatha," 212.

2. Case, *Seeing Krishna,* 100, fig. 17, includes a clear diagram of these architectural components.

3. Asher, "Amber and Jaipur," 74; Nath, "Sri Govindadeva's Itinerary," 180.

4. Case, *Seeing Krishna,* 101. See also the photograph in Asher's "Amber and Jaipur," 73, fig. 7, which shows a scene of *darshan* in the period before the patio was added.

5. There is also a collection of personal objects of worship belonging to previous *goswami*s on the dais in the sanctum.

6. Goma Tila literally means "Mother Cow Mound." See the account by Rosen in *Six Goswamis,* 99–100.

7. Interestingly, this image is never mentioned in the historical documents relating to the transfer of the Vrindaban images to Jaipur. See Horstmann, *In Favour of Govinddevji,* 4–5.

8. Goswami and Beeche, *Celebrating Krishna,* 23. Vajranabh is also credited with building the temple of Dwarka in one night.

9. Haberman, *Journey through the Twelve Forests,* 33–38, gives a clear and readable account of the complicated history; see also Case, *Seeing Krishna,* 98–101.

10. R. Nath suggests that the god was perhaps at first enshrined in a simple hut and then, in 1534, moved into a red sandstone temple. He identifies some remains at the site with this first structural temple, "Sri Govindadeva's Itinerary," 161.

11. Horstmann, *In Favour of Govinddevji*, 2. A wonderful dramatization of this period in Rajput-Mughal history is *Jodhaa Akbar*, a 2008 film directed by Ashutosh Gowariker; see www.jodhaaakbar.com.

12. Sachdev and Tillotson, *Building Jaipur*, 33.

13. While most writers focus on his patronage of the Govindadeva temple, Cathy Asher, in "Amber and Jaipur: Temples in a Changing State," points out the important fact that Raja Man Singh patronized secular as well as religious structures—including temples, mosques, and shrines—both within his own domains and much farther afield.

14. Thakur, "The Building of Govindadeva," 13.

15. Haberman, *Journey through the Twelve Forests*, 35.

16. Ibid.

17. Michell, "The Missing Sanctuary," 115–122.

18. Nath, "Sri Govindadeva's Itinerary," 163, discusses the vow.

19. Legend has it that this image of Radha originally came from Vrindaban; see Bahura, "Sri Govinda Gatha," 206. Chandramani Singh, "Bhoga, Puja, Utsava, and Srngara," 261, states that this image was sent in VS 1690.

20. Monika Horstmann, in *In Favour of Govinddevji*, 2, notes that the title *mirza*, which was sometimes earlier used for Man Singh, denotes a status that puts its holder on a par with the imperial family.

21. Haberman, *Journey through the Twelve Forests*, 36.

22. Details of this are in Nath, "Sri Govindadeva's Itinerary," 163.

23. Asher, "Amber and Jaipur," 69–70. See also Michell, "The Missing Sanctuary," 121; and Nath, "Sri Govindadeva's Itinerary," 163–164.

24. Michell, "The Missing Sanctuary," 121.

25. Ibid.

26. Nath, "Sri Govindadeva's Itinerary," 168, notes documentation that suggests that Govindadeva was headed to his own village, Govindapura, near Amber. See also Asher, "Amber and Jaipur," 72.

27. Nath, "Sri Govindadeva's Itinerary," 172.

28. Horstmann, *In Favour of Govinddevji*, 18–19. Nath, "Sri Govindadeva's Itinerary," 174–178.

29. "Sawai" is often colloquially translated as "one-up," referring to Jai Singh II's cleverness in responding to a question posed to him by the emperor Aurengzeb when he was but a young boy. For the full story, see Sachdev and Tillotson, *Building Jaipur*, 36.

30. Ibid., 34.

31. Horstmann, *In Favour of Govinddevji*, 18.

32. Nath, "Sri Govindadeva's Itinerary," 174–175.

33. Sachdev and Tillotson, *Building Jaipur*, 38.

34. Horstmann dates this transfer to 1716 in *In Favour of Govinddevji*, 20. Shrivatsa Goswami emphasized that "the image of Govindadeva never 'belonged'" to the ruler until the time of Jai Singh, although rulers had given grants in support of the god's maintenance. Govindadeva's image was originally the property of the *goswamis* who took care of him. See Habib, "Documentary History of the Gosa'ins," 185–193, for documentation on the *goswamis*' requests and petitions for the return of Govindadeva and for information on the ongoing disputes over ownership; see esp. 186–187.

35. Temple custodians say the kitchen; Sachdev and Tillotson speculate that it was a converted hunting lodge; *Building Jaipur*, 56.

36. Nath, "Sri Govindadeva's Itinerary," 180; Horstmann, *In Favour of Govinddevji*, 19; and Bahura, "Sri Govinda Gatha," 207–208, discuss his interest in Chaitanyaite Vaishnavism.

37. Sachdev and Tillotson, *Building Jaipur*, 53.

38. Asher, "Amber and Jaipur," 72.

39. Horstmann, *In Favour of Govinddevji*, 23.

40. Sachdev and Tillotson, *Building Jaipur*, 53; see also 52, fig. 37, which shows the relationship of these three temples.

41. See the Philadelphia Museum of Art website for this image: *Maharao Bhim Singh of Kota Attending Krishna as Brijnathji*, made in Kota, Rajasthan, India, ca. 1719–1720, attributed to the Kota master, opaque watercolor and gold on paper, 13¼ × 18¼ inches (33.7 × 46.4 cm), 1997-25-1, gift of Stuart Cary Welch Jr. in memory of William P. Wood, 1997. See http://www.philamuseum.org/collections/permanent/91404.html.

42. Peabody, "The King Is Dead, Long Live the King!" 75–76. Intriguingly, the image of Brijnathji was lost temporarily on the battlefield; see 76 and fig. 20, 120–121.

43. See also a slightly later painting of his successor Arjun Singh in a very similar position, in Welch, *Gods, Kings, and Tigers*, 116, fig. 19.

44. Taylor, "Picture Practice," 65.

45. Nath, "Sri Govindadeva's Itinerary," 180 and n. 53.

46. Davis, *Lives of Indian Images*, 54.

47. Asher, "Kacchavaha Pride and Prestige," 220; Sachdev and Tillotson, *Building Jaipur*, 56.

48. See also Horstmann, *In Favour of Govinddevji*, 8.

49. Asher, "Amber and Jaipur," 76.

50. Sachdev and Tillotson, *Building Jaipur*, 55–56: "unlike the *shikhara*-topped *nagara* temples described, and equally unlike the more fashionable haveli-plan temples, this building is organized like a garden palace pavilion. The external form and their [*sic*] internal disposition of rooms find their closest parallel in palace structures such as the pavilions at Dig, built in the 1760s."

51. See Aman Nath, *Jaipur: The Last Destination*, 29, for an image of a Mughal tent.

52. Asher comments on the fact that this vista would not really be possible, as all that Sawai Jai Singh could have seen was the temple and its formal garden setting, and not the image; see "Amber and Jaipur," 72. R. Nath comments further on the south-facing orientation of the temple, making connections between the specific iconographic form of the god as a "popular form of Visnu" and the presiding deity of Jaipur, who could receive veneration from this direction; "Sri Govindadeva's Itinerary," 180.

53. Bahura, "Sri Govinda Gatha," 209–210.

54. Dasa, "Srigovindavarsikadvadasakam," 241–259; see also Singh, "Bhoga, Puja, Utsava, and Srngara," 261–266.

55. Singh, "Bhoga, Puja, Utsava, and Srngara," 261. I tried to find these paintings, but Anjan Kumar Goswami, the current head *goswami*, says he does not recall them being in the temple's collection. Singh did see them in the 1990s, when Anjan Kumar Goswami's father, Pradyumna Goswami, was still alive.

56. Horstmann, *In Favour of Govinddevji,* 27.

57. Ibid., 3.

58. Tillotson, *Jaipur Nama,* 56–57.

59. Devi and Rau, *A Princess Remembers.*

60. Horstmann, "Govindadeva and His Custodians," 186.

61. Case, *Seeing Krishna,* 101–110.

62. See also the temple's cheerful website: http://www.govinddevji.net.

63. Horstmann, "Govindadeva and His Custodians," 186.

64. For more on this, see Case, *Seeing Krishna,* 35.

65. Dasa, "Srigovindavarsikadvadasakam," 244.

66. See Horstmann, "Govindadeva and His Custodians," 188–192.

67. Horstmann, *In Favour of Govinddevji,* 129–130, 148, 155.

68. Kumar, *Costumes and Textiles of Royal India,* 38.

69. Hambly, "The Emperor's Clothes," 31.

70. Ibid., 40–41; Beach and Koch, *King of the World,* see esp. 35–36, 46, 95, as but a fraction of the examples.

71. Tod, *Annals and Antiquities of Rajasthan,* 422. Tod also discusses other kingdoms whose rulers worship Krishna: Kota, Bundi, Marwar, and "Shivpur."

72. Singh, "Bhoga, Puja, Utsava, and Srngara," 262.

73. See Haberman, *Journey through the Twelve Forests,* 18–19, on the significance of Seva Kunj.

74. Anjan Kumar Goswami told me that, in the past, in Vrindaban, all the other Chaitanya temples did their *abhisheks* at 12 noon, and then they all congregated together at the Govindadeva temple to do his *abhishek* at midnight. Now, in this modern era, no one does this any longer. When the images of Madan Mohan, Radha Vinodilal, Govindadeva, Gopinatha, and Radhadamodar shifted to Jaipur, all the relationships were disturbed. The other *goswamis* no longer attend Govindadeva's ceremony.

75. For a photograph of the current uses of parts of the Chandra Mahal, see Martinelli and Michell, *Palaces of Rajasthan,* 37.

76. In 2010, approximately his 475th!

77. Haberman, *Journey through the Twelve Forests,* 22; Goswami and Beeche, *Celebrating Krishna,* 56.

78. Rosen, *Six Goswamis,* 132–133. There is a different account, which is a wonderful story of Sanatana Goswami being granted the image of Madan Mohan, which he installed and worshiped in a hut in Vrindaban. Eventually, Sanatana became annoyed with the responsibility of Madan Mohan's upkeep and left the image behind when he departed from Vrindaban to reestablish himself in Govardhan. Madan Mohan was ultimately relocated to a temple in Karauli, Rajasthan. Beeche, *Celebrating Krishna,* 59.

4. Krishna to Go

1. Available from Shethia AudioVideo: http://www.shethia.com.

2. Lakshmi, "In India, Gods Rule the 'Toon' Universe."

3. Brajesh Singh, "Muslim Tailors Clothe Hindu Deities in Vrindavan." The same article also used the fact that Muslim tailors are sewing and embellishing clothing for Hindu gods as an opportunity to comment favorably on Muslims: "The Muslim artists command high respect among the Hindus who feel that the tailors help in fighting the communal divide." See also an article about fashion designer Nishka Lulla, who designed an outfit for the Mumbai ISKCON temple's Radha: Dasi, "Radharani Adorns Dress by India's Youngest Fashion Designer."

4. Lyons, *Artists of Nathadwara,* 22.

5. See Ambalal, *Krishna as Srinathji;* Bennett, *The Path of Grace.*

6. See Taylor, "Picture Practice," 61–69.

7. See the front covers of *Newsweek* (Mar. 6, 2006) and *Time* (June 26, 2006). Fareed Zakaria, in "The New Indian Powerhouse," 34, observed that, at the World Economic Forum in Davos, Switzerland, the power and presence of the new India was inescapably apparent: "'INDIA EVERYWHERE,' said the ubiquitous logo. It was."

8. See www.akshardham.com/news/2007/guinnessworldrecord/%20index.htm.

9. Allen, "Letter from Delhi."

10. "President to Inaugurate Akshardham Temple Today," http://www.thehindu.com/2005/11/06/stories/2005110612710300.htm.

11. See http://www.mandir.org/murtidarshan/index.php.

12. See http://www.sagarresort.com/aboutus.htm.

13. See www.sagarresort.com/sagarworld.htm.

14. David, "Paean to a Goddess," 66–67.

15. Lutgendorf, "My Hanuman Is Bigger than Yours."

16. Waghorne, *Diaspora of the Gods,* 25.

17. Ibid., 30.

18. Ibid., 231–232.

19. Narayanan, "Heterogeneous Spaces and Modernities," 128.

20. Waghorne, *Diaspora of the Gods,* 235.

21. Ibid., 235–236.

22. Saraswati, *The Divine Vision of Radha Krishn,* 414.

23. Vasudha Narayanan in "Heterogeneous Spaces and Modernities," 143–146, does discuss temples in Hawaii that have their own claims to indigenous holiness.

Conclusion

1. McCracken, *Culture and Consumption,* 68–69.

2. I borrow this concept of "event" from Bryant, *Poems to the Child God,* 40, where he explores the performative role of poetry as an expression of devotion to Krishna.

3. "Krishna in Jeans."

4. Greenblatt, "The Circulation of Social Energy," 517–518.

5. See Schweig, *Dance of Divine Love,* 125.

6. Greene, "Hindu Holy Place Altered."

7. Ibid.

8. Gladwell, "The Vanishing," 72.

9. Varma, *Being Indian,* 102, gives some sobering insight into this perspective:

> A Hindu is impervious to the milieu, and indeed to the very visible pain and suffering around him, because anything outside of his own narrow ken of interest matters little to him. . . . There is . . . almost no emphasis on the need for the individual to contribute to his community within the arena of spiritual search and fulfillment. The emphasis on the self as the centerpiece of the spiritual endeavour tends to stunt the individual's concern for the community. This insensitivity to the external milieu, coterminous often with the most overt preoccupation with spiritual pursuits, has become so much a part of life that it is mostly not even noticeable to the educated Hindu.

Bibliography

Aitken, Molly Emma. *When Gold Blossoms: Indian Jewelry from the Susan L. Beningson Collection*. New York: Asia Society and Philip Wilson Publishers, 2004.

Allen, Jonathan. "Letter from Delhi: The Disney Touch at a Hindu Temple," *New York Times* (June 8, 2006), http://travel2.nytimes.com/2006/06/08/travel/08letter.html.

Ambalal, Amit. *Krishna as Shrinathji: Rajasthani Paintings from Nathdvara*. New York: Mapin, 1987.

Asher, Catherine B. "Amber and Jaipur: Temples in a Changing State." In *Stones in the Sand: The Architecture of Rajasthan*, ed. Giles Tillotson, 68–77. Mumbai: Marg, 2001.

———. "Kacchavaha Pride and Prestige: The Temple Patronage of Raja Mana Simha." In *Govindadeva: A Dialogue in Stone*, ed. Margaret H. Case, 215–238. New Delhi: Indira Gandhi National Centre for the Arts, 1996.

Babb, Lawrence A. *The Divine Hierarchy: Popular Hinduism in Central India*. New York: Columbia University Press, 1983.

———. "Glancing: Visual Interaction in Hinduism." *Journal of Anthropological Research* 37, no. 4 (1981): 387–401.

Bahura, Gopal Narayan. "Sri Govinda Gatha: Service Rendered to Govinda by the Rulers of Amera and Jayapura." In *Govindadeva: A Dialogue in Stone*, ed. Margaret H. Case, 195–213. New Delhi: Indira Gandhi National Centre for the Arts, 1996.

The Baseball Almanac. http://www.baseball-almanac.com/quotes/quoberr2.shtml.

Beach, Milo Cleveland, and Ebba Koch. *King of the World: The Padshahnama, an Imperial Mughal Manuscript from the Royal Library, Windsor Castle*. London: Azimuth, 1997.

Beck, Guy L. "Krishna as Loving Husband of God." In *Alternative Krishnas: Regional and Vernacular Variations on a Hindu Deity*, ed. Guy L. Beck, 65–90. Albany: State University of New York Press, 2005.

———. "Samaj-Gayan for Radha and Krishna: Devotional Music in the Radhavallabha Sampradaya." *Journal of Vaisnava Studies* 7, no. 1 (Fall 1998): 85–100.

Beck, Guy L., ed. *Alternative Krishnas: Regional and Vernacular Variations on a Hindu Deity*. Albany: State University of New York Press, 2005.

Bennett, Peter. *The Path of Grace: Social Organisation and Temple Worship in a Vaishnava Sect*. Delhi: Hindustan Publishing, 1993.

Borden, Carla M., ed. *Contemporary Indian Tradition: Voices on Culture, Nature, and the Challenge of Change*. Washington, D.C.: Smithsonian Institution Press, 1989.

Brosius, Christiane, and Melissa Butcher, eds. *Image Journeys: Audio-Visual Media and Cultural Change in India*. New Delhi: Sage, 1999.

Bryant, Kenneth E. *Poems to the Child God: Structures and Strategies in the Poetry of Surdas*. Berkeley: University of California Press, 1978.

Brzezinski, Jan K. "Hit Harivamsa and the *Radha-rasa-sudha-nidhi*." *Journal of Vaisnava Studies* 7, no. 1 (Fall 1998): 19–61.

Burton-Page, John. "The Early Vrndavana Temples: The 'Hindu-Muslim Synthesis' Rejected." In *Govindadeva: A Dialogue in Stone*, ed. Margaret H. Case, 123–127. New Delhi: Indira Gandhi National Centre for the Arts, 1996.

Carroll, Lewis. *Through the Looking Glass and What Alice Found There*, 1898. Reprint, Norwood, Mass.: Norwood Press, Berwick & Smith Co., 1906.

Case, Margaret H. *Seeing Krishna: The Religious World of a Brahman Family in Vrindaban*. New York: Oxford University Press, 2000.

Case, Margaret H., ed. *Govindadeva: A Dialogue in Stone*. New Delhi: Indira Gandhi National Centre for the Arts, 1996.

Chadwick, Alex. "Geography of Heaven," *National Geographic Radio Expedition*, National Public Radio, Oct. 31–Nov. 2, 2005, http://www.npr.org/templates/story/story.php?storyId=4980453.

Coomaraswamy, Ananda K. "Ornament." In *Coomaraswamy,* vol. 1: *Selected Papers: Traditional Art and Symbolism,* ed. Roger Lipsey, 241–253. Princeton, N.J.: Princeton University Press, 1977.

Cort, John. "Bhakti in the Early Jain Tradition: Understanding Devotional Religion in South Asia." *History of Religions* 42 (2002): 59–86.

———. *Jains in the World: Religious Values and Ideology in India.* New York: Oxford University Press, 2001.

———. "The Jina as King." In *Vasantagauravam: Essays in Honour of Professor M. D. Vasantha Raj of Mysore, on the Occasion of His Seventy-fifth Birthday,* ed. Jayandra Soni, 27–50. Mumbai: Vakils, 2001.

Dasa, Asimakrishna. *Evening Blossoms: The Temple Tradition of Sanjhi in Vrndavana.* New Delhi: Indira Gandhi National Centre for the Arts, 1996.

———. "Srigovindavarsikadvadasakam: Twelve Verses on the Yearly Festivals of Sri Govinda." In *Govindadeva: A Dialogue in Stone,* ed. Margaret H. Case, 241–259. New Delhi: Indira Gandhi National Centre for the Arts, 1996.

Dasgupta, Shashi Bhushan. *Obscure Religious Cults,* 2nd ed. Calcutta: Mukhopadhyay, 1962.

David, Stephen. "Paean to a Goddess. A Rs 10.5 Crore Plan Intends to Make Talacauvery, the Birthplace of the Cauvery River, a Major Tourist and Pilgrim Attraction." *India Today* (May 23, 2005): 66–67.

Dasi, Parijata Devi. "Radharani Adorns Dress by India's Youngest Fashion Designer." *ISKCON News Weekly* (Sept. 5, 2009), http://www.iskconnews.com/node/2263/2009-09-05/radharani_adorns_dress_indias_youngest_fashion_designer.

Davis, Richard H. "Introduction." In *Religions of India in Practice,* ed. Donald S. Lopez Jr., 3–52. Princeton, N.J.: Princeton University Press, 1995.

——— *Lives of Indian Images.* Princeton, N.J.: Princeton University Press, 1997.

———. "Religions of India in Practice." In *Asian Religions in Practice: An Introduction,* ed. Donald S. Lopez Jr., 8–55. Princeton, N.J.: Princeton University Press, 1999.

———. *Ritual in an Oscillating Universe: Worshiping Siva in Medieval India.* Princeton, N.J.: Princeton University Press, 1991.

Dehejia, Vidya. *The Body Adorned: Dissolving Boundaries between Sacred and Profane in India's Art.* New York: Columbia University Press, 2009.

Delmonico, Neil. "How to Partake in the Love of Krishna." In *Religions of India in Practice,* ed. Donald S. Lopez Jr., 244–268. Princeton, N.J.: Princeton University Press, 1995.

———. "Radha's Bath: An Excerpt from *Govindalilamrta.*" *Journal of Vaisnava Studies* 10, no. 1 (Fall 2001): 81–90.

Devi, Gayatri of Jaipur, and Santha Rama Rau. *A Princess Remembers: The Memoirs of the Maharani of Jaipur.* Lippincott Williams & Wilkins, 1976.

Dimock, Edward C., Jr., and Tony K. Stewart. *Caitanya Caritamrita of Krsnadasa Kaviraja: A Translation and Commentary.* Cambridge, Mass.: Harvard University Press, 1999.

Dirks, Nicholas B., Geoff Eley, and Sherry B. Ortner, eds. *Culture/Power/History: A Reader in Contemporary Social Theory.* Princeton, N.J.: Princeton University Press, 1994.

Doniger O'Flaherty, Wendy. "Impermanence and Eternity." In *Contemporary Indian Tradition: Voices on Culture, Nature, and the Challenge of Change,* ed. Carla M. Borden, 83–85. Washington, D.C.: Smithsonian Institution Press, 1989.

Eck, Diana L. *Darsan: Seeing the Divine Image,* 3rd ed. New York: Columbia University Press, 1996.

Entwistle, A. W. *Braj: Centre of Krishna Pilgrimage.* Groningen, Netherlands: Forsten, 1987.

Freed, Stanley A., and Ruth S. Freed. *Hindu Festivals in a North Indian Village.* Seattle: University of Washington Press, 1998.

Fuller, C. J. *The Camphor Flame: Popular Hinduism and Society in India.* Princeton, N.J.: Princeton University Press, 2004.

Ghosh, Pika. "Tales, Tanks, and Temples: The Creation of a Sacred Center in Seventeenth-Century Bengal." *Asian Folklore Studies* 59, no. 2 (2002): 193–222.

———. *Temple to Love: Architecture and Devotion in Seventeenth-Century Bengal.* Bloomington: Indiana University Press, 2005.

Gladwell, Malcolm. "The Vanishing: In 'Collapse,' Jared Diamond Shows How Societies Destroy Themselves." *New Yorker* (Jan. 3, 2005), http://www.gladwell.com/2005/2005_01_15_a_collapse.html.

Gordon, Stewart, ed. *Robes of Honour: Khil'at in Pre-Colonial and Colonial India.* New Delhi: Oxford University Press, 2003.

Goswami, C. L., trans. *Srimad Bhagavata Mahapurana:* part II, Books 9–12, 4th ed. Govind Bhawan Karyalaya: Gita Press, 1997.

Goswami, Shrivatsa, and Robyn Beeche. *Celebrating Krishna.* Vrindaban: Shri Chaitanya Prem Sansthana, 2001.

Greenblatt, Stephen. "The Circulation of Social Energy." In *Culture/Power/History: A Reader in Contemporary Social Theory,* ed. Nicholas B. Dirks, Geoff Eley, and Sherry B. Ortner, 504–520. Princeton, N.J.: Princeton University Press, 1994.

Greene, Joshua M. "Hindu Holy Place Altered by Technology, Development, Pollution." *Religion News Service* (May 27, 2005), http//www.hvk.org/articles/0605/45.html.

Growse, Frederick S. *Mathura: A District Memoir.* 1882; reprint, New Delhi: Asian Educational Services, 1979.

Haberman, David L. *Acting as a Way of Salvation: A Study of Raganuga Bhakti Sadhana.* New York: Oxford University Press, 1988.

———. *The Bhaktirasamrtasindhu of Rupa Goswami.* New Delhi: Indira Gandhi National Centre for the Arts in association with Motilal Banarsidass, 2003.

———. *Journey through the Twelve Forests: An Encounter with Krishna.* New York: Oxford University Press, 1994.

Habib, Irfan. "A Documentary History of the Gosa'ins (Goswamis) of the Caitanya Sect at Vrndavana." In *Govindadeva: A Dialogue in Stone,* ed. Margaret H. Case, 131–159. New Delhi: Indira Gandhi National Centre for the Arts, 1996.

Hambly, Gavin. "The Emperor's Clothes: Robing and 'Robes of Honour' in Mughal India." In *Robes of Honour: Khil'at in Pre-Colonial and Colonial India,* ed. Stewart Gordon, 31–49. New Delhi: Oxford University Press, 2003.

Hardy, Friedhelm. *The Religious Culture of India: Power, Love and Wisdom.* New York: Cambridge University Press, 1994.

Harlan, Lindsey. *The Goddesses' Henchmen.* New York: Oxford University Press, 2003.

Hawkins, Sophie. "Bordering Realism: The Aesthetics of Sai Baba's Mediated Universe." In *Image Journeys: Audio-Visual Media and Cultural Change in India,* ed. Christiane Brosius and Melissa Butcher, 139–162. New Delhi: Sage, 1999.

Hawley, John Stratton, and Shrivatsa Goswami. *At Play with Krishna: Pilgrimage Dramas from Brindavan.* Princeton, N.J.: Princeton University Press, 1981.

Hopkins, Steven P. "Extravagant Beholding: Love, Ideal Bodies, and Particularity." *History of Religions* 47, no. 1 (Aug. 2007): 1–50.

———. "In Love with the Body of God: Eros and the Praise of Icons in South Indian Devotion." *Journal of Vaisnava Studies* 2, no. 1 (Winter 1993): 17–54.

Horstmann, Monika. "Govindadeva and His Custodians from 1643 through the Time of Jaya Simha II (1700–1743)." In *Govindadeva: A Dialogue in Stone,* ed. Margaret H. Case, 185–193. New Delhi: Indira Gandhi National Centre for the Arts, 1996.

Horstmann, Monika, ed. *In Favour of Govinddevji: Historical Documents Relating to a Deity of Vrindaban and Eastern Rajasthan.* New Delhi: Manohar, 2002.

Huyler, Stephen P. *Meeting God: Elements of Hindu Devotion.* New Haven, Conn.: Yale University Press, 1999.

Ingalls, Daniel H. H., trans. *Sanskrit Poetry from Vidyakara's Treasury.* Cambridge, Mass.: Belknap Press of Harvard University Press, 1965.

Jain, Kajiri. *Gods in the Bazaar: The Economies of Indian Calendar Art.* Durham, N.C.: Duke University Press, 2007.

———. "More than Meets the Eye: The Circulation of Images and the Embodiment of Value." In *Beyond Appearances? Visual Practices and Ideologies in Modern India,* ed. Sumathi Ramaswamy, 33–70. New Delhi: Sage, 2003.

———. "New Visual Technologies in the Bazaar." In *Sarai Reader 2003: Shaping Technologies,* http://www.sarai.net/publications/readers/03-shaping-technologies/044_057_kjain.pdf.

Joshi, Sam. "How to Watch a Hindi Film: The Example of Kuch Kuch Hota Hai." *Education about Asia* 9, no. 1 (Spring 2004): 22–25.

Kapur, Anuradha. "Deity to Crusader: The Changing Iconography of Ram." In *Hindus and Others: The Question of Identity in India Today,* ed. Gyanendra Pande, 74–109. New Delhi: Viking, 1993.

Karnad, Girish. "In Search of a New Theater." In *Contemporary Indian Tradition: Voices on Culture, Nature, and the Challenge of Change,* ed. Carla M. Borden, 93–105. Washington, D.C.: Smithsonian Institution Press, 1989.

"Krishna in Jeans: *Leela* or Healing Touch?" *Telegraph* (Calcutta, India) (Sept. 19, 2006), http://www.telegraphindia.com/1060919/asp/nation/story_6764908.asp.

Kumar, Ritu. *Costumes and Textiles of Royal India.* London: Christie's Books, 1999.

Lakshmi, Rama. "In India, Gods Rule the 'Toon' Universe: Hindu Myth a Fount of Superheroes," *Washington Post* (Jan. 9, 2008).

Lipsey, Roger, ed. *Coomaraswamy,* vol. 1: *Selected Papers: Traditional Art and Symbolism.* Princeton, N.J.: Princeton University Press, 1977.

Lopez, Donald S., Jr., ed. *Asian Religions in Practice: An Introduction.* Princeton, N.J.: Princeton University Press, 1999.

———. *Religions of India in Practice.* Princeton, N.J.: Princeton University Press, 1995.

Lutgendorf, Philip. "My Hanuman Is Bigger than Yours." *History of Religions* 33, no. 3 (Feb. 1994): 211–245.

Lyons, Tryna. *The Artists of Nathadwara: The Practice of Painting in Rajasthan.* Bloomington: Indiana University Press; and Ahmedabad: Mapin, 2004.

Martinelli, Antonio, and George Michell. *Palaces of Rajasthan.* Mumbai: India Book House, 2004.

Masson, J. L. *Aesthetic Rapture: The Rasadhyaya of the Natyasastra,* vol. 1. Poona: Deccan College, 1970.

McCaul, Kathleen. "World's First Hindu Theme Park," http://news.bbc.co.uk/2/hi/south_asia/4494747.stm.

McCracken, Grant David. *Culture and Consumption: New Approaches to the Symbolic Character of Consumer Goods and Activities.* Bloomington: Indiana University Press, 1988.

McDannell, Colleen. *Material Christianity.* New Haven, Conn.: Yale University Press, 1995.

Michell, George. "The Missing Sanctuary." In *Govindadeva: A Dialogue in Stone,* ed. Margaret H. Case, 115–122. New Delhi: Indira Gandhi National Centre for the Arts, 1996.

Miller, Barbara Stoler, ed. and trans. *Love Song of the Dark Lord: Jayadeva's Gitagovinda.* New York: Columbia University Press, 1977.

Mishra, Vijay. *Devotional Poetics and the Indian Sublime.* Albany: State University of New York Press, 1998.

Morgan, David. *Visual Piety: A History and Theory of Popular Religious Images.* Berkeley: University of California Press, 1998.

Narayanan, Vasudha. "Arcavatara: On Earth as He Is in Heaven." In *Gods of Flesh, Gods of Stone,* ed. Joanne Punzo Waghorne and Norman Cutler in association with Vasudha Narayanan, 53–66. Chambersburg, Pa.: Anima, 1985.

———. "Heterogeneous Spaces and Modernities: Hindu Rituals to Sacralize the American Landscape." *Journal of Vaisnava Studies* 13, no. 2 (Spring 2005): 127–148.

Nath, Aman. *Jaipur: The Last Destination.* Mumbai: India Book House, 2007.

Nath, R. "Sri Govindadeva's Itinerary from Vrndavana to Jayapura c. 1534–1727." In *Govindadeva: A Dialogue in Stone,* ed. Margaret H. Case, 161–183. New Delhi: Indira Gandhi National Centre for the Arts, 1996.

Nayar, Nancy Ann. 1992. *Poetry as Theology: The Srivaisnava Stotra in the Age of Ramanuja.* Wiesbaden: Harrassowitz, 1992.

Nelson, Lance. "Bhakti-Rasa for the Advaitin Renunciate: Madhusudana Sarasvati's Theory of Devotional Sentiment." *Religious Traditions: A Journal in the Study of Religion* 12, no. 9 (1988): 1–16.

Neumayer, Erwin, and Christine Schelberger. *Popular Indian Art: Raja Ravi Varma and the Printed Gods of India.* New Delhi: Oxford University Press, 2003.

Packert Atherton, Cynthia. "Time and Time Again: Notes from India." *New England Review* 21, no. 4 (Fall 2000): 47–65.

———. "A Web of Deceit: Khichri Utsav at the Radhavallabh Temple in Vrindaban." *Journal of Vaishnava Studies* 13, no. 2 (Spring 2005): 57–74.

Pandey, Gyanendra, ed. *Hindus and Others: The Question of Identity in India Today.* New Delhi: Viking, 1993.

Patil, Vimla. *Celebrations: Festive Days of India.* Mumbai: India Book House, n.d.

Peabody, Norbert. "The King Is Dead, Long Live the King! Karmic Kin(g)ship in Kotah." In *Gods, Kings, and Tigers: The Art of Kotah,* ed. Stuart Cary Welch, 73–82. New York: Asia Society Galleries; and Cambridge, Mass.: Harvard University Art Museums, 1997.

Pinney, Christopher. *"Photos of the Gods": The Printed Image and Political Struggle in India.* London: Reaktion, 2004.

———. "'A Secret of Their Own Country'; or, How Indian Nationalism Made Itself Irrefutable." In *Beyond Appearances? Visual Practices and Ideologies in Modern India,* ed. Sumathi Ramaswamy, 113–150. New Delhi: Sage, 2003.

Ramaswamy, Sumathi, ed. *Beyond Appearances? Visual Practices and Ideologies in Modern India.* New Delhi: Sage, 2003.

Rosen, Steven J. "Introduction." *Journal of Vaisnava Studies* 4, no. 4 (Fall 1996): 1–4.

———. *The Six Goswamis of Vrindavan,* rev. ed. Vrindaban: Ras Bihari Lal and Sons, 2000.

Rosenstein, Lucy. "The Radhavallabh and Haridasi Sampradyas." *Journal of Vaisnava Studies* 7, no. 1 (Fall 1998): 5–18.

Sachdev, Vibhuti, and G. H. R. Tillotson, eds. *Building Jaipur: The Making of an Indian City.* London: Reaktion, 2002.

Sanford, A. Whitney. "Shifting the Center: Yakshas on the Margins of Contemporary Practice." *Journal of the American Academy of Religion* 73, no. 1 (Mar. 2005): 89–110.

———. *Singing Krishna: Sound Becomes Sight in Paramanand's Poetry.* Albany: State University of New York Press, 2008.

Saraswati, H. D. Swami Prakashanand. *The Divine Vision of Radha Krishn.* Barsana Dham: International Society of Divine Love, 1995.

Schweig, Graham M. *Dance of Divine Love: India's Classic Sacred Love Story: The Rasa Lila of Krishna.* Princeton, N.J.: Princeton University Press, 2005.

Sen Gupta, Subhadra. *Chaar Dhaam: A Guide to the Hindu Pilgrimages.* New Delhi: Rupa, 2003.

Shukla, Pravina. *The Grace of Four Moons: Dress, Adornment, and the Art of the Body in Modern India.* Bloomington: Indiana University Press, 2008.

Singh, Brajesh. "Muslim Tailors Clothe Hindu Deities in Vrindavan." *Sampradaya Sun* (Aug. 2005), http://indiatraveltimes.com/travel/special/specia12005/aug05.html#1.

Singh, Chandramani. "Bhoga, Puja, Utsava, and Srngara of Sri Govindadeva." In *Govindadeva: A Dialogue in Stone,* ed. Margaret H. Case, 261–266. New Delhi: Indira Gandhi National Centre for the Arts, 1996.

Snell, Rupert. *The Eighty-four Hymns of Hita Harivamsa: An Edition of the Caurasi Pada.* Delhi: Motilal Banarsidass; and London: School of Oriental and African Studies, 1991.

———. "The Nikunja as Sacred Space in the Poetry of the Radhavallabhi Tradition." *Journal of Vaisnava Studies* 7, no. 1 (1998): 63–84.

Soni, Jayandra, ed. *Vasantagauravam: Essays in Honour of Professor M. D. Vasantha Raj of Mysore, on the Occasion of His Seventy-fifth Birthday.* Mumbai: Vakils, 2001.

Srinivasin, Doris Meth. "Vaisnava Art and Iconography at Mathura." In *Mathura: The Cultural Heritage,* ed. Doris Meth Srinivasin, 383–392. New Delhi: South

Asia Books for American Institute of Indian Studies, 1989.

Taylor, Woodman. "Picture Practice: Painting Programs, Manuscript Production, and Liturgical Performances at the Kotah Royal Palace." In *Gods, Kings, and Tigers: The Art of Kotah,* ed. Stuart Cary Welch, 61–72. New York: Asia Society Galleries; and Cambridge, Mass.: Harvard University Art Museums, 1997.

Thakur, Nalini. "The Building of Govindadeva." In *Govindadeva: A Dialogue in Stone,* ed. Margaret H. Case, 11–68. New Delhi: Indira Gandhi National Centre for the Arts, 1996.

Tillotson, G. H. R. *Jaipur Nama: Tales from the Pink City.* New Delhi: Penguin Books India, 2006.

Tillotson, G. H. R., ed. *Stones in the Sand: The Architecture of Rajasthan.* Mumbai: Marg, 2001.

Tod, James. *Annals and Antiquities of Rajasthan; or, The Central and Western Rajput States of India,* vol. 1. London: Routledge and Kegan Paul, 1829; reprint, New Delhi: Rupa, 1997.

Untracht, Oppi. *Traditional Jewelry of India.* London: Thames and Hudson, 1997.

Valpey, Kenneth. *Attending Krishna's Image: Caitanya Murti-Seva as Devotional Truth.* London: Routledge, 2006.

Varma, Pavan K. *Being Indian: The Truth about Why the Twenty-First Century Will Be India's.* New Delhi: Penguin Books India, 2004.

Vaudeville, Charlotte. "Braj, Lost and Found." *Indo-Iranian Journal* 18 (1976): 195–213.

———. "The Cowherd-God in Ancient India." In *Pastoralists and Nomads in South Asia,* ed. Lawrence Saadia Leshnik and Gunther-Dietz Sontheimer, 92–116. Wiesbaden: Harrassowitz, 1975.

Waghorne, Joanne Punzo. *Diaspora of the Gods: Modern Hindu Temples in an Urban Middle-Class World.* New York: Oxford University Press, 2004.

———. "Dressing the Body of God: South Indian Bronze Sculpture in Its Temple Setting." *Asian Art* 5, no. 3 (Summer 1992): 9–33.

Waghorne, Joanne Punzo, and Norman Cutler, eds., in association with Vasudha Narayanan. *Gods of Flesh, Gods of Stone.* Chambersburg, Pa.: Anima, 1985.

Welch, Stuart Cary, ed. *Gods, Kings, and Tigers: The Art of Kotah.* New York: Asia Society Galleries; and Cambridge, Mass.: Harvard University Art Museums, 1997.

Zakaria, Fareed. "The New Indian Powerhouse," *Newsweek* (Mar. 6, 2006), 32–42.

Index

Page numbers in italics indicate illustrations.

abhishek (lustration ceremony), 71, 153, *170*, 194, 216n74
achintyabhedabhedha (inconceivable difference in non-difference), 45
adhik mas (extra month), xi, 95–97, 100, 104–106, 108, 202, 214n28
Adhikari (custodian), 84, 143
Agra, 2, 80, 131–132
Akbar, xxiii, 6, 131–134, 146, 156, 173, 215n11
Akshardham (temple), 190, 216nn8,10
Akshay Teej, 116, 186
alaukika (cosmic world), 19
amavasya (new moon), 40, 51, 179
amber, 127, 131, 133–137, 139–140, 213n49, 215n26
ananda (bliss), 42, 50
Annakut, 91, 120
anubhava (experience), 211n38
arati (lamp offering), 43, 76–78, 85, 109–110, 117, 121, 143, 171–173, 186, 189, 212nn25,30
architecture, 2, 28, 43, 141, 190, 197, 199, 205, 207
asana (seat), 32
ashtayama, 35, 38, 77–78, 82, 87, 93, 145, 212n15, 214n14
Ashvin (month), 83, 89, 100–101, 147
Atmadeva, 81
Aurengzeb, 134–136, 215n29

Bad (village of), 80
Badrinath, 71
Bal Krishna, 178–180, 182, 187. *See also* Krishna, baby
banana pith, 42, 53–55, *56*, 59, 101, 105, *106*, 160, 162, 167
bangala, xx, 67, *107*, 157, 213nn41,52; decoration of, 53, 59, 120, 171; floral (*phul*), 29, 42, 53–55, *56*, 72, 86, 89, 91, 99, 101, 103, *106*, *107*, 122, 147; frame(s) of, 28–29; importance of, 70, 86, 103; making of, 46–47, 55–56, 61–62, 94, 105; types

of, 60, 160, 162–164; winter, 66, *68*, *69*
Banke Bihari (temple), 101, 110, 116–118, 184–186, 204, 213n2
Barsana Dham, 195, 198–199, 207
Barsana Hill, 196
Beeche, Robyn, x, xix, 41, 67–70, 183–184, 213nn42,50
Bengal, xii, xxi–xxii, 33, 66, 70, 78, 140, 210n22, 213n6
Bhadrapad (month), 156
Bhagavata Purana, xvi, 2, 7–8, 83, 97, 113, 144–145, 212n30
bhajan (song), 67
bhakti-rasa, 8, 11, 16, 34, 210n15
Bhaktirasamrtasindhu (The Ocean of the Essence of Devotional Rasa), 33, 57, 129
Bharmal (Raja), 131
Bhatta, Gopala, xxii–xxiii, 9, 30–32, 40–41, 70–72, 209n9, 212nn4,7, 213n9
Bhattar, 13–14
bhav[a] (emotion, feeling), 16, 50, 65, 104, 157, 211n62, 212n29
Birla (temple), 182
Bochasanvasi Shri Akshar Purushottam Swaminaryan Sanstha (BAPS), 191
Bollywood, 3, 162, 176. *See also* Hindi films
Bombay. *See* Mumbai
Brahman, 80–81, 133, 141
Braj (Vraja), ix, xviii, 162, 187, 208, 209nn6,11, 210nn12,22, 212n2, 214nn23,33; depiction of, 20, 24, 68, 118, 180, 194, 196, 198–199; history of, xviii, xxi, xxiv, 1–7, 9–10, 14, 70–71, 78, 80–82, 132, 135, 174, 201; festival(s) in, 40, 91, 97; landscape of, 30, 42, 176–177, 205–206; mythology of, 17, 42–43, 83, 91, 207; pilgrimage to, xix, 106, 117; temple(s) of, 129–130, 146
Brijnathji, 139, 215nn41,42
Buddha Jayanti, 32

Buddhism, 3, 32
butter, 109, 113–114, 117, 168, 178

Calcutta, 23, 43, 62–64, 87, 101, 171, 182, 204, 213n32
calendar, xi, xvi, xxii–xxiii, 21, 38, 40–41, 72, 75, 84, 89, 91, 95–96, 108, 121, 151, 184, 194, 198, 205, 206
Chaitanya, 31, 52, 69, 76, 120, 209n6, 210nn11–14, 212nn5,7,14, 213n6, 215n36, 216n74; hagiography of, 6–7, 30, 80–82, 156, 183; presence in Vrindaban, 9–10, 17, 30, 32–34, 40, 50, 66, 70–72, 78, 128–129, 145–146, 201; theology of, 19, 35, 41, 45–46, 186, 203–204; Vaishnavism (Gaudiya sect), viii, xx–xxiii, 46–47, 77, 93, 114, 117, 138, 141, 148, 159, 174
Chandra Mahal, 123–127, *125*, 141–142, 165, 216n75
Char Dham Yatra, 70
charanamrit, xiv, 12, 85, 128
Charthawal, 81
Chaurasi (pada), 82
Chennai, 193, 214n26
City Palace (Jaipur), 123, 144, 165
costume, 109–110, 116, 159, 191, 205

darbar (royal audience), 12
darshan, 62, 99, 210n26, 212n29, 214n4; of deity, xx–xxii, 11, 18, 23–24, 36–37, 71, 109–110, 126–128, 171, 174, 184–186; among Hindu diaspora, 197–198; importance of, 11–13, 16, 22, 41, 50–51, 65, 93, 122, 144–146, 156–157, 200–201, 205, 208; in media culture, 113, 119, 121, 188–189, 191, 196; sequence(s) of, 75–77, 84–87, 152–154; temple, x–xi, xv, 34, 38–39, 43, 46–49, 58, 67–70, 72, 77, 79; timing of, 142, 148, 151, 160
Dashara (festival), 149. *See also* Dussehra
dating system, Hindu, 80

decoration, 151, 178; art of, 88–89, 105–106, 188; of deity, xvi, xix–xx, xxii, 11, 14–15, 24, 26, 50, 65–66, 86–87, 93–94, 148, 167, 182, 187, 202; for festival, 120–122; importance of, 16–18, 20–21, 26, 47–48; material for, 53–55, 57–59, 77, 111, 150, 155, 162; of temple, xvii, 34, 41, 44, 170, 203

Delhi, xii–xiii, xviii, 2, 43, 131, 139, 177, 190–191, 206

Deoband, 80

dhoti, 45, 57, 92, 115, 142, 155

dhup, 77

Disney, 176, 190

Diwali (festival), 40, 88, 91, 97, 100, 120, 149, 179

Durga, 125, 180, 188

Dussehra, 59. *See also* Dashara (festival)

Dwarka, 71, 130, 214n8

ekadashi, 40, 54, 59, 61, 80, 88, 91, 116, 125, 146–147, 157, 179

environmental degradation, xxiv, 42, 206–208

Euro-American art, 25, 64

European modernism, 24

Fatehpur Sikri, 131–132

festival, 151, 214n37; annual, 39, 120, 142, 148; calendar of, 89, 91, 121, 157, 194, 198; meaning of, xi; in media culture, 188–189; preparation of, xx, 101, 122, 157, 173; ritual(s) of, 170–171; sponsor of, 95, 157; type of, 40, 97, 149, 164. *See also* Dashara (festival); Dussehra; Holi (festival); Janamashtami (Krishna's birth festival); Khichri (ustav); Sanjhi (festival); Snan Yatra (festival); *utsav* (festival)

Ganesha, 1, 124–125, 127, 177, 180, 188

Ganga, 59, 192

Gaud[a] (Bengal), 33, 213n6

Gaudiya, xviii, 7, 33, 174, 186, 209n6, 210n14, 214n32

Gaur Govind, 129

Gayatri Devi, 143

Gitagovinda, 7–8, 42, 210n27

Gokul, 3, 78

Goma Tila (mound), 129–130, 214n6

Gopal, 178–180, *180,* 182, 187. *See also* Krishna, baby

Gopashtami (festival), 40, 91, 117, 120

gopi, 4, 6, 11, 36, 52, 71, 82–83, 89, 111, 113, 115, 117, 209n1, 210n19

Gopinath[a], 130, 135, 164, 171, 173–174, 216n74

gopuram (South Indian temple tower), 70, 194

goswami (priests), 7, 10–11, 28, 34–36, 40–41, 43, 46–47, 61, 63–64, 72, 76, 83–85, 89, 91, 98–100, 102, 105, 108–

109, 111, 114, 120, 142–143, 146, 149, 156, 165, 167, 176, 183, 188, 193, 197, 204, 206

Goswami, Anjan Kumar, xi, 138, 145, 147–148, 155–156, 158, 165, 168, 170–174

Goswami, Gopala Bhatta, 30, 32. *See also* Bhatta, Gopala

Goswami, Jiva, 33, 40, 131–132, 138

Goswami, Manas, xi, 145, 170, 174

Goswami, Mohit, x–xi, 84, 86, 92–93, 95, 121, 206

Goswami, Neha, xi, 99, 100, 108, 197

Goswami, Pradhyumna Kumarji, 146, 156

Goswami, Purushottama, x, 41–42, 51, 59, 62, 70, 144, 171, 183, 204

Goswami, Radheshlal, x, 93–94, 97, 103, 121

Goswami, Rupa, xxiii, 8–9, 32–34, 56, 129, 132, 138, 146, 158, 174, 201, 212n33

Goswami, Sanatana, 9, 30, 32, 174, 212n4, 213n6, 216n78

Goswami, Sandhya, 58, 63

Goswami, Shrivatsa, ix–x, 41, 47–48, 50, 58, 63, 96, 144, 183, 186, 192, 197, 207, 212nn4,13, 213n32, 214n21, 215n34

Govardhan (mount), 10, 40, 58, 71, 91, 106, 117, 120, 133, 135, 187, 196, 209n11, 216n78

Govardhan (puja), 40, 77, 91, 117, 120

Govind Darshan, xi, 145–146, 148, 153, 156, 184

Govinda (Mahal), 124

Govindadeva, 10, 143, 212n9, 213n44, 215nn13,34, 216n74; architecture of, xiv, *124, 125,* 127, *134,* 141, 152, 158–159, 172, *172;* history of, xi, xix, xx, xxiii, 9, 123, 126, 131–140, 142, 156, 162, 174–175, 177, 198–201; importance of, xxiv, 133, 154, 171; management of, 142–144, 146, 165, 184; in media culture, 189; ritual(s), 125, 128–130, 142, 145, *147,* 147–149, 151, 153, *154,* 155, 159–160, *160, 161,* 163–164, 166–169, *170,* 173

Guinness Book of World Records, 190

Gujarat, 71, 186, 191, 209n5

Haberman, David, x, xvii; research, 5, 19; theory, 6, 11, 23, 33; on Vrindaban, 130

Hanuman, 1, 124–125, 177, 180, 192–193

Hari (an epithet of Krishna), 30, 213n7

Hari Bhakti Vilasa, 30, 212n4

Haridasa, 110, 112, 117–118, 185

Haridasi (sect), 110, 214n32

Hindi films, 37–38, 162, 176

Hit Harivansha, 7, 9, 74, 78, 80–85, 87,

89, 91, 101, 110–111, 113, 117–121, 185, 209n9, 213nn4,5,9

Holi (festival), 13, 40, 88, 91, 97–100, 103, 114, 120, 149, 179, 213n40

Humayun, 80, 119, 150

Internet, xxiv, 189–190

Iowa Archana, 193–195

ISKCON (International Society for Krishna Consciousness), 43, 179, 182, 197, 207, 216n3

Jagannath (temple), 6, 68–69, *69,* 70, 213n52

Jahangir, 134

Jai Niwas, 124, 137, 139, 141

Jainism, 1, 3, 209n3

Jaipur, xiii, *xviii,* 63–64, 213n32, 216n74; Govindadeva temple of, xix, xxiii, 97, 124, *124,* 144, 146, *147, 154, 170,* 182–189; history of, xii, 137–138, 156, 171–174, 199, 201; Krishna worship of, ix, 123, 127–130, 145, 157, 164; palace of, 165; royal family of, 140–143, *159*

jal yatra, 45, 151, 153

jali, 28

Janamashtami (Krishna's birth festival), xi, xxiii, 72, 156–169, *166, 170,* 171, 173, 179

Jantar Mantar, 165

Jaya (king), 151–152

Jayadeva, 7, 210n27

jewelry, xv, xvii, xx, 15, 24, 26, 36, 44–46, 51–53, 55, 57, 60, 62–64, 66, 91–93, 105, 107, 116, 148, 153, 155, 159, 167, 179, 182

jhanki (glimpse), 110, 185

Jyeshta (month), 59, 151, 153

Kachchwaha, 131, 134–140, 150, 158, 174, 201

kadamba, 6, 113

kama (desire), 19

Kamadeva, 115

Kanaka (Vrindaban), 136–139, 173

Karnataka, 33, 192

Kartik (month), 100, 144, 147

kaupina (renunciate's loin cloth), 32

Kedarnath (temple), 71

Khichri (ustav), xi, 108–109, 113, 116–118, 202, 205

Kolkata (Calcutta), 43, 62–64, 87, 101, 171, 182, 204. *See also* Calcutta

Kota, xviii, 139–140, 216n71

Krishna, xv–xxiv, 14, 36, 52; baby, 178–180, *180,* 182, 187; butter, 109, 113–114, 117, 168; *bhakti* (devotional practices), xxi, 2, 7, 11, 15–17, 19, 23, 26, 30, 33–34, 118, 129, 197–198; cartoon, 176–177; *darshan* of, 65, 68, 86–87, 109, 115, 121–122, 165, 176, 190; flute,

xvii, 32, 49, 59, 75, 80–81, 83–86, 88, 92, 111, 116, 118–120, 125, 147–148, 153, 165, 167–168, 173; *lila*, xix, 4, 6–8, 14, 19, 35, 38, 48, 52, 78, 83, 113, 117, 144–145, 157, 160, 163, 186, 196–197; ornamentation of, 15, 37, 40, 52, 54, 96, 178; representations of, 10, 12, 16, 19–21, 23–26, 30–31, *31*, 33, 35, 45–47, 52, 56–59, 65, 70–71, 73, 75, 81, 83, 91–92, 101–102, *102*, 107, 110, 113, 115–116, 118; schedule, 36, 39, 58; story of, 1–7, 17, 32–33, 35, 52, 70, 80–82, 89, 116, 117; temples or shrines to, 12–13, 26, 30, 42, 48, 86, 88–89, 103; temple souvenir, xxiii, 124, 177, 183–184, 187; worship of, 7–9, 11, 16, 19, 31, 34, 37, 40, 43, 65, 72, 78, 81, 97, 109, 115, 119. *See also* Bal Krishna; Gopal
Kumhabhishekam (ceremony), 194
kunj (forest arbor), 29, 55, 81–82, 162, 197. *See also nikunj*
kunj mahal, 55

Lakshmi (goddess), 40, 62, 138, 180, 188
Lalita (*sakhi*), 110, 128, 142
laukika (things of this world), 19
linga, 59
liturgy, 11, 39, 46, 75, 212n25
Lodi, Sikander, 80
Loi bazaar, xx, 178
London, 191
Lotus, 28, 42, 55, 59, 71, 101, 105, 153, 165, 196
lotus pond, 171, 196

Madan Mohan, 9, 130, 135, 171, 174, 216nn74,78
madhura-bhakti-rasa, 34
Madras, 193. *See also* Chennai
Magh (month), 108
Maharajah (of Jaipur), xxiii, 123, 156, 172
mala (garland), 32, 110, 125, 147, 151, 153, 159, 163, 167–169, 172, 184, 191, 194
mandir (temple), 1, 123, 125, 191
mangala arati, 76, 78, 109, 117, 121, 143, 186
Marwari (merchant community), 178, 186
Mathura, xviii, 2–3, 6, 80, 118–119, 132, 135, 161, 174, 178, 182, 206, 209n4
Mewar, 133, 135–136, 139
modernism, 22, 24
Mughal, xxiii, 6, 28, 64, 74, 118–119, 125, 131–136, 141, 150, 215nn11,51
mukut (crown), 178
Mumbai, 182, 216n3

naga (snake deity), 3
Nandotsav (festival), 164, 169, 171–172, *172*, 174

Narada (sage), 37
Nathdwara, 135, 139, 150, 182, 186–187, 211n58
Nathji, Shri, 9–10, 133, 135, 139, 150, 174, 186–187
National Public Radio, 5
Nepal, 30
New Delhi, xviii, 43, 177, 190
Nidhi Bandh, 185
nikunj, 17, 78, 83, 94, 158, 197
nirguna, 15
nitya (*vihara*), 78, 83, 93
Nrsimha (Krishna in the form of a man-lion), 32

Orissa, 6, 33, 68, 70, 134, 213n52

pan (betel leaf), 67, 115, 129
panchamrit, 72
parakiya (married to another), 33
Paramananda, xii, 14, 173
parikarama (circumambulatory pathway), 206
Parvati, 116, 125, 180, 188
Paush (month), 108
pavitra dvadashi, 158
picchwai, 187
Phuldol, 149
poshak (clothing), xx, 36, 46–47, 52, 54–57, 61–64, 75, 88, 91–92, 98–103, 108, 115–117, 145–152, 155, 163, 167, 169, 173, 178–181, 183, 191, 194, 202–203
Prahlada, 32, 71
prashad[a], 12, 23, 77, 85–86, 98, 102, 105, 108, 111, 116, 121, 128, 150, 164, 166, 168–170, 173, 184
prema (love), 19
pujari (ritual assistant), 127, 154
Puri, 6, 33, 68–69, 70, 129
purnima (full moon), 6, 40, 52–53, 83, 88–89, 101, 120, 144, 147, 179
Pushti Marg (Vallabhacharya sect), 7, 97, 186, 209n6, 212nn15,28

Radha, 28, 106, 114, 128; adornment of, 45, 47–48, 50, *54*, 66, 88, 103, 147, 149, 153; birthday of, 89; history of worship of, 5–7, 134; Krishna with, xv–xvi, xx, 14, 25, 32–36, 67, 70, 78, 91–93, 101, 109–111, 130, 203; literature of worship of, 16, 56–57, 87, 115–118, 145, 151–152; in media culture, 188; mythology of, 3, 80–84, 135; play, 161–164; representation of, 76, 97, *102*, 206; worship in Braj of, xi, xxii, 1, 74, 119–120, 125, 142, 148, 154, 167–168, 185; worship outside Braj of, 177–178, 182, 187, 195–199
Radhakund, 171, 196
Radharamana, ix–xi, xix–xx, 10, *31*, 55, 56, 60, 61, 59–64, 73, 135, 204,

212nn5,13,23,25, 213nn34,44; architecture of, 70–71, 74, 77, 84, 86–87, 152, 157, 181; history of, xxi–xxiv, 9, 31–32, 35, 59, 78; importance of, 51, 174, 177, 197–201; management of, 28, 32, 34–35, 39, 54, 62–64, 144; in media culture, 183–184, 188–189; ritual(s) in, *29*, 30, 33, 36–37, 40–42, 44, 44–46, 48–51, *52*, 53, 66–69, 72, 75–76, 82, 97, 108, 127–128, 147, 185
Radhasudhanidhi, 87
Radhavallabha, x–xi, xix–xx, xxii, xxiv, 7, 9; *adhik mas* festival, 95–108, *100*, *107*; description of, 74–76, 79, 84–86, 88, *90*; founder (Hit Harivansha), 78–82, 119–120; Khichri Utsav festival, 108–118, *112*, *113*, *114*; schedule, 76–78, 79, 84–86, 87–91; sectarian distinctiveness, 80–83; website, 118–122. *See also* Hit Harivansha; Krishna, flute; Radha; *sakhi* (girlfriend)
rag seva, 60
Rajasthan, xvii–xviii, xxiii, 1, 111, 127, 130–131, 142–143, 146, 156, 158, 164, 178, 186, 209n6
Rajput, xxiii, 1, 15, 28, 64, 67, 123, 125, 131–136, 139, 141, 150, 158, 175, 187, 215n11
rakhi, 149, 159
Rama, 138, 180, 188
Ramanuja, 13
Ramayana (TV series), 192
Rameshwaram, 71
Ras Purnima (autumnal full moon), 6, 147
rasavada (aesthetic relish), 186
ras-lila, xix, 6–7, 48, 52, 144, 213n36
religious television, 188–189
ritual, x–xi, xv, xix–xx, xxii–xxiii, 5, 13, 18, 20, 30, 32–33, 42, 48, 59, 84, 86, 89, 100, 103–104, 108, 111, 128, 138, 140, 142–143, 145, 147, 150, 155–156, 166–169, *166*, 171, 176, 178, 187, 189, 195, 199, 203; assistant, 127; kingship, 137; liturgy, 11; paraphernalia, 124; tools and offerings, xv, 12, 44, 47, 77, 85, 92, 98, 107, 153, 172, 182; year, schedule, xx, xxii–xxiii, 40–41, 72, 87–88, 95, 97, 117, 120–121, 186, 194, 200
rudraksha (beads), 124
Rukmini, 80

sadhana (religious practice), 5
saffron, 54, 57, 72, 75, 99, 147, 153, 162, 164, 169, 173, 212n30
Sagar Theme Park, 191–192
saguna, 15
sakhi (girlfriend), 11, 71, 78, 83, 101, 110–111, 113, 115–117, 128, 142, 145–146, 153, 163, 168, 212n29, 214n33; *sakhi bhav*, 212n29

samaj, 86, 89, 97–99, 101–102, 105, 121, 171

sampradaya, 33, 78, 80, 118, 146, 174, 181

sandal-paste, xvi, 72, 77, 212n30

Sanjhi (festival), 100–102, *102,* 120–121, 220

Sanskar TV, 188

Sanskrit, 8, 80, 195

sati (immolation of a woman on her husband's funeral pyre), 15

seva (service), 11, 22, 32, 35, 41–43, 48, 59–60, 62–63, 66–68, 70, 77–78, 81–82, 87, 93, 162, 165, 179, 183, 186–187

Shah Jahan, 134

Shaivaite, 111, 124, 132

shalagrama (sacred black stones), 30, 71, 146

Sharad Purnima (festival), 40, 52–53, 83, 89, 101, 120, 147

shayan arati, 143, 189

Sheesh Mahal (mirror palace), 66–68, 163

Shila Mata, 140

Shiva, 1, 19–20, 37, 59, 81, 115, 117, 119, 124–125, 163, 180, 188, 209n1

shola pith, 60, 66, 70

Shravan (monsoon season), 88

Shri Chaitanya Prem Sansthana, 31, 41, 52, 69

Shri Nathji (main deity of Pushti Marg sect), 9–10, 133, 135, 139, 150

shrine, xv–xvi, xxiii, 1–3, 9–10, 59, 80–81, 103, 124, 131, 135, 143, 146, 177, 182, 193, 214n11, 215n13

shringar (ornamentation), x, xiv, xx, 9, 15, 48, 50, 64–65, 68–69, 84–85, 87, 121, 151, 211n37. *See also* decoration; jewelry

shringara rasa, 9, 48, 87, 211n37

Shrirangam (temple), 12–14, 30, 70

Shrirangaraja Stava I (collection of poems), 14

Shrivaishnava (sect), 13

Singh, Maharao Bhim, 139, 215

Singh, Sawai Jai, 123, 136–142, 145, 156, 173, 216n52

Singh, Sawai Man, 123, 131–134, 139–140, 215nn13,20

Singh, Sawai Pratap, 142

singing, 11, 44, 68, 74, 86–87, 89, 93, 99, 122, 157. *See also bhajan* (song); *samaj*

Sita, 138, 180, 188

Snan Yatra (festival), 153

South India, 7, 13–14, 30, 57, 64, 70, 192–194

Sri Govinda Varsikadvadasakam, 142, 148, 151

Surya Mahal, 123–126, 137–138, 141, 145, 173

svarupa (self-manifestation), xix, 30–32, 115–116, 129, 210n11

Taj Mahal, 180, 207

Tamil Nadu, 13, 30, 70

Times of India, 176

Tiruchirapalli (Trichy), 70

tribhanga (triple-bent), 32

tulsi (sacred basil leaves), xvi, 5, 29, 30, 106, 110, 128, 209n6, 211n1

Udaipur, 136, 139

Uddhava, xvi, 130

United States, 190, 194–196

utsav (festival), xx, 39, 43, 97, 120, 183, 201, 210n26, 214n37; Khichri *ustav,* 108–109, 113, 116–118, 202, 205. *See also* festival

uttaphan (arati), 85

Uttar Pradesh, 1

Uttarakhand, 71, 130

Vaishakha (month), 30, 71, 80, 89, 151

Vaishnava, xvii, xix–xx, xxii, 6–7, 9–10, 13–14, 17, 30, 33–34, 40, 77, 93, 119, 138, 186, 195

Vajranabh, 129–130, 138, 173–174, 201, 214n8

Vallabhacharya, 7, 9, 133, 139, 186. *See also* Pushti Marg (Vallabhacharya sect)

Vamana, 115

Varanasi, 43, 63–64, 135, 182, 209n7, 213n32

Varma, Ravi, 24, 197

Vedantadeshika, 14

Vikrama Samvat (dating system), 80

Vinodilal, 97, 135, 174, 216n74

viraha (separation), 34

Vitthalnath, 7

Vrindaban, ix–xiii, xv, xx, xxiv, 30, 31, 36, 42, 51, *57,* 61, 71, 78, 87, 91, 98, 103–104, 106, 108, 111, 124–125, 128, 146, 161, 164, 171, 174, 177–188, 196, 201, 207; history of, 5–7, 30, 32–33, 70, 72, 74, 80–83, 117–121, 123, 129–145; named for, 30; temples of, xviii, xxi, xxiii, 1, 9–10, 43, 48, 101, 121, 157, 173, 178–179, 183, 188, 204; worship in, 10, 17, 49, 53, 80, 109, 115, 149, 206

Vrindadevi, 31

Vyasa Mishra, 80

yaksha (protector deity), 3

Yamuna (river), xv, 3–4, 6, 30, 55–57, 71–72, 81, 83, 101, 111, 118, 132, 196, 207, 211n1

Yashoda, 36, 114, 163

yoga, 23, 198

yoga-pitha, 130, 133, 138

yugal (couple), 116–117

Cynthia Packert is Professor in the Department of History of Art and Architecture at Middlebury College. She is author of *The Sculpture of Early Medieval Rajasthan*.